SAVAGE TALES

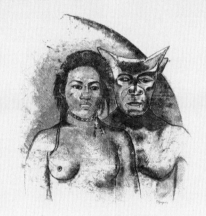

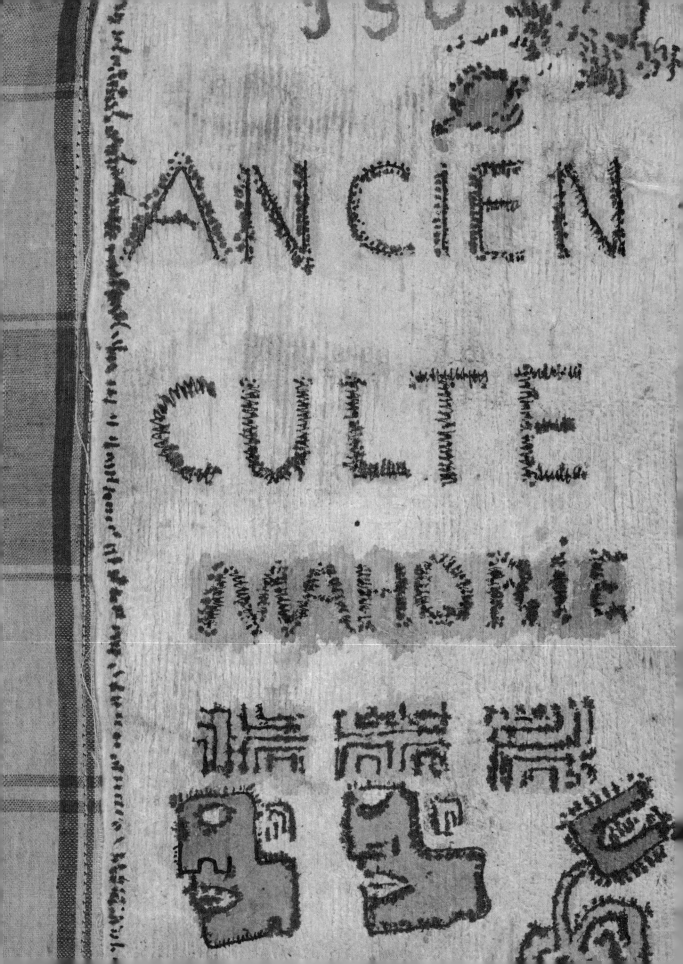

SAVAGE TALES

The writings of

PAUL GAUGUIN

LINDA GODDARD

YALE UNIVERSITY PRESS, NEW HAVEN AND LONDON

First published by Yale University Press 2019

302 Temple Street, P.O. Box 209040, New Haven CT 06520-9040

47 Bedford Square, London WC1B 3DP

yalebooks.com / yalebooks.co.uk

Published with assistance from the Charles S. Brooks
Publication Fund

ISBN 978-0-300-24059-7 HB

Library of Congress Control Number: 2019939698

10 9 8 7 6 5 4 3 2 1

2023 2022 2021 2020 2019

Designer: Georgia Vaux

Copy-editor: Lise Connellan

Printed in China

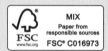

MIX
Paper from
responsible sources
FSC FSC® C016973
www.fsc.org

Front cover (clockwise from top left): *L'Esprit moderne et le
catholicisme* (detail, fig. 56); original issue of *Le Sourire: Journal sérieux*
(detail, fig. 60); *Le Sourire*, 1899–1900. Masthead (detail, fig. 63);
original issue of *Le Sourire: Journal sérieux* (detail, fig. 60); *Le Sourire:
Journal méchant*, March 1900. Title page showing *Composition with
a Turkey* (fig. 1); *Cahier pour Aline*, 1893, double page about *Manaò
tupapaú* (*Spirit of the Dead Watching*) (detail, fig. 24); cover of the
manuscript *Ancien Culte mahorie* (detail, fig. 49); *Noa Noa*, 1894–1901,
folio 39 recto (p. 71, detail, fig. 44)

Back cover (and front cover, central panel): *Le Sourire*, 1899–1900.
Masthead (detail, fig. 63).

Frontispieces: *Tahitian Woman with Evil Spirit*, *c.*1900. Recto (detail,
fig. 13); cover of the manuscript *Ancien Culte mahorie* (detail, fig. 49)

Contents

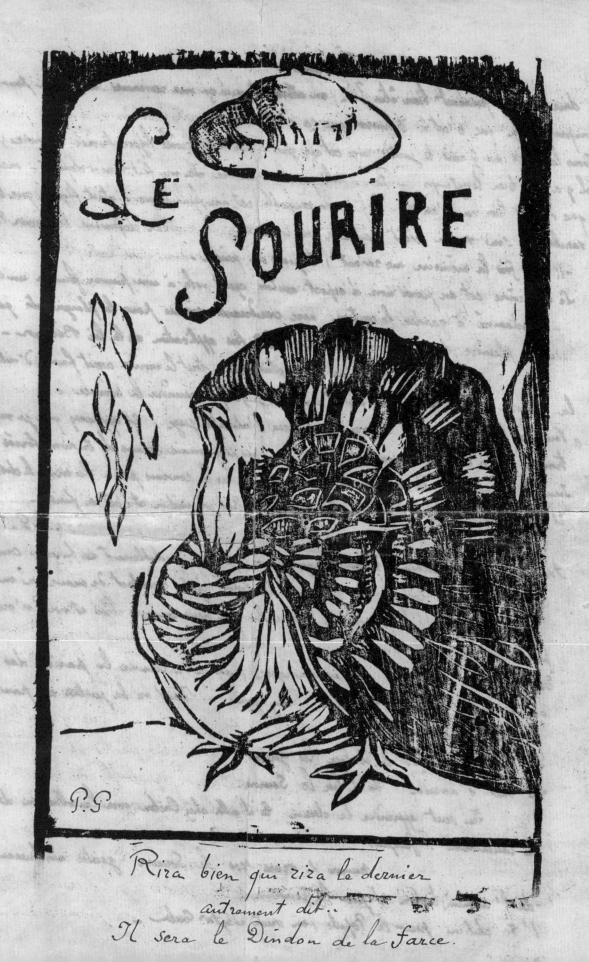

Rira bien qui rira le dernier
autrement dit..
Il sera le Dindon de la Farce.

Introduction

------·······------

8

'THIS IS NOT A BOOK', Paul Gauguin (1848–1903) declared in the opening words of his unconventional memoir *Avant et après* (Before and after), completed a few months before his death in the Marquesas Islands, and 'I am not a writer. I should like to write as I paint my pictures – that is to say, following my fancy, following the moon, and finding the title long afterwards.'¹ As childhood reminiscences follow opinion pieces on art and politics, tirades against colonial officials, assorted aphorisms and anecdotes, and passages copied from other authors, all interspersed – in the original manuscript – with pen and ink drawings and monotypes that do not directly illustrate the text, *Avant et après* might indeed seem haphazardly composed (fig. 2). But Gauguin's aspiration to write 'following his fancy' is no more convincing than his corresponding claim to paint with total spontaneity. His introductory disclaimer, 'This is not a book', reappears a further nine times, punctuating the narrative with an insistence that calls its innocence into question. The phrase itself recalls a literary precedent, *Ceci n'est pas un conte*

(*This is Not a Story*), by the philosopher Denis Diderot (1713–1784), whose writings Gauguin admired, and who inaugurated the discourse of art criticism with which the artist polemically engaged.² Structured in the form of a dialogue, Diderot's text drew attention to the conventions of storytelling by incorporating a 'listener' who mocked the predictability of every twist in the narrator's tale of love affairs gone wrong; likewise, in his *Jacques le Fataliste et son maître* (*Jacques the Fatalist and his Master*), the narrator repeatedly addresses a 'reader' with the reminder that 'this is not a novel', since it lacks the plot coincidences and other narrative devices belonging to that genre.³ On the opening page of *Avant et après*, Gauguin reflects sardonically on the conventions that dictate the form of a book – 'A sentence that might be excellent in the fourth chapter would be all wrong in the second, and not everybody knows the tricks of the trade' – and of autobiography – 'Memoirs! That means history, dates. Everything in them is interesting except the author. And one has to say who one is and where one comes from.'⁴

Previous:
Fig. 1 *Le Sourire: Journal méchant*, March 1900. Title page showing *Composition with a Turkey*. Mimeograph in brownish-black ink, with woodblock print in black ink on cream wove paper, 31.8 × 50.5 cm (full sheet), 31.8 × 25.3 cm (folded sheet), 26.5 × 16.5 cm (image). The Art Institute of Chicago

Fig. 2 *Avant et après* [1903], facsimile edition (Copenhagen: Scripta / Poul Carit Andersen, 1951), p. 127. 21.7 × 29.6 cm

INTRODUCTION

In the French Enlightenment tradition of the anti-novel, self-reflexive references to the novelist's craft drew attention to the inescapability of literary conventions, even while mocking recourse to outworn devices. In aligning himself with this counter-tradition via the allusion to Diderot, Gauguin likewise signalled his literary credentials in the very process of denying them. His assertion that he is 'not a writer' should not be accepted at face value.

But I do want to take seriously Gauguin's analogy between his art and writing: not to credit his own suggestion that he wrote and painted with equal artlessness, but to argue that the apparent naivety of his writing was as deliberately constructed as that of his paintings and 'savage' persona. Like other well-known nineteenth-century painters, notably Eugène Delacroix (1798–1863) and Vincent van Gogh (1853–1890), Gauguin was also a committed and engaging writer. Over the course of his career in France and Polynesia, he produced seven extant manuscripts (thirteen in total were recorded in his estate sale), a substantial correspondence, articles in French and Polynesian newspapers, and his own satirical broadsheet.[5] Ever since the naval doctor and

budding ethnographer Victor Segalen – entrusted with a bundle of Gauguin's manuscripts when he arrived on the Marquesas shortly after the artist's death – copied passages into his diary, Gauguin's own words have been foundational to his legendary status as interpreter of the 'exotic'.[6] Fictionalised retellings of his life, from W. Somerset Maugham's *The Moon and Sixpence* (1919), to the latest biopic starring celebrated French actor Vincent Cassel (2017), owe much to the artist's own story of his escape from 'civilisation'. This film, *Gauguin – Voyage de Tahiti* (*Gauguin: Voyage to Tahiti*), shares its subtitle with Gauguin's account of his first years in Polynesia, *Noa Noa: Voyage de Tahiti*, on which it is loosely based. Maugham, meanwhile, took inspiration from the volume of Gauguin's correspondence with his friend George-Daniel (also known as Daniel) de Monfreid, which was first published in 1918.[7]

Despite – or perhaps more accurately because of – the biographical appeal of Gauguin's writings, they are rarely analysed in literary or visual terms. Pocket editions obscure the material complexity of the original manuscripts, making it easier to read them as unmediated guides to the artist's inner thoughts,

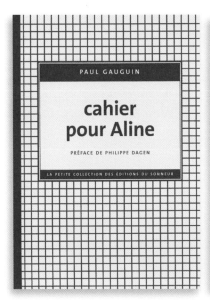

À ma fille Aline, ce cahier est dédié.

Notes éparses, sans suite comme les rêves, comme la vie toute faite de morceaux.

Ces méditations sont un reflet de moi-même. Elle aussi est une sauvage, elle me comprendra. Mes pensées lui seront-elles utiles ? Qu'importe. Je sais qu'elle aime son père, qu'elle le respecte. Je lui donne un souvenir.

Dans maints passages, la morale acceptée aujourd'hui est outragée. Qui a raison ? La foule ou moi ? Mystère.

En tout cas, Aline a, Dieu merci, la tête et le cœur assez haut placés pour ne pas s'effaroucher, se corrompre au contact du cerveau démoniaque que la nature m'a donné.

La foi et l'amour sont de l'oxygène. Eux seuls font vivre.

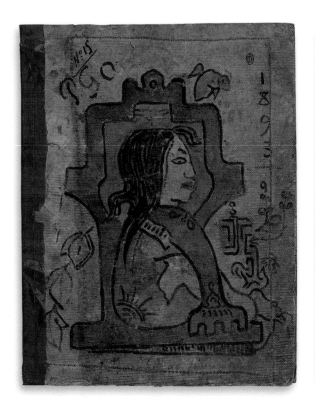

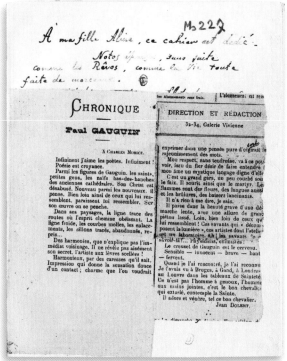

rather than as carefully constructed documents (figs 3–6). Daniel Guérin's anthology of excerpts, *Oviri: Écrits d'un sauvage* (1974; translated as *The Writings of a Savage*, 1996), remains the standard reference work for citations from Gauguin's texts, despite its wilful reorganisation of his intentionally fragmentary narratives. The attention accorded to his various writings has also been radically uneven. At an estimate, there are well over a hundred distinct editions of *Noa Noa* in its different versions, but some of his other writings remain unpublished or obscure; the satirical journalism that he penned in Tahiti, for example, is rendered doubly inaccessible by the rarity of the editions and the frequent provincialism of Gauguin's attacks on local colonial officials. This striking discrepancy in publishing fortune is paralleled by an imbalance in scholarly attention. With a few exceptions, analyses of his writing (including my own so far) have been limited to individual texts – primarily *Noa Noa*, and to a lesser extent *Avant et après*.[8] In this book, I adopt a broader perspective. I counter the tendency to interpret his writings merely as a source of information about his life, and instead take them seriously as a literary endeavour, and as part of an artistic practice that ranged experimentally across media.

It is in his illustrated manuscripts that Gauguin's well-known tendency to rework existing subjects – whether of his own invention or copied from others – is most explicit. Here, he recycles both words and images, combining them on the page, and often reflecting on his own cross-disciplinary activity as an artist-writer. It has long been established that his paintings, especially after his move to Tahiti in 1891, consist of a bricolage of motifs that are derived from European, Oceanian, Asian and South American sources, usually via reproduced images; his sampling of poses from the photographs that he owned of the Borobudur Temple reliefs of the Life of Buddha is a notable example. As is sometimes observed, his writings are constructed in a similar manner, incorporating transcribed passages of literature and art criticism, aphorisms and poetry, extracts from philosophical, religious or anthropological essays, travelogues and colonial guides, often without identifying their provenance. Since 2010, a number of key exhibitions have radically expanded Gauguin's profile from Post-Impressionist painter to equally experimental printmaker, woodcarver and ceramicist. In the process of tracking themes across different art forms, these exhibitions have centred attention on the fact that Gauguin not only *borrowed* motifs, but also reiterated and adapted them from one work to the next.[9] Scholars have offered productive explorations of hybridity, repetition and reproduction as active principles in Gauguin's art, complicating the standard view of his eclectic patchwork of sources as simply exploitative or superficial.[10]

It is time to integrate fully Gauguin's writing into these conversations. For not only is his fragmentary manner of textual composition equivalent to the procedure that he adopted for his painting, sculpture and printmaking (he reiterated as well as borrowed texts from other sources, including his own earlier writings), but the manuscripts vividly materialise the process of appropriation, so that it becomes much more palpable and deliberate in this format. The qualities of reiteration and appropriation that are typical of his work therefore come into sharper focus if his writing is accepted as an integral component of his creative practice, rather than merely a commentary upon it.[11] The still-unpublished *Diverses choses* (Miscellaneous things, 1896–8), for instance, whose very title announces its episodic form, reveals itself as

Fig. 3 Cover of *Cahier pour Aline* [1893], ed. Philippe Dagen (Paris: Éditions du Sonneur, 2009), 14.9 × 10.5 cm
Fig. 5 *Cahier pour Aline*, 1893, cover. Ink and gouache on paper, 21.5 × 17 cm. Bibliothèque de l'Institut National d'Histoire de l'Art, Paris, Collections Jacques Doucet, NUM MS 227

Fig. 4 Dedication page of *Cahier pour Aline* [1893], ed. Philippe Dagen (Paris: Éditions du Sonneur, 2009), p. 17. 14.9 × 10.5 cm
Fig. 6 *Cahier pour Aline*, 1893, dedication page. Ink and press clippings, 21.5 × 17 cm. Bibliothèque de l'Institut National d'Histoire de l'Art, Paris, Collections Jacques Doucet, NUM MS 227

échauffé en écrivant, je commence à avoir une certaine compréhension de l'art de Gauguin.

On a reproché à un auteur moderne de ne pas dépeindre des êtres réels, mais de construire tout simplement lui même ses personnages. Tout simplement!

Bon voyage, Maître; seulement revenez-nous et revenez me trouver. J'aurai peut-être alors appris à mieux comprendre votre art, ce qui me permettra de faire une vraie préface pour un nouveau catalogue dans un nouvel hôtel Drouot, car je commence aussi à sentir un besoin immense de devenir sauvage et de créer un monde nouveau.

Aug. Strindberg.

— Ma réponse —

Cher Strindberg.

Je reçois aujourd'hui votre lettre; votre lettre qui est une préface pour mon catalogue. J'eus l'idée de vous demander cette préface lorsque je vous vis l'autre jour, dans mon atelier, jouer de la guitare et chanter; votre œil bleu du Nord regardait attentivement les tableaux pendus aux murs. J'eus comme le pressentiment d'une révolte; tout un choc entre votre civilisation et ma barbarie.

Civilisation dont vous souffrez. Barbarie qui est pour moi un rajeunissement.

Devant l'Ève de mon choix que j'ai peinte en formes et harmonies d'un autre monde, vos souvenirs d'élection ont évoqué peut-être un passé douloureux. L'Ève de votre conception civilisée vous rend et nous rend presque tous misogynes; l'Ève ancienne, celle qui dans mon

a chorus of voices through the citation (even if partial and inconsistent) of names, as in the transcription of his correspondence with Swedish playwright August Strindberg (1849–1912), or changes in ink colour and pasted-in newspaper cuttings (figs 7 and 8). In one double-page spread, the visual interest already supplied by the combination of handwriting, sketch, press cutting, and reproduced photographs of Gauguin and his work, is augmented by the arrangement of the text in a variety of configurations dictated by the conventional formats of diverse literary genres: poem, letter, caption or proverb (fig. 9).

If Gauguin's habitual borrowing takes time to uncover in his painting and sculpture, in the cut-and-paste composition of his manuscripts it is immediately apparent. In their original form, the manuscripts themselves host some of the motifs that he appropriated and repurposed in his artworks, in sequences of collaged reproductions (figs 10 and 11).[12] The principle of assemblage that governs their narrative content extends to their physical format, resulting in a striking scrapbook aesthetic that is lost in the printed editions, and rarely taken into account when his writings are consulted for their biographical interest, or to assist in the iconographical interpretation of his artworks. In this book, I interpret these features of his writing not as naive or derivative, but as a canny response to the necessarily partial nature of his encounter with Polynesian culture, and as embedded in the nineteenth-century European fascination with the fragment.

In addition to their analogous compositional procedures, Gauguin's writings are also connected to his art via shared materials and methods of reproduction. For his satirical newspaper *Le Sourire* (The Smile), which he wrote, printed and distributed in Tahiti in nine monthly issues between 1899 and 1900, he used an Edison mimeograph machine to produce both the text and the sketch-like illustrations (fig. 12).

It has been suggested that his engagement with this early form of copier, which produced small print runs from a stencilled handwritten text, together with his awareness of carbon-paper methods of duplicating letters, which he would have used during his brief employment as a draftsman-clerk in the Public Works Department in Papeete, inspired Gauguin's concurrent invention of the transfer drawing, or *dessin-empreinte*. In this technique, the acts of drawing and printing are simultaneous: he placed a blank sheet of paper on top of a support coated in ink, then drew on its surface, exerting pressure with a fine pencil so as to transfer a reversed echo of the drawing, which became the final product, to the underside of the top sheet (fig. 13).[13]

Gauguin's journalistic endeavour also intersected with his artistic production via the woodcuts that he used, from the fourth issue onwards, as the journal's decorative masthead (fig. 1), which belong to the same campaign of production as the group of late woodblock prints (1898–9) known as the Vollard suite. Although relatively few sets of *Le Sourire* survive (Gauguin seems to have printed about 25 copies of each number), it is apparent that he varied the masthead design for different copies of the same issue, thus troubling the distinction between the unique and the multiple. He also recycled the *Le Sourire* woodcuts, producing independent impressions that he sent back to France as freestanding works of art, or pasting fragments onto the pages of his manuscript *Noa Noa* (1894–1901, fig. 14), establishing a crossover between his art and writing that encompassed motifs, materials, reproduction technologies and approaches to composition. This symbiosis of text and image deserves to be given due weight in appraisals of Gauguin as an artist who worked across media and turned copying to creative effect.

However, if Gauguin's working methods brought art and literature together, he was also firm about

Fig. 7 *Diverses choses*, 1896–8, folio 126 (p. 244). Manuscript notes, pen and ink, 31.5 × 23.2 cm. Musée d'Orsay (held at the Musée du Louvre), Paris, RF 7259, 1

Les po. Velasquez est essentiellement royal

Rembrandt le magicien essentiellement. Prophète.

Je ne sais plus quel auteur anglais a dit qu'on devait reconnaître le roi quoique nu dans une foule de baigneurs. Il en est de même pour l'artiste, on doit le distinguer quoique caché derrière les fleurs qu'il a peintes. Courbet fit cette belle réponse à une dame qui lui demandait ce qu'il pensait devant un paysage que celui-ci était en train de peindre - "

Je ne pense pas Madame, je suis ému - Oui le peintre doit en action, doit être ému mais auparavant il pense. Qui peut m'assurer que telle pensée, telle lecture, telle jouissance n'ait point influencé quelques années plus tard une de mes œuvres.

Forgez votre âme, jeunes Artistes, donnez lui constamment une nourriture saine, soyez grands, forts, et nobles, je vous le dis en vérité, votre œuvre sera à votre image. —

J'ai un coq aux ailes pourpres, au cou d'or, à la queue noire. Dieu qu'il est beau ; Et il m'amuse -

« En matière d'art j'avoue que je ne hais pas l'outrance ; la modération ne m'a jamais semblé le signe d'une nature artistique vigoureuse. J'aime ces excès de santé, ces débordements de volonté qui s'inscrivent dans les œuvres comme le bitume enflammé dans le sol d'un volcan... »

BAUDELAIRE.

J'ai une poule grise au plumage hérissé ; elle gratte, elle picote, elle abîme mes fleurs. Ça ne fait rien elle est drôle, puis elle n'est pas bégueule : le coq lui fait signe et aussitôt elle offre son croupion. Lestement et vigoureusement il monte dessus. Ah c'est bientôt fait ! Est-ce de la chance ? je ne sais. Les enfants rient, je ris. Mon Dieu que c'est bête - Quelle disette, rien à bouloter, si je mangeais le coq (j'ai faim Il serait trop dur. La poule alors ? Mais je ne m'amuserais plus à voir mon coq aux ailes pourpres, au cou d'or à la queue noire, monter sur la poule ; les enfants ne riraient plus - J'ai toujours faim

the distinctions between them, both as forms of expression and as professions aligned with disparate social identities. This opposition is crucial to understanding the anti-literary character of his writing. To return to his statement at the beginning of *Avant et après*, where he linked his approaches to writing and painting, his ambition to 'write as I paint my pictures' not only indicates the stylistic or compositional similarity between his art and texts, but also the *difference* between his own writing and that of professional 'men of letters'. It is a distinction that he repeatedly insisted upon, as when he declared in his late diatribe against critics, *Racontars de rapin* (recently published in translation as *Ramblings of a Wannabe Painter*), written in 1902, that 'I'm going to try to talk about painting, not as one of the Literati, but as a painter'.[14] Sending the 'hastily written' manuscript to the sympathetic critic André Fontainas at *Le Mercure de France*, where he hoped to get it published, Gauguin asserted that it was written with 'no literary pretention'.[15] Although the journal rejected his manuscript, he renewed his efforts the following year, urging Fontainas to secure the publication of his latest literary endeavour *Avant et après*, whose 'stripped down' style came easily, he wrote, since (borrowing a phrase from the manuscript itself), 'I am not a writer'.[16]

In crafting his unpretentious style, Gauguin drew on precedents such as Delacroix's *Journal* (which he quoted), Maurice Denis's art criticism and Van Gogh's letters (some of which were published posthumously between 1893 and 1897).[17] Richard Hobbs has insisted upon the specificity of artists' writing as a category of text, and argued that Gauguin's simultaneous adoption and denial of literary conventions needs

to be understood in relation to the flourishing of this genre in nineteenth-century France.[18] The artist and his colleagues operated in a climate of intense competition with literature, as they struggled to resist the interpretations imposed upon their work by writers made newly powerful by the speculative 'dealer-critic system', in which artists were reliant on the press to establish their reputations in a free market.[19] (Gauguin complained that the 'rule of the Literati' had simply replaced the former monopoly of the state-controlled institutions such as the Académie des Beaux-Arts that he dubbed the 'rule of the Sword').[20] In this context, writing became a strategic, if paradoxical, means of defending the autonomy of visual art, particularly as painters such as Gauguin rejected easily readable narratives in favour of the suggestive properties that they associated with the non-referential art of music. Like other *peintres-écrivains*, Gauguin exploited conventional literary formats to promote the cause of the visual arts (using autobiography to forge a public identity, for instance), and his texts should be read, as Hobbs argues, with this 'duality' in mind.[21]

Gauguin's case therefore helps to explain the strategies and predicaments of other artist-writers, not only in the nineteenth century but beyond. The informal and anti-intellectual tone of voice that he adopted continues a pre-existing tradition, which persists into the present century. Thomas Couture, for example, prefaced his thoughts on painting, published in 1867, with the disclaimer 'what I am writing is not literature'.[22] Denials of literary ambition protected artists from accusations of trespassing into the writer's domain, but they also answered a public demand for authentic insights into the artist's craft. In an 1883 study on artist-writers, for instance, its

Fig. 8 *Diverses choses*, 1896–8, folio 108 (p. 208). Manuscript notes, pen and ink, with press cutting, pasted, 31.5 × 23.2 cm. Musée d'Orsay (held at the Musée du Louvre), Paris, RF 7259, 1
Following pages:
Fig. 9 *Diverses choses*, 1896–8, folios 117 verso and 118 recto (pp. 228–9). Manuscript notes and (pen and ink) sketch and press cuttings, 31.5 × 23.2 cm (each sheet). Musée d'Orsay (held at the Musée du Louvre), Paris, RF 7259, 1

Fig. 10 *Diverses choses*, 1896–8, folios 121 verso and 122 recto (pp. 236–7). Photograph of fresco by the School of Giotto and collaged reproductions of lithographs by Daumier and Forain, 31.5 × 23.2 cm (each). Musée d'Orsay (held at the Musée du Louvre), Paris, RF 7259, 1
Fig. 11 *Diverses choses*, 1896–8, folios 122 verso and 123 recto (pp. 238–9). Collaged illustrations by Hokusai, pen and ink drawings after Delacroix and collaged reproduction of engraving by Lucas van Leyden, 31.5 × 23.2 cm (each sheet). Musée d'Orsay (held at the Musée du Louvre), Paris, RF 7259, 1

Mon portrait par ma Vahiné Pahura.

Vers de Verlaine.

Le ciel est par dessus le toit
Si Bleu , si calme !
Un Arbre, par-dessus le toit
Berce sa palme.

La cloche dans le Ciel qu'on voit
Doucement tinte.
Un Oiseau sur l'arbre qu'on voit
Chante sa plainte.

— Qu'as-tu fait, ô toi que voilà
Pleurant sans cesse,
Dis , qu'as tu fait, toi que voilà
De ta jeunesse ?

Mon Dieu, mon Dieu , la vie est là
Simple et tranquille
Cette paisible rumeur là
Vient de la ville.

————————

— Tea Teo —
Accompagnement de la mer se brisant sur les rochers
de corail,

St Bernard — O beata solitudo !
O Sola beatitudo !

encore de l'état de nature, où le drame humain se déroule dans un cadre plus somptueux, sous une lumière plus intense. Chez Baudelaire déjà — embarqué l'âge de jeunesse à peine atteint, comme Gauguin — s'était rencontrée cette nostalgie des pays de rêve à peine entrevus, inoubliablement aimés. Relisez le sonnet *À une créole*, les vers *À une Malabraise*, et, parmi les *Petits poèmes en prose*, celui-ci : *Les Projets*, annonciateur fidèle des hantises de Gauguin : « Au bord de la mer, une belle case en bois enveloppée « de tous ces arbres bizarres et luisants « dont j'ai oublié les noms...; dans l'atmo- « sphère une odeur enivrante, indéfinis- « sable...; dans la case, un puissant par- « fum de rose et de musc...; plus loin, « derrière notre petit domaine, des bouts « de mâts balancés par la houle; autour « de nous, au delà de la chambre éclairée « d'une lumière rose tamisée par les stores, « décorée de nattes fraîches et de fleurs « capiteuses, avec de rares sièges, au delà « de la varangue le tapage des oiseaux ivres « de lumière et le jacassement des petites « négresses..., et, la nuit, pour servir d'ac- « compagnement à nos songes, le chant « plaintif des arbres à musique, des mé- « lancoliques filaos ! Oui, en vérité, c'est « bien *là* le décor que je cherchais. Qu'ai-je « à faire de palais ? » Tel est le décor dans les ...

Paul GAUGUIN, peintre et sculpteur, né à Paris le 7 juin 1848.

GAUGUIN.—Bois sculpté.

...ieurs sentinelles ...
...ées contre le mur .
...dessus sur la chaux ;
...che se détache en noir
...scription
...té, égalité, Fraternité.
...iberté : Oui —

Égalité Pas beaucoup
Fraternité Pas du tout.
Esprit naturaliste —

———

La pire des souffrances :
la

Finement, malicieusement, mais aussi, Autoritairement, le critiquer. (Celui qui ne coupe pas dans le pont, qui attend les conversations de la postérité. avant de ... hurler) — ceux-là hurlent l'admiration comme l'injure : ne craignez rien, ne tremblez pas — le fauve n'a point d'ongles, n'a point de dents, même point de cervelle : il est empaillé) ... Le critique me demande (« Vous êtes symboliste ? je suis bon enfant et je voudrais m'instruire, expliquez-moi donc le symbolisme »). Timidement, (je ne hurle pas) je lui réponds — Que vous seriez aimable de me ... plus en hébreu, une langue que, ni vous, ni moi nous ne comprenons pas — La situation deviendrait de ce fait un peu analogue à ...
 À quoi donc Monsieur le symboliste ? Toujours finement malicieusement...
 Timidement, sans finesse, sans malice — Mais ... mes tableaux parlent probablement hébreu que vous ne comprenez pas, inutile donc de continuer la conversation.
 Agréez cher Critique etc...
 P Gauguin.

Regrets Daumier

Tu commences à me raser
avec ton Panama!

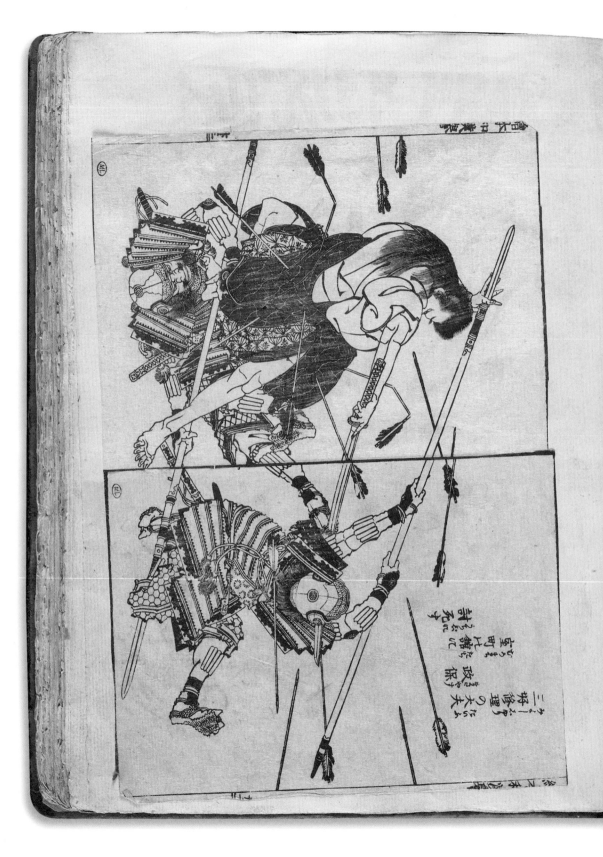

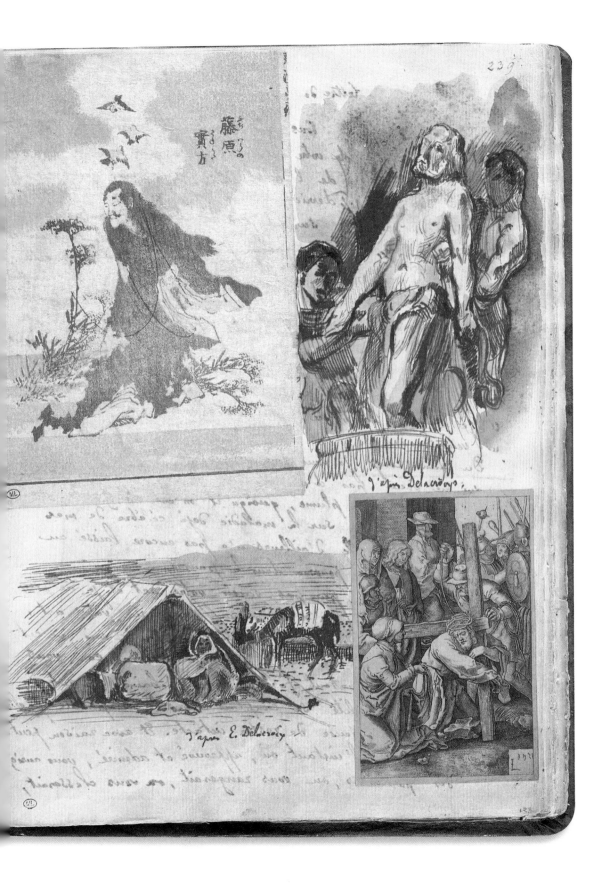

藤原
實方

d'après Delacroix

d'après E. Delacroix

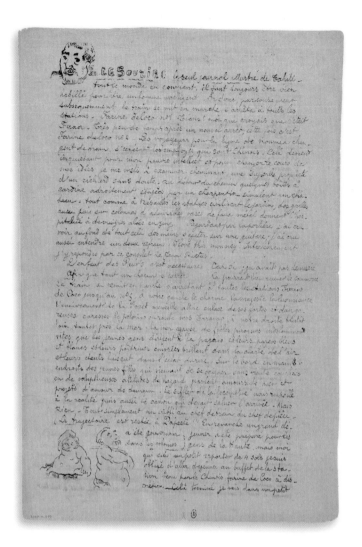

editor cited influential critic Charles Blanc's opinion that artists are 'not always adept at speaking about themselves', but that 'even in their most unstructured accounts, it is rare that they fail to interest us far more acutely than would an experienced biographer'.[23]

As for other artists, then, writing had a tactical purpose for Gauguin, who declared in a letter to his artist-friend George-Daniel de Monfreid that he had written *Racontars de rapin* specifically to prove that 'under no circumstances do painters need the support or instruction of literary men'.[24] To press the point, he took up the pen himself. Starting in 1885, not long after becoming a full-time painter following the loss of his job as a broker on the Paris stock exchange,

he began to set out his Symbolist conception of art as non-naturalistic in his correspondence with fellow artists, arriving at the term 'abstraction' in letters to Van Gogh and Émile Schuffenecker by 1888.[25] These letters were not simply personal exchanges, but a means for Gauguin to disseminate ideas that are also found in his more formal theoretical statements from this period: 'Notes synthétiques' (1884–5) in particular, published posthumously in 1910, celebrates the superiority of painting over the other arts on the grounds of its greater immediacy.[26] It was also around this time that he penned a treatise on colour theory, published in *L'Art Moderne* in 1887, which he passed off as the words of a fictional painter of unspecified

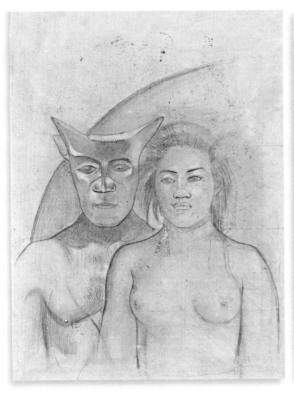

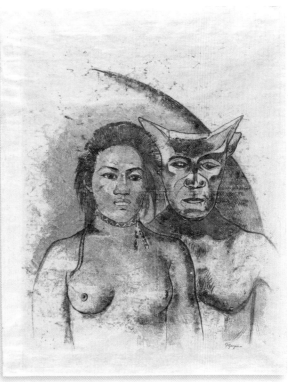

eastern origin, hinting at the interest in alter egos that would later become a feature of his writing.[27]

Gauguin first published under his own name in 1889, when he wrote three essays protesting against the inequities of the art world, partly in response to the Exposition Universelle in Paris. He reprised this journalistic activity in 1894–5 when back in France during the two-year hiatus between his Polynesian sojourns, contributing articles and opinion pieces to French periodicals and newspapers, on topics including the decorative arts, life in the tropics, and reminiscences and critical accounts of artists such as Van Gogh, Armand Seguin (1869–1903) and Odilon Redon (1840–1916).[28] During his first stay in Tahiti, from 1891 to 1893, he produced two longer texts in ornamentally bound volumes: the manuscript dedicated to his daughter, *Cahier pour*

Aline (Notebook for Aline, 1893), and *Ancien Culte mahorie* (Ancient Maori religion, 1893), a compilation of Polynesian legends, selectively drawn from French-Belgian diplomat Jacques-Antoine Moerenhout's ethnographic study *Voyages aux îles du grand océan* and richly illustrated with ink and watercolour illustrations loosely evoking the legends.[29] With its mix of anecdote, opinion, memoir, and theoretical statements borrowed and invented, *Cahier pour Aline* inaugurated the collage approach that would characterise his manuscripts from then on. Although unillustrated apart from a small watercolour sketch of his painting *Manaò tupapaú* (*Spirit of the Dead Watching*, 1892, fig. 24), its pages of pasted-in press cuttings from reviews of his work and richly decorated endpapers, juxtaposing watercolours with reproductions, establish the pattern of a visual as

Fig. 12 *Le Sourire*, August 1899, recto of second sheet. Mimeograph, 37 × 25 cm. Bibliothèque de l'Institut National d'Histoire de l'Art, Paris, Collections Jacques Doucet, NUM EM GAUGUIN 32

Fig. 13 *Tahitian Woman with Evil Spirit*, c.1900. Verso (left): graphite and blue pencil; recto (right): oil transfer drawing, 65 × 46 cm. The Museum of Modern Art, New York

well as verbal assemblage of voices and materials (figs 15 and 16).

Back in Paris, in the run-up to a solo exhibition of his work at the Galerie Durand-Ruel in 1893, Gauguin began drafting *Noa Noa*, a fictionalised account of the two years that he had just spent in Tahiti. By far the best known of his texts, it combines references to Polynesian myths with narrative episodes modelled on the tropes of Orientalist travel writing, which Gauguin claimed would aid in the interpretation of his painting.[30] After completing an initial draft, he secured the collaboration of Symbolist poet Charles Morice (1860–1919), who contributed poems and edited the manuscript, but the project stalled before Gauguin returned to Polynesia. There, he continued to adapt his copy of the collaborative text, adding a lengthy appendix entitled *Diverses choses* (Miscellaneous things) by 1898. The manuscript incorporating these two texts, held in the Musée du Louvre, also contains pages of original illustrations combined with reproductions, newspaper cuttings and photographs, in the manner of a commonplace book or scrapbook (see fig. 35).

Towards the end of his time in Tahiti, Gauguin branched into political journalism, attacking local colonial officials with a combination of verbal satire and visual caricature in his own publication *Le Sourire* and contributing to *Les Guêpes* (The Wasps), the propaganda organ of Tahiti's opposition Catholic party. He launched vituperative attacks on rival Protestant government officials with whom he happened to have quarrelled, often using the pseudonym Tit-Oïl (which is close to the Tahitian words for 'shit' and 'masturbation'), whose obscenity encapsulates the aggression and ambivalence of his status as colonial dissident. Taking over the editorship of *Les Guêpes* in February 1900, a few months after the journal's launch, at the invitation of its owner, Tahiti's mayor François Cardella, was no doubt an opportunity for Gauguin to settle scores and earn some money. However, it also allowed him to showcase his flair for political satire, and to position himself as heir

to the literary legacies of his Republican journalist father, Clovis Gauguin, and radical socialist feminist grandmother, Flora Tristan.[31] In all he published 24 articles in *Les Guêpes*, as Gauguin or Tit-Oïl, and was most likely the author of numerous other unsigned pieces for the journal.

Gauguin became increasingly prolific as a writer following his move to the Marquesas Islands in late 1901. No longer in the employ of Catholic party officials, he resumed the attack on the moral hypocrisy of the Catholic Church that he had initially drafted as a section of *Diverses choses*, under the subheading 'L'Église catholique et les temps modernes' (The Catholic Church and modern times). Carefully transcribing this essay into a bound volume decorated with woodcuts and transfer drawings, he reordered and expanded it to form the still unpublished *L'Esprit moderne et le catholicisme* (The Modern Mind and Catholicism), which attacks the institutions of state-organised religion, marriage and legitimacy, while providing a résumé of comparative religion largely derived from the writings of the English spiritualist Gerald Massey.[32] In these last two years of his life, Gauguin also wrote *Racontars de rapin*, his acerbic 'piece of counter-criticism', as he called it, and the substantially longer *Avant et après*.[33] Both are similar in structure to *Cahier pour Aline* and *Diverses choses*, consisting likewise of borrowed and repeated reminiscences, observations and anecdotes, but evoke more directly, even if ironically, conventional genres of text: art criticism and memoir respectively.

Despite this prodigious output, scholars have traditionally avoided these texts, viewing them as amateur and self-serving. Even those who have edited his manuscripts tend to consider his writing as a secondary activity, undertaken out of misplaced ambition, as a regrettable form of self-defence, or simply as a default occupation when he was too physically weak to make art. Accepting at face value Gauguin's denials of literary expertise, they insist on the crudeness and simplicity of his prose, claiming

that he 'was not a writer' and 'lacked the essential strategies of rhetoric'.[34] In relation to *Noa Noa*, Jean Loize argued that 'As soon as he takes up a pen, Gauguin is entirely spontaneous, with no literary tricks: he knows that he is barbarous and shocking.'[35] In his monograph on Gauguin, Henri Dorra similarly described his writings as 'spontaneous and untidy' and 'hopelessly wordy and repetitious', while Richard Brettell concurred in his foreword that the painter 'fortunately, operated more fully in the realm of the visual than the verbal'.[36]

This book challenges these assumptions of naivety. The apparently crude techniques of Gauguin's visual art have long been recognised as an avant-garde rejection of academic conventions, and his deliberately anti-literary writing style needs to be understood in similar terms. It enabled him both to deflect accusations of authorial pretension and to evoke the 'primitive' culture that he celebrated; that is, to write in a manner that suited his self-image as both artist and savage. Describing his attraction to Brittany in 1888, Gauguin linked the character of the place with his own artistic (and personal) style in an often-quoted statement: 'When my clogs ring out on this granite ground, I hear the muted, dull and powerful note that I seek in my paintings.'[37] In a parallel manner, he connected the tone that he sought in his writing with the image that he projected of himself as a savage, as when he wrote to Fontainas, regarding *Avant et après*, that 'the style must be in harmony with the subject, stripped down like the whole man, and frequently shocking.'[38] To dismiss his writings as the unpolished outpourings of an amateur is to accept such statements uncritically, and thus to overlook a crucial dimension of his primitivist self-fashioning. Gauguin's fragmentary, non-linear and apparently simple writing style was not innate, but deliberately cultivated to complement his putatively savage identity.

I position Gauguin's writing as a central element in his construction of an artistic identity, but not simply as a self-promotional tool.[39] He identified writing as an instrument of imperialism, and aligned visual art with the primitivist opposition to civilisation. The spontaneity and immediacy that he identified as inherent to art were also features that he valued in so-called primitive societies: those outside modern Europe, or the metropolitan centre, which he believed to be closer to nature and free from economic and moral oppression. The concept of the primitive does not denote any essential feature of these societies; it is an ideological construct inextricably bound up with the conditions of colonialism and capitalist modernity.[40] In line with European stereotypes, Gauguin viewed non-western cultures, such as that of Polynesia, as timeless and under threat from the homogenising impulse of colonialism. In a similar way, he presented artists as the innocent victims of critics, whom he called 'corrupt judges'.[41] In *Diverses choses* he implored 'learned men' to 'forgive these poor artists who have never grown up', and implicitly likened artists' condition to that of a primitive culture coming into contact with civilisation: 'Like flowers, they bloom at the slightest ray of sun, releasing their perfume, but they wither at the impure contact of the hand that tarnishes them.'[42] He thus mapped the contrast between 'savage' and 'civilised' onto that between 'artist' and 'writer', equating literary criticism's malignant influence on art with European society's contamination of Polynesian culture.

Following pages:
Fig. 14 *Noa Noa*, 1894–1901, folios 91 verso and 92 recto (pp. 176–7). Left: masthead for *Le Sourire*, 1899, collaged woodcut; right: Polynesian landscape in watercolour, cut out and pasted, 31.5 × 23.2 cm (each sheet). Musée d'Orsay (held at the Musée du Louvre), Paris, RF 7259, 1
Fig. 15 *Cahier pour Aline*, 1893. Manuscript notes, pen and ink, and press cuttings, 21.5 × 34 cm. Bibliothèque de l'Institut National d'Histoire de l'Art, Paris, Collections Jacques Doucet, NUM MS 227

Fig. 16 *Cahier pour Aline*, 1893, inside back cover. Watercolour, and photograph of Eugène Delacroix, *Arab Mounting a Horse* (1850s), 21.5 × 34 cm. Bibliothèque de l'Institut National d'Histoire de l'Art, Paris, Collections Jacques Doucet, NUM MS 227

P Gauguin



Leur aspect mystérieux, hostile et fruste
isolait de l'ambiance les œuvres de
M. Paul Gauguin, peintre et sculpteur,
aux expositions impressionnistes de 1880, 81,
82 et 86; maints détails de facture, et ce
fait qu'il taillait dans le bois ses bas-reliefs
et les coloriait marquaient bien une
tendance à l'archaïsme; la forme de
ses vases de grès témoignait d'un goût
exotique: tous caractères qui atteignaient
[un] degré
saturation dans
ses toiles récentes.

— Félix Fénéon



L'initiateur incontestable de ce mouvement artistique — peut-être, un jour, pourra-t-on dire de cette renaissance — fut Paul Gauguin.

À la fois peintre, sculpteur sur bois, ornemaniste, céramiste, il a, un des premiers, explicitement affirmé la nécessité de la simplification des modes expressifs, la légitimité de la recherche d'effets autres que les effets de la servile imitation des matérialistes, le droit, pour l'artiste, de se préoccuper du spirituel et de l'intangible. Son œuvre picturale, bien connue, est déjà considérable. Elle est empreinte d'une philosophie profonde et hautement idéaliste, exprimée par des moyens élémentaires qui ont particulièrement perturbé le public et la critique. C'est, on pourrait presque dire, du Platon plastiquement interprété par un sauvage de génie. Il y a, en effet, du sauvage, dans Gauguin, du primitif, de l'Indien qui, d'instinct, sculpte en l'ébène, des rêves étranges et merveilleux, bien plus troublants que les banales rêvasseries des maîtres patentés de nos académies!... Et c'est sans doute par une vague conscience de cela qu'il s'est décidé à partir loin de nos laides civilisations, à s'exiler dans ces lointaines et prestigieuses îles encore impolluées par les usines européennes, dans cette vierge nature de la barbare et splendide Tahiti — d'où il rapportera, il faut l'affirmer, de nouvelles œuvres superbes et bizarres, telles que l'on ne peut plus concevoir la cervelle anémiée et sénile d'un Arya contemporain.

PRÉFACE

Par OCTAVE MIRBEAU

J'apprends que M. Paul Gauguin va partir pour Tahiti. Son intention est de vivre là, plusieurs années, seul, d'y construire sa hutte, d'y retravailler à neuf à des choses qui le hantent. Le cas d'un homme fuyant la civilisation, recherchant volontairement l'oubli et le silence, pour mieux se sentir, pour mieux écouter les voix intérieures, qui s'étouffent au bruit de nos passions et de nos disputent, m'a paru curieux et touchant. M. Paul Gauguin est un artiste très exceptionnel, très troublant, qui ne se manifeste guère au public et que, par conséquent, le public connaît peu. Je m'étais bien des fois promis de parler de lui. Hélas! je ne sais pourquoi, il me semble que l'on n'a plus le temps de rien. Et puis, j'ai peut-être reculé devant la difficulté d'une telle tâche et la crainte de mal parler d'un homme pour qui je professe une haute et tout à fait particulière estime. Fixer en notes brèves et rapides la signification de l'art si compliqué et si primitif, si

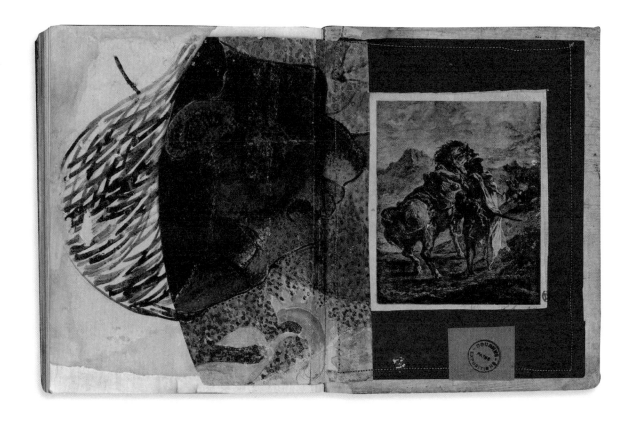

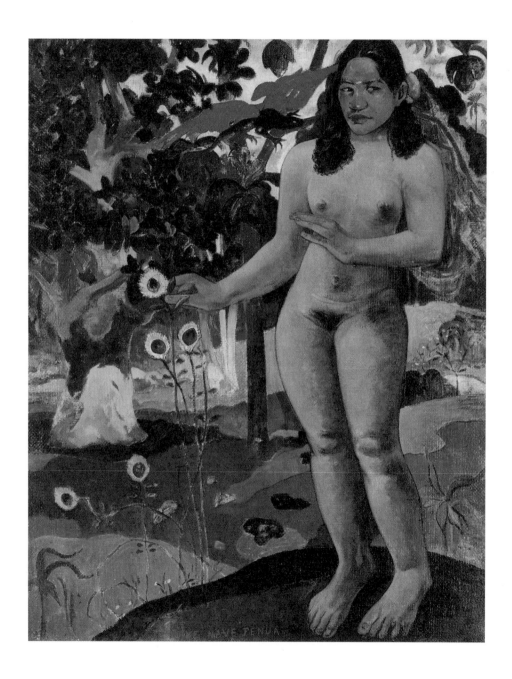

In this sense, a study of Gauguin's writings that gives due weight to their conscious primitivism has much to add to newer perspectives on his colonial identity. Until the 1980s, he was commonly heralded as a 'noble savage' who revitalised modern art through his contact with exotic Oceanic culture. A turning point occurred when his self-centred motives for relocating to Polynesia, and his imperialist and sexist assumptions, were exposed in the pioneering studies of Abigail Solomon-Godeau and Griselda Pollock.[43] Subsequent scholars have in various ways nuanced the portrayal of Gauguin as racist and sexist aggressor, drawing attention to the insecurities and limitations of his primitivist posturing, but also to the way in which his experience of Polynesian culture encouraged his exploration of alternative gender identities. Despite their internal differences, collectively these readings have led to a focus in the Gauguin literature on the mutability of the self, in its psychic, social and sexual dimensions, premised on an understanding of the colonial encounter as both reciprocal and ambivalent.[44]

Considered in their totality, Gauguin's writings affirm the ambiguity of his position in relation to the 'intertwined stigmas of both colonialism and sexism'.[45] Depending on one's perspective, the characteristic stasis and bulk of a figure like the one in *Te Nave Nave Fenua* (*Delightful Land*, 1892, fig. 17), and her association with the surrounding flora and fauna, configures her as atavistic and monstrously other, or signifies her resistance to the norms of feminine passivity associated with the ideal nude of the western academic tradition.[46] Both interpretations are justifiable; and ample fodder can be found in Gauguin's statements to support either view with recourse to his own words. In support of her case that Gauguin's primitivism was premised on sexual exploitation, Solomon-Godeau could cite his boast, in a letter of 1897 to the artist Armand Seguin, that 'I have a fifteen-year-old wife who cooks my simple everyday fare and gets down on her back for me whenever I want, all for the modest reward of a frock.'[47] Alternatively, those who wish to emphasise instead his incipient feminism can call to witness his declaration, in *L'Esprit moderne*, that 'woman, who is after all our mother, our daughter, our sister, has the right to earn her bread ... has the right to dispose of her own body ... has the right to spit in the face of he who oppresses her'.[48]

Similarly, Gauguin's ardent support of Marquesan families' protest against the forced sending of their children to convent schools, documented in archival records, is equally open to interpretation, as Stephen Eisenman notes. It could be taken as evidence of his anti-colonial activism and opposition to the assimilationist agenda of the *mission civilisatrice*. Conversely, it could be understood as opportunistic (liberated from the school, the girls were 'free' to become his *vahines*).[49] In this and many other instances of Gauguin's rebellion against the authorities, 'colonial resistance and self-interest comfortably folded into each other', as Margaret Jolly neatly puts it.[50] Reading across the breadth of his published journalism, manuscripts and letters brings these contradictions to the fore. As part of a small community of French settlers, Gauguin belonged neither to the larger, Indigenous society, nor to the itinerant colonial elite. Estimates suggest that in the 1890s the French settler community, comprised largely of ex-sailors, traders and farmers, and the occasional photographer or artist like Gauguin, amounted to around 200 of the approximately 3,000 inhabitants of Tahiti's capital Papeete, which also included around 600 non-French settlers, notably Chinese and British, with the remaining majority being Polynesians or of mixed heritage. The smaller group of French government officials, numbering around 40, who occupied the top posts in the colonial administration, tended to be peripatetic and little invested in improving the lot of the socially inferior settler class.[51]

Fig. 17 *Te Nave Nave Fenua* (*Delightful Land*), 1892. Oil on canvas, 91.3 × 72.1 cm. Ohara Museum of Art, Kurashiki, Japan

In this context, Gauguin could attack 'civilisation', in the form of its elite metropolitan representatives, while still defending his rights as a 'Frenchman' and a taxpaying settler.

With his move to Hiva Oa in the Marquesas Islands, however, Gauguin does seem to have adopted a more genuinely adversarial stance towards colonialism, as well as a more culturally mixed social set. His allies and acquaintances during the last years of his life included a Protestant pastor, Paul Vernier (previously the target of one of Gauguin's tirades in *Les Guêpes*), a highly cultured, politically dissident Vietnamese exile, Nguyen Van Cam (known as Ky Dong), and a Marquesan, Tioka, with whom Gauguin reportedly exchanged names in a traditional ceremony.[52] He invested considerable energy in defending Indigenous people in letters to colonial magistrates and inspectors, demanding better legal representation and lower taxes, and complaining about unfair punishments and punitive laws.[53]

Exacerbating his shifting allegiances is the fact that Gauguin adopted authorial personae, not unlike a novelist who invents a character or an unreliable first-person narrator. At various points, he wrote as a Tahitian woman, an ancient oriental painter and – as we have seen – the pseudonymous Tit-Oïl. He cited the words of others as though they were his own, sometimes used a colloquial or satirical voice, and delighted in juxtaposing divergent perspectives or drawing attention to his split personality.[54] Although this ventriloquism and shifting of registers does not exonerate him of responsibility for his statements, it militates against taking them entirely at face value, and cautions against biographical interpretations that reduce the local complexities and structural power relations of colonialism to a matter of interpersonal relations.

Gauguin's ambiguities and contradictions are part and parcel of his inherently marginal status as a 'left-wing coloniser' or 'ethnographic liberal', inescapably a white settler in a French colony but also a critic of imperialism.[55] Whether one chooses to emphasise his opposition to colonial ideology, or the *limits* of this resistance; the extent of his exploitation of Polynesian culture, or the Indigenous people's resilience in the face of it, depends on one's position with regard to primitivism and imperialism more broadly. As the widely quoted observation by Henry Louis Gates, Jr has it: 'You can empower discursively the native, and open yourself up to charges of downplaying the epistemic (and literal) violence of colonialism; or play up the absolute nature of colonial domination, and be open to charges of negating the subjectivity and agency of the colonised, thus textually replicating the repressive operations of colonialism.'[56] However radical Gauguin's art, neither it nor he stand outside the terms of this predicament. Polynesia was not simply the passive victim of Gauguin's distortions and misrepresentations. His art and way of life was itself affected by the societies he encountered, which shaped his artistic interests and modified, for instance, his negotiation of same-sex desire and masculinity.[57]

The inconsistency of Gauguin's position is thus that of modernist primitivism writ large. Often couched as a critique of industrial capitalism, it ostensibly inverts imperialism's insistence on the superiority of the coloniser over the colonised, but its 'state of nature' fantasy also exists in inevitable relation to the condition that it seeks to escape. As Daniel Sherman writes, one of the 'inherent contradictions' of primitivism's self-proclaimed opposition to imperialism is that primitivists 'continue to occupy the privileged position afforded white Europeans in the imperial system, or in any case do little to call into question the continued existence of that system'. Sherman's identification (in passing) of Gauguin as the 'most notorious' case of such political failure, although accurate in its assessment of his reputation, is perhaps unfair, given that his seditious anti-colonial activities in the Marquesas Islands landed him with a prison sentence. But it does point to the fact that a professed empathy with the 'primitive' serves primarily to highlight

the advocate's bourgeois origins, regardless of the force with which they critique them.[58]

Gauguin's efforts to negotiate his uncertain social status in the colonial context manifest themselves in the hybridity and conflicts of his artistic identity. The perception of racial and sexual alterity, mixed with a desire to transcend it, which structured his primitivist outlook, is also pertinent to his sense of the opposing characteristics of visual and verbal expression. Although he aligned the visual artist with the 'primitive' and the writer with the 'civilised', in both pairings he was ambivalently suspended between the two. Just as he inevitably remained implicated in the imperialist culture that he denounced (participating, by his very presence, in the same process of Europeanisation that he was attacking), he could only assert his autonomy as a visual artist by adopting the privileged voice of the writer. In its uneasy confrontation of roles that he sought to distinguish, his conflicted identity as an artist-writer complements his liminal status as a critical primitivist or reluctant coloniser, on the margins of both the Indigenous and settler communities.[59]

This analogy has provided me with a new framework in which to develop my earlier work on Gauguin's writings. In previous publications, focused on *Noa Noa* and *Diverses choses*, I examined his adoption of a deliberately naive voice as a facet of his primitivism and a response to the hegemony of the art critic.[60] In this book, I examine a larger range of texts and newly address the role of writing in his negotiation of an identity on the borders between the French colonial and the Polynesian communities. My account is not exhaustive: Gauguin was a prolific writer, and the task of identifying all his letters and manuscripts, as well as the (often unacknowledged) textual sources

that he paraphrased or copied is an ongoing one. Scholars will continue to explore his writings as rich sources of information about his art, life and ideas; my own emphasis is on their literary and material forms and strategies.[61] His use of titles and inscriptions, and his interest in linguistics, wordplay and semiotics receive only occasional attention here. This is partly because others have explored it productively, and partly because I have chosen instead to emphasise the role that writing played in Gauguin's construction of a public identity, and in his conflicted sense of self.[62]

In order to recognise the simultaneous embrace and denial of the literary in Gauguin's texts as more than idiosyncratic and personal, it is necessary to take account of the long, and continuing, tension between artists and professional writers. He fits into a larger history of art writing that has yet to be fully written, but equally his example is itself instructive for gaining a deeper understanding of this field. In the sense that self-proclaimed naivety is *de rigueur* in artists' texts, and that they tend to be read transparently, the concept of the 'primitive' always comes into play regardless of the period and context in which they were written. A figure who disrupts the dichotomy between (intuitive) practice and (intellectual) interpretation, the artist-writer is infantilised by scholars and critics who take his or her literary naivety at face value, while he or she is also capable of strategically appropriating this 'primitive' stance to their own advantage. Such conscious primitivism is doubly motivated in Gauguin's case by his attempt to identify with peoples outside the modern West. His hybrid texts are therefore central to the history both of word-image relations and of artistic encounters in the French colonial context.

Février 1898.

Mon cher Daniel.

Je ne vous ai pas écrit le mois dernier, je n'avais plus rien à vous dire sinon répéter, puis ensuite je n'en avais pas le courage. Aussitôt le courrier arrivé, n'ayant rien reçu de Chaudet, ma santé tout à coup presque rétablie c'est à dire sans plus de chance de mourir naturellement j'ai voulu me tuer. Je suis parti me cacher dans la montagne où mon cadavre aurait été dévoré par les fourmis. Je n'avais pas de révolver mais j'avais de l'arsenic que j'avais thésaurisé durant ma maladie d'eczéma est ce la dose qui était trop forte, ou bien le fait des vomissements qui ont annulé l'action du poison en le rejetant, je ne sais. Enfin après une nuit de terribles souffrances, je suis rentré au logis. Durant tout ce mois j'ai été tracassé par des pressements aux tempes, puis des étourdissements, des nausées à mes repas minimes. Je reçois ce mois-ci 700f de Chaudet et 150f de Maufra : avec cela je paye les créanciers les plus acharnés, et recontinue à vivre comme avant, de misères et de honte jusqu'au mois de Mai où la banque me fera saisir et vendre à vil prix ce que je possède entre autres mes tableaux. Enfin nous verrons à cette époque à recommencer d'une autre façon.

Il faut vous dire que ma résolution était bien prise pour le mois de Décembre alors j'ai voulu avant de mourir peindre une grande toile que j'avais en tête et durant tout le mois j'ai travaillé jour et nuit dans une fièvre inouïe. Dame ce n'est pas une toile faite comme un Puvis de Chavannes études d'après nature, puis carton préparatoire etc. Tout cela est fait de chic au bout de la brosse, sur une toile à sac pleine de nœuds et rugosités aussi l'aspect en est terriblement fruste. D'où venons nous ? Que sommes nous ? Où allons nous ?

On dira que c'est lâché etc.

Chapter One

THE ARTIST *as* ANTI-CRITIC

The serious criticism of today, however full of good intentions and well informed, tends to impose on us a method of thinking and dreaming, and this threatens to become a new form of slavery. Preoccupied with its own concern, its special domain – literature – it risks losing sight of our concern, which is painting. If that came to pass, I would proudly quote Mallarmé's dictum to you: A critic! A gentleman who meddles in something that is none of his business.

S O WROTE GAUGUIN IN MARCH 1899 to André Fontainas, the resident art critic of the periodical *Le Mercure de France*.[1] Fontainas's review of his exhibition at Ambroise Vollard's gallery in Paris the previous year had provoked in him a 'mad urge' to respond.[2] The exchange is well known, but is worth revisiting as it sets up the tension between declarations of self-sufficiency and dependency on critical networks that is central to Gauguin's activities as an 'anti-critic'. What moved him to address Fontainas directly was the critic's unfavourable comparison of his ambitious painting *D'où venons-nous? Que sommes-nous? Où allons-nous?* (Where do

we come from? What are we? Where are we going?, 1897–8, fig. 19) with the allegorical compositions of Pierre Puvis de Chavannes (1824–1898). Fontainas argued that, while Puvis was able to communicate abstract notions using 'concrete forms', Gauguin suffered from a 'tendency towards the abstract', and it was only by recourse to his painting's title that the viewer could grasp 'the meaning of the allegory'.[3]

In response, Gauguin did not refute the critic's accusations of obscurity, but insisted that his picture was never intended to be a comprehensible allegory. He likened it instead to a 'dream' that was not meant to be interpreted, and – using what he claimed were the words of Stéphane Mallarmé (1842–1898) – described it as a 'musical poem' that 'needs no libretto'. The very title that Fontainas deemed so indispensable was, he protested, entirely separate from the picture; it did not refer to a preselected theme that he had tried unsuccessfully to illustrate, but was more like a 'signature', applied retrospectively. On awakening from the trance-like state in which he had composed the picture, Gauguin explained, his primary goal was to 'translate my dream without any

Previous:
Fig. 18 Letter to George-Daniel de Monfreid, February 1898 (Tahiti). Signed letter, sketched in pen and ink wash, 27 × 20.4 cm. Musée d'Orsay (held at the Musée du Louvre), Paris, RF 41648, recto

Fig. 19 *D'où venons-nous? Que sommes-nous? Où allons-nous?* (Where do we come from? What are we? Where are we going?), 1897–8. Oil on canvas, 139.1 × 374.6 cm. Museum of Fine Arts, Boston

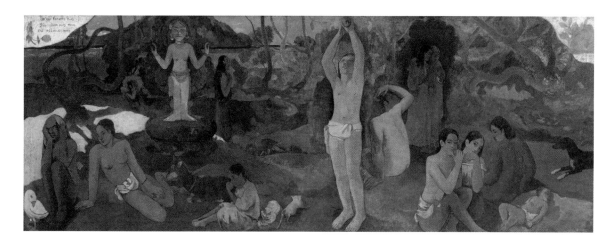

recourse to literary methods'.[4] He closed the letter with the warning about the literary bias of art critics quoted above (having made sure, at the outset, to acknowledge his correspondent's sincere attempt to understand his work). A few months later, apparently in receipt of a satisfactory reply, he wrote to Fontainas again, expressing his pleasure that the critic, 'enlightened' by Gauguin's earlier communication, had corrected his previous misconception: he no longer mistakenly believed that Gauguin's working method, like that of Puvis, consisted in finding a suitable form for an 'a priori, abstract idea'.[5]

These two letters encapsulate Gauguin's inconsistent attitude to interpretation, and his calculating strategies in dealing with critics. Defending his picture in March, he asserts that the Buddha-like idol to the left does not serve any 'literary explanation', and ventures that it is his own 'lack of literary education' that prevents him from reaching for a ready-made allegory à la Puvis. However, despite these proclamations of scholarly innocence, he uses the first quatrain of 'Un grand sommeil noir' (from *Sagesse*) by Paul Verlaine (1844–1896) as an epigraph, and makes several references to Mallarmé.[6] In the August letter, he blames the public's misunderstanding of his art on the fact that he lets his pictures speak for themselves, but hints at deeper meanings by referring to them as 'parables'.[7] He twice describes himself as an avid reader, and explains that he keeps up with 'good

literature' via his free subscription to *Le Mercure*, but he stresses that this is simply a means of staying connected, since his brain is 'resistant to instruction'.[8] He claims to avoid self-justification, declaring in March his belief that painters should not respond to criticism (his own letter, he maintains, is not actually a formal 'response', but merely a 'simple chat about art').[9] And yet he manipulates his correspondent by quoting, in both letters, what he considers to be model interpretations of his work: first Mallarmé's reported exclamation that 'It is extraordinary that one is able to put so much mystery into so much brilliance', and then a review by the critic Achille Delaroche, published in 1894, in which 'mystery' and 'the unknown' are also keywords.[10]

Three years later, it was to Fontainas that Gauguin turned in his efforts to publish *Racontars de rapin*, soliciting his intervention at *Le Mercure de France*, and, when that failed, attempting to engage him as a literary agent for *Avant et après* (Before and after), asking him to insert the shorter polemic essay into the latter volume of anecdotes and memories if he managed to find a publisher.[11] Although this manoeuvring was unsuccessful, the fact that he relied on a professional writer to promote his invectives against art criticism shows that he remained reliant on the very critical networks that he denounced. Just as he could not fully escape his colonial identity, nor could he entirely reject the community of critics that

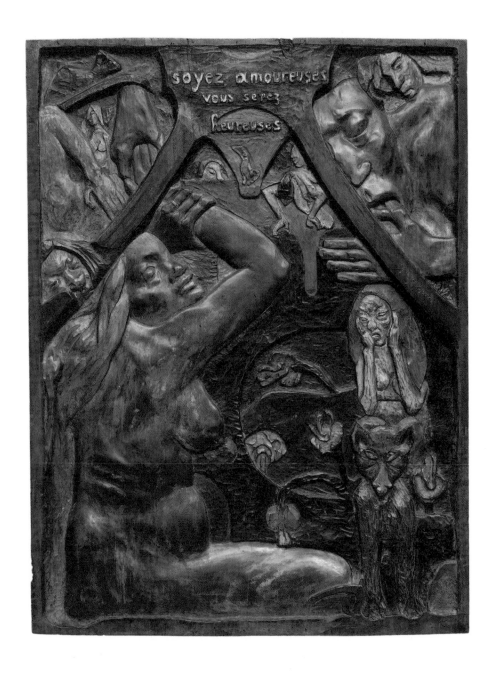

he battled against. In this sense his stance as an anti-critic is equivalent to his equivocal position as an ethnographic liberal: as much as he denounced the European coloniser, or the professional writer, their advantages and methods were also his.

Gauguin was not alone among nineteenth-century artists in his conflicted attitude to the written word. Factors including the professionalisation of art criticism and the increasing threat to literary hegemony posed by visual art's move away from narrative themes resulted in antagonism between artists and critics. Painters such as Eugène Delacroix (1798–1863), Gustave Moreau (1826–1898) and Odilon Redon (1840–1916) all shared Gauguin's uneasy combination of a strong commitment to visual art's autonomy and an equally deep engagement with literature and poetry.[12] They intervened in critical debate in an attempt to wrest back authority from writers, whose knowledge of visual art they disputed, but whose personal preferences they knew had the power to make or break an artist's fortune.[13] Gauguin was particularly vocal in his opposition to the critic's unwarranted power (this is essentially the subject of *Racontars de rapin*) and his jibes at men of letters are often cited in this context.[14] Despite his principled stance on the self-sufficiency of visual art, he was adept at securing literary patronage, engaging rising stars such as Albert Aurier, August Strindberg and Charles Morice as reviewers or co-authors.[15] From Polynesia, he assiduously kept track of his critical fortunes, using writing as a self-mythologising tool that enabled him to position his creations as the natural products of his 'savage' personality.[16]

However, Gauguin did not simply remonstrate against criticism from a position outside the discourse, but produced a substantial body of writing that was itself a contribution to the genre. This included published exhibition reviews, prose portraits of artist-colleagues, catalogue prefaces, opinions

on art and artists, and equivocal accounts of his own work in letters and manuscripts. Throughout, he positioned himself as a defender of his *métier*, generating what he called 'counter-criticism' to counteract the damaging misconceptions of professional writers, as well as their tedious methods of assessment. To avoid replicating the type of prose that he attacked (which could have exposed him to charges of hypocrisy), he adopted a style that was deliberately colloquial and seemingly unstructured. Thus, when in 1889 *Le Moderniste illustré* announced his forthcoming review of the Paris Exposition Universelle as being written 'without any literary pretention', Gauguin scored on two fronts: he could get his point across (in this case, one of his themes was the mediocrity of state-sponsored art), while also avoiding the appearance of contradicting his own opposition to theorising.[17]

But this informal, oppositional authorial voice itself had precedents within the tradition of art writing. From the early decades of French art criticism, artists were actively involved as commentators, whether respectably, as in the venerable tradition of the technical treatise or Académie des Beaux-Arts speech, or more covertly, as (suspected) authors of anonymous pamphlets reviewing the Académie's exhibition, the Salon. While artists were dissuaded from publicly writing Salon reviews due to the stigma of self-interest, and frequently railed against the harsh judgements meted out to them, the battle lines between artist and critic were in effect more porous than this conflict of interests might suggest, since writers often relied heavily on artists' insider knowledge in composing their Salon reviews, and in some cases had previously been practising artists themselves.[18] From its emergence as a literary genre in the late eighteenth century, one of criticism's overarching themes had been the question of whether the practitioner or the man of letters was better

Fig. 20 *Soyez amoureuses, vous serez heureuses* (Be in love and you will be happy), 1889. Carved and painted linden wood, 95 × 72 × 6.4 cm. Museum of Fine Arts, Boston

positioned to pass judgement on art. While artists were deemed to lack the education necessary to debate coherently on aesthetic matters, their opinions were nonetheless accorded a special authority as coming 'from the horse's mouth', whereas writers could claim competence in crafting lucid prose but were often accused of neglecting strictly pictorial matters.[19] By taking up this topic (as he did in his warning to Fontainas, for instance), Gauguin was therefore pursuing a theme indigenous to criticism itself, not simply resisting it as an outsider.

THE GENESIS OF A PICTURE

In 1889, Gauguin supplied the art dealer Theo van Gogh with a brief exegesis of his bas-relief *Soyez amoureuses, vous serez heureuses* (Be in love and you will be happy, 1889, fig. 20), which he had recently sent him on consignment. Complying with Theo's request for an explanation of the work, although he protested that it was 'simple', he conceded: 'since you want literature, I am going to give you some (for you only)'. He concluded his summary with the statement: 'For those who want literature, there it is. But it is not for examination', implying that Theo might discreetly draw on the information in discussions with clients, but should not reveal its source.[20] However, despite this promise of exclusivity, Gauguin had sent very similar reports to the dealer's brother Vincent and to their mutual colleague, Émile Bernard. To the former he described it as 'the best thing I've done up to now as regards power and harmony – but the literary side of it is insane to many', emphasising its importance but also vaunting its inscrutability.[21]

With minor differences among the letters, he provided his three correspondents with an iconographic reading that identifies the upper part of the relief as representing the city of Babylon, the lower part a countryside scene, and the main characters as a 'monster', bearing his own features, who grabs a reluctant woman by the hand, and a fox, which he calls an 'Indian symbol of perversity'.[22] In themselves, these isolated details hardly cohere into an intelligible narrative, and the closest he came to defining the work's broader significance was to note that the mood belies the happiness promised by the title, thus hinting that it could be interpreted as a parody of romantic love, with him as the anti-hero.[23] This rather literal explanation does not account for the sculpture's full effect (as Gauguin himself said to Vincent, 'you have to see the colour of the wood ... there are reflections where the light hits the parts in relief, imparting richness'), but that is precisely the point: in its very incompleteness the explanation suggests the inadequacy of verbal description, while disclosing just enough information to give the would-be interpreter a starting point, without being so exhaustive as to dampen curiosity.

Gauguin's attitude towards the elucidation of his art was therefore conflicted. He took pride in his obscurity, celebrating his work's difficulty as a natural consequence of its avoidance of narrative legibility, as when he explained to George-Daniel de Monfreid that 'I am sometimes accused of being incomprehensible precisely because people look for an explanatory side to my paintings even though there isn't one'.[24] However, he also recognised the need to attract critical attention by hinting at meanings without divulging them fully. He used his correspondents as conduits for the dissemination of his ideas, but addressed each one as though they were personal confidants, and supplied specific keys to interpretation even while expressing a fundamental distaste for clarification.[25] For instance, writing to De Monfreid about *Manaò tupapaú* (*Spirit of the Dead Watching*, 1892, fig. 21), one of nine works from his first Tahitian period that he shipped to Europe for exhibition at Den Frie Udstilling (The Free Exhibition) in Copenhagen in 1893, he confided 'Here is the genesis (for you alone)', yet he also wrote about this same painting in a letter to his wife, Mette, who was to receive the works from De Monfreid, 'so that you can understand and, as they say, act the clever clogs'.[26] He then followed a

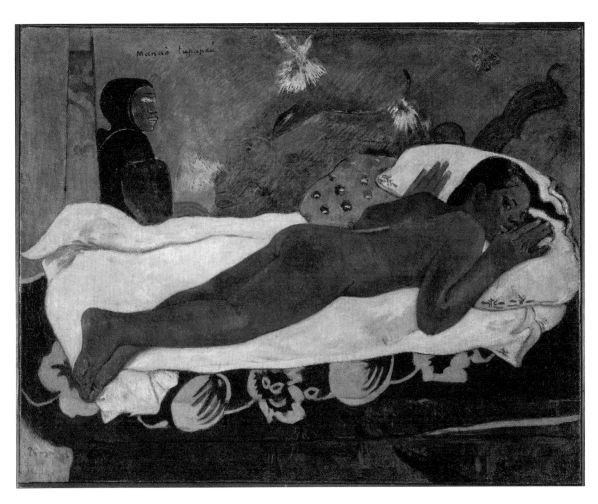

detailed discussion of the painting with the dismissive statement 'There you have a little text that will make you look clever in front of the critics when they bombard you with their mischievous questions' and concluded that 'What I'm writing to you is very dull, but I think that it is necessary for you over there.'[27]

Acknowledging the fact that 'naturally many of the pictures will be incomprehensible', he chose to exacerbate their obscurity by inscribing titles in Tahitian on the canvases themselves.[28] At the same time, he supplied his wife with a list of French translations, writing 'This translation is for you alone, so you can give it to those who ask for it.'[29] Stipulating exclusivity – 'for you alone' – he also implied the expectation of wider dissemination, and indeed Gauguin sent the translations of his picture titles to De Monfreid too. When he exhibited the works at the Galerie Durand-Ruel in Paris a few months later, the catalogue prepared by Morice included French translations alongside the original Tahitian titles.[30] In this way, he could intrigue viewers by employing an unfamiliar language, but also provide them with the code needed to interpret it. Several years later, in a passage from *Diverses choses* (Miscellaneous things), Gauguin set out to answer those critics who had reacted negatively to his Paris exhibition

Fig. 21 *Manaò tupapaú* (*Spirit of the Dead Watching*), 1892. Oil on jute mounted on canvas, 73 × 92.4 cm. Albright-Knox Art Gallery, Buffalo, NY

in 1893, by justifying his non-naturalistic approach to representation. He prefaced this defence with the disclaimer: 'Although it's boring to have to talk about myself, I'm doing it here in order to explain my Tahitian art, since it is thought to be incomprehensible ... I want to defend myself.'[31]

Despite his distrust of criticism, then, Gauguin was aware of the need to steer commentators in the right direction, and his disavowals of interpretation should be treated with caution. Dario Gamboni has argued that Gauguin rarely described his own individual works and that his resistance to literary formulas 'makes the relative absence of verbalisation accompanying his works entirely logical'.[32] It is true that he avoided offering concrete elucidations of specific works, in keeping, for instance, with his advice to De Monfreid that 'one should aim for suggestion rather than description in painting, as in music'.[33] His accounts appear spontaneous, personal and elliptical rather than deliberately exegetical. But the fact that his self-commentaries are indirect and enigmatic does not mean that they were rare. In fact, Gauguin repeatedly discussed his own works in his letters, while his fictionalised travel memoir Noa Noa – drafted in 1893 in the run-up to his Paris exhibition, although not published at the time – contains several episodes relating to specific works of art that are, in effect, descriptions of works presented as memories of actual events.[34]

Gauguin's explanation of Manaò tupapaú, for instance, exists in multiple versions, indicating the level of strategy involved. In Noa Noa, he associated the picture with a supposedly autobiographical episode (subsequently reworked in a later version of the text, written in collaboration with the poet Charles Morice), in which the first-person narrator describes returning home from a trip to find his vahine, petrified by her fear of the dark and of night-time spirits. It is impossible to confirm that this story is true, and even if it did have a basis in the reality of

Gauguin's life in Tahiti, in Noa Noa it takes its place in a series of scripted episodes that dramatise the narrator's awkward integration into Tahitian life. What is striking, in fact, is the discrepancy in tone between what is described and what is shown. While the emphasis in the painting is on silence, stillness, and the mysterious world of the spirits, the text reports a mundane domestic dispute. It is hard to imagine the figure in this painting energetically protesting, as she does in Noa Noa, 'Never leave me alone again like this without light! What have you been doing in town? – you've been to see women, the kind who go to the market to drink and dance, then give themselves to the officers, to the sailors, to everybody?'[35]

This disjunction between the episode in Noa Noa and the painting that it claims to elucidate can also be found in a passage describing Gauguin's efforts to paint a portrait of his neighbour, represented in the painting Vahine no te tiare (Tahitian Woman with a Flower, 1891, fig. 22). As the narrator describes: 'I tried to sketch some of her features, especially that enigmatic smile of hers. She made a nasty grimace, went away, – then she came back. Was it an inner struggle, or caprice (a very Maori trait), or even an impulse of coquetry that will surrender only after resistance?'[36] Arguably, the 'enigmatic smile' that Gauguin records can be seen in the picture, but not the 'nasty grimace' or 'impulse of coquetry' that are also supposed to have marked his neighbour's features. In keeping with his description of painting as an art that 'embraces everything and at the same time simplifies', the temporal flow of the narrative – which describes the narrator's rush to finish the portrait and his model's capricious resistance and eventual surrender – is distilled into a vision of solidity and calm.[37]

Rather than explaining the scenes depicted in Gauguin's paintings, the episodes in Noa Noa serve, if anything, to mystify them further. The phrase 'Description of the picture Pape Moe', for instance,

Fig. 22 Vahine no te tiare (Tahitian Woman with a Flower), 1891. Oil on canvas, 70 × 46.5 cm. Ny Carlsberg Glyptotek, Copenhagen

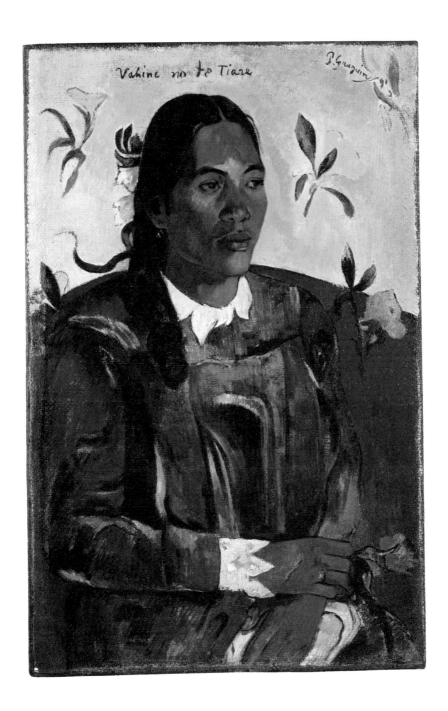

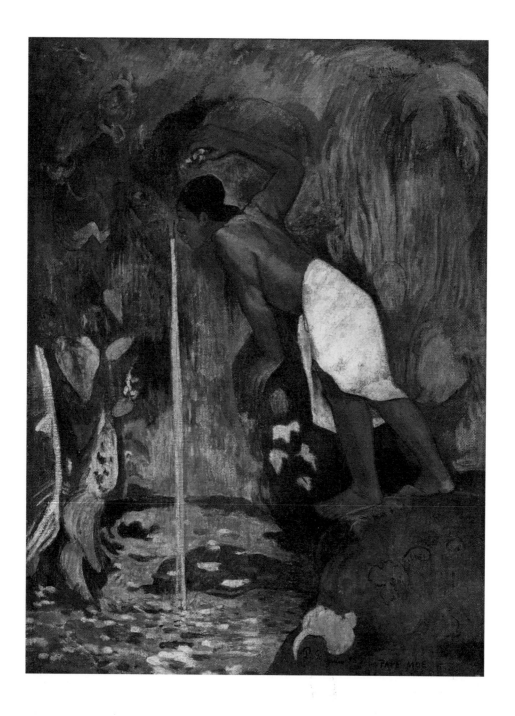

interrupts the story of a journey to the Tamanu plateau, where the narrator startles a woman drinking from a waterfall. However, the text, in which she is compared to an 'uneasy antelope' who 'violently dived' as he approached, relates awkwardly to the corresponding painting, in which the figure appears static and undisturbed (fig. 23).[38] The episode's biographical authenticity is undermined by the painting's actual source in a colonial photograph of a person drinking from a waterfall, while the theme of the female bather surprised, evoked in Gauguin's vignette, is a common subject in travel writing on Polynesia.[39] Because Noa Noa is generally understood to be autobiographical (an assumption that I contest in the following chapter), the status of these passages as art writing – accounts of artworks rather than of events – is not always recognised. But while criticism, in Gauguin's view, tended to colonise the visual by laying claim to the meaning of an image, he sought to disrupt the typical authority of literary interpretation by disseminating multiple, contradictory accounts of the same work.

In addition to the episode in Noa Noa, Gauguin also described Manaò tupapaú in the two letters discussed earlier, to his wife and to De Monfreid. His warning to his wife that his commentary was 'dull' but 'necessary' makes it clear that he expected his words to spread. Accordingly, he treads a fine line – again – between preserving the painting's mystery and providing enough of a clue about the subject matter to keep the critics interested. He explains to his correspondents that the pale yellow colour of the bed sheets has a real-world referent – telling his wife that it represents the tree bark from which Tahitians made their linen, and De Monfreid that it

evokes night-time – but that it also operates on the level of what he calls a 'musical harmony', by complementing the neighbouring colours of orange and blue. Likewise, the floral motifs in the background can be seen as purely decorative, but were simultaneously intended to evoke the night-time 'sparks' that for the Tahitians were a sign of the tupapau or spirit of the dead.[40]

In the manuscript dedicated to his daughter Aline, known as the Cahier pour Aline (Notebook for Aline) and written in 1893, he developed this dual level explanation into a more programmatic account, to which he gave the subtitle 'La genèse d'un tableau' (The genesis of a picture) and added a watercolour sketch (fig. 24). As has long been established, this phrase refers unmistakably to Edgar Allan Poe's essay 'The Philosophy of Composition', translated by Charles Baudelaire as 'La Genèse d'un poème' (The genesis of a poem).[41] In his rhetorical exegesis of his poem 'The Raven', Poe claimed that he began by selecting harmonious patterns of sounds, to which the meaning of the words was secondary in importance. Accordingly, in his 'genesis', as in his letters, Gauguin claimed that his composition was prompted by a simple aesthetic motivation: 'seduced by a form, a movement, I paint them without any concern other than to do a nude'.[42] Realising – he says disingenuously – that a naked young woman on a bed might carry inappropriate sexual connotations, he seeks a pretext for her condition: sleeping might imply a recent sexual encounter, and so he settles instead on the idea that she is afraid, making her emblematic of her culture's fear of ghosts. He concludes with a reminder that the painting's form and subject matter correspond respectively to its

Fig. 23 Pape Moe (Mysterious Waters), 1893. Oil on canvas, 99 × 75 cm. Private collection
Following pages:
Fig. 24 Cahier pour Aline, 1893, double page about Manaò tupapaú (Spirit of the Dead Watching). Ink and watercolour on paper, 21.5 × 34 cm. Bibliothèque de l'Institut National d'Histoire de l'Art, Paris, Collections Jacques Doucet, NUM MS 227

Fig. 25 Letter to Charles Morice, July 1901, p. 2 verso. Ink on commercial graph paper (papier quadrillé); letter consists of 3 double-sided sheets; 22.7 × 17.6 cm (each sheet). Museum of Fine Arts, Boston
Fig. 26 Letter to Vincent van Gogh, last page, with sketches of Soyez amoureuses and Christ in the Garden of Olives, November 1889. Pen, ink and watercolour on paper, 42 × 27 cm. Van Gogh Museum, Amsterdam (Vincent van Gogh Foundation)

plusieurs ensemble — une fois mon Tupapau
trouvé je m'y attache complètement et
j'en fais le motif de mon tableau. Le nu
passe au 2me plan —

Quel peut bien être pour une Canaque un
revenant. Elle ne connaît pas le théâtre,
la lecture des romans; et lorsqu' elle pense
à un mort elle pense nécessairement à
quelqu'un déjà vu — Mon revenant ne
peut être qu'une petite bonne femme quel..
Sa main s'allonge comme pour saisir
une proie. Le sens décoratif m'amène à
parsemer le fond de fleurs, Ces fleurs
sont des fleurs de Tupapau, des phosp..
rescences, signe que le revenant s'occup..
de vous. Croyances tahitiennes —

Le titre Manao Tupapau (deux

Sens — Pensée Revenant)
 croyance

Ou elle pense au revenant
ou le revenant pense à elle —

———

Récapitulons - Partie musicale - Lignes horizontales
ondulantes - accords d'orangé et de bleu
liés par des jaunes et des violets leurs
dérivés - Eclairés par étincelles verdâtres -
Partie littéraire - L'esprit d'une vivante lié
à l'esprit des Morts - La mort et le jour.

Cette genèse est écrite pour ceux qui
veulent toujours savoir les pourquoi les
Parceque -
Sinon c'est tout simplement une étude
de nu océanien.

ensuite.

Dans ce grand tableau

que nous sommes nous d'où venons
 nous

 existence journalière

près de la mort l'homme d'instinct Source
une vieille femme se demande ce que
un oiseau étrange tout cela veut dire enfant
stupide conduit le la vie commence

poème en comparaison de l'être inférieur vis à vis de l'être
intelligent dans ce grand tout qui est le problème
annoncé par le titre —

Derrière un arbre deux figures sinistres envelopées de
vêtements de couleur triste mettent près de l'arbre
de la science leur note de douleur causée par cette
science même en comparaison avec des êtres simples
dans une nature vierge qui pourrait être un paradis
de conception humain, se laissant aller au bonheur
de vivre.

Des attributs explicatifs - symboles connus - figeraient
la toile dans une triste réalité et le problème
annoncé ne serait plus un poème.

 En peu de mots je t'explique le tableau
à ton intelligence il en faut peu, mais pour le
public pourquoi mon pinceau libre de toute con-
trainte serait-il obligé d'ouvrir les yeux à tous.

 Quant aux autres il leur sera parlé en
paraboles afin qu'ayant des yeux ils ne —

Les formes sont rudimentaires ? Il le faut
L'exécution en est par trop simple Il le faut

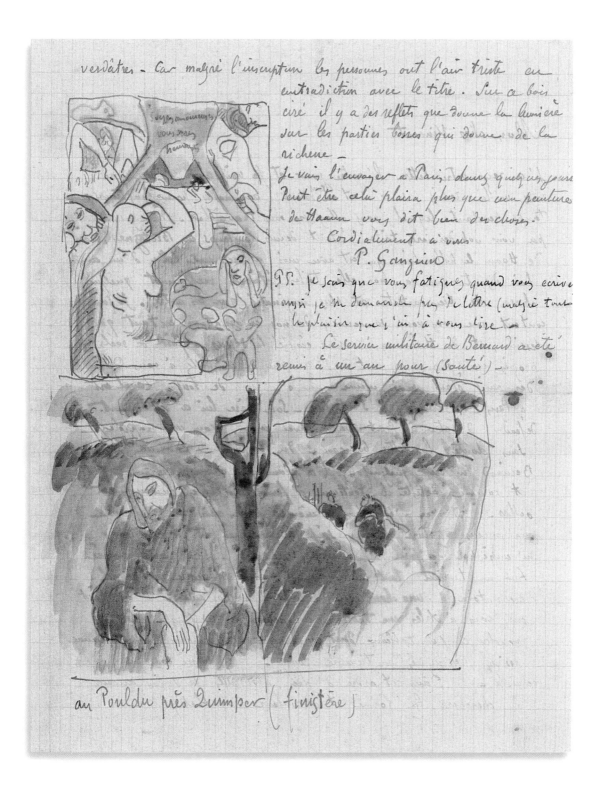

'musical' and 'literary' dimensions, and remarks that 'this genesis is written for those who always want to know the whys and the wherefores; otherwise, it's just a study of an Oceanic nude'.[43]

Gauguin's claim, in the letters and in *Cahier pour Aline*, to have alighted upon the idea of the woman's fear only *after* he had begun the painting, intended as a justification for her potentially scandalous nudity, directly contradicts the account in *Noa Noa*, according to which the painting is a representation of an event that had already occurred (and in which the woman's fear of the spirits was prompted by a specific situation, her lover having abandoned her at night-time without sufficient oil to keep the lamp alight). At least one of these two scenarios (the painting as a record of a personal drama, or as a purely formal exercise, requiring retrospective justification) must be false. But the point is not to determine which is more accurate – no doubt both are fabricated to a degree. Since Gauguin expected the information in his letters to be shared with critics, but also claimed that *Noa Noa* would help with the understanding of his pictures, he must have been content to allow contradictory accounts to circulate. To do so would enable him to keep his commentators guessing, as I have already suggested, but also to adjust his story as necessary, depending upon the recipient and the context.

A clear case of this is Gauguin's adaptation of his accounts of *D'où venons-nous?* according to the correspondent.[44] His insistence to Fontainas that his painting was intended to be elusive and not to illustrate a pre-established theme was driven, as we have seen, by the need to contradict the critic's overly literal approach, but in an earlier letter of 1898 to De Monfreid he had been much more explicit about the work's meaning. Instead of disassociating the title from the painting, as in his letter to Fontainas, he drew De Monfreid's attention to it, pointing out, in an allusion to his text 'L'Église catholique et les temps modernes', that 'I've finished a philosophical work on this theme comparable with the gospel'.[45]

Alongside a fairly detailed sketch (fig. 18), he enumerated the painting's main elements and provided an iconographical interpretation of some of its more opaque motifs, noting for instance that the large idol 'seems to indicate the Beyond', while 'a strange white bird holding a lizard in its claw represents the futility of words'. He also gave the work a dramatic biographical framework by associating it with an apparent suicide attempt in which he retreated to the mountains to swallow arsenic. There is no external corroboration for this event, which could have been invented to add flavour to the painting's existential themes, as well as a sense of urgency to its purportedly spontaneous execution ('Before dying I put all my energy into it, such agonising passion amid terrible circumstances, and such a clear vision without any corrections').[46]

Two years after the exchange with Fontainas, he wrote about the painting a third time, to Morice, his collaborator on *Noa Noa* (who was proposing a scheme to purchase it), repeating the story about his suicide attempt. On this occasion, combining the approaches from his two previous letters, he struck a balance between continuing to defend the painting's deliberate lack of readability and warding off the possibility of further incomprehension. Still smarting from Fontainas's unfavourable comparison of his work to the 'always comprehensible' Puvis, he complains to Morice about the tendency for critics to make comparisons to 'old ideas, and other authors' when confronted with a new work: unless they find what they already expected to see, they are unable to understand, and are therefore unmoved. In contrast, Gauguin advises 'Emotion first! understanding later'. He differentiates his approach from that of Puvis, who 'explains his idea ... but does not paint it', and refers to his own painting several times as a 'poem'.[47] Asking 'why should my brush ... be obliged to enlighten everyone?', he nonetheless provided a clear breakdown of the work's themes, which he arranged in a table according to the tripartite division of the title, from the 'communal life' of 'Where do we come

from?' on the right-hand side, to the 'strange stupid bird' that 'concludes the poem' (fig. 25).[48]

Gauguin's decision to disseminate his ideas via his correspondence tapped into a public interest in artists' statements in the form of letters and diaries. In nineteenth-century France there was an increasing tendency for writers to make use of artists' correspondence in order to lend flavour and authenticity to biographical studies.[49] Bernard's publication of extracts from letters to him and Theo from Van Gogh in Le Mercure de France beginning in 1893, three years after Vincent's death, and continuing until 1897, could not have failed to alert Gauguin to the potential public impact of conventionally 'private' genres of writing.[50] Indeed, he mentioned Van Gogh's published letters during the course of a section devoted to his colleague in Avant et après, indicating his awareness of the role they had played in crafting his posthumous reputation.[51] Gauguin is himself a regular topic of conversation in Van Gogh's letters published in Le Mercure, and one written to Theo in the 1897 instalment approvingly cites Gauguin's own epistolary projection of his identity: 'Included herewith a quite, quite remarkable letter from Gauguin, which I'll ask you to put aside as being of extraordinary importance. I'm speaking of his description of himself, which touches me in my heart of hearts.'[52]

Gauguin could thus be confident that his artistic ideas would garner esteem via the circulation of his correspondence. His letters functioned alongside his self-portraits, which are themselves often sketched and described there (see fig. 26), his performative wearing of extravagant costumes (as recorded by his contemporaries), and photographs of himself that he distributed to friends and colleagues, in order to establish a connection between his creative productions and his 'exotic' artistic identity.[53] Accordingly, even brief accounts of individual works have a significant strategic role to play in contributing to an image of the artist as quasi-divine creator and misunderstood outsider that had wide currency at the time.[54] His descriptions frequently link the stylistic

or formal qualities of a work to his own personality, especially its putatively primitive aspects, as when he described Children Wrestling (1888) in a letter of 1888 to Émile Schuffenecker as 'completely Japanese, by a savage from Peru. Very little finished, green lawn and the upper part white',[55] or asked Bernard in 1888 to bequeath to Bernard's sister Madeleine an 'unpolished' and 'savage' pot (most likely Vase with Two Openings, 1886–7) that he called an 'expression of myself', fantasising that she would think of him when filling it with flowers.[56]

In the case of the ceramic, Gauguin further dramatised his self-identification with his work via the erotic nature of his (perhaps unwanted) gift to Madeleine: although the pot has now cooled, he explains to Bernard, upon closer inspection the careful viewer might still be able to sense the heat that emanated from the kiln and can be detected, too, in the object's maker.[57] Referring to his attempt to bestow a further pot on Madeleine – this time the Self-Portrait in the Form of a Grotesque Head (fig. 27) – in another letter to Bernard, in 1889, he expanded the personal connection between self and artwork to incorporate a broader notion of the artist as devilish creator, 'glimpsed by Dante in his visit to the Inferno'.[58] Once again the experience of heat that determines the character of stoneware also characterises, according to Gauguin, the passion and torments endured by the 'figure burned in that hell', whose features appear to be melting on the vessel's surface.[59]

The association between the 'character' of the material and the temperament of the artist that Gauguin developed in relation to these individual ceramics is also found in his published writing, showing the crossover between his ostensibly private correspondence and his public statements. As Gauguin reminded Bernard in his letter of 1889, during the course of that year he had expounded upon the importance of adapting the form of an object to the natural properties of its material in an essay on the decorative arts at the Exposition Universelle for Le Moderniste illustré.[60] In this article, Gauguin

celebrated pottery as the earliest art form, practised 'in the remotest times, among the American Indians', and as emblematic of the divine power of creativity: 'God made man out of a little mud. With a bit of mud one can make metal, precious stones, with a bit of mud and also a bit of genius.'[61] It was a theme that he would revisit six years later, in an open letter published in Le Soir, in which he protested the inauguration of a new kiln at the Sèvres factory, contrasting the generic productions of the porcelain industry with his own 'handmade' creations, which, he claimed, managed to 'impart the life of a figure to a vase and yet remain true to the character of the material'.[62] In this context, Gauguin quoted Aurier's observation (from his 1891 article, 'Le Symbolisme en peinture: Paul Gauguin') that in his ceramics Gauguin 'kneaded "the soul even more powerfully than the clay"', thus indicating the success of his epistolary efforts to influence the critical response to his work.[63]

Gauguin's tactic of using the description of a specific work to elaborate a larger artistic persona is taken to a manifesto-like level in his exegesis of his painting Self-Portrait with Portrait of Émile Bernard (Les Misérables) (1888, fig. 28) in letters to Schuffenecker and Vincent van Gogh in 1888. Here he employed the metaphor of the kiln again, explaining to Van Gogh that the colours he had used around the eyes resemble the 'tones of a fiery smithy', which in turn 'suggest the red-hot lava that sets our painters' soul ablaze' (thus activating the volcano as a related, Baudelairean, metaphor for creative inspiration, which Gauguin also used on other occasions).[64] To Schuffenecker he made the link to his ceramics even more explicit, comparing the colours of his face, which are indeed exaggeratedly reddened in the portrait, to 'pottery twisted in the great fire' – the reference to a 'furnace burning in the eyes, the home of the painter's mental struggles' recalling the comparison, in his

letter to Bernard, of his Self-Portrait pot to a tortured artist glimpsed by Dante in hell.[65]

Gauguin's performed affinity with Jean Valjean, the protagonist of Les Misérables who is driven to criminal acts by society's incomprehension but ultimately redeemed, is already signalled on the canvas itself by the inscription of the title of Victor Hugo's novel at the lower right, but both letters make the incarnation explicit. As he writes to Schuffenecker, he has portrayed himself as 'a Jean Valjean (Les Misérables) personifying at the same time an Impressionist painter'.[66] His letter to Van Gogh spells out particularly clearly the association between his literary alter ego, 'whom society oppresses', and visual artists who are rejected by the establishment, asking 'isn't he too the image of an Impressionist today?' It also emphasises the allegorical work that his own image does in symbolising a wider conception of artistic identity: 'By doing him with my features, you have my individual image, as well as a portrait of us all, poor victims of society.'[67]

Gauguin's descriptions of his self-portrait combine attention to its visual, stylistic features with elaboration of its metaphorical significance – a duality that, as we have seen, he would come to define a few years later in terms of the 'musical' and 'literary' aspects of a work, respectively. In the case of Self-Portrait with Portrait of Émile Bernard (Les Misérables), the 'literary' element could hardly be more so, evoking as it does nineteenth-century France's most illustrious writer. As with the summaries of his ceramics, he linked the work's material form to its symbolic function as an expression of his artistic identity. To both correspondents he described the portrait's facial features as resembling 'flowers on Persian carpets', implicitly connecting the decorative abstraction of his design – with colours 'far from nature', as he told Schuffenecker – to Valjean's exotic outsider status.[68]

Fig. 27 Self-Portrait in the Form of a Grotesque Head, 1889. Glazed stoneware, 28.4 × 21.5 × 21.5 cm. Musée d'Orsay, Paris

Following pages:
Fig. 28 Self-Portrait with Portrait of Émile Bernard (Les Misérables), 1888. Oil on canvas, 44.5 × 50.3 cm. Van Gogh Museum, Amsterdam (Vincent van Gogh Foundation)

les misérables

à l'ami Vincent

P Gauguin 88

However, although both letters impart the same information, they differ in terms of the relative attention that they pay to subject matter and form.

To Van Gogh, for whom the picture was intended as part of a three-way self-portrait exchange with Bernard, and whom Gauguin knew to be an avid reader and 'romantic', Gauguin stressed its drama and conception of artistic identity.[69] His précis begins with a characterful description of his pictorial persona: 'The mask of a thief, badly dressed and powerful like Jean Valjean ... The rutting blood floods the face.'[70] In contrast, to Schuffenecker he emphasised the painting's formal qualities, supplying considerably more detail about the colours, and linking it to his goal to prioritise 'style' over 'execution'. He begins his description not with the painting's protagonist, but with an assessment of its success as a work of art, judging it 'one of my best things, absolutely incomprehensible ... it is so abstract'.[71] While to Van Gogh he expresses anxiety that he has not got his meaning across, saying 'I feel the need to explain what I was trying to do, not that you're not capable of guessing by yourself, but because I don't believe that I've achieved it in my work', to Schuffenecker he boasted of his satisfaction with the outcome, and this precisely *because* it was 'abstract' and therefore perplexing. These discrepancies indicate the extent to which Gauguin opportunistically tailored accounts of his work according to the recipient, and are also a measure of his conflicting desire to both elucidate its symbolism and simultaneously protect its inscrutability.

'I AM NOT AN ART CRITIC'

The notion that art does not require any verbal explanation, and that only artists have the authority to comment on it, is a leitmotif in Gauguin's writing. It accords with his conviction that art's meaning lies not in fidelity to nature, or the illustration of stories, but in 'arrangements of colours and lines' that, like music, 'do not directly express any idea'.[72] He worked hard to dispel the notion that his own art was reliant on literature, but this denial was typically ambivalent. Writing to De Monfreid about *Nevermore* (1897, fig. 29), in which a reclining woman is watched over by a bird framed in a doorway, he insisted that there was no relation to Poe's poem 'The Raven': '*Nevermore*; definitely not Edgar Poe's raven, but the devil bird who lies in wait'.[73] However, the title, inscribed prominently on the canvas at upper left, unavoidably recalls Poe's poem, in which the eponymous bird intones this word repeatedly while perched on the bereaved poet's windowsill. It was this poem that formed the basis of Poe's self-analysis in 'The Philosophy of Composition', emulated by Gauguin in his own 'genesis' of *Manaò tupapaú*. In refuting the allusion to Poe, Gauguin in effect ensured that it would not go unnoticed.

In adopting this paradoxical stance, Gauguin was not merely being contrary, but striking a careful balance between intellectual credibility and pictorial autonomy. On the one hand, he sought to counter the prevailing perception among writers, including those sympathetic to Symbolist art, that painting could transcend the depiction of material reality to a lesser degree than literature, because it 'lacks immateriality'.[74] He insisted that painting's remit extended beyond the faithful representation of the external world, to the realm of ideas; in *Diverses choses*, for instance, he criticised the Impressionists for focusing on the 'domain of sight' instead of the 'mysterious centre of thought' ('*autour de l'œil et non au centre mystérieux de la pensée*').[75] On the other hand, he was adamant that in moving beyond a mimetic approach, painting was realising its own destiny, not merely following the lead of writers. Thus he protested to Van Gogh that 'I know nothing about *poetic ideas* ... forms and colours conducted harmoniously produce poetry of their own accord: without letting myself be surprised by the subject, in front of someone else's painting, I feel a sensation that transports me to a poetic state.'[76]

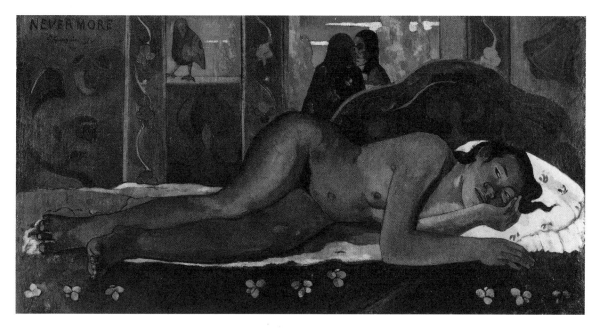

Gauguin was using 'poetic' here, as it was widely used, in a generic sense: to denote a quality potentially belonging to any art form.[77] He argued that it was best represented by music or painting, and was by no means the unique preserve of the verbal arts. In *Cahier pour Aline* he wrote that, in literature, two warring sides had reached a stalemate: 'That which wants to tell more or less well imagined stories. And that which prioritises beautiful language, beautiful forms'; unlike writers of prose, 'only the poet can justifiably demand that verses be beautiful verses and nothing else'. In contrast to literature, music is able to escape this impasse, since it consists only of 'Sounds, harmonies. Nothing more'. But visual art too, he claimed, deserves this exceptional status: 'sister of music, she lives off forms and colours'.[78] Gauguin therefore asserted that painting could be liberated from an anecdotal approach without being deferential to literature; indeed it was *more* capable than literature of divorcing itself from material reality.

Since the 'painter's poetry', in Gauguin's formulation, arose from a work's inherently pictorial aspects, rather than a narrative theme, it stood to

reason that it could not easily be described in words.[79] In a letter of 1885 to Schuffenecker, he alighted on the biblical theme of the parable to convey the essentially mystical nature of painting, with reference to Paul Cézanne (1839–1906): 'like Virgil which has several meanings and can be interpreted at will, the literature of his painting has a double meaning in a parabolic sense; his backgrounds are as imaginary as they are real'.[80] Anticipating his later distinction between the 'literary' and 'musical' aspects of painting (in reference to *Manaò tupapaú*), the parable analogy enabled him to suggest a more profound dimension to a work of art, beyond what is literally depicted.

It was also a means of discriminating between those who were alert to this deeper meaning, and those who were not, as he made explicit in another letter to Schuffenecker, written in 1888. Here, he decoded the symbolism of some of the colours in his painting *Vendages à Arle, Misères humaines* (*The Wine Harvest, Human Miseries*, 1888, fig. 30) – black conveying 'mourning' and the red glow of the sun 'consolation' – without detailing the story behind the central figure's glum expression. As if to justify his

Fig. 29 *Nevermore*, 1897. Oil on canvas, 60.5 × 116 cm. The Courtauld Gallery, London

allusive approach, he pronounced that 'Explaining in painting is not the same as describing. That is why I prefer a colour that is suggestive of form, and in composition the parable rather than a painted novel.' Since words have conventional meanings, he mused, why could colour not be used symbolically rather than literally, to 'create various harmonies that correspond to the state of our soul? Too bad for those who will not be able to read them; we are not obliged to explain.'[81]

As well as inaugurating the idea of painting as parable, the initial letter of 1885 to Schuffenecker also established the theme that would underpin all his later writings: that the fundamental mystery of visual art, and the rare capacity to interpret it, were faculties

inherent to the primitive. Thus the 'misunderstood' Cézanne, he observed, possessed 'the essentially mystical nature of the Orient (his face resembles an ancient from the Levant)'. His rustic character (he spends his days 'at the top of mountains reading Virgil and gazing at the sky') expresses itself in colours that are strikingly intense and also 'grave like the character of orientals'. He also compared the effect of Cézanne's paintings, cryptically, to a 's e p a r a t e d mystical writing; *drawing* as well', which was likely to be misunderstood and perceived by most as 'madness'. Despite its linguistic basis, it is clear that Gauguin intended this analogy to position Cézanne's pictorial language as the opposite of literary. He followed the

Fig. 30 *Vendanges à Arles, Misères humaines* (*The Wine Harvest, Human Miseries*), 1888. Oil on jute sackcloth, 72.5 × 92 cm. Ordrupgaard, Copenhagen

comparison by declaring himself 'increasingly in agreement with this translation of thought by any means other than literature'.[82]

The probable source for Gauguin's fascination with graphology – the Abbot Jean-Hippolyte Michon's *Système de Graphologie* (1875) – makes a categorical distinction between the character of orientals and westerners, based on their handwriting: those from the 'mystic and sensual' Orient do not join up their letters, while the 'deductive, logical, reasoning' West is characterised by a cursive script.[83] Gauguin was inspired by Michon's comparison. He positioned Cézanne as primitive by presenting his painting as an oriental language – an analogy that he used of his own work too. But he also used the contrast to distinguish more broadly between the intuitive, even esoteric understanding of artists and their disciples, and the dry, rational judgements of art critics, whose sterility is reflected in their wooden prose.

The terms in which Michon defined western culture, as evidenced in its writing – 'deductive, logical, reasoning' – are close to those in which Gauguin, in *Racontars de rapin*, described the critic Ferdinand Brunetière, as 'erudite, a writer, a logician'.[84] In contrast, Gauguin presented himself as a different kind of writer – one who avoided logical linearity. The visual and verbal effect of this assemblage method will be discussed in chapter three, but suffice it to say here that a deliberately unrefined, loosely structured approach characterises his criticism from the start. Replete with non sequiturs, shifts in tone, and fable-like tales of art-world injustices, this manner of writing was intended to preserve the mystery of visual art, in opposition to the logical, deductive methods of the professional critic. He used this anti-linear style to defend 'primitive' artists from the literary biases of 'civilised' writers, whose demand for legible subject matter led them to over-value the merits of a correct, linear drawing technique.

Gauguin first set out this charge fully in 'Notes synthétiques' (1884–5), in which he bemoaned the fact that professional writers monopolised art criticism.

He mocked them for their habit of starting their own books with a self-justificatory preface, 'as though a truly good work could not defend itself'. As Gauguin typifies it here, the attitude of the critic is like that of the coloniser: resistant to difference and believing themselves superior: 'Yes, men of letters, you are incapable of criticising a work of art, even a book. Because as judges you are already corrupt; you have a preconceived idea, that of the writer, and you consider yourselves too important to take someone else's idea into account.' He even presents writers as physiologically incapable of understanding visual art on the grounds of their restricted emotional range. While 'intelligence' and 'education' are necessary to assess a work of literature, in order to judge music or visual art, one must also be able to 'feel'. This is a rare faculty, he claims, possessed only by those who are born artists, 'and few are elected among all those who have the calling'.[85]

Accordingly, Gauguin defended art that, as he saw it, privileged emotional effect over exactitude, and in so doing aligned itself with the primitive. In 'Huysmans et Redon' (1889), he took the novelist and critic Joris-Karl Huysmans to task for his take on Redon in his collected essays on art, *Certains* (1889). He contests Huysmans's verdict that Redon creates 'monsters', and asserts instead that they are 'imaginary beings'. They only appear to be monsters because we are not familiar with them, and tend to recognise as normal only that which is most common (for 'monsters', read 'savages', especially given Redon's association with the primeval).[86] In contrast, Moreau, whom Huysmans admires, 'can speak only a language already written by men of letters; the illustration, as it were, of old stories'. Instead of emotions, he 'loves the richness of material goods', and turns every human being into 'a jewel covered with jewels'. Redon's 'embryonic beings' suggest an art also blossoming into life, whereas Moreau's 'finely tooled work' implies sterile perfection.[87]

In 'Sous deux latitudes' (In two latitudes), published in *Essais d'art libre* in May 1894, Gauguin

overtly connects criticism's resistance to innovation with the mercantile outlook of European society, by juxtaposing the 'two latitudes' of France and Polynesia. In contrasting the squalor of the former with the charmed life of the latter, he suggests an ironic reversal of the classic binary of civilised and savage. He begins by setting the scene of the '17th latitude', in Tahiti, where 'the nights are all beautiful', and describes how the whole community gathers to sing the *himene* (a Tahitian polyphonic chant with lyrics partly derived from Protestant hymns). Although 'not very learned', the performance is powerfully expressive.[88] The second section recounts his visit to an aristocratic conductor and composer, Eugène d'Harcourt, in a seedy area of Paris. Here, in the '47th [sic] latitude', 'noises are no longer musical', and instead of coconut trees and starry skies there are putrid drains and prostitution. He attempts to interest d'Harcourt in the work of his friend, the composer William Molard, but d'Harcourt asks: 'Is your friend famous, prix de Rome?' When Gauguin remarks that geniuses have to be discovered by someone, d'Harcourt replies that he is unwilling to take a chance, and to risk a bad review in the press. Exiting the interview, Gauguin muses: 'What if we went again to the 17th latitude? There the nights are all beautiful.'[89] Via the repetition of the essay's opening phrase, the exposition of French degeneration in its central episode is framed by the memory of Tahiti, and the anticipation of a return there, in the manner of a musical refrain.

If 'Sous deux latitudes' aims at something of a poetic effect, Gauguin was capable, too, of writing more conventional art criticism. For example, in 1895 he composed a catalogue essay for an exhibition of works by the Pont-Aven painter Armand Seguin (1869–1903), which was also printed in the venerable *Mercure de France*. In this context, Gauguin stressed his credentials as a practising artist, with an innate understanding of the craft. He began by citing the Swedish philosopher Emanuel Swedenborg's theory of a 'mysterious book where the eternal laws of Beauty are inscribed. Only artists can unlock its meaning, and because God has chosen them to understand, I will name them the Elect.'[90] He then made it clear that he offered this analysis of Seguin's work (to those 'capable of understanding') in his capacity as a fellow initiate, and not with the intention of establishing 'aesthetic theories, whether of a movement or a profession: I am not an art critic'. Similarly, Seguin, he explained, was a 'cerebral' artist, but by no means a 'literary' one, because he 'expresses not what he sees, but what he thinks, by means of an original harmony of lines'. His large painting of a Breton peasant girl resting contains 'no literature'; its meaning is conveyed purely 'in the arabesque of lines that make up the figure, in the curves that run parallel, in some cases, to the picture frame, that intertwine with one another'. Implicitly, the flattened forms of the canvas – 'with no horizon' – correspond to the simplicity and self-sufficiency of its subject: a humble country girl, simply lying there 'without dreams, without coquettishness'.[91] Seguin does not provide a literal depiction of a witnessed scene, but expresses his inner thoughts by means of autonomous decorative forms that can be understood only by a fellow artist, not by a critic attempting to reduce their mystery to a readable narrative.

Gauguin's efforts at counter-criticism culminated in the polemical essay of 1902, *Racontars de rapin*. Opening with the words 'Criticism is our censorship', it continues the anti-institutional critique evident in Gauguin's earliest published writings dating from 1889.[92] In his choice of title, he brazenly adopts the identity of an amateur and makes it clear that he is writing 'as a painter', for whom passion is more important than coherence.[93] He dismisses both accumulated knowledge and literary polish as merely mechanical attainments, and derides critics as 'typographers ... who think they *know* painting when the only artful thing they do is open their mouths'.[94] Picking up on the theme established in 'Notes synthétiques', he emphasises that feeling and intuition are more important for the appreciation of

visual art than erudition. Learning the names of artists in catalogues is of little use to the 'so-called well-educated critic', he argues, since even artists with their 'special gifts' are 'hardly able to learn the secrets of the masters'.[95]

Towards the end of *Racontars*, Gauguin announces that he will try his own hand at interpretation by 'talking about' a literary work that he 'loves' – H. G. Wells's 'A Story of the Stone Age' (1897). He stresses that 'talking about' and 'loving' are directly opposed to the mechanical, 'typographical' act of 'critiquing'. His appreciation of this work stems from his ability to empathise with the primitive way of life that it describes. Just as the 'savages' in the story love each other instinctively, 'without knowing it', and 'act on the same thought' without communicating directly, Gauguin's preference for the tale is, he wants us to believe, intuitive, not rational.[96] In contrast, the critic makes judgements – for example on the quality of an artist's drawing – based on accumulated knowledge, even though, Gauguin insists, he cannot know 'where drawing begins and where it ends'.[97]

As should be clear by now, Gauguin's claim that visual art could manage perfectly well 'without the intervention of an interpreter' was in no way backed up by his own silence: art's autonomy ironically required his constant verbal intervention.[98] While insisting on painting's resistance to explanation, he manipulated the reception of his art by writing strategic accounts of individual works in his letters and manuscripts. He railed against the verbal bias of critics, but copied out and distributed favourable reviews of his work, and regularly displayed his own literary knowledge through citations and textual allusions in his art and writing. Despite disdaining the function of the critic, he produced a series of essays and published articles in which he mounted a defence of an alternative canon of primitive anti-heroes.[99] His counter-critical stance was a rhetorical strategy that exploited the tropes of a 'savage' naivety and intuition to oppose the 'civilised' values of the rational art critic.

Chapter Two

NOA NOA

and the ARTIFICE OF AUTOBIOGRAPHY

IF GAUGUIN'S WRITINGS ARE LITTLE KNOWN, the one clear exception to that rule is *Noa Noa*, the apparently autobiographical tale of his first two years in Tahiti (1891–3). In contrast to the collections of anecdotes, borrowed phrases and opinions on art and politics that characterise most of his writing, *Noa Noa* reads like a story with a plot and characters. Although the first-person narrator is not named, he is identified as a male artist, and events are framed by his excitement at arriving in Tahiti – 'I burn to reach the longed-for land' – and his melancholy departure, 'two years older, younger by twenty years; more of a barbarian, too, and yet knowing more'.[1] The tale opens with the funeral of Pomare V, the last king of Tahiti, which did indeed occur a few days after Gauguin's landing, a symbolic marker of the demise of 'authentic' Polynesian culture.[2] This overlap is enough to make *Noa Noa* apparently irresistible as a source of information about his life in Tahiti: through a series of intimate cross-cultural encounters, it provides the script of his attempt at 'going native', while the narrator's romance with the 13-year-old

Tehamana breathes life into the Tahitian women portrayed in Gauguin's paintings, many of whom are assumed to represent her.

Of course, people have not been completely taken in by Gauguin's version of events. Pointing to the discrepancy between the prosaic accounts in his letters of money troubles, health worries and plans for repatriation, and the idealised vision, in *Noa Noa*, of life lived among the Tahitians, 'carefree and calm and loving', many have drawn attention to its distortion of the truth.[3] But such exposure has posed little threat to the concept of *Noa Noa* as testimony. Since its first publication in 1901, in a significantly revised form, it has been published in a minimum of 17 languages, and at least one new edition or reprint has appeared in 75 of the years leading up to 2018. Such is its popular appeal that the actor Keanu Reeves was persuaded to read from it in a sold-out, hour-long performance at the Fondation Beyeler in Switzerland to mark the opening of their major Gauguin exhibition in 2015.[4] As read by Reeves, who was selected because of his part-Polynesian heritage (his father is Hawaiian),

Previous:
Fig. 31 Detail: *Noa Noa*, 1894–1901, folio 87 verso (p. 168). Geometric decorative motifs, graphite and watercolour on paper, cut out and pasted, 31.5 × 23.2 cm. Musée d'Orsay (held at the Musée du Louvre), Paris, RF 7259, 1

Fig. 32 *Merahi metua no Tehamana* (*Tehamana has Many Parents* or *The Ancestors of Tehamana*), 1893. Oil on jute canvas, 75 × 53 cm. The Art Institute of Chicago

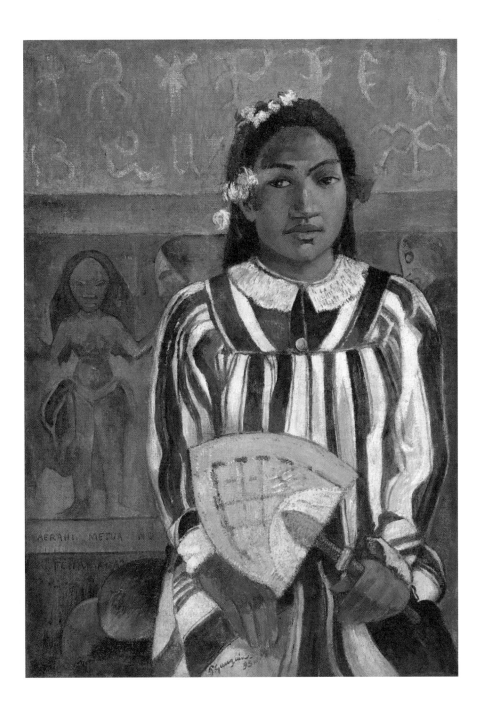

Appendice —

Après l'œuvre d'art — La vérité la sale vérité —

Parti de France avec une mission.

Qui les obligeait à me la donner..

Peut être un avertissement à
l'officiel, avertissement de la foule
qui scrute fouille l'âme des artistes
et plus tard fait loi —

Peut-être avec ce semblant de
satisfaction m'éloigner et ne me
revoir plus jamais —

Et en me quittant — N'ayez crainte
de nous écrire pour vous rapatrier comme nous l'avons déjà fait
pour M. D... qui avait une mission au Japon —
Et quand vous reviendrez nous vous achèterons quelques uns de vos
travaux — Comme nous l'avons fait pour M. D.
notre budget ne se distribue qu'indirectement

Qui m'obligeait à accepter Je ne sais ...
Pauvre mais riche de mon art je ne pouvais devais dans mon voyage
avoir être obligé de recourir aux navires de guerre pour arriver
à Tahiti — pour aller dans les Îles voisines où je comptais étudier

à mon arrivée à Papeete mon devoir (chargé d'une mission
était d'aller voir faire ma visite au gouverneur — le nègre Lacascade
célèbre par sa couleur, par ses mauvaises mœurs, par ses
exploits antérieurs à la banque de la Guadeloupe, récemment
par ses exploits à Raiatea aux Îles sous le Vent, Malgré toutes
ses dettes toutes les cris de la population récriminations du roi
Pomaré, les cris de la colonie française à Tahiti cet homme
néfaste et incapable était inamovible — Partout dans le
ministère on répondait invariablement (dettes à payer)
n'obtenait une place du souverain distributeur que celui
qui avait une femme ou une fille à lui offrir.

De part et d'autre quelle vénalité —

Ce fut donc avec tristesse et peut être l'arrogance d'un

Noa Noa appears to bring Gauguin back to life. The actor's recitation creates the impression of privileged access to the artist's original experience and unique voice. But this oral performance, abstracted from the printed page, obscures the narrative's textual complexity. Here I will make *Noa Noa* the object of literary and visual analysis in itself.

For much of the twentieth century, *Noa Noa* formed the basis of heroising biographies detailing Gauguin's escape from civilisation and willingness to sacrifice his family life and material comfort for art.[5] More recently, it has played a central role in critiques of his imperialist and sexist assumptions, and of his self-serving motivations for relocating to Polynesia.[6] But the question of *Noa Noa*'s veracity is essentially circular. Testing its narrative against biographies of the artist proves futile as these, in turn, depend on *Noa Noa* for much of their information about his first stay in Tahiti.[7] For example, in a move typical of Gauguin's biographers, David Sweetman recognises the potential unreliability of the artist's narrative – 'Because of his deliberate mixing of fact and fiction, it is always difficult to extract the complete truth from his writings' – but goes on to assert its authority nonetheless. Referring to the episode in *Noa Noa* in which the narrator, taking a trip around the island, meets a family at Fa'aone and, having explained that he is looking for a wife, is offered their 13-year-old daughter, Sweetman claims that we know that Tehamana (in Tahitian orthography, Teha'amana) actually existed. 'Nor', he adds, 'is there any reason to doubt Gauguin's story of how he found her, which is detailed enough to be a first-hand account.'[8] In fact, biographical evidence of Tehamana/Teha'amana's existence is at best minimal and, arguably, inconclusive.[9] The name, meaning 'she who gives strength', is found in 'ancient prayers, myths and legends', according to Danielsson, but never in Gauguin's correspondence.[10] He mentions it on only one other occasion: in the title of the painting *Merahi*

metua no Tehamana (*Tehamana has Many Parents* or *The Ancestors of Tehamana*, 1893, fig. 32), while in later versions of *Noa Noa* the narrator's lover is renamed Tehura.[11]

In my view, it is a mistake to read *Noa Noa* biographically, or even to see it as an embellishment or falsification of Gauguin's life in Tahiti. Even in its first rendition (the version known as the Draft manuscript), Gauguin's account was not a pure record of personal experience. It combines episodes that, on the surface, have a plausible basis in everyday life – a description of a fishing expedition, the story of how the narrator meets Tehamana, the tale of a journey with a local guide to find wood for carving (the latter much cited for its supposedly pivotal role in his conversion to a primitive state, as we shall see) – with stories of Polynesian gods copied from an ethnographic study by the French-Belgian diplomat Jacques-Antoine Moerenhout.[12] Gauguin himself warned his readers against too literal an interpretation of his story. He followed it with an 'Appendice' (fig. 33) whose mundaneness and precision contrasts with the more literary episodes of the narrative proper, and which is not retained in the later versions of the text. Detailing the colonial bureaucracy surrounding his trip, this section begins 'After the work of art – The truth, the dirty truth', thus hinting at the fictional nature of what has gone before.[13]

Indeed, apart from Pomare's funeral, none of the events or characters in the main body of the text is corroborated by external sources. Instead, precedents for the narrator's romantic heroine, his disappointment in the Europeanisation of Tahiti, and even his tendency to mix apparently personal experience with Polynesian legend, can all be found in contemporary travel writing on Polynesia. At the same time, I argue that *Noa Noa* is more complex than some of its models, which notably include the hugely successful romance *Le Mariage de Loti* (1880) by the naval officer and novelist Pierre Loti (real name,

Fig. 33 *Noa Noa* Draft manuscript, 1893, p. 33. Mixed media, 40 × 27.5 cm. Getty Research Institute, Los Angeles, 850041

Julien Viaud). Most scholars assume that in *Noa Noa* Gauguin charts his transformation, now more widely understood to be staged rather than authentic, into a savage. However, in comparison to Loti's *Mariage*, he actually offers a considerably more ambivalent and unstable account of colonial identity, and allows the reader to sense the difficulty of accessing another culture.[14] The narrator labels himself a 'European', 'Frenchman' and 'civilised man' as often as he does a 'Maori' and a 'savage'. His assimilation into the local culture is not so much triumphantly performed, as undermined and anxiously replayed.

Noa Noa as Palimpsest

In *Noa Noa*, then, Gauguin strategically constructs a public identity, rather than simply narrating his real experiences. However, that identity itself was far from stable, as the complicated history of the project shows. He may have initially intended the publication of *Noa Noa* to coincide with the exhibition of his Tahitian work that was held at the Galerie Durand-Ruel in Paris, following his return to France in 1893. In October of that year, he wrote to his wife that he was preparing a 'book on Tahiti' that would 'be really useful in making my painting understood' and the Draft manuscript is punctuated with references to the titles of paintings that were included in the exhibition.[15] Indications such as 'Portrait of a woman *Vahine no te tiare*' suggest that fuller descriptions will be inserted at the designated point in the episode, which by implication purports to narrate a real event that gave rise to the scene depicted.[16] As we saw in the previous chapter, Gauguin used both *Noa Noa* and his letters to excite interest in his artworks by presenting them as expressions of his primitive personality. But if he hoped that the tale of his tropical adventures would help to contextualise the work on show at Durand-Ruel, *Noa Noa* nonetheless remained incomplete when the exhibition opened the following month.

At some point before returning definitively to Polynesia in July 1895, Gauguin enlisted Charles Morice, who had written the catalogue essay for his exhibition, to help develop the project, and their collaboration led to the version that is now known as the Louvre manuscript. During this phase, while Gauguin was still in France, the basic conceit of chapters roughly alternating between painter and poet was established. His initial Draft was broken down into sections in which '*le conteur parle*' (the storyteller speaks) and interspersed with prose poems and verses by Morice; the title *Noa Noa* – meaning 'fragrant' – was selected; and a preface and introduction were added. In addition, Gauguin's tale as told in the Draft was considerably fleshed out: annotations or ellipses that had indicated areas for further development were elaborated, Gauguin's prose was generally tidied up and rendered more literary, and further detail was added to each episode.

The precise division of labour between artist and poet in 1894–5 remains unresolved, and may never be possible to determine conclusively. What is clear, however, is that Gauguin did not spend his time passively awaiting Morice's revisions and additions. Instead, he began actively to conceive of the text as part of a larger performative project that could serve to promote his image as an artist-savage. During gatherings in his Paris studio, whose decorative scheme was in itself a 'visual manifesto' for his primitive persona, he gave readings from his work in progress.[17] Meanwhile, he cajoled Morice to complete his portion of the work, since he wanted the book to be available alongside the suite of ten woodcuts that he had created to accompany it, and which he exhibited in his Paris studio in 1894.[18] On the eve of his departure in 1895, in an interview published in *L'Écho de Paris*, he advertised the book in terms that positioned it as holding the key to his art's exotic foundations: 'I describe my life in Tahiti and my thoughts on art. Morice comments in verse on the work I have brought back from there. It will explain to you how and why I went there.'[19]

Although Morice's contributions are often disparaged for burdening the artist's unpretentious script with additional overwrought prose and insipid poetry, this clash of styles was – crucially – integral to the intended effect.[20] As Gauguin later explained to his friend George-Daniel de Monfreid:

On the subject of non-civilised people, it had occurred to me to bring out the contrast between their character and ours, and I had thought it would be an original idea to write (me quite simply as a savage) next to the *style* of a civilised man – Morice. So I *conceived* and *directed* the collaboration along these lines; and also, not being a professional, as they say, to get a sense of which of the two of us was better; the naive and brutal savage or the rotten civilised man.[21]

The opposition between Morice's professional style and his own naive one could be construed, then, as intended to reflect the confrontation between Europe and Polynesia that is explored in *Noa Noa* through the narrator's various encounters with Tahiti and its inhabitants. By casting Morice's florid prose as a foil to his own simpler text, he could enhance his primitive credentials. This self-conscious strategy contradicts Gauguin's protestations of naivety. It points to his literary ambitions and calls into question the idea that *Noa Noa* was simply an artless travel diary or memoir.

In any case, the partnership quickly soured, leading to a complicated history of multiple draft versions and partial publications.[22] On Gauguin's return to Polynesia, each author kept a copy of the revised text. Morice published the first full edition in 1901, with substantial further alterations beyond those mutually agreed in 1894–5, which Gauguin never saw.[23] For his part, Gauguin augmented and illustrated his copy of the revised narrative back in Tahiti over

a number of years, adding the essay *Diverses choses* (Miscellaneous things) and unevenly adorning the album containing these two texts with clusters of original and reproduced images (fig. 34). This version of *Noa Noa* – the Louvre manuscript – bears the traces of the project's piecemeal progress.[24]

At the start of chapter XI, for example, collaged rubbings of Marquesan motifs from a carved wooden object, retouched in watercolour and pencil, cover the left-hand side of the double-page spread and continue over the margin (fig. 35). Below the chapter's title, 'Nave Nave Fenua', these decorative fragments visually connect a schematic list of predicted chapter contents (for example, 'lyrical episodes'; 'prose and poems') at the top of the page to a poem by Morice lower down, linking two areas of text that are otherwise separated by a blank zone marked only by the words 'to follow'.[25] Brought together in one space, then, are the transcribed words of another author, appropriated motifs mechanically reproduced, Gauguin's own handiwork and provisional notations, and an empty space that is suggestive of the manuscript's evolving status.[26] With its apparently haphazard structure, and juxtaposition of borrowed material from different sources, this page encapsulates the sense of *Noa Noa* as a collaborative, unresolved work – a multilayered physical document, rather than a spontaneously recorded personal story.

Nonetheless, critics have often been preoccupied with disentangling Gauguin's original script of 1893 from the manuscript's later states. The fact that the successive versions of the text were published in reverse order has exacerbated the sense of gradually peeling back the layers to reveal Gauguin's original conception, uncorrupted by Morice's later interference.[27] After Morice's rendering of the collaborative text was published in 1901, the

Following pages:
Fig. 34 *Noa Noa*, 1894–1901, folios 30–31 (pp. 56–7). Left: photograph; watercolour, pen and ink of *Tii* (*Spirits*); photographs of *Head with Horns* (1895–7). Right: *Te Atua* (*The Gods*) (1893–4); photograph; watercolour, pen and ink of Hiro, god of thieves, 31.5 × 23.2 cm (each sheet). Musée d'Orsay (held at the Musée du Louvre), Paris, RF 7259, 1

Fig. 35 *Noa Noa*, 1894–1901, folios 87 verso and 88 recto (pp. 168–9). Geometric decorative motifs, graphite and watercolour on paper, cut out and pasted, 31.5 × 23.2 cm (each sheet). Musée d'Orsay (held at the Musée du Louvre), Paris, RF 7259, 1

Chapitre XI. IX.

Nave Nave Fenua

Petits tableaux et grands cadres

Épisodes lyriques

La Nature commente les légendes

Prose et Vers

—

à venir

Souriant au soleil de rêve qui se lève
Ce continent de fleurs dans ces flots de feu d'or
— Eden — Eldorado, Floride, Labrador
Et ce un pays qu'on pourrait voir, ou bien mon rêve?
Suggestion de la nature: ligne et Couleurs — la Mer, les
Arbres (la forêt, la montagne — parfums, silence; Hina.

Une idole massive impose à l'horizon
L'immémorial poids de ses lourdes saisons
Et les fleurs à ses pieds ne cessent pas d'éclore.
Et tout n'est que jeunesse, et tout n'est que splendeur

next version to appear was Gauguin's copy of the joint work (the Louvre manuscript), which had passed to De Monfreid after the artist's death. It was published in 1924, in a transcript that gives no sense of the physical appearance of the volume, and does not include *Diverses choses*. (After De Monfreid bequeathed the manuscript to the Louvre in 1925, an incomplete limited edition facsimile was published the following year, again omitting *Diverses choses*.)[28] An extract published in *Les Marges* in 1910 had already seeded the idea that it represented an original state, essentially unblemished by Morice; the journal's editor introduced it as being 'simpler, spicier, more gripping'.[29] It was this 'error' that Jean Loize set out to correct after discovering the Draft manuscript in the attic of the print dealer Edmond Sagot's family in 1951; it was published in facsimile in 1954, and then in Loize's critical edition of 1966.[30]

Given his own role in its belated unearthing, it is not surprising that Loize, writing in the 1960s, stressed the significance of Gauguin's first Draft, dismissing the Louvre manuscript as no more than a rough sketch for Morice's 1901 edition, and concluding that 'Gauguin's initial idea was quickly betrayed by his overly literary companion'.[31] It was Nicholas Wadley (in 1985) who first challenged the prevailing view that the Draft manuscript was the only authentic version. He points out that Gauguin must have approved Morice's changes, since he transcribed them into the Louvre manuscript, and that he had knowingly engaged Morice with the explicit intention of drawing out the contrast between his own intuitive response to Tahiti and Morice's cultured one.[32] Nonetheless, he still proposes that Gauguin asked Morice to help him because he 'was not a writer himself' and was 'consistently attracted to young men intellectually more articulate than himself'.[33] He therefore leaves untested the assumption on which the idea of Morice's corrupting influence rests in the first place: that, on his own, Gauguin would have been incapable of developing *Noa Noa* beyond its initial rough state. He also goes too far in suggesting that

'the final form published in 1901 more or less corresponds to Gauguin's first conception'.[34] Although he entered willingly into the partnership, Gauguin did not cede control to the poet. He continued to insist on maintaining the appropriate balance between their respective styles, writing to an unnamed correspondent (probably Morice's wife) that 'verses are expected from Morice, I know, but if there are many in this book all the narrator's naivety will disappear and the flavour, the *Noa Noa* will lose its origins'.[35]

According to Loize, since he 'almost never corrected himself', the initial text of *Noa Noa* 'would have been scarcely altered by Gauguin if he had published it alone'.[36] But this hankering after an untouched state, free from the interference of other voices, is all too reminiscent of the artist's own apparent desire to uncover an original Tahiti, unsullied by the taint of civilisation. It is also just as futile.[37] Even in the Draft, the sense of a gap between Gauguin's initial experience or idea, and its recording and reworking, is palpable, at least in the manuscript's original form (it is mostly lost in the transcripts). Upon opening its pages the reader encounters not its engaging first sentence – 'For 63 days I've been on my way, and I burn to reach the longed-for land' – but a brief passage of text relating to a later episode, under the heading 'assorted notes'.[38] This is accompanied by a puzzling sketch, followed by two blank pages (fig. 36). The text itself then begins with 19 lines scored through with a large cross, in which Gauguin tried out an opening that he must have considered too pedestrian (fig. 37).[39]

Throughout the script, numerous crossings-out record reconsidered word choices, but also straightforward errors (where the variant is close in spelling but not in meaning), which suggest that Gauguin was working from prior notes.[40] In addition, there are three additional episodes appearing in the 'storyteller's' (i.e. Gauguin's) chapters of the Louvre manuscript that do not appear in the Draft. It is clear that these were based on manuscripts in Gauguin's

hand, as a page from one of them was reproduced, after Morice's death, in the 1920 edition of his monograph on the artist.[41] The minimal differences between this text and the episode as it appears in the Louvre manuscript indicate that Morice did not always overhaul Gauguin's prose; the artist, too, was probably responsible for some of the refinements. Other factors point to this hypothesis. Most strikingly, five supplementary leaves of paper containing additional or edited script in Gauguin's hand are appended to the Draft manuscript's pages, in one case so as to incorporate Polynesian myths culled from Moerenhout, which Gauguin had first transcribed into his richly illustrated notebook *Ancien Culte mahorie* (Ancient Maori religion).[42]

In another instance, Gauguin stuck in a revised version of an episode that was already fully written (fig. 38). It describes his attempt to execute a portrait of his neighbour, and corresponds to the painting *Vahine no te tiare* (*Tahitian Woman with a Flower*, 1891, fig. 22). Gauguin related her refusal and capitulation twice, once in the main body of the text, which finishes with the note 'Portrait of a woman *Vahine no te tiare*', and again on a separate sheet, so that the narrative appears to circle back on itself if the two sections are run together. These alternative renditions of the same event reveal the extent to which Gauguin was involved in editing his own work, even at this initial stage, especially as the appended version is noticeably more literary. For instance, where her indecision is described in the main text simply as 'Caprice, desire for the forbidden fruit', the inserted version reads 'Was it an inner struggle, or caprice (a very Maori trait), or even an impulse of coquetry that will surrender only after resistance?'[43] These revisions contradict Loize's claim that Gauguin 'writes as he speaks' and is 'unwilling and scarcely able to revisit his initial

thoughts or words'.[44] The appended sheets in the Draft show Gauguin both refining his own prose and drawing on extraneous (not autobiographical) material from the beginning, while the evidence of the lost text demonstrates that some of the additional material in the collaborative Louvre manuscript originated with Gauguin, and was little touched by Morice.[45] These interventions cast doubt on the assumption that Morice was solely responsible for developing areas of the Draft that were left in note form. For instance, numbered notes in the margin which commence 'The androgynous aspect of the savage, the slight difference of sex among animals' (fig. 39) are elaborated, in the Louvre manuscript, into a comparison between Polynesian and European attitudes to sexual difference, now incorporated into the main body of the narrative.[46] I am not suggesting that Gauguin necessarily authored the expanded passage on this occasion. Morice was probably responsible for a good number of such refinements, as he introduced further changes in the same vein in his 1901 edition. But I would argue that, with the exception of Morice's poems, most of the additions to Gauguin's initial Draft that were made in 1894–5 are difficult to attribute definitively to one or other partner, and that, overall, Gauguin's involvement in elaborating the text was greater than has been allowed.

If the full extent of Gauguin's role in transforming his own original draft remains uncertain, what is clear is that Morice substantially altered their collaborative text after 1895 without Gauguin's approval, adding more poems and further refining the narrative chapters to create his 1901 edition. He removed altogether the brief preface, found in the Louvre manuscript, entitled '*La mémoire et l'imagination*' (Memory and imagination), and opened the volume instead with one of his new poems. The purpose of the preface had been to introduce

Following pages:
Fig. 36 *Noa Noa* Draft manuscript, 1893, inside front cover. Mixed media, 40 × 27.5 cm. Getty Research Institute, Los Angeles, 850041
Fig. 37 *Noa Noa* Draft manuscript, 1893, p. 1. Mixed media, 40 × 27.5 cm. Getty Research Institute, Los Angeles, 850041

Fig. 38 *Noa Noa* Draft manuscript, 1893, p. 8, and sheet of paper pasted in between p. 8 and p. 9. Mixed media, 40 × 27.5 cm. Getty Research Institute, Los Angeles, 850041
Fig. 39 *Noa Noa* Draft manuscript, 1893, p. 12. Mixed media, 40 × 27.5 cm. Getty Research Institute, Los Angeles, 850041

notes diverses.

A — La forme sculpturale de l'ibas —
 Deux colonnes d'un temple, simples et droites —
 Deux yeux de la poitrine
 Et le haut vaste se terminant en pointe
 le grand Triangle de la Trinité —
 Le pouvoir d'en haut —
 Le Grand Taaroa existe, l'univers existe, le chaos
 de Sa volonté Suprême il les réunit.'

—————————

— à introduire —
 Il était
 Taaroa était son nom — . . .

 .

 —————

— Légende des Aréois —

Je ne sais pourquoi mon gouvernement m'avait accordé cette mission –
pour avoir l'air probablement de protéger un artiste –
on sait cependant ce qu'il en coûterait à un directeur des
Beaux-arts s'il se [rayé]
Je ne sais pourquoi j'ai fait ce voyage avec ce morceau de papier
dans ma poche ? C'est que pour arriver là-bas il faut
quelquefois monter à bord d'un navire de l'État, et pour un
rien on vous mettrait devant avec les matelots. Grâce à mon
papier, grâce à la courtoisie de Monsieur Guarou directeur
de l'intérieur à Nouméa [rayé] j'embarquai sur la Vire
au carré des officiers. Et n'en fut pas de même au retour.
Le nègre Lacascade gouverneur de Tahiti avait demandé passage
pour moi au commandant du Duchaffault, bien entendu
au poste des maîtres. Malgré tout on rencontre quelquefois
de la courtoisie surtout dans la marine. Le commandant Manseron
le second Mr Allemand et tous les autres officiers M Dufaure Martin
m'accueillirent très bien et je fus installé au
carré des officiers. Grâce à ces messieurs je revins en France
assez agréablement –
Depuis 63 jours je suis en route et je brûle d'aborder en la
terre désirée – Le 8 Juin dans nous apercevions des feux bizarres
se promenant en zigzag d'une pêcheurs Sur un ciel sombre
se détachait un cône noir à deux teurs. Nous tournions
Moréa pour découvrir Tahiti – Quelques heures après le petit
jour s'annonçait et lentement nous nous approchions des récifs
de Tahiti pour entrer dans la rade passé et mouiller sans
avaries dans la rade – Pour quelqu'un qui a beaucoup voyagé
cette petite île n'a pas comme la baie de Rio Janeiro un
aspect féérique – Quelques pointes de montagne subm

8

Je commençai à travailler, notes croquis de toutes sortes. Tout
m'aveuglait m'éblouissait dans le paysage. Venant de l'Europe
j'étais toujours incertain d'une couleur cherchant de midi à
14 heures : cela était cependant si simple de mettre naturellement
sur ma toile un rouge et un bleu. Dans les ruisseaux
des formes en or m'enchantaient — Pourquoi hésitais-je
à faire couler sur ma toile tout cet or et toute cette réjouissance
de soleil — Probablement de vieilles habitudes d'Europe, toute
cette timidité d'expression de nos races abâtardies —

Pour bien m'initier à ce caractère d'un visage tahitien à
tout ce charme d'un sourire Maorie je désirais depuis longtemps
faire un portrait d'une voisine de vraie race tahitienne —

Je le lui demandais un jour qu'elle s'était enhardie à venir
regarder dans ma case des images photographiés de tableaux.

Pendant qu'elle examinait avec beaucoup d'intérêt quelques tableaux religieux
des primitifs Italiens j'essayai d'esquisser quelques uns de ses traits ce
sourire surtout si énigmatique. Elle fit une moue désagréable —
Sortie puis elle rentra. Était-ce une lutte intérieure, ou le Caprice,
(caractère très maorie) ou bien encore un mouvement de Coquetterie
qui ne veut se livrer qu'après résistance. J'eus conscience que dans
mon examen de peintre il y avait comme une demande tacite de se livrer
se livrer pour toujours sans pouvoir se reprendre, une fouille
perspicace de ce qui était au dedans. Peu jolie en somme comme
règle Européenne : belle pourtant = tous ses traits avaient une
harmonie raphaélique dans la rencontre des courbes, la bouche modelée
par un sculpteur parlant tous les langues du langage et du
baiser de la joie et de la souffrance ; cette mélancolie
d'un ton presque ...

De ce refus j'en fus bien attristé —

Une heure après elle revint dans une belle robe = Caprice désir
du fruit défendu — Elle sentait bon elle était parée.

12

De chaque côté du ruisseau cascadant un semblant de chemin
des arbres pêle mêle des fougères monstrueuses, toute végétation
qui s'ensauvageant se faisant impénétrable de plus en plus
à mesure que l'on monte vers le centre de l'île.
nous allions tous deux être nus avec le linge à la ceinture et
la hache à la main, traversant mainte fois la rivière pour reprendre
un bout de sentier que mon compagnon connaissait comme par
l'odorat, si peu visible, si ombragé - Le silence complet,
seul le bruit de l'eau gémissant sur le rocher monotone comme
le silence. Et nous étions bien deux, deux amis, lui tout

jeune homme et moi
presque un vieillard, de
corps et d'âme, de vices
de civilisation: d'illusions
perdues - Son corps souple
d'animal avait de gracieuses
formes, il marchait devant
moi sans sexe
De toute cette jeunesse de
cette parfaite harmonie avec
la nature qui nous entourait
il se dégageait une beauté un

> Le côté androgyne du sauvage, le
> peu de différence de sexe chez les animaux
> la pureté qu'entraîne la vue du nu
> et les mœurs faciles entre les deux sexes -
>
> L'inconnu du vice chez des sauvages -
>
> Désir d'être un instant faible, femme,
> . . .

parfum (noa noa) qui enchantaient mon âme d'artiste.
De cette amitié si bien cimentée par attraction mutuelle du
simple au composé l'amour en moi prenait éclosion -
 Et nous étions seulement Tous deux -
j'eus comme un pressentiment de crime, le désir d'inconnu.
le réveil du mal. Puis la lassitude du rôle de mâle qui doit
toujours être fort protecteur; de lourdes épaules à supporter. Être
une minute l'être faible qui aime et obéit.
Je m'approchai, sans peur d'être loin. le trouble aux temps.
Le sentier était fini il fallait traverser la rivière; mon compagnon
se détournait en ce moment me présentant la poitrine.
l'androgyne avait disparu ce fut bien un jeune homme,
ses yeux innocents présentaient l'aspect de la limpidité des
 eaux. Le calme soudain rentra dans mon âme

the terms of the collaboration, defined as a combin-
ation of the painter's memories – to be recorded
in pictures and 'the simplest tale' – and the poet's
reactions, which occur as he 'dreams among the
works of the painter'.[47] This dichotomy between
memory and imagination establishes the enterprise
as a contrast between nature (the artist) and culture
(the poet). In omitting it, Morice shifted the focus
away from the dynamics of the partnership, which had
been vital to the project as Gauguin conceived it in
1894–5, and instead allowed his own verses to set the
tone for the narrative to follow.

In addition, Morice rewrote the first chapter
of the Louvre manuscript, 'Songeries' (Reverie),
which has always been attributed entirely to him,
and retitled it 'Point de vue' (Point of view) in his
1901 edition. Among the features excised to create
this new opening chapter, some are likely to have
originated with Gauguin. The epigraph reporting
Stéphane Mallarmé's reaction to the Durand-Ruel
exhibition, for example, which the artist was fond
of repeating, is in keeping with his penchant for
sprinkling his texts with quotations about his work.[48]
In the Louvre manuscript, 'Songeries' was framed by
the conceit of a disciple's visit to Gauguin's studio,
but Morice maintained this device only loosely at the
end of 'Point de vue', eliminating the sensationalist
description of the visitor's arrival: 'he had hurried
there, passionately longing, but also afraid to see
Paul Gauguin's new work'.[49] He suppressed a number
of further references to Gauguin in the introduction
to his 1901 edition, including an allusion to 'notes
written by the painter', with the result that the accent
fell more sharply on his own poetic evocations of
Tahitian life.[50] These dominate the first two-thirds
of 'Point de vue', and it is only in the final pages
that he turns to the question of the painter's
approach to his subject, justifying his right to
interpret nature subjectively.

This section comes first in the Louvre
manuscript's 'Songeries', lending it more weight, and
Gauguin is referenced by name on several occasions

(in the 1901 edition, he becomes simply 'the painter',
and is mentioned less). At the very least, Gauguin
must have approved of the emphasis placed, in
'Songeries', on the defence of his non-naturalistic
approach: the leitmotif is of Tahiti 'faithfully imagined',
rather than mechanically reproduced. It is quite
possible that he suggested the theme, even if the
words are not his.[51] Also strongly reflecting Gauguin's
point of view is the implicit attack on criticism,
which Morice cut from his 1901 edition, in which
the disciple's encounter with Gauguin's paintings
transported him to the 'innocent point of departure',
via the necessary evils of 'ingenious interpretations
that purport to substitute for the artist's masterful
eye the effusive gesture of the critic'.[52] If the laboured
phrasing seems typical of Morice, the sentiment we
know to be Gauguin's.

Gauguin might also have come up with the
rhetorical device (unique to the Louvre manuscript's
first chapter) of the studio visitor who dramatises
the path to comprehension, seeking to acclimatise
himself following his 'initial shock'.[53] This is
reprised in an exchange of letters between himself
and August Strindberg, occurring in 1895, while he
and Morice were working on the revisions to Noa
Noa. Strindberg's letter was ostensibly a refusal of
Gauguin's request that Strindberg write the catalogue
preface for an auction of his work designed to fund
his return to Polynesia, on the grounds that he could
not understand Gauguin's 'exclusively Tahitian' art.
However, his letter describes how, haunted by the
bizarre apparitions that he saw on the artist's studio
walls, his initial stunned response gradually gave way
to 'a certain understanding'.[54] Allison Morehead has
persuasively argued that this was a staged dialogue
– a mutual myth-making enterprise that allowed both
parties to perform the patience needed to appreciate
avant-garde art.[55] Gauguin transcribed the playwright's
letter alongside his own reply in several places, thus
establishing, as he wrote to Strindberg, a 'clash
between your civilisation and my barbarousness'.[56]
That two authors with whom Gauguin was

collaborating in the same year both employed the theme of the gradually enlightened civilised viewer, in responses to his work, indicates that Gauguin himself may have suggested the topos.

According to Loize, the Draft manuscript of *Noa Noa* and the 1901 edition are the 'the only two texts that count, from start to finish: what Gauguin proposed initially – and what Morice did with it ultimately'.[57] But this is to ignore the significance of the Louvre manuscript as a physical document – a *livre d'artiste* that needs to be seen in the context of Gauguin's other illustrated writings. The textual messiness of *Noa Noa*'s multiple, interrelated versions, and the emphasis on citation, repetition and reproduction most evident in the Louvre manuscript, are in fact much more characteristic of his approach to composition in writing, as we shall see in the next chapter. Equally, the in-between status of the Louvre manuscript, in which the respective contributions of 'primitive' painter and 'civilised' poet are hard to distinguish, reflects Gauguin's own status as a self-declared 'civilised savage'.[58] He posed as the naive 'storyteller' (an epithet that suggests an affinity with the oral traditions of Polynesia, while also conveying the apparent spontaneity of his contributions), but his orchestration of the partnership with Morice belies this pretence at innocence, while his nod to the popular tradition of travel writing reveals his literary awareness.

GAUGUIN'S GUIDEBOOKS

By the time Gauguin came to write *Noa Noa* there was an established literary tradition of travel accounts about Polynesia.[59] He read a number of these, both before and after his departure from France. Drawing on early accounts by late eighteenth-century European voyagers, nineteenth-century colonial texts presented an image of Tahiti and its inhabitants that combined the imaginary virtues of the 'noble savage' in a prelapsarian primitive paradise with the titillating undercurrent of savagery, chaos and sexual violence. Beginning with Louis-Antoine de Bougainville's romantic celebration of Tahiti as a 'new Cythera' in *Voyage autour du monde* (*A Voyage round the World*), his 1771 account of his journey to the Pacific, and Denis Diderot's lament about the corrupting impact of European civilisation on this innocent utopia, in his *Supplément au voyage de Bougainville* (1772, published 1796), Tahiti was, from the start, understood in literary or biblical terms as a classical Eden whose supposedly primitive qualities served above all as a foil for the repressive morality and corruption of European civilisation.[60]

Increasingly during the nineteenth century, the familiar trope of a land of plenty, characterised by leisure and sexual liberty, whose beauty was embodied by the compliant and youthful Tahitian woman, became tainted by fatalistic narratives of extinction.[61] The Enlightenment ideal of rejuvenating contact with a primitive culture became a nostalgic vision of inevitable demise fuelled by the French *fin de siècle* fascination with decadence and degeneration. While nineteenth-century writing on Polynesia ostensibly blamed excessive European influence for this impending doom, it also presented it as the inevitable fate of an inherently weaker race, tragically and heroically spent in the course of re-energising its stronger European protector. According to Edmond de Bovis, for example, it was the Tahitians' unfortunate destiny to entrust their beautiful land to 'more active races with a greater capacity for development', whose duty it was to assist them in wiping themselves out.[62] Similarly, noting the eradication of Tahiti's cultural heritage, Henri Le Chartier targeted the malign influence of 'degenerate whites' with their 'decadent diseases', but not without highlighting the indolence and impulsiveness of the Indigenous population.[63]

These guidebooks were both the model for and antithesis of Gauguin's encounter with the exotic. His utopian vision of Tahiti was informed by a blend of imperialist ideology and romantic travel writing, absorbed during his 1888 stay with Vincent van Gogh

in the short-lived 'studio of the South' in Arles, and his visits to the Colonial Exhibition at the 1889 Paris Exposition Universelle.[64] His correspondence reveals that in the course of planning what he hoped would become a tropical artists' colony, he consulted *Le Mariage de Loti*, as well as literature issued by the colonial authorities, to help him decide between Madagascar and Tahiti. His letters directly quote, or paraphrase, these texts, stressing the paradigmatic contrast between European labour and Oceanic leisure. In a letter to his wife, he boasts that in Tahiti, 'far from this European struggle for money', he will be free to 'love, sing and die'.[65] Here he is borrowing from a guidebook produced by the Ministère des Colonies, under the direction of Louis Henrique, who claimed that in Tahiti, 'to live, is to sing and to love'.[66]

In addition to Henrique, Gauguin read voyagers' reports in the periodical *Le Tour du Monde*, which he directly credited with inspiring him to flee European civilisation.[67] He may also have consulted a range of readily available voyagers' accounts, including Monchoisy's *La Nouvelle Cythère* (1888) and Edmond Cotteau's *En Océanie: voyage autour du monde en 365 jours, 1884–1885* (1888), both of which appear in Henrique's bibliography, and Le Chartier's *Tahiti et les colonies françaises de la Polynésie* (1887).[68] Endorsing the French Republic's expansionist policies, such publications extolled the virtues and pleasures of a simple life among a welcoming population in a heavenly climate, while reinforcing the need for a paternalistic French presence to cultivate an inherently naive and indolent population. Capitalising on the phenomenal success of Loti's Tahitian romance, they combined statistical information on population, cost of living and produce, with personalised adventure narratives and subjective 'portraits' of Polynesian physique and character.[69]

These European literary sources not only structured Gauguin's perception of Tahiti and supplied imaginative fuel for his visual symbolism, but also informed his written account in *Noa Noa*. It is not simply that there are echoes of travel writing in what

is otherwise ostensibly a memoir. Rather, *Noa Noa* is itself a contribution to this literary tradition. As Gauguin did, colonial voyage memoirs relied as much on existing accounts as on empirical observation. Henrique's survey, for example, claims to be 'a sincere work', offering 'a faithful description of faraway lands' and 'an exact picture of their inhabitants', yet its bibliography mixes scientific treatises with the sensationalist fiction of Loti's *Mariage*.[70] Gauguin's incorporation of legends from Moerenhout also has a precedent in these guidebooks. Both Monchoisy and Le Chartier quote passages from the Polynesian creation myths, to which Gauguin alludes in the Draft manuscript and which he develops, together with Morice, in the revised text of *Noa Noa*.[71] In blending legends drawn from Moerenhout with supposedly autobiographical events, Gauguin was not simply falsifying his experiences in an idiosyncratic manner, but following an established pattern.

It was not only the mythical Arcadian vision of Tahiti that Gauguin borrowed; his sense of disillusionment had a literary heritage too. Almost every account of his arrival in the capital city, Papeete, assumes that his naively idealistic vision of Polynesian paradise came crashing down when he found it already infested by the European society he had been trying to escape. It is true that his first sight of the island, as recounted in *Noa Noa*, is underwhelming: 'To a man who has travelled a good deal this small island is not, like the bay of Rio [de] Janeiro, a magic sight.'[72] The narrator declares himself 'disgusted ... by all this European triviality' and announces his intention to leave the 'European centre' for more distant, supposedly untouched areas of the island.[73] However, far from being a genuine expression of shattered illusion, this tale of disenchantment comes directly from the likes of Loti and Henrique. The guidebook directed by Henrique admits that 'Of the past, almost nothing remains', while Loti acknowledges the discrepancy between his dreams and the prosaic reality of Papeete before he has even landed on shore.[74] Loti blames this directly on 'our

hateful colonial civilisation', which has encroached on the capital, eliminating 'the customs and traditions of the past' and advises the same path that Gauguin advocates in *Noa Noa*: 'go far from Papeete, whither civilisation has not penetrated'.[75]

Disappointment upon first sight of the island's capital, followed by symbolic penetration into its wilder depths, is a recurrent trope in travel writing on Polynesia. Monchoisy, for example, describes how, after a long journey full of anticipation, 'one disembarks at last ... the initial impression ... falls far short of what one had imagined'. He discredits the 'philosophical' and 'poetic' myths established respectively by Diderot and Loti, noting that after six months this 'Oceanic Cythera' seems 'slightly less seductive'.[76] Thus Gauguin's guidebooks supplied him not only with a traveller's dream of tropical paradise, but also with a model for paying literary homage to its picturesque demise. The insistence that *fin de siècle* Papeete genuinely fell so short of his expectations merely reinforces the mythical notion of a bygone era destroyed by a 'fatal impact'.

Indeed, a letter of June 1890 to his fellow artist Émile Bernard counters the notion that Gauguin naively expected to land in an untouched paradise. Responding to Bernard's suggestion that Loti's novel proved Tahiti the ideal location for a 'studio of the tropics', Gauguin protested that Loti had described Tahiti from the unrealistic perspective of a '*littérateur*', evoking a life easily sustained by plucking fruit from trees. In fact, Gauguin insisted, Tahiti was also populated by the English and French, and in reality 'to be able to live off these foods you need some time to acclimatise'.[77] Although relatively isolated, this note of realism casts doubt on the sincerity of Gauguin's predictions, in letters to his wife and friends, of a life free of stress and financial burden. His aim, after all, in these semi-public missives, was to justify his course of action to his family, and to encourage his colleagues to join him. It is therefore not surprising that he should have exaggerated the imagined pleasures of life overseas and minimised its potential difficulties.

Nor does *Noa Noa*, as is often claimed, maintain the illusion of a blissful escape from materialism. Once he left Europe, the tone of Gauguin's correspondence changed, complaints of poverty and ill health replacing his predictions of paradise. However, it is not the case that none of these problems was 'allowed to darken the brightly coloured pages of *Noa Noa*', nor that it 'omits references to workaday worries'.[78] In fact, the narrator confesses early on that his lack of practical skills renders him destitute. While there is no shortage of natural supplies, as a European incapable of climbing trees or catching fish they are not accessible to him. His mistake, he claims, is to have 'imagined that with money I would find all that is necessary for nourishment'.[79] Given Gauguin's repeated insistence on the possibility of surviving *without* money in Tahiti, and his anticipation of the need for acclimatisation, it is clear that this predicament is scripted. *Noa Noa* does not present a falsely idyllic picture of his experiences, in contrast to the sordid 'truth' of his letters. Nor does it present the reality of his situation. Instead, drawing on literary precedent, it conveys the insecurities of displacement and dramatises his faltering efforts towards cultural integration.

But if *Noa Noa* drew more on literature than on life, Gauguin was shrewd enough to distinguish his own tale from overly popular prototypes. Although Loti's exotic romances set in Brittany and Japan had inspired Van Gogh's and Gauguin's cult of the primitive in Arles in 1888, the popular success of *Le Mariage de Loti* (which had reached a 45th edition by 1892) and its author's election to the Académie Française in 1891 led Gauguin to play down the association, which would have damaged his avant-garde credentials.[80] Accordingly, as is well known, the artist's supporters mounted a concerted campaign on the occasion of the first exhibition of his Tahitian paintings in Paris in 1893 to distance his representations of Tahiti from those of Loti.[81] As press clippings preserved by Gauguin show, friendly critics such as Octave Mirbeau and Morice (in his catalogue

preface) constructed an opposition between painter and author on the grounds that Gauguin's immersion in the culture went far deeper than Loti's superficial tourist vision. In particular, Mirbeau (probably schooled by Gauguin) stressed the 'unbridgeable distance' between author and artist, criticising the brevity of Loti's visit and claiming he moved only in official circles, while Gauguin 'lived exclusively among the natives' and 'mixed his life with the Maori to such an extent that he recognised their past as his'.[82]

Clearly this opposition was exaggerated and disingenuous, denying Gauguin's reliance on Loti and attributing to the artist an absolute identification with Indigenous society that is blatantly illusory.[83] However, Gauguin's account *does* diverge significantly from Loti's, but on opposite grounds from those asserted by his acolytes in his publicity campaign. It does not lay claim to a deeper engagement with the culture. On the contrary, the narrator's awareness of his failure to fit in undermines the pretence to authoritative knowledge and possession on which imperialist rhetoric depends, to a greater degree than Loti's *Mariage*.[84]

It is true that the similarities between Loti's and Gauguin's tales are unavoidable. In both cases, the confrontation between Europe and Polynesia is symbolised by a romance related (mostly, in Loti's case) in the first person between the protagonist and an adolescent Tahitian girl. The relationship between France and its exotic Other is therefore cast as a (gendered) contrast between mature and cultured wisdom versus youthful and intuitive innocence. In both cases the protagonist's marriage to the local girl symbolises communion with the Indigenous population. Following the standard structure of the voyage memoir, both accounts are structured as a series of journeys, progressing from initial disappointment on arrival in the capital, to insights gained during excursions to less populated areas, and ending in the bittersweet sorrow of departure. They are alike, too, in their exoticist typecasting. Both authors repeatedly compare the Tahitian women and men to animals; are preoccupied with distinguishing 'true'

Tahitians from those of 'mixed race'; and describe the land and its inhabitants in conventional terms of natural beauty, mystery and indolence.

Gauguin seems to have taken cues from the composition as well as the themes of *Le Mariage de Loti*. Like *Noa Noa*, *Le Mariage* is structured as a series of vignettes – brief episodes describing a scene or an encounter – that are only loosely linked. Although there is a stronger narrative thread in Loti, centred on the fate of the narrator's child-bride Rarahu, as well as his frustrated search for his dead brother's Tahitian offspring, both books consist of short, disjointed chapters. Even at the level of specific incidents or observations, there is crossover. When Gauguin's narrator encounters Queen Marau at the funeral of her husband, Pomare V, the last king of Tahiti, she becomes, like other women in both texts, a signifier of Tahiti itself, in this case its disappointments mixed with vestigial promise: 'I saw in the already ageing queen a stout ordinary woman with some remnants of beauty.' His observation closely echoes Loti's reaction to the Tahitian queen (Pomare IV, mother of Pomare V; Loti's tale is set twenty years earlier) in an audience at her court: 'In the massive ugliness of her old age I could still trace what might have lent her in youth the attractions and prestige of which the navigators of a past time have left a record.'[85]

However, the ease with which Loti slips into his new habitat is in marked contrast to the sense of displacement that Gauguin's narrator experiences in *Noa Noa*. On arrival in Papeete, the latter describes himself as 'quite alone, without any support', and later as 'truly alone' and 'alone again'.[86] Whether or not this accurately reflects the conditions experienced by Gauguin, it again contradicts the view that *Noa Noa* presented an unproblematic idyll. Nor does the narrative provide a cathartic release from this sense of displacement. On another occasion, after participating in his neighbours' evening gatherings, he appears to be acclimatising: 'I became, each day, a little more savage – my neighbours were almost my friends.' Believing himself one of the crowd, he offers

to join in the proposed communal rebuilding of the village, but the following morning, having been stood up, finds himself the target of mocking smiles.[87]

I do not wish to suggest that such episodes avoid stereotyping Tahitians – presented here as mysterious and cunning – but that they do resist, on the one hand, the detached superiority of absolute racial difference and, on the other, the masquerade of total cultural immersion. In contrast, Loti, while asserting the insurmountable racial divide between Europeans and Polynesians – 'a great gate forever shut' – is paradoxically able to adapt unproblematically to his environment.[88] This easy cultural assimilation is embodied in the baptism with which the novel opens.[89] After a quick and simple ceremony – which mirrors the author's own adoption of his pseudonym – the fictitious naval officer Harry Grant (alter ego of the real-life author Julien Viaud) 'had no further existence in Oceania' (although he notes that he 'still kept that name in all official documents').[90]

The role of the central female character also differs in the two accounts. Loti's Rarahu, who is dying of tuberculosis, is an unequivocal synecdoche for her expiring race, 'a sad and pathetic personification of the Polynesian race as it gradually dies out under contact with our civilisation and our vices, soon to be no more than a memory'. From the start the affair is viewed from Loti's perspective as temporary, partly due to his ultimate commitment to France and partly to the girl's untimely demise, which is continually foreshadowed. In every aspect of their relationship, Rarahu remains a passive victim. While Tahiti (in the figure of Rarahu) is a 'poor wild-flower' whose bloom is tarnished by contact with civilisation, France has the active role of both aggressor and saviour; for if Rarahu is ill from the beginning, it is only when Loti finally abandons her that she succumbs to death. It is a death symbolically caused, on the one hand, by the sophisticated Europeanised temptations of Papeete, but on the other, by a fatal flaw in her inherently savage mentality that prevents her from resisting them. As Loti predicts: 'you will

lapse into a little Maori girl again, ignorant and wild; you will die'.[91]

Gauguin's narrator likewise abandons his Tahitian wife, Tehamana, at the end of his stay, although she does not die as a result. But while Rarahu incessantly pines for Loti, who predicts her every emotion, Gauguin's narrator confesses himself an 'open book' in contrast to his 'impenetrable' wife; he declares himself childish and unable to suppress declarations of love, while she 'seemed to love me, and never told me so'. Loti confidently asserts his superiority over Rarahu, who 'apprehended vaguely that there must be gulfs, in the intellectual order, fixed between Loti and herself, whole worlds of undreamed-of ideas and knowledge'.[92] His behaviour towards her is unfalteringly paternalistic, whereas in *Noa Noa* the narrator's attitude towards women veers more ambiguously between fantasies of submission and aggression. During his first encounter with Tehamana, for example, she is described as 'proud', 'serene' and 'mocking', whereas he repeatedly declares himself 'shy', 'hesitant' and 'scared', concluding that 'the danger was for me, not for her'.[93]

This is not to suggest that Gauguin's account escapes the charges of racism and misogyny. The blend of fear and desire that his narrator exhibits in this scene is, after all, inherent to primitivism: the urge to become the Other is predicated upon an assumption of difference, which in itself incites anxiety as well as fascination.[94] This ambivalence is present in Loti, too, of course, and in both texts golden-skinned *vahines* coexist with crones exhibiting their 'cannibal teeth', and ghoulish spectres (these nightmarish scenes are more frequent in Loti). However, *Noa Noa* more strongly conveys the narrator's sense of alienation as an outsider, and this casts doubt on the myth, largely upheld in Loti, of a readily available paradise. For instance, Loti's love affair with Rarahu seems to blossom naturally (it is only after their romance has begun that the queen suggests a marriage), but Gauguin does not dissemble over the practicalities of the arrangement

with Tehamana. It is presented quite explicitly as an exchange, with the narrator suspecting that the girl's mother may have willed it, 'her mind on money'. He, in turn, seeks to ensure the soundness of the deal, posing mercenary questions about her looks, youth and 'health' (i.e. whether she is infected with venereal disease).[95]

This bluntness does not make any less problematic either his own position, or his venal characterisation of the Tahitians, but it exposes the less than idyllic nature of the encounter in a way that Loti's seamless romance does not. On other occasions too, in *Noa Noa*, visions of aggression mingle with a sense of impotence. Early on, the narrator describes himself as 'intimidated' by the Tahitian women's frankness, ponders whether it is necessary to '*take them* in the Maori fashion', and concedes that 'I did not know their languages'.[96] A little later, he admits to sensing that they were willing to be 'taken brutally. In a way a longing for rape', although in the end, he notes, 'I dared not resign myself to the effort'.[97] The vacillation between scenarios of domination and surrender hints at the insecurity underlying the narrator's efforts to possess Tahiti and its women. To register such moments of self-doubt is not to minimise the violence of the fantasy, but to acknowledge that the patriarchal authority of imperialism is not invincible.[98]

Moreover, at other points in the narrative, Gauguin explicitly challenged conventional boundaries of colonial, sexual and gender identity. Rather than framing his entire experience on the island, as Loti's romance does, the narrator's relationship with Tehamana constitutes one among a series of episodes that set up his immersion into a primitive way of life, only ironically to undercut it. The most prominent example is the often-discussed 'woodcutter' episode, in which a young Tahitian man guides him to the island's interior, on a journey to find wood for carving. As the character who displays the most explicit interest in the narrator's skills as an artist, the young man arouses in him a feeling of kinship mingled with sexual attraction: 'From this friendship

so well cemented by the mutual attraction between simple and composite, love took power to blossom in me.'[99] Following his semi-naked companion along the narrow track, the sight of his 'lithe animal body' with its 'graceful contours' brings the narrator to the brink of a 'crime' – 'I drew close, without fear of laws, my temples throbbing'.[100] However, when his friend turns round to face him, he sees that 'The androgyne had vanished; it was a young man after all', and his fever cools. As they reach their destination and chop down the chosen tree, he metaphorically deracinates himself from Europe: 'I struck furiously and, my hands covered with blood, hacked away with the pleasure of sating one's brutality ... well and truly destroyed indeed, all the old remnant of civilised man in me. I returned at peace, feeling myself thenceforward a different man, a Maori.'[101]

For many commentators, this symbolic encounter marks the climactic moment in what is assumed to be Gauguin's own 'evolution from a civilised state into a savage one'.[102] However, Rod Edmond's verdict is more apt; he concludes that 'its resolution is no more stable than the shifting states within the scene itself'.[103] Rather than a fully resolved conversion, it charts a fraught alternation between identification and distance. As several scholars have shown, albeit with differing emphases, the scene entails a simultaneous registering and disavowal of male same-sex desire.[104] The narrator is physically attracted to the Tahitian man as long as he can perceive him, from behind, as 'sexless'. In the form of an androgyne, the youth, who is 'in perfect harmony with the nature which surrounded us', represents the utopian possibility of transcending difference, the primitivist fantasy of a return to origins and a complete integration with nature. His apparent freedom from binary gender identification provokes in the narrator a desire to switch genders himself, a 'weariness of the male role' and a longing 'to be for a minute the weak being who loves and obeys'.[105] However, this inversion of roles lasts only as long as the illusion of androgyny can be maintained. When the Tahitian turns round, thus

making his masculinity visible again, the narrator is relieved, and order is (at least temporarily) restored.

Nor is the conversion stable after the supposedly conclusive 'woodcutter' scene, as the narrator makes it clear that other characters still view him as foreign.[106] As he prepares to embark on the trip during which he meets Tehamana, a neighbour chastises him: 'You Europeans always promise to stay ... but you never come back', and as he returns with his new companion, passers-by remark to her: 'Well, well, you're the *vahine* of a Frenchman, now, are you?' Sometimes, the narrator identifies his European nationality explicitly as a cause of disgrace. When the French wife of a local gendarme calls Tehamana a 'trollop', for instance, he confides: 'I felt ashamed of my race.' At other times he calls attention to it as an apparent badge of pride, only to undermine it as a marker of his gullibility. When he successfully catches fish on an outing with local men, he boasts 'decidedly the Frenchman brought luck', only to discover that, according to local tradition, his catch is an omen of his wife's infidelity.[107] In one of the additional narrative episodes included in the Louvre manuscript, he attempts to show off to Tehura and her friends by swimming to the end of a grotto, but upon his return, the group has lost interest. When she teases him by asking 'Weren't you afraid?', he brags 'We French, we are never afraid', but receives in response 'no sign of admiration from Tehura'.[108]

At an earlier point in the story, recording how he ran out of provisions and became reliant on the charity of his Tahitian neighbours, the narrator portrays the situation as an ironic reversal: 'there I was, a civilised man, for the time being definitely inferior to the savage'. After describing the benevolence of the locals who brought him food, he observes: 'These black people, these cannibal teeth, brought the word "savages" to my mouth. For them too, I was the savage. Rightly perhaps.' The discrepancy between their gentle acts of kindness – offered 'silently', 'timorously' and 'with a kindly expression' – contrasts with the epithet of 'savage' in a manner

presumably intended to reveal its inappropriateness (while at the same time it allows him to describe them in alternately stigmatising terms as either meek or frightening).[109] In turn, he applies the label to himself, not as a marker of integration, but of his own difference, thereby addressing the relativity of the concept. Like his flirtation with the idea of trying out the 'weak' female role, this projected shift in subject position simply reverses the terms of the hierarchical opposition between male and female, coloniser and colonised; it does not dismantle it. Nonetheless, in this very inversion, the constructed and arbitrary nature of gender or colonial identity is exposed.

In its scripted series of intercultural predicaments, *Noa Noa* is no more, nor less, autobiographical than *Le Mariage de Loti*. Like Gauguin, Loti travelled to Tahiti and set his novel in the same year as his actual journey (although Gauguin does not mention a date, Pomare's death acts as a chronological marker). Like his protagonist, whose name he later adopted as his own, Loti/Viaud also had an older brother who had travelled to Polynesia. Yet despite the correlation with real-life experiences, Loti's *Mariage* is regarded primarily as literature, not memoir. In contrast, *Noa Noa* is still commonly treated as a source of factual information about the artist's life. But Gauguin's exploitation of the tropes of travel writing demonstrates that it is both strategic and complex. Echoing his own position as outsider to both Indigenous and colonial communities, the narrator shifts between 'savage' and 'civilised' identities. This ambivalence extends to his collaboration with Morice. Gauguin was neither corrupted by, nor simply acquiescent to, his more sophisticated partner; to suggest as much is to lend weight to his own self-image as a primitive. He was an active participant in the development of his initial Draft manuscript. It is fitting that the intended contrast between primitive storyteller and cultured European respondent ultimately became blurred. Never simply an innocent recorder of his own experiences, Gauguin himself operated on both sides of this apparent divide.

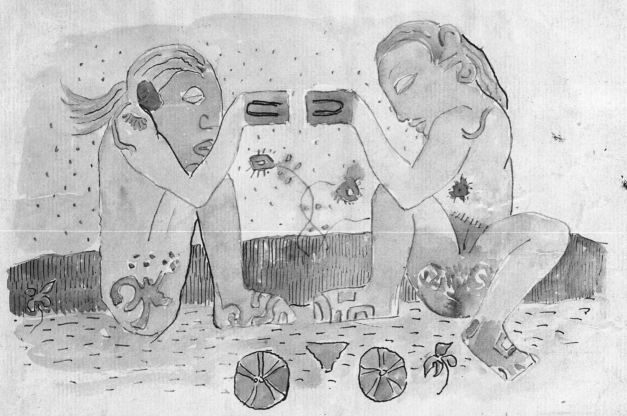

Chapter Three

'SCATTERED Notes'

ONCE GAUGUIN HAD FINISHED transcribing the version of *Noa Noa* co-authored with Charles Morice into the 346-page album now held at the Musée du Louvre, he started filling the remaining pages. Opposite the closing words of his travelogue, he began a new text, whose title, *Diverses choses* (Miscellaneous things), and the date 1896–7, appear next to a sketch by Vincent van Gogh of his painting *La Mousmé*, cut and torn from a letter and topped with Gauguin's inscription 'By the much-missed Vincent van Gogh' ('*du regretté Vincent van Gogh*'; fig. 41).[1] Although separated by its title, *Diverses choses* is linked to *Noa Noa* stylistically. Exacerbating the sense of multivocality conveyed in *Noa Noa* by the dialogue with Morice and the incorporation of Polynesian legends drawn from Jacques-Antoine Moerenhout, it includes multiple textual borrowings, whose sources are not always acknowledged. It also continues the sequences of illustrated pages, found in *Noa Noa* too, in which pasted-in reproductions, photographs and fragments of woodcuts abut watercolours painted directly on the page (see, for example, figs 11 and 34).

The album containing these two texts calls attention to Gauguin's fascination with assemblage, but *Diverses choses* has not been published in full and has never been included in printed or facsimile editions of *Noa Noa*.[2] In the manner of an epigraph, its opening sentence confirms the miscellaneous approach promised by its title, and announces the commitment to collaborative authorship suggested by the presence of Van Gogh's sketch: 'Scattered notes, without sequence like Dreams, like life all made up of fragments: and because others have collaborated in it, the love of beautiful things seen in your neighbour's house.'[3] This was a creed that Gauguin reiterated: the first clause supplied the opening sentence of *Cahier pour Aline*, and he repeated the motto as a whole in *Avant et après*, establishing the notion of the piecemeal as a recurring theme.[4] In the previous two chapters I examined the stakes of Gauguin's devotion to a non-linear writing style that suited his identity as a 'savage' artist. Here I explore in more detail what

Previous:
Fig. 40 *Noa Noa*, 1894–1901, folio 30 recto (p. 55). Photograph of Polynesian women, cut out and pasted; watercolour, pen and ink, similar to *Ancien Culte mahorie*, p. 13, 31.5 × 23.2 cm. Musée d'Orsay (held at the Musée du Louvre), Paris, RF 7259, 1

Following pages:
Fig. 41 *Noa Noa* and title page of *Diverses choses*, 1896–8, folios 105 verso and 106 recto (pp. 204–5). Manuscript notes, pen and ink, and pen and ink drawing by Vincent van Gogh, *La Mousmé*, July 1888, pasted, 31.5 × 23.2 cm (each sheet). Musée d'Orsay (held at the Musée du Louvre), Paris, RF 7259, 1

that method entailed, and situate it in its cultural and literary context.

Although *Noa Noa* and *Diverses choses* are separate texts, I discuss them together in this chapter in terms of their shared scrapbook-style appearance, which is brought home by their presence in the same volume, referred to here as the Louvre album. I focus on how Gauguin mobilised the process of piecing together diverse images and fragments of text – in this album as well as related manuscripts – in order to connect his writing with the supposedly primitive values of shared consciousness and resistance to linearity. This cultivated disjointedness also neatly paralleled the patchiness of his encounter with Polynesian society, owing to the deleterious effects of evangelisation and colonialism as well as the limits of his own comprehension as an outsider. I argue that it was the incomplete nature of that experience that attracted him in the first place, since it corresponded to his stated preference for suggestion over description, and for what could be evoked but not fully captured. Rather than seeking the full recovery of a lost past, he allied his experience of cultural displacement to the nineteenth-century proclivity for the fragment.[5]

Gauguin explicitly aligned his citational and non-consecutive approach to literary composition with a primitive mentality. Following the title page, *Diverses choses* continues with the exclamation: 'My goodness, how many childish things one can find in these pages, written partly for personal relaxation, partly to bring together certain favourite ideas'. Although he alerted the reader to the apparent naivety of his compendium, he stressed that his assorted reflections were interconnected, since 'if a work of art was a work of chance, all these notes would be more or less useless. But I don't think so: I believe that the thoughts that guide my work, or a part of it, are very mysteriously linked to thousands of others, whether my own or heard from other people.'[6] In identifying his jottings as infantile, he was not confessing to a lack of skill, but boasting of the freshness of his insights: in the nineteenth-century cult of childhood,

the infant was an established cipher for the primitive, evoking similar qualities of spontaneity, innocence and temporal regression.[7] Gauguin regularly made a three-way connection between the artist, the child and the savage – as when he announced to a journalist in 1891 that he was going to Tahiti in order to 'render, as a child would, the conceptions of my brain with the sole aid of primitive means of art, which are the only ones that are good and true' – and in this opening section of *Diverses choses* he compared artists to children who 'have never grown up' ('*restés toujours enfants*'), and to flowers that 'wither at the impure contact of hands that tarnish them' ('*s'étiolent au contact impur de la main qui les souille*').[8]

Gauguin also connected memory to a state of youthful purity, and opposed it to the mechanical recording procedures of technological modernity, such as the camera. Whereas the advent of the 'snapshot' ('*l'instantané*'), he writes, has enabled popular Salon artists such as Ernest Meissonier (1815–1891) to paint horses with anatomical accuracy, he himself prefers to go 'right back, way beyond the horses of the Parthenon ... to the hobby horse of my childhood, the good old wooden horse!'[9] He likens the act of recording his disparate sources of artistic inspiration to a child's game: 'If ... I've been drawn to a certain fact, a particular image, or something I've read, should I not, in a slim volume, take note of it? I think that man has certain moments of play, and childish things are far from being harmful to a work of art'.[10] In line with the codes of primitivism, Gauguin's psychic return to infancy summons up the collective childhood of humanity. He thus positions his writing as primitive by virtue of its 'childish' assemblage of apparently trivial fragments and its activation of the past through memory (he also describes himself as humming Robert Schumann's *Scenes from Childhood: Knight of the Rocking Horse* during his reverie).[11] To the extent that he considered the true artist and the primitive to be synonymous, in designating his literary method as naive, he was also declaring it to be a suitable authorial mode for an artist.[12]

oreille était tombée sur ses genoux, fanée

De distance en distance, d'autres com[me]
elle regardaient, fatiguées, muettes, sans
pensées, la lourde fumée du navire qui
nous emportait tous, amants d'un jour.
Et de la passerelle du navire avec la
lorgnette, longtemps encore il nous sembla
lire sur leurs lèvres, ce vieux discours maore

(" Vous, légères brises du Sud et
" de l'Est, qui vous joignez pour vous
" jouer et vous caresser au dessus de ma
" tête, hâtez-vous de courir ensemble à
" l'autre Île; vous y trouverez celui qui m'a
" abandonnée, assis à l'ombre de son arbre
" favori. Dites-lui que vous m'avez vue en
" pleurs.

Fin

du regretté Vincent Van Gogh.

Diverses.
Choses

SÉS

1896. 97

Notes éparses, sans suite comme les Rêves,
comme la vie toute faite de morceaux.

Et de ce fait que plusieurs y
collaborent ; l'amour des belles choses aperçues
dans la maison du prochain.

50

dans et par cette civilisation même qu'elle
ignorait).

V Chante le *Vivo* tahitien. (le bonheur unique est
dans la nature, et, de s'être retrempé au souvenir
de sa jeunesse, le poète se sent capable de
s'unir avec cet idéal —

VI Et le vent sur la mer ouvre de larges ailes
(mais il a cet idéal, ses amertumes, qui
d'ailleurs ne sont pas étrangères à sa
beauté).

Teie iho te rui, i te rai rumaruma haati hia i te fetia
Ua riro ta'u aroe i na vahine toopiti,
Rava'tou i te auta raa o ta'u mafatu i to vivo te uto nei
Eaha ta'na i manao ra, te faatai upaupa ovici e tahatai iti
Eaha ta'na e manao ra, ovii atoa, teie nei mafatu haamauiui
Ua riro ta'u aroe i na vahine toopiti
Rava'tou i te mehu ore roa, e pihauho o si te aten e, ta'u
mafatu e te vivo te uto nei
Ei haamauiui nei ta'u aau e te po avae
I te avae e iho mai na roto i te areapatéa o ta'u fare
Ua riro ta'u aau e na vahine toopiti,
Rava'tou i roto ia'u, e pihauho o i te atoa e, ta'u mafatu
e te vivo te uto nei
E ua haere roa rava, ua te niti, ma te haamauiui o te
I te niti maoe hia o tei faa i te mai i te mehu ore

51

e tu'u ra oto, i te toati raa o te fenua nei
I te atoa e, I te atoa e rava' toa, tau mafatu e
te vivo te uto nei.

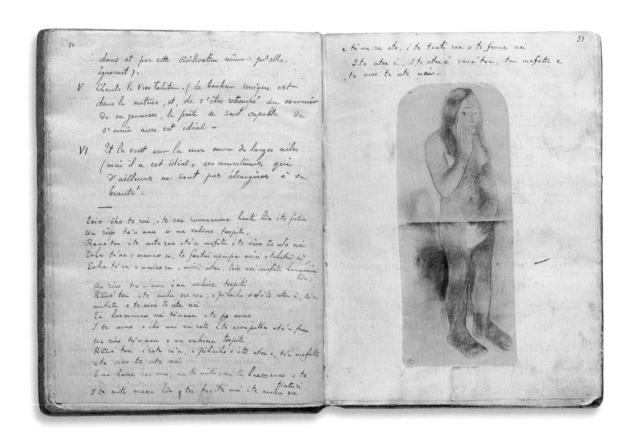

In their eclecticism and seemingly haphazard arrangement, the images that populate the pages of the Louvre album make explicitly visible its logic of fragmentation. On several occasions, Gauguin claimed that the capacity to synthesise and suggest, rather than blandly describe, was a unique property of the visual, and he demonstrates this effect here. For example, in its depiction of adolescence, Van Gogh's sketch of *La Mousmé* consolidates the theme of childishness with which *Diverses choses* opens, but without directly illustrating Gauguin's words.[13] In another instance, on the pages of *Noa Noa*, Gauguin pasted in a photograph of one of his drawings representing a Polynesian Eve, below some Tahitian words that he neatly transcribed in purple ink, which are a continuation of verses beginning on the previous page (fig. 42).

This arrangement evokes the exchange of letters with August Strindberg that Gauguin reproduced later in the album, on the pages of *Diverses choses* (see fig. 7), without referring to it explicitly.[14] In his letter to Strindberg, Gauguin used a linguistic analogy to defend the crudely drawn forms of his Eve figures, to which Strindberg had objected on the grounds of their deviation from a feminine ideal.[15] Gauguin explains that the difference between his 'primordial' (*'ancienne'*) Eve and Strindberg's civilised model is equivalent to the contrast between the 'Maori or Turanian language' (*'la langue maorie ou touranienne'*) and the European. Oceanic languages, Gauguin claims, consist of 'essential elements preserved in all their primitiveness' (*'éléments essentiels, conservés dans leur rudesse'*), whereas European languages resemble a 'perfect mosaic' (*'une mosaïque perfectionnée'*) in which 'you can no longer see where the more or less roughly assembled stones are joined' (*'l'on cesse de voir la jointure des pierres, plus ou moins grossièrement*

rapprochées') and the 'construction process' (*'le procédé de la construction'*) is hidden. By positioning his drawing of Eve alongside Tahitian words, Gauguin cements this analogy between his 'savage' drawing style (*'dessin sauvage'*) and the 'naked and primeval' (*'nu'*, *'primordial'*) Oceanic language, which, he says, is spoken by his Eve.[16] The drawing itself, which is pricked for transfer, makes its 'construction process' visible, as does the fact that the photograph of it is pasted onto the manuscript.[17] On the adjacent page, the Tahitian passage is set against a portion of French text, in differently coloured ink and larger handwriting, detailing a provisional list of poems to be supplied by Morice, so that the 'joins' are made visible from one segment to the next of this double-page spread.[18]

Gauguin therefore used visual methods of assemblage to signal his appreciation for the way in which the elements of Oceanic languages were, according to him, 'isolated or welded together without any thought for polish' (*'isolés ou sondés sans nul souci de polir'*).[19] His incorporation of Tahitian verse into his own prose, without attribution or introduction, also disrupts the narrative flow of *Noa Noa*.[20] In this sense, his habit of freely 'poaching' and adapting the words (and images) of others resonates with specifically *textual* theories about non-consecutive modes of literary composition at the *fin de siècle*. Stéphane Mallarmé, for example, whom Gauguin revered, published a collection of prose poems in 1897 with the title *Divagations* (meaning 'digressions' or 'ramblings'), and the tendency towards the anecdotal and the aphoristic in Gauguin's writing is reflected in nineteenth-century literary culture's engagement with the *fait divers* (short news story).[21] As always, then, his advocacy of explicitly visual modes of expression was in productive tension with, rather than direct opposition to, the literary.

Fig. 42 *Noa Noa*, 1894–1901, folios 27 verso and 28 recto (pp. 50–51). Right: photograph cut out and pasted, from a pounced drawing coloured in pastel, *Eve*, study for *Parau na te varua ino* (*The Words of the Devil*), 1892 (Öffentliche Kunstsammlung, Basel), 31.5 × 23.2 cm (each sheet). Musée d'Orsay (held at the Musée du Louvre), Paris, RF 7259, 1

'A Book to be Seen as well as Read'

Previous discussions of Gauguin's writing have tended
to consider the content of his texts separately from
their form. A clear instance of this is the assumption
that the images that accompany *Noa Noa* in the
Louvre album are fortuitous, since they do not directly
illustrate the text. Scholars have concluded that
they served merely to fill the space on blank pages
reserved for poems by Morice, when these failed to
appear.[22] But Gauguin included similar arrangements
of pictures in *Diverses choses*, where there was no need
to keep blank pages for awaited contributions from
a co-author.[23] The preface to this version of *Noa Noa*
introduces it as a 'book to be seen as well as read',
implying that the images were planned, and it is clear
that he conceived of some form of visual dimension
to *Noa Noa* as early as 1894, while he was developing
his initial draft.[24] It was during this period that he
produced a series of ten woodcuts, now known as
the *Noa Noa* suite, intended to accompany the text.[25]
In the course of his attempts to find a publisher, Morice
also referred on a number of occasions to 'drawings'
by Gauguin that were difficult to reproduce.[26]
Alongside a related series of monotypes, paintings
and ethnographic objects, Gauguin displayed these
prints and drawings in a semi-public exhibition
in his Paris studio that same year. Reviewers, and
contemporary witnesses who were regular visitors to
the artist's *soirées*, emphasised not only the works on
display but also the atmosphere of the studio, where
Gauguin read aloud from *Noa Noa* and in one instance
publicly printed a woodcut 'in a most primitive way'.[27]

Therefore, a campaign of visual production did
supplement his project from the start, even though
no publication incorporating either the woodcuts or
the 'drawings' ever materialised, and it is unclear
how precisely he expected them to be integrated
with his narrative.

The collaged images that Gauguin later added
to the Louvre album were also not an afterthought,
for they recall the eclectic display that visitors to his
studio exhibition noticed in 1894. Alongside his own
work, Gauguin also showed some of the Japanese
prints from his collection, and reproductions of works
by other artists. In his review, Julien Leclercq remarked
that 'on the yellow walls of the radiant studio ...
there are, between the canvases, Japanese prints
and photographs of works old (Cranach, Holbein,
Botticelli) and modern (Puvis de Chavannes, Manet,
Degas)'.[28] Gauguin pasted a similar constellation
of images into his album. He also referred to them
in terms that evoked the earlier display, calling the
'Japanese sketches, prints by Hokusai, lithographs
by Daumier and Forain, school of Giotto' that filled
two double-page spreads in *Diverses choses* a 'little
exhibition' (*'petite exposition'*; figs 10 and 11).[29] This
connection suggests that the distinctive pattern of
images in the Louvre album had already gestated
several years earlier, precisely while he was rewriting
Noa Noa and experimenting with different ways of
illustrating it. Like the walls of his studio, the pages of
his manuscript provided an environment in which to
bring together visual sources from disparate cultural
traditions – 'beautiful things seen in your neighbour's
house' – and to explore the links between them.[30]

Fig. 43 *Noa Noa*, 1894–1901, folio 37 recto (p. 67). Ink wash after
Te faruru (*Here we make love*); *Manaò tupapaú* (*Spirit of the Dead
Watching*), before March 1894, lithograph with light watercolour
highlights, pasted, 31.5 × 23.2 cm. Musée d'Orsay (held at the Musée
du Louvre), Paris, RF 7259, 1
Following pages:
Fig. 44 *Noa Noa*, 1894–1901, folios 38 verso and 39 recto (pp. 70–71).
Landscape with Huts, seated Figures and a Horse, watercolour, pen and
ink, cut out and pasted; *Mountain Landscape with a Hut*, watercolour,
pen and ink, cut out, pasted, 31.5 × 23.2 cm (each sheet). Musée
d'Orsay (held at the Musée du Louvre), Paris, RF 7259, 1

Fig. 45 *Noa Noa*, 1894–1901, folios 39 verso and 40 recto (pp. 72–3).
Figure, watercolour, pen and ink, similar to *Ancien Culte mahorie*, p. 25;
Fisherman drinking beside his canoe, 1894, woodcut watercoloured and
pasted, 31.5 × 23.2 cm (each sheet). Musée d'Orsay (held at the Musée
du Louvre), Paris, RF 7259, 1
Fig. 46 *Noa Noa*, 1894–1901, folios 40 verso and 41 recto (pp. 74–5).
Couple embracing, watercolour, pen and ink; *Manaò tupapaú*, pasted
woodcut, 31.5 × 23.2 cm (each sheet). Musée d'Orsay (held at the
Musée du Louvre), Paris, RF 7259, 1

Chapitre IV —

Le Conteur parle —

Mes voisins sont devenus pour moi presque des amis.
Je m'habille, je mange comme eux. Quand
je ne travaille pas je partage leur
vie d'indolence et de joie, avec
de brusques passages de gravité.

　　Le soir, au pied des
buissons touffus que
domine la tête échevelée des
cocotiers, on se réunit par
groupes, — hommes, femmes
et enfants. Les uns sont de
Tahiti, les autres des Tongas,
puis des Arorai, des Marquises.
Les tons mats de leur corps
font une belle
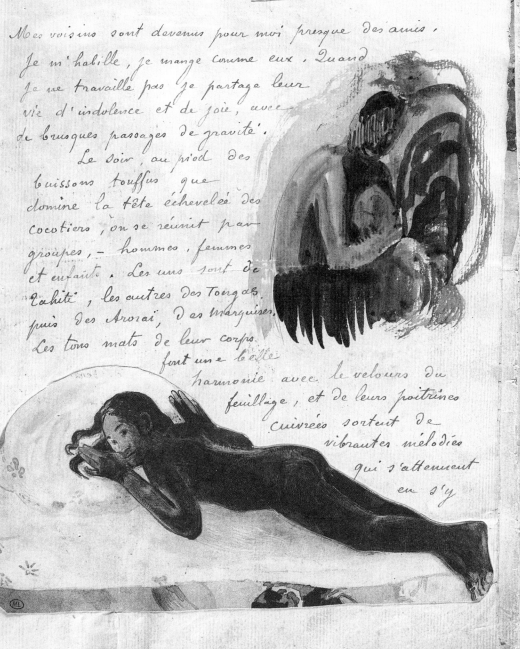
harmonie avec le velours du
feuillage, et de leurs poitrines
cuivrées sortent de
vibrantes mélodies
qui s'atténuent
en s'y

par hazard, il pleut. Pourquoi ? tout le monde
doit être abrité. Le bois et le feuillage ne
manquent pas pour confectionner des toitures.
Je propose que nous mettions notre travail en
commun pendant quelque temps pour construire
des cases spacieuses et solides à la place de
celles qui sont devenues inhabitables. Nous
y donnerons tous successivement la main.

 Tous les assistants sans exception
applaudirent. –

 – Cela est bien. –
Et la proposition du vieillard fut votée
à l'unanimité.

 Voilà un peuple sage, pensai-je ce soir là
en rentrant chez moi.

 Mais le lendemain, comme j'allais aux
informations m'enquérant d'un commencement
d'exécution des travaux décidés, je m'apercevais
que personne n'y pensait plus. À mes questions
on ne répondait que par des sourires évasifs qui
pourtant soulignaient de significatives lignes
ces vastes fronts rêveurs – Je me retirai, plein
de pensées difficiles à concilier entre elles :
on avait eu raison d'applaudir à la
proposition du vieillard, et peut-être avait-on

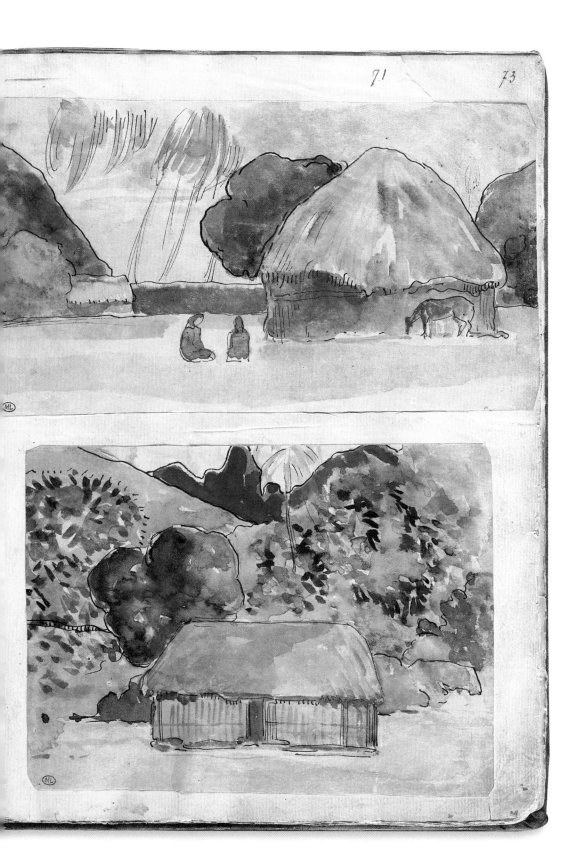

raison aussi de ne point faire ce qu'il avait
conseillé. {Pourquoi travailler ? Les Dieux de
Tahiti ne donnent-ils pas à leurs fidèles la
subsistance quotidienne ?, Demain ? Peut-être !
Et demain le soleil, en tout cas, se lèvera
comme il s'est levé aujourd'hui, bienfaisant
et serein. { Est-ce là de l'insouciance, de
la légèreté ou — Qui sait ?. — de la plus profonde
philosophie ?" Prends garde au luxe, prends
garde d'en contracter le goût sous prétexte
de prévoyance ;!.......

Chaque jour se fait meilleur
pour moi. Je finis par comprendre la langue
assez bien. Mes voisins — trois très proches et
les autres nombreux de distance en distance —
me regardent comme des leurs. Mes pieds,
au contact perpétuel du caillou, se sont durcis,
familiarisés au sol; et mon corps, presque
constamment nu, ne souffre plus du soleil.
La civilisation s'en va petit à petit
de moi. Je commence à penser simplement,
à n'avoir que peu de haine pour mon prochain —
mieux, à l'aimer. J'ai toutes les jouissances
de la vie libre, animale et humaine. J'échappe
au factice, j'entre dans la nature; avec la

certitude d'un lendemain pareil au jour présent,
aussi libre, aussi beau, la paix descend en moi :
je me développe normalement et je n'ai plus de
vains soucis.

Un ami m'est venu, de lui-même et
certes ! sans bas intérêt. C'est un de mes
voisins, un jeune homme, très simple et très beau.
Mes images coloriées, mes travaux dans le bois
l'ont intrigué, mes réponses à ses questions
l'ont instruit. Pas de jour où il ne vienne
me regarder peindre ou sculpter.

Et le soir, quand je me reposais
de ma journée, nous causions, il me faisait des
questions de jeune sauvage curieux des choses
européennes, surtout des choses de l'amour,
et souvent ses questions m'embarrassaient.
Mais ses réponses étaient plus naïves encore
que ses questions. Un jour que, lui confiant
mes outils, je lui demandais d'essayer une
sculpture, il me considéra, très étonné et me
dit avec simplicité, avec sincérité, que, moi,
je n'étais pas comme les autres, que je pouvais
des choses dont les autres étaient incapables.
Je crois que Jotépha est le premier homme

au monde qui m'ait tenu ce langage, –
ce langage d'enfant; car il faut l'être,
n'est-ce pas pour s'imaginer qu'un

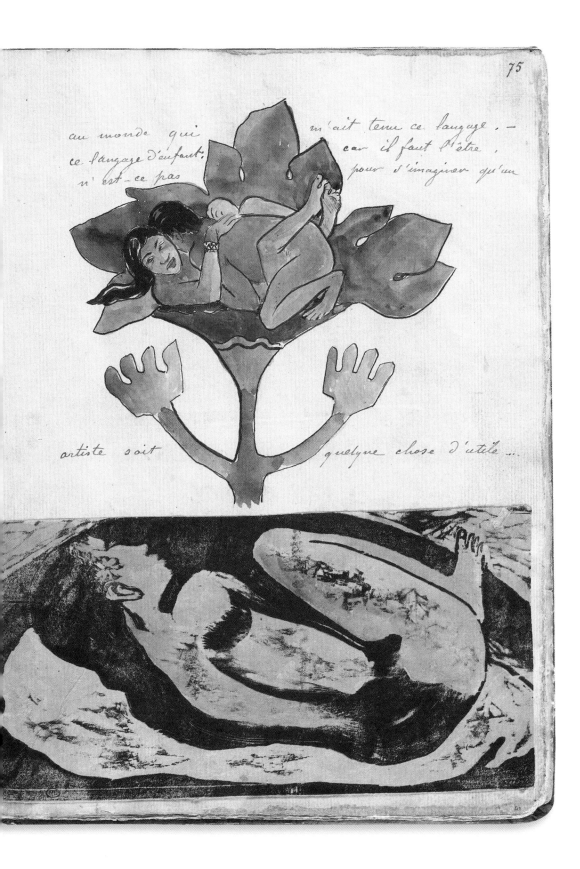

artiste soit quelque chose d'utile …

A significant number of the illustrations in *Noa Noa*, in any case, were evidently an integral feature from the start, since the words wrap around them, or they alternate with the script from one page to the next (figs 43–6). Nor is the visual-verbal hybridity of the Louvre album an anomaly, as Gauguin had already created similarly composed manuscripts. One of these, *Ancien Culte mahorie* (Ancient Maori religion, 1893), was a blueprint of sorts for *Noa Noa*. Here, in a text that is entirely copied or paraphrased from Moerenhout's ethnographic account of Tahiti, Gauguin recorded the creation myths of the Polynesian pantheon, giving imaginary form to these deities in vivid watercolours. Essentially all of the legends, and a selection of the illustrations (now divorced from the episodes that they originally accompanied), reappear in *Noa Noa* (compare fig. 34 to figs 47 and 48).[31] *Diverses choses*, meanwhile, echoes the format of *Cahier pour Aline*, a notebook that Gauguin compiled in 1893 and dedicated to his daughter. He filled it with anecdotes, proverbs, and passages transcribed from other authors (Poe, Wagner, Verlaine), many of which re-emerge in *Diverses choses*, and bookended it with newspaper cuttings and reproductions that also prefigure the collaged spreads in the later volume (see figs 5, 6 and 16).

There is no evidence that Gauguin sought to publish his illustrated and collaged manuscripts as facsimiles, but their format was nonetheless deliberate, as he produced variations on it from one volume to the next. The conspicuous neatness of his handwriting implies that he intended them to be read in their original form, even if only by a small number of people.[32] If they appear provisional and personal, it is because this was a calculated part of their effect. Although idiosyncratic in their self-conscious design (predominantly text-based, unlike sketchbooks, but distinct from most notebooks or journals in their artful

arrangements of images), they share features with a number of textual and visual genres that are similarly positioned between public and private. Notebooks, diaries, travelogues and scrapbooks, despite their differences, all create an illusion of unmediated access to their maker's inner self, but are typically crafted with a small but significant audience in mind, or with a view to posterity.

Gauguin's activation of the creative tension between media – particularly in places where he directly juxtaposed original watercolours and commercial photographs (see figs 34 and 40) – recalls the assortment of sketches, copies, reproductions and photographs found in the albums or keepsake books of nineteenth-century amateur women artists, as well as vernacular forms such as sailors' journals.[33] Related to the Anglo-American tradition of the scrapbook, the album in the French context could denote a variety of compendia, including collections of autographs or prints, as well as volumes that mixed media and incorporated writing.[34] In 1832, writer and caricaturist Henry Monnier (1799–1877) pejoratively described the 'mania' for albums among amateurs and society women. Originally a means for travellers to assemble sketches, verses and letters, so that 'far from home, the book became a travel companion, a friend', it had lost this affective dimension, according to the author, and degenerated into a ruse for collecting and trading artists' drawings.[35] Monnier's remarks, although disparaging, indicate that albums were associated with two social identities that were also central to Gauguin's own projected image: that of the uncultivated *rapin*, or amateur (as he labelled himself in *Racontars de rapin*), and the traveller.

Although personal in nature, albums were also displayed in domestic settings, where visitors could inspect them and contribute a sketch or a *bon mot*, and their carefully crafted covers disclose their status

Fig. 47 *Ancien Culte mahorie*, 1893, folio 10 recto (p. 17). Watercolour, pen and ink drawing, 21.5 × 17 cm. Musée d'Orsay (held at the Musée du Louvre), Paris, RF 10755-17

Following pages:
Fig. 48 *Ancien Culte mahorie*, 1893, folios 10 verso and 11 recto (pp. 20–21). Watercolour, pen and ink drawing, 21.5 × 17 cm (each sheet). Musée d'Orsay (held at the Musée du Louvre), Paris, RF 10755-17

Hiro (Dieu des voleurs) faisait avec ses doigts des trous dans les rochers. Il délivra une vierge retenue dans un lieu enchanté, gardée par des géans. Il arracha d'une seule main les arbres qui tenaient le lieu enchanté. Le charme fut rompu

Ceinture Rouge (Symbole de la divinité et du feu.

Tiis. Ils étaient fort nombreux. Ils étaient
fils de Taaroa et de la Lune (Hina).
C'étaient des esprits inférieurs aux dieux
qui, d'après la cosmogonie et l'usage
qu'on faisait de leurs images, servaient, en
quelque sorte, d'intermédiaires et de ligne
de démarcation entre les êtres organiques et
les êtres inorganiques, dont ils indiquaient et
maintenaient, contre toute usurpation, les
droits les pouvoirs et les prérogatives.
Dormait TAAROA avec Hina la grande de la le
Et d'eux naquit TII.
Dormait Tii avec la femme Ani, désir,
Souhait. D'eux sont nés.
Désir de la nuit, messager de l'Obscurité
des tombeaux ou de la Mort.
Désir du Jour, messager de la Clarté
et de la Vie.
Désir des Dieux, messagers des intérêts
des Dieux.
Désir des hommes, messagers des intérêts
des hommes —
 Sont nés après
Tii de l'intérieur, surveillant des animau
des plantes etc..
Tii du dehors ou de la mer — Gardiens d
tout ce qui est dans la mer.

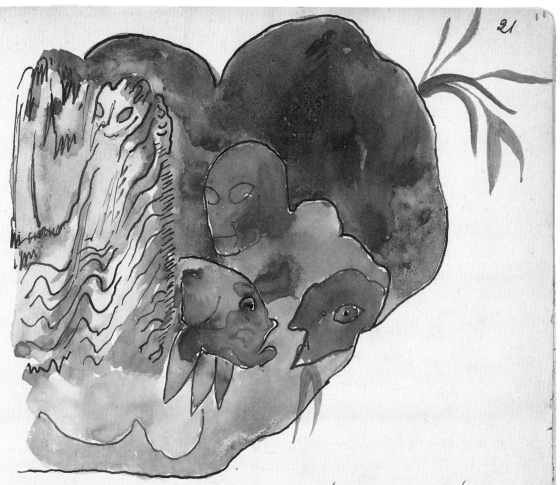

Qui des sables et rivages ou terres mouvantes.
Qui des roches et parties solides.
 Sont nés après
Evenemens de la nuit, de l'Obscurité.
Evenements du jour ou de la Vie.
 L'Allen et le ~~Retour~~ Venir. Flux et Reflux.
 Le Donner et le Recevoir du Plaisir.

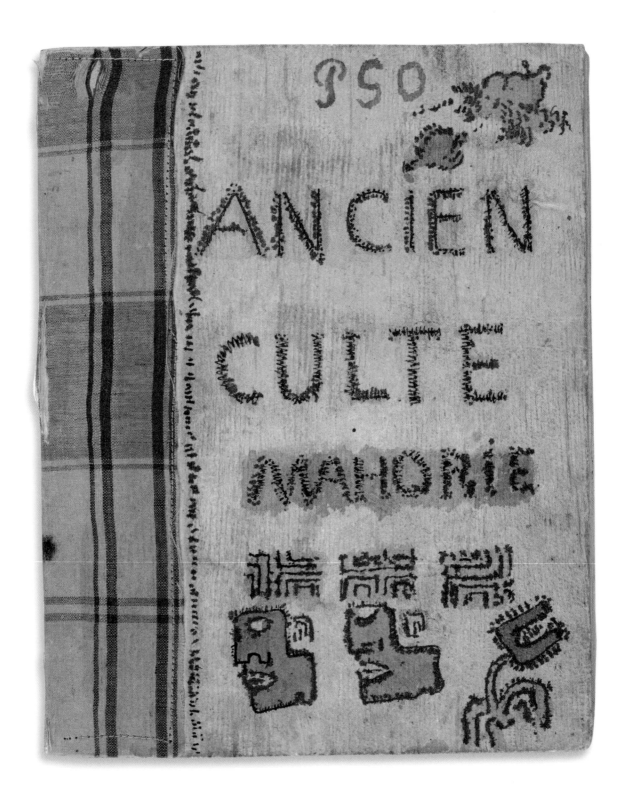

as 'display objects'.[36] It is likely that Gauguin, similarly, showed *Ancien Culte mahorie* and *Cahier pour Aline* (figs 49 and 4), which also have embellished (and monogrammed) bindings, to the visitors who admired the decorative scheme of his Paris studio and listened to his readings from *Noa Noa*. Artists' sketchbooks could likewise take on a social function. Edgar Degas regularly used two albums at the home of his friend the librettist Ludovic Halévy, where composing and viewing them became a public activity and acquaintances occasionally added their own jottings.[37] On the pages of another *carnet* (figs 50–52), Degas – a patron and supporter of Gauguin, and admired by the latter in return – combined text and image, juxtaposed media and explored the effects of repetition in a manner that recalls Gauguin's assemblages in the Louvre album.[38]

Eugène Delacroix's notes on his journey of 1832 to North Africa, recorded in his sketchbooks, and incorporated into an edition of his *Journal*, were a notable precedent for *Noa Noa*, as several scholars have pointed out.[39] The visual format of Delacroix's annotated sketchbooks may have inspired Gauguin, although they are distinct from the Louvre *Noa Noa* in that they do not incorporate assemblages of mixed media. What is certain is that Gauguin would have registered the level of public interest generated by the artist's personal record.[40] In the preface to the first volume of an edition of Delacroix's *Journal* published between 1893 and 1895, the editors celebrate its 'free flowing' entries, written 'without order, plan, or transitions' and implicitly connect this seemingly artless approach to its precious revelation of the 'intimate Delacroix'. It is his 'personal impressions', they claim, which 'allow us to penetrate the very life of

this artist'.[41] An anecdote in the introduction written by Paul Flat makes it clear that Delacroix was himself 'preoccupied with the effect that his writings could produce': he reportedly showed his *Journal* to his friend and aunt Madame Reisener and her husband, confessed to them his 'natural facility for writing', and admitted the great care he took over even his correspondence, on account of the current craze for 'preserving, in order to publish them later, the slightest signatures of men in the public eye'.[42]

Gauguin knew Delacroix's writings, as he copied into *Diverses choses* a section from an anthology of the latter's notes and articles published in 1865.[43] In a passage from this same volume discussing his unrealised project for a Dictionary of Fine Arts, Delacroix insisted that the structural difficulties of writing a book, with its divisions of material and thematic developments, are all the more acute 'when one is not a professional author, when one writes only in order to give in to the need to express ideas as and when they come'. Delacroix's casual approach is willed, not natural: he reworked and repeated this sentence about jotting down ideas spontaneously, thus undermining its very premise.[44] Even if he did genuinely struggle to organise his thoughts consecutively, it is also clear that he avoided conventional literary composition deliberately. He frequently commented on the boredom induced by words, noting, for instance, that it 'takes twenty pages to describe what [as a painter] I could have captured in its entirety in a few instants'.[45]

Michèle Hannoosh has shown how, in his *Journal* and other texts, Delacroix sought to imbue his own writing with this 'visual' quality of immediacy – resisting chronology through repetition and

Fig. 49 Cover of the manuscript *Ancien Culte mahorie*, c.1892–3. Watercolour, pen and black ink drawing, 21.5 × 17 cm. Musée d'Orsay (held at the Musée du Louvre), Paris, RF 10755-1

Following pages:
Fig. 50 Edgar Degas, '*Carnet 1*' [sketchbook] (c.1859–64), p. 105. Notes, sketches and scrapbook additions (trial impression of an etching by Degas and photograph of a young man), 25.4 × 19.5 cm. Bibliothèque nationale de France, Paris, RESERVE 4-DC-327 (D,1)
Fig. 51 Edgar Degas, '*Carnet 1*' [sketchbook] (c.1859–64), p. 162. Notes, sketches and scrapbook additions (manuscript notes and sketch in brown ink, reworked in brown and grey wash), 25.4 × 19.5 cm. Bibliothèque Nationale de France, Paris, RESERVE 4-DC-327 (D,1)

cross-referencing, and juxtaposing incongruous observations to create an effect equivalent to the tonal contrasts of painting.[46] Gauguin's anti-linear, fragmentary approach to textual composition was likewise premised on an opposition between the logical, temporal flow of narrative and the all-encompassing immediacy of visual image. This he absorbed, in part, from Delacroix's writings, and re-inforced through the physical form of his manuscripts.

I shall focus here on a sequence of pages from *Diverses choses* in which Gauguin used collaged images and text to construct a multifaceted, multimedia dramatisation of his artistic identity.[47] In one double-page spread, he penned an imaginary 'letter to the editor' at the bottom of the right-hand page, to which he added his signature (fig. 9). Here, he pursued his attack on art criticism, mocking critics who seek to categorise and label artistic styles and movements. Yet on the same page he pasted several press clippings from a review by Roger Marx of his 1893 Galerie Durand-Ruel exhibition, which include photographs of himself and his artistic creations, undermining his claim that artists should defend their own work 'without the intervention of an interpreter'.[48] He sought to minimise this contradiction, however, by using a careful arrangement of text and images to shift the focus away from the context of art criticism, and towards his affiliations with poetry and the primitive. At the top of the left-hand page, a simplified, stylised sketch of the artist, which he falsely attributed to 'my *vahine* Pahura' but actually executed himself, confirms his savage credentials. He placed it above a transcription of Paul Verlaine's confessional poem from *Sagesse* (1881), 'Le ciel est, par-dessus le toit' (The sky is, above the roof) – a poem celebrating freedom and the beauty of nature, written while Verlaine was in prison for shooting his lover and fellow poet Arthur Rimbaud. The poem is followed by a reference to the twelfth-century Cistercian monk Saint

Bernard of Clairvaux, quoting his paean to asceticism: '*O Beata solitudo! O sola beatitudo!*' ('Oh blessed solitude! Oh only blessing!'). By placing his self-portrait at the head of the page, above these borrowed texts, Gauguin suggestively linked his own exile from civilisation to the virtuous isolation of the pious monk or the incarcerated poet.

On the right-hand page, the pasted-in section of Marx's review juxtaposes one of Gauguin's cylinder sculptures of the Polynesian moon goddess Hina with a passage from Charles Baudelaire's prose poem 'Les Projets' (1857), evoking a tropical landscape, and directly compares painter and poet in terms of their rejection of materialism and experience of exotic travel.[49] In the cluster of images at the top, clipped from the same article, Gauguin placed a photographic portrait of himself in profile – which closely mirrors the profile of his 'savage' likeness on the opposite page – alongside his representations of Tahitian women. Here, he stands in front of the seated figure from *Te Faaturuma* (*The Brooding Woman*, 1891), whose pose reflects that of the female Buddha in the reproduction of his *Idol with a Pearl* (1892) carving to the right; directly below, a cropped reproduction of *Vahine no te tiare* (*Tahitian Woman with a Flower*, 1891, fig. 22) focuses attention on the androgynous face of the woman, whose contemplative demeanour echoes Gauguin's own static pose. Again, this arrangement visually cements his identification with the Tahitian figures. Together, these various textual and visual associations build up a portrait of the artist as both poetic and savage. Using a variety of media, authorial voices and literary registers – aphorism, criticism, poetry, polemic – Gauguin avoided the linear logic and labelling of the critical writing that he despised, in favour of the suggestive and synthetic approach that he associated with visual art.

It is on the page immediately following this multifaceted 'self-portrait' that Gauguin introduced

Fig. 52 Edgar Degas, '*Carnet 1*' [sketchbook] (*c.*1859–64), p. 247. Notes, sketches and scrapbook additions (sketch of a horse's head, on tracing paper, and sketch of the head of a woman in profile), 25.4 × 19.5 cm. Bibliothèque Nationale de France, Paris, RESERVE 4-DC-327 (D,1)

the sequence of pasted-in Japanese prints, repro-
ductions of lithographs by Honoré Daumier and
Jean-Louis Forain, and photograph of a fresco by the
School of Giotto that follows shortly after (see fig. 10).
He does so by stressing the connection between
their multiple sources: 'grouped in this volume; not
by chance, but by choice, deliberately – because I
wanted to show the links between their different
appearances'.[50] For Gauguin, what unites these
disparate artistic models is that, whether categorised
as non-western, pre-Renaissance or popular, they
were considered primitive from the perspective of
the European academic tradition. To him, this meant
that they eschewed representational conventions
and perspectival illusionism in favour of 'primordial
qualities' ('*qualités primordiales*'). His preference
for those artists whom 'incompetent critics and the
ignorant crowd' ('*de maladroits critiques ou ... la foule
ignorante*') tend to dismiss as 'caricatures or trivial
art' ('*caricatures ou art léger*') corroborates his claim
that a serious work can benefit from 'childish things'.[51]
Thus, regardless of its simplicity and errors of
perspective, Giotto's art possesses an 'immense depth
of conception' ('*une immense fécondité de conception*')
and a 'love and tenderness that is utterly divine' ('*une
tendresse, un amour tout à fait divin*').[52] Its emotional
effect cannot be explained in logical terms, since,
'just like listening to music' ('*tout comme une audition
musicale*'), it resists conventional understanding.[53]

Gauguin aligned himself with Giotto's primitive
approach. Referring to a critic's dismissive account of
himself as a 'so-called great painter [who] tramples
with both feet on the rules of perspective', he noted
that this critique could equally be applied to the
fourteenth-century Italian master.[54] In a passage
outlining the composition of a future painting, he
then proudly adopted the same phrase as a slogan,
vowing to 'trample on the rules with both feet'
('*je marcherai à pieds joints sur les règles*') in order
to achieve his desired effect.[55] Just as Giotto's art
could not be judged by its adherence to academic
precepts, Gauguin sought to achieve effects – such

as the juxtaposition of bright and sombre tones –
that defied naturalistic conventions. Observing that
'painting is difficult when one wants to express one's
thoughts with pictorial rather than literary means',
he anticipated his failure to complete this projected
painting and lamented his weakness by quoting again
from 'Le ciel est, par-dessus le toit': 'And I will say, like
Paul Verlaine. You that are here, what have you done.'[56]
With these reiterated refrains, Gauguin strengthened
the association between his own art and what he
saw as the rebellious non-conformism of Giotto and
Verlaine, using precisely the 'non-literary' methods of
harmonious repetition and association that he valued
in their work.

Borrowed Voices

Citation is central to Gauguin's writing, and he
made no effort to disguise it. In *Diverses choses*, there
are 27 different names to whom quoted words or
passages are attributed, including musicians, artists,
authors, critics, and other cultural figures ancient and
modern (from Epicurus to Emanuel Swedenborg, to
contemporaries such as the musician Ernest Cabaner
or the critic Rémy de Gourmont). Gauguin ascribes
other sayings simply to 'a woman' ('*une femme*'),
'some saint or other' ('*un saint quelconque*'), 'an
inmate from the Charenton asylum' ('*un pensionnaire
de Charenton*') – or introduces them with the words
'I have forgotten which English author said that ...'
('*Je ne sais plus quel auteur anglais a dit qu[e] ...*') – as
if to highlight the shared ownership and mutability of
ideas.[57] He interrupts lengthy passages on aesthetics
or religion with light-hearted sound bites or snatches
of verse, interspersed with Norse myth or passages
from the Bible; sometimes misattributes or fails to
acknowledge a source; and, in the case of one passage
that he frequently recycled, credits his own words to a
fictional author.[58]

He not only composed *Diverses choses* from
disparate portions of other people's words, but also

incorporated similarly structured texts within it. For example, the passages that make up the 'Notes d'Edgar Poe' come from the American writer's *Marginalia* (1844–9), which are themselves a series of observations on, and from, texts by other authors, as well as Poe's own previous work. As with other sections of *Diverses choses*, Gauguin first transcribed these extracts in *Cahier pour Aline*, where they constitute the opening passage.[59] In this earlier manuscript, they immediately follow a preliminary page (fig. 6) on which four names appear in succession, initiating the chorus of voices that continues in the remainder of the volume: Aline, in the handwritten dedication at the top; Gauguin, Morice and Jean Dolent, as the subject, dedicatee and author, respectively, of a collaged newspaper article, the multivocality emphasised by the combination of handwriting and newsprint.[60]

Poe's gathered reflections end with quotations from other famous epigrammatists, Nicolas Chamfort and Epicurus, and are followed, in *Cahier pour Aline*, by the words of Richard Wagner, likewise cited on other occasions by Gauguin.[61] In both cases, the 'guest author', as it were, is clearly announced. But at the same time a principle of proverbialism, of shared and potentially anonymous authorship, is established. This is emphasised by the segue between the aphorisms embedded in the Poe text, and those that follow, either of Gauguin's own invention, or too generic to be attributed, such as 'Everything is forgiven, nothing is erased, everything that has been will always be.'[62] These and other sound bites, including the two by Symbolist writer Joséphin Péladan that constitute the final words of the handwritten text, in place of any closing statement by Gauguin himself, lend *Cahier pour Aline* the air of a commonplace book – a collection of witty phrases or thematically grouped quotations to be dipped into.[63]

The volume as a whole concludes as it began, with newspaper cuttings, which fill the 18 pages prior to the decorated endpaper. For the most part, these are reviews of his exhibition at the Galerie Durand-Ruel in 1893, sent to him by a press-cutting agency (fig. 53). This literal, physical cutting and pasting of newspaper corresponds to the figurative cut-and-paste of textual fragments in the main body of the manuscript. It also continues the free play between anonymity and attribution found there. For instance, on one double-page spread (fig. 15), Gauguin copied out part of an article by Félix Fénéon, including his name, so that an author is identified but his words rendered in another hand. To the lower right of this passage he pasted a newspaper cutting, whose mechanically printed words lack title or author, while on the opposite page, Octave Mirbeau's name is emblazoned on the first page of a collaged article announcing Gauguin's departure (in 1891) for Tahiti. This principle of citation is crystallised on a page of *Diverses choses* (fig. 54), onto which Gauguin pasted a small piece of paper containing some printed lines attributed to Baudelaire. Extracted from its original context (the poet's essay of 1861, 'Richard Wagner et *Tannhäuser* à Paris'), the quotation marks that frame the passage reveal that Gauguin excised it from another, now unknowable location. Iteration itself is foregrounded here, the dislocated quotation marks signalling the adaptability of such textual fragments.[64]

Critics have tended either to condemn or to minimise Gauguin's plundering of both textual and visual sources.[65] Camille Pissarro's frustration with his former pupil's preference for mystical themes over social realities prompted his complaint, in 1893, that the younger artist, having worked his way through the European repertoire, was now 'pillaging the savages of Oceania'.[66] In a similar vein, Abigail Solomon-Godeau understood his tendency towards

Following pages:
Fig. 53 *Cahier pour Aline*, 1893, p. 26. Press cuttings, 21.5 × 17 cm (each sheet). Bibliothèque de l'Institut National d'Histoire de l'Art, Paris, Collections Jacques Doucet, NUM MS 227

Fig. 54 *Diverses choses*, 1896–8, folios 108 verso and 109 recto (pp. 208–9). Manuscript notes, pen and ink, with press cutting, pasted, 31.5 × 23.2 cm (each sheet). Musée d'Orsay (held at the Musée du Louvre), Paris, RF 7259, 1

M. Paul Gauguin, le peintre dont le nom
déjà connu il y a deux ans, lors de son dé-
part, n'est pas encore oublié, revient d'un
long voyage à Taïti, et c'est le produit de
son travail exotique qu'il expose aujour-
d'hui dans les galeries Durand-Ruel.

Etant admis que la bonne foi de l'artiste
est indiscutable, — et il n'est pas hors de
propos de poser d'abord ce principe —
qu'il me soit permis de le trouver au moins
déroutant.

Il faut se garder, dit-on, des effarouche-
ments trop prématurés comme des enthou-
siasmes trop hâtifs qui peuvent les uns et
les autres exposer, dit-on encore, à de fâ-
cheuses contradictions.

Cela n'est vrai qu'en partie, car refuser
au spectateur le droit de modifier sa ma-
nière de voir lorsqu'il est sincère, c'est l'o-
bliger à persister dans une erreur et à sou-
tenir une opinion qu'il reconnaît excessive,
uniquement pour n'avoir pas l'air de se dé-
juger.

J'avancerai donc sans nulle fausse honte,
mais avec la plus entière franchise, que je
ne comprends, quant à présent, rien de
rien à l'art que pratique M. Gauguin.

Je ne sais rien de plus enfantin que ce
retour affecté vers d'incertains primitifs
dont on n'a gardé que les défauts, sans
voir leur naïveté ou leur bonne volonté de
bien faire.

M. Gauguin met une coquetterie au moins
bizarre à violer les éléments les plus vul-
gaires du dessin, et il se trouve d'intrépides
admirateurs pour en paraître émerveillés
sous prétexte de synthèse.

Que ce mot de « synthèse » est agréable
lorsqu'on est à bout d'arguments ! Un pein-
tre ne sait pas son métier ? Synthèse. Un
écrivain demeure inintelligible ? Synthèse.
Un poète s'embourbe en d'insondables di-
vagations ! Synthèse. Synthèse en tout et
partout. Synthèse toujours. Cela veut dire
simplement que tout est en tout, que cha-
cun peut voir ce qu'il veut en la plus piètre
chose et que l'anarchie universelle est le
fin du fin de la synthèse.

Que M. Gauguin surprenne parfois des
expressions curieuses, qu'il retrace quel-
ques jolis mouvements, qu'il imagine des
heurts de couleurs souvent non dépourvus
d'intérêt, je me garderai d'y contredire.
Mais je mentirais impudemment si je di-
sais qu'à mon avis, le peintre enferme, en
une ligne, tout le génie d'une race, qu'il a
inventé des éblouissements de couleur in-
connus avant lui, qu'il est, en un mot,
un des premiers « chercheurs » de notre
temps.

Il se peut, après tout, que je n'enten-
rien à la synthèse. C'est mon opinion qu'
me demande. Je la donne avec d'aut
plus d'aisance que nul n'est tenu de la pa
tager.

L'EXPOSITION PAUL GAUGUI

CHEZ DURAN-RUEL

Aujourd'hui, à deux heures, s'ouvrir
dans les galeries Duran-Ruel, l'expositio
des œuvres récentes du peintre Gaugui
Les passionnés d'art, ceux à qui l'aven
de la peinture n'est pas indifférent, appré
cient hautement l'artiste dont les travau
personnels et voulus ont depuis longtem
forcé l'attention. Le talent de M. Gaugui
marqué au coin d'une grande originalit
s'affirme cette fois d'irréfutable manièr
ce n'est pas — quelle que soit l'esthétiqu
dont on procède — sans un charme péné
trant que l'on verra, rue Laffitte, une ci
quantaine de ses peintures.

A l'heure où nous pénétrons dans les l
caux, les cadres sont empilés pêle-mêle
long des murs et nous ne pouvons qu
noter, au hasard d'un captivant souven
les *Batteuses*, *Femme au Mango*, *Femm
de la Fleur*, la *Cueillée des citrons*, F
royale. Nous recommandons particulièr
ment *Ave Maria*, d'une coloration intens
et délicate, d'une grande profondeur
sentiment — œuvre devant laquelle aucu
peintre, aucun érudit en l'art d'amalg
mer les tons ne saurait rester indifféren
Il y a chez M. Gauguin un tempéramen
extraordinaire de coloriste, sa palette r
celle des pierres précieuses ; elle évoqu
des émaux, des majoliques ; son dessi
est d'une ampleur rarement égalée.

Ajoutons que ce sont MM. Duran fi
qui, en l'absence de leur père, ont pris l
initiative d'organiser cette exhibition r
marquable, pour laquelle les locaux on
été fraîchement décorés. Nous les en félic
tons très sincèrement, car nous constator
qu'ils ont tenu à ne pas faire mentir
proverbe : Race oblige !

Louis Cardon.

L'EXPOSITION PAUL GAUGUIN

CHEZ DURAN-RUEL

Aujourd'hui, à deux heures, s'ouvrira, dans les galeries Duran-Ruel, l'exposition des œuvres récentes du peintre Gauguin. Les passionnés d'art, ceux à qui l'avenir de la peinture n'est pas indifférent, apprécient hautement l'artiste dont les travaux personnels et voulus ont depuis longtemps forcé l'attention. Le talent de M. Gauguin, marqué au coin d'une grande originalité, s'affirme cette fois d'irréfutable manière et ne n'est pas — quelle que soit l'esthétique dont on procède — sans un charme pénétrant que l'on verra, rue Laffitte, une cinquantaine de ses peintures.

A l'heure où nous pénétrons dans les locaux, les cadres sont empilés pêle-mêle le long des murs et nous ne pouvons que noter, au hasard d'un captivant souvenir, les *Batteuses*, *Femme au Mango*, *Femme de la Fleur*, la *Cueillée des citrons*, *Fin royale*. Nous recommandons particulièrement *Ave Maria*, d'une coloration intense et délicate, d'une grande profondeur de sentiment — œuvre devant laquelle aucun peintre, aucun érudit en l'art d'amalgamer les tons ne saurait rester indifférent. Il y a chez M. Gauguin un tempérament extraordinaire de coloriste, sa palette rappelle des pierres précieuses ; elle évoque des émaux, des majoliques ; son dessin est d'une ampleur rarement égalée.

Ajoutons que ce sont MM. Duran fils qui, en l'absence de leur père, ont pris l'initiative d'organiser cette exhibition remarquable, pour laquelle les locaux ont été fraîchement décorés. Nous les en félicitons très sincèrement, car nous constatons qu'ils ont tenu à ne pas faire mentir le proverbe : Race oblige !

Louis Cardon.

PETITES EXPOSITIONS

Deux expositions, l'une comprenant les œuvres récentes de Paul Gauguin, l'autre organisée chez Le Barc de Boutteville par les peintres impressionnistes et symbolistes, se sont ouvertes hier.

Le nom de Paul Gauguin, ignoré encore de nombre de Parisiens, est cependant fort connu, surtout depuis deux ans, dans le monde où l'on s'intéresse aux choses de l'art. Le peintre qui le porte s'est, il y a quelque temps, révélé comme un curieux caractère et un esprit original, et la réunion d'œuvres qu'il met aujourd'hui sous les yeux du public dans les galeries Durand-Ruel montre que son art est loin d'être sans vigueur.

Paul Gauguin, amoureux des atmosphères lumineuses et vibrantes et las des banalités dont il avait autour de lui le spectacle, s'est embarqué il y a deux ans pour de très lointaines contrées. Il désirait à la fois remplir ses yeux des beautés d'une nature luxuriante et nouvelle et puiser dans le trésor de traditions demeurées mystérieuses à l'Europe, des inspirations à la fois poétiques et puissantes.

Gauguin s'était fixé à Tahiti. C'est du pays de la petite Itarahu qu'il a rapporté l'œuvre exposée. Dans les cinquante toiles réunies là, l'artiste se montre sûr de lui, en possession d'un sens synthétique parfait et d'une facture très nettement personnelle. Le tableau intitulé *Sa Orana Maria (Ave Maria)*, particulièrement, permet de classer Gauguin au nombre de nos peintres les meilleurs et les plus originaux. Il nous suffira de le signaler à l'attention des esprits éclairés et que le parti pris n'égare point.

A l'exposition des peintres impressionnistes et symbolistes, en revanche, rien de bien nouveau ni de bien puissant ne nous est montré. Incontestablement il y a parmi les exposants des personnalités intéressantes, mais aucune encore ne mérite les honneurs d'une critique sérieuse.

On nous saura donc gré de ne retenir ici que quelques noms : ceux de MM. Maurice Denis, Anquetin, Pierre Bonnard, Sérusier, Lacombe et Jules Chéret. — A.

Les po. Velasquez est essentiellement royal

Rembrandt le magicien essentiellement. Prophète.

Je ne sais plus quel auteur anglais a dit qu'on
devait reconnaître le roi quoique nu dans une foule
de baigneurs. Il en est de même pour l'artiste, on
doit le distinguer quoique caché derrière les fleurs
qu'il a peintes. Courbet fit cette belle réponse à une
dame qui lui demandait ce qu'il pensait devant un
paysage que celui-ci était en train de peindre — «

Je ne pense pas Madame, je suis ému —
Oui le peintre. do en action. Doit être ému mais
auparavant il pense. Qui peut m'assurer que
telle pensée, telle lecture, telle jouissance n'ait point
influencé quelques années plus tard une de mes œuvres

Forgez votre âme, jeunes Artistes,
donnez-lui constamment une nourriture saine, soyez
grands, forts et nobles, je vous le dis en vérité, vo
œuvre sera à votre image. —

J'ai un coq aux ailes
pourpres, au cou d'or,
à la queue noire. Dieu
qu'il est beau, Et il m'amuse —

« En matière d'art j'avoue que je ne hais pas
l'outrance ; la modération ne m'a jamais semblé
le signe d'une nature artistique vigoureuse.
J'aime ces excès de santé, ces débordements de
volonté qui s'inscrivent dans les œuvres comme
le bitume enflammé dans le sol d'un volcan...
 BAUDELAIRE.

J'ai une poule grise
plumage herissé ; e
gratte, elle picote,
abîme mes fleurs. Ça ne f

rien elle est drôle, puis elle n'est pas bégueule : le coq lui fait
et aussitôt elle offre son croupion. Lertement et vigoureu
il monte dessus. Ah c'est bientôt fait ! Est-ce de la chance ? je
sais. Les enfants rient, je ris - Mon Dieu que c'est bête -
Quelle disette, rien à boulotter, si je mangeais le Coq (j'ai
Il serait trop dur. La poule alors ? Mais je ne m'amuserais plu
voir mon coq aux ailes pourpres, au cou d'or à la queue noire, m
sur la poule ; les enfants ne riraient plus — J'ai toujours f

Ce fut à l'époque des Tamerlan je crois en l'an X avant
ou après Jésus-Christ — Qu'importe ; souvent précision nuit au
rêve, décaractérise la Fable — Là-bas du côté où le soleil
se lève ce qui fit appeler cette vaste ~~contrée~~ contrée. Le
Levant, en un bosquet odorant quelques jeunes gens au
teint basané, mais cheveux longs contrairement aux usages
de la foule — indice de leur future proffession —
se trouvaient réunis Ils écoutaient, je ne sais si res-
pectueusement. le grand proffesseur mani Vehbi-Zunbul-
Zadi, le peintre donneur de préceptes. Si vous êtes
curieux de savoir ce que pouvait dire cet artiste en
des temps barbares écoutez.
 Il disait :
 Employer toujours
des couleurs de même origine. L'indigo est la meilleure
base ; il vient jaune traité par l'esprit de nitre et rouge
dans le vinaigre. Les droguistes en ont toujours.
Tenez-vous à ces trois colorations. Avec de la patience
vous saurez ainsi composer toutes les teintes. Laisser le
fond de votre papier éclaircir vos teintes et faire le
blanc, mais ne le laissez jamais absolument nu. Le
linge et la chair ne se peignent que si l'on a le secret de
l'art. Qui vous dit que le vermillon clair est la chair
et que le linge s'ombre de gris ? mettez une étoffe blanche
à côté d'un chou ou à côté d'une ~~étoffe~~ touffe de roses
et vous verrez si elle sera teintée de gris.
Rejetez le noir et ce mélange de blanc et de noir qu'on

quotation and repetition as symptomatic of the artifice of his tourist vision. She targeted in particular his claim, in *Noa Noa*, that he learned the Polynesian creation myths that he recounts there from his Tahitian wife (Tehamana in the Draft manuscript or Tehura in the Louvre album), when he in fact gleaned them from a second-hand, European volume.[67] Her analysis brilliantly draws attention to the way in which Gauguin's representations of Polynesia are mediated through layers of pre-existing texts and images. However, her charge that the artist was guilty of 'plagiarism' and 'denial' rings less true, since it was Gauguin himself who revealed that Moerenhout was his guide. In the Louvre album, he admits to being indebted to 'Monsieur Goupil, settler in Tahiti' for his access to 'documents found in a collection by Moerenhout the former consul'. It is thanks to this detail that historians have been able to identify not only the source of the Tahitian legends he records, but also the manner in which he acquired it.[68]

The standard rejoinder to the accusation that Gauguin was a plagiarist has been to stress that artists throughout history have borrowed motifs without feeling the need to acknowledge them. According to this argument, Gauguin did not deceitfully conceal the images and words that he appropriated, but adapted them so inventively as to make them his own.[69] However, in *Noa Noa*, he does not just absorb the material from Moerenhout seamlessly, but actually foregrounds his own pretence, as when the narrator claims, with reference to his new companion, that 'she gave me a complete course in Tahitian theology', but adds the footnote: 'taken from Moerenhout'.[70] In another instance, the narrator presents Moerenhout and Tehura as simultaneous informants, when he ponders: 'Who created the sky and the moon? Morenhout and Tehura replied to me ...'[71]

The attribution of traditional knowledge in *Noa Noa* to both Tehura and Moerenhout, however conspicuously fabricated, underscores the necessarily piecemeal and partial basis of Gauguin's access to local lore.[72] Despite the suppression of

Polynesian religion, and certain cultural practices, by evangelisation and subsequently colonial rule, Indigenous customs still survived, often in hybridised forms, and Tahitians were actively involved in preserving the memory of the old ways and legends – for example, through the recitation of genealogies.[73] Gauguin did not have the same connection to elite Tahitian society as that enjoyed almost contemporaneously by the American historian Henry Adams, who recorded the genealogies recounted to him in private gatherings by Queen Marau and her mother, the matriarch of the Teva clan, Arii Taimai.[74] The real-life equivalent of the fictional Tehamana/ Tehura may not have been a likely mouthpiece for tales of the Polynesian gods. But to insist on her complete ignorance is to silence her further. It is to erase what Indigenous women knew of their traditional culture that was not written down, or that fell outside their official domain of expertise as established by the codes of gender or class.[75]

As Gauguin's main source, Moerenhout's ethnohistory was itself fragmentary. It was based partly on the unpublished oral-history research of the English missionary John Muggridge Orsmond, as well as oral testimony that Moerenhout apparently gathered with the help of Chief Tati of the Papara district, and was compiled back in Paris in 1835 before being published two years later.[76] Gauguin's references to Moerenhout in *Noa Noa* pinpoint this element of syncretism in the ethnographer's account. As a prelude to relating the legend of the founding of the Arioi society (an elite religious sect), the narrator describes how, having exhausted Tehura's reserves of knowledge, he searched everywhere for further information. The story that he 'managed to piece together' is, he admits, 'a mythical yarn through which historical truth is only half revealed'. Undercutting this pretence at personal testimony supplemented by extensive research, in a footnote he adds, as before, 'drawn from Moerenhout'.[77] By implication, then, it is Moerenhout as much as his own supposed efforts at reconstruction that he

is characterising as only partly reliable. Elsewhere, he draws attention to another literary interpreter of Moerenhout: when recounting the genesis of the creation god Ta'aroa, he adds in a footnote 'see Poëmes barbares (Comte de Lisle) [sic]', thus showing Moerenhout's ethnographic account to be a source of poetic inspiration as much as documentary evidence.[78]

Gauguin's access, then, to traditional Tahitian myth was belated and patchy, but this was a crucial part of its appeal. He did not seek to compensate for his partial knowledge with a false veneer of authenticity. Nor was his sense of modern Tahiti's distance from its ancient past necessarily a cause of disappointment or melancholy, since it chimed perfectly with his deep investment in the nineteenth-century cult of the fragment. Whether in the form of architectural ruins, the painterly sketch, or seemingly deracinated prose, as in the conceit of the author masquerading as the discoverer of a 'found' document, the power of the fragment lay in its capacity to suggest a larger, lost whole, whose value in turn depended on its being too universal to be captured in full.[79] Stephane Mallarmé's vision of an all-encompassing 'Livre' ('Book'), for instance, whose purpose was to express the interconnectedness of the universe, could only ever exist in a perpetual state of becoming.[80] In the preface to his poem 'Un coup de Dés jamais n'abolira le Hasard' ('A Throw of the Dice will Never Abolish Chance', 1897), often thought to represent a fragment of this projected masterwork, Mallarmé characterised his poem as consisting not of regular lines of verse but of 'prismatic subdivisions of the idea'.[81]

A tendency towards non-consecutive prose was pervasive in the nineteenth-century literary culture in which Gauguin was steeped. Baudelaire, for example, wrote of his collection of prose poems, Le Spleen de Paris: 'Take out a vertebra, and the two pieces of this tortuous fantasy will easily rejoin. Chop it into multiple fragments, and you will see that each one can exist on its own.'[82] In June 1891, a couple of months after the writer Octave Mirbeau dedicated an article to Gauguin to mark his departure for Tahiti, L'Art Moderne published a favourable account of Les Cahiers d'André Walter – André Gide's anonymously published tale of a doomed love affair – in which the reviewer observed how 'without plot, action, events, without pretension, almost without sentences, [the Cahiers] are presented to us like a fabric of sown-together thoughts' amounting at times to a 'messy outpouring of disparate objects'.[83] Gauguin claimed a similar aesthetic for his own manuscripts, confessing at the end of Diverses choses: 'Rereading this, I should be embarrassed by the naivety of these daily scribblings, had I not set out my childish inclinations at the start.'[84] Ever strategic, he transferred this disjointed sensibility to his encounter with Polynesia, interpreting the patchwork condition of traditional Tahitian culture under colonialism from the point of view of the European fascination with the fragment.

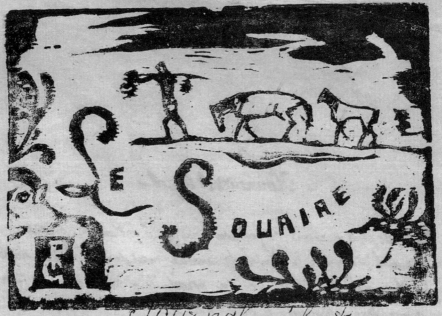

LE SOUAIRE

Journal méchant.

air connu.

La trinité se passe
Mironton, tonton, mirontaine.
La trinité se passe,
Malbrough ne revient pas (ter)

Chacun mit ventre à terre
Mironton Mirontaine;
Chacun mit cul par terre
Et puis regarda (ter)

Pour admirer les vestes
Mironton taine;
Pour admirer les vestes
Que Malbrough remporta (ter)

Chapter Four

GAUGUIN'S Avatars

⟋ ⟋ ⟋ ⟋ ⟋ ⟋ ━━

I N THE FINAL FIVE YEARS OF HIS LIFE, FROM 1899 to 1903, Gauguin's activities as a writer were intense, diverse and avowedly geared towards a public audience. Beginning in June 1899, and continuing on and off until August 1901, he wrote as a journalist for the Tahitian monthly *Les Guêpes* (The Wasps), and from August 1899 to April 1900 produced nine issues of his own newspaper *Le Sourire* (The Smile). Two years later, by then living in the Marquesas Islands, he wrote *L'Esprit moderne et le catholicisme* (The Modern Mind and Catholicism), based on his earlier essay 'L'Église catholique et les temps modernes' (The Catholic Church and modern times) that had formed part of *Diverses choses*. It was also in 1902 that he penned *Racontars de rapin*, followed the next year by *Avant et après*, which has subsequently become his most frequently published manuscript after *Noa Noa*.

Each of these projects was ambitious in scope. The two newspapers were by definition directed at a public readership, albeit a restricted one of fellow colonists united in their opposition to the leading 'Protestant party' faction of the local colonial administration, but Gauguin also endeavoured to extend his journalistic influence to the metropole by sending a run of *Le Sourire* to his friend and patron George-Daniel de Monfreid in Paris.[1] The 92-page manuscript of *L'Esprit moderne* remained among his possessions at his death, but Gauguin had taken great care over its presentation, decorating the binding and inner covers (fig. 56), and he advertised it to Charles Morice, to whom he had planned to send it, as 'the best thing that I have expressed in my life from a philosophical point of view'.[2] His two final manuscripts, meanwhile, he pressed on the critic André Fontainas in an urgent, but ultimately unsuccessful, bid to get them published in Paris.[3]

This late campaign of writing is often characterised as a distraction from his art, functioning primarily as an outlet for the bitterness and frustration brought on by the increasing infirmity and isolation of his twilight years, and as a desperate attempt at self-advertisement.[4] But, although prolific, his rapid production of three manuscripts and two newspapers

Previous:
Fig. 55 *Le Sourire: Journal méchant*, February 1900. Masthead: *Man Carrying Bananas Followed by Two Horses* (only state). Mimeograph in brownish-black ink, with woodblock print in black ink, on cream wove paper, 37.4 × 50.9 cm (full sheet), 37.4 × 25.6 cm (folded sheet). The Art Institute of Chicago

did not constitute an unprecedented burst of literary activity. It consolidated a longstanding commitment to polemical self-expression, which had begun in 1889 with articles in Parisian journals attacking art-world institutions, and it intensified earlier efforts, in the case of *Noa Noa*, to publish his manuscripts. For Gauguin, writing was not only a tool with which to construct a public image that would promote his art, but also an alternative forum in which to explore the shifting parameters of artistic and colonial identity. Scholars have interpreted his propensity for role play and impersonation in his self-portraits – from Christ to the androgynous monster *Oviri* – alternatively as self-propagandising or as posing a challenge to conventional divisions between masculine and feminine, civilised and savage.[5] Here, I draw attention to the parallel process, particularly noticeable in the late writings, by which he created multiple authorial positions in his texts, employing pseudonyms or writing under different guises. These various authorial avatars, each in some way an embodiment of the primitive, enabled him to write without compromising his image as an artist-savage.

Despite his disdain for elements of the colonial administration in Tahiti, and for 'civilisation' more broadly, Gauguin was not willing to relinquish the privileges to which he felt entitled as a French settler: this is acutely apparent from the pages of *Les Guêpes* and *Le Sourire*, which are devoted to colonial infighting, and not, primarily, to the defence of Indigenous rights. However, as a visual artist with minimal resources or reputation (locally, at least) he lacked both the social status of the wealthy colonial elite and the cultural authority of the Parisian men of letters on whom he depended for support. Writing was a means of accruing both financial and cultural capital. As he wrote to De Monfreid, the circulation

of *Le Sourire* was bringing in 'around fifty francs per month', but more significantly, it brought him influence and notoriety: 'I've increased my *credibility*', he boasted.[6] At the same time, a certain distance was required from the profession of writing, given its status as a tool of civilisation and the opprobrium with which artists who defended themselves in print were typically viewed.[7] The conspicuous artifice of Gauguin's various *noms de plume* suggests his awareness that to write as an artist was to play a role – one that required the strategic adoption of alternative voices.[8]

ZUNBUL-ZADI, PARETENIA AND TIT-OÏL

One of Gauguin's earliest forays into writing, predating his published art criticism and first full-length manuscripts, was written under the guise of a borrowed identity. In the best-known instance of his use of pseudonyms, he circulated in 1886 an aesthetic credo among artists and critics including Georges Seurat, Camille Pissarro and Félix Fénéon, which he passed off as the words of 'Mani, the painter giver of precepts', or in later renditions 'the great professor Mani Vehbi-Zunbul-Zadi'. It has been suggested that this pseudonym conflates the historical figures of Mani, founder of Manicheism in third-century Persia – whose status as a persecuted prophet and reputed painter clearly would have appealed to Gauguin – and an eighteenth-century Ottoman poet, Vehbi Sünbülzade.[9] Regardless of his potential sources of inspiration for the name, Gauguin deliberately gave his alter ego the vaguest of historical coordinates as an 'artist in Barbarian times', who delivered his counsel 'in the time of Tamerlane' (which would be the fourteenth century)

Following pages:
Fig. 56 *L'Esprit moderne et le catholicisme*, drafted 1897–8 and transcribed in this form 1902. Manuscript with two woodcuts and two transfer drawings on the cover, 32.1 × 17.9 × 2.1 cm, Saint Louis Art Museum, MO

Fig. 57 *Cahier pour Aline*, 1893. Inside front cover with reproduction of Camille Corot's *Italian Woman Playing the Mandolin*, 21.5 × 34 cm. Bibliothèque de l'Institut National d'Histoire de l'Art, Paris, Collections Jacques Doucet, NUM MS 227

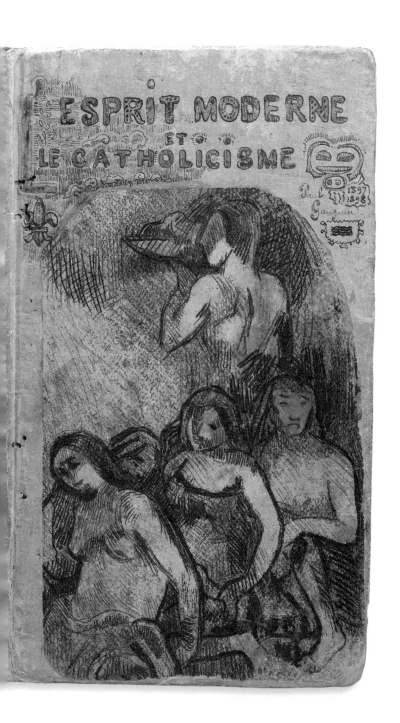

L'ESPRIT MODERNE
ET
LE CATHOLICISME

Paul
Gauguin
1897
1898

(inv. 149.)

'in the year X before or after Christ', adding that the precise date did not matter, since 'precision is often harmful to the dream'.[10]

'Mani' advises painting from the imagination, not the model, using colour harmonies and static poses, and compares inspiration to boiling lava, in a Baudelairean metaphor that recurs in Gauguin's texts.[11] In other words, his ideas are suspiciously close to Gauguin's own. It is now accepted that the 'great professor' was Gauguin himself. What has not been emphasised is how he recycled and reframed his fake treatise, in a manner antithetical to a forger's dependence on consistency. His initial conceit was that it was an extract from an oriental *Livre de métiers* (Book of Crafts), and this is how it was presented when Fénéon published it in *L'Art Moderne* in 1887.[12] But when Gauguin included the credo in *Diverses choses* (and later *Avant et après*) he gave it the more fanciful form of a lecture to disciples, overheard in a wood in the Levant: the reader is invited to join a group of long-haired youths, gathered to hear Mani's words.[13] He also quoted a favourite sentence in his letters and elsewhere, either describing it as 'the Arabic words of Mani the giver of precepts', or simply incorporating it into his own sentences without attribution.[14]

Gauguin may have been amused at the idea of fooling his peers – especially rivals such as Seurat – with his assumed identity, but this was less a serious effort at deception than an experiment with the framing and attribution of text.[15] Writing as 'Mani' enabled him to lend his words the authority of an ancient, oriental perspective, one that added weight – in a playful manner – to the recurrent association that he made between colour and the primitive.[16] In locating Mani's lecture in 'the Levant' and describing him as a 'painter from the East', Gauguin also alluded to another artist whom he had characterised in similar terms: Paul Cézanne. In the letter of 1885 to Pissarro (written around the time of the Zunbul-Zadi hoax) in which Gauguin compared Cézanne's painting to an oriental script, he also described the artist as

possessing the 'mystical nature of the orient' and resembling 'an ancient from the Levant'.[17] This is not to say that Zunbul-Zadi was meant to be Cézanne, exactly, but that the persona of an ancient oriental painter was clearly a fabrication that aligned with a particular image of the artist: one that Gauguin applied to his peers and that would have been recognised by them.[18]

Gauguin's incarnation as Mani represents his most blatant adoption of a pseudonym, but it was not the only occasion on which he recast himself. The manuscript that he dedicated to his daughter in 1893 is known as the *Cahier pour Aline* (Notebook for Aline), but in fact its name has been extrapolated from the dedication on the first page: 'To my daughter, Aline, this notebook is dedicated.' The assumption that the text was conceived for his daughter allows it to be read as private, and fits with the inclination to interpret artists' writings as personal and spontaneous, not written with a view to public consumption. It has led commentators to puzzle over why he might think that his 15-year-old daughter would be interested in his musings on aesthetics, politics and morality, including passages on prostitution, free love and executions. But a dedicatee is not usually a book's unique intended recipient, or even necessarily its ideal reader. It tends to be someone whom the author wants to thank, honour or celebrate, and so the presence of a dedication generally marks a book as public, rather than private.

Nonetheless, the case is complicated because Gauguin originally penned a longer dedication, later discovered during the manuscript's conservation, before obscuring all but the first line with newspaper cuttings (see fig. 6).[19] Asking, 'Will my thoughts be useful to her? No matter, since she loves and respects her father, I will give her a keepsake', and reassuring himself that Aline has a 'sufficiently noble head and heart not to be shocked – corrupted by contact with the devilish mind that nature has given me', these words do seem to indicate that he expected his daughter to read the volume. His subsequent

decision to conceal the bulk of the dedication might indicate a change of heart about the book's intended audience. And yet, had it originally been destined for Aline's eyes alone, his address would have been in the second person, as in: 'Will my thoughts be useful to *you*?' Instead, it reads more like a public declaration of association, a projection of his own self-image onto her: 'She too is a savage, she will understand me.'[20] Aline operates more as an alter ego for Gauguin than an imagined reader; it is a case of writing *as* her, rather than writing *for* her. This interpretation is suggested by the barely visible phrase that appears at the bottom of the front cover: '*Journal de jeune fille*' ('Diary of a young girl'). Although it has all but disappeared, if the notebook does have a title, then this is it: the Diary *of* a young girl, not the Notebook *for* Aline.[21]

Starting from this premise, the persona of the young girl as surrogate author is further implied by the placement on the inside front cover (fig. 57) of a reproduction of Camille Corot's *Italian Woman Playing the Mandolin* (1865–70), which establishes a youthful female figure at an inaugural position in relation to the text, especially if one compares it to the opening page of *Diverses choses* (fig. 41), where Vincent van Gogh's sketch of his painting of a young Provençal girl, *La Mousmé* (1888), accompanies those same lines with which both books open: 'scattered notes, without sequence like Dreams, like life all made up of fragments'.[22]

Gauguin adopted a feminine persona on other occasions, as when he attributed his self-portrait sketch in *Diverses choses* to 'my *vahine* Pahura' (see fig. 9), or signed his painting *Still Life: Fête Gloanec* (1888) as 'Madeleine B.', in reference to the younger sister of his fellow artist Émile Bernard, reportedly so as to justify its crude technique, when offering it to the owner of the guest house where he was staying in Pont-Aven that year, by passing it off as the work of an amateur.[23] In these instances, Gauguin aligns his putative female authorship with forms of creativity that were associated with young womanhood: amateur painting or – in the case of the scrapbook format of *Cahier pour Aline* – album-making.[24]

Additionally, in the opening issue of *Le Sourire*, Gauguin assumed the identity of a female theatre critic. In a review of a one-act play by a Tahitian author, he wrote: 'I must confess that I am a woman, and that I am always prepared to applaud when I see another woman who is bolder than I fighting for equivalent moral freedoms to men.'[25] In the voice of the female reviewer, he goes on to describe how Anna, the play's protagonist, believes in friendship and sexual freedom, but mocks romantic love and marriage. Wishing to dissuade her naive suitor from his insistence on marriage, she confesses to having had a sexual relationship with her father, the one true love of her life; the play closes as her would-be fiancé dies of shock at this revelation. The review ends with a call to arms, entreating men to help liberate women, body and soul, from the enslavement and prostitution of marriage, since 'we women don't have the strength to free ourselves' ('*nous autres femmes nous n'avons pas la force de nous libérer nous même[s]*'). It is signed 'Paretenia' – Tahitian for Virgin. At the base of the page (fig. 58), underneath the 'Paretenia' byline, is a sketch of a puppet theatre and, alongside, one of customers rushing to buy Gauguin's newspaper, with the caption 'Hurry, hurry, let's go and find *Le Sourire*' ('*Vite, vite, allons chercher le Sourire*').[26] Via the Guignol, an emblem for his own satirical broadsheet, Gauguin affiliates his publication with the subversive morality of the (probably fictional) Polynesian play.

In another copy of the same issue of *Le Sourire*, Gauguin replaced the sketch of the Guignol with one of his monstrous alter ego, *Oviri* (meaning 'savage' in Tahitian), a ceramic made in 1894 (fig. 59) and

Following pages:
Fig. 58 *Le Sourire*, August 1899. Mimeograph. 37.2 × 24.1 (each sheet). Musée du quai Branly – Jacques Chirac, Paris, 75.1056.1-2 IA
Fig. 59 *Oviri*, 1894. Stoneware and glaze, 75 × 19 × 27 cm. Musée d'Orsay, Paris, OAO1114

Fig. 60 Original issue of *Le Sourire: Journal sérieux*, August 1899. Musée d'Orsay (held at the Musée du Louvre), Paris, RF28844-recto

GAUGUIN'S AVATARS

seul sanctifié par l'anneau sacramentel. Ah mais cela devient grave et
Anna Demono qui est une fille sérieuse et dévouée cherche à ouvrir les yeux
de son amoureux, s'anime au feu de la discussion au point de livrer son
secret. Ah mais cela devient très grave. Anna Demono raconte son
existence seule avec son père dans un endroit sauvage des montagnes
de la Catalogne. Son père son créateur devenu son amant son maître
Cet anneau criminel. Oh elle était douce à mon bras. L'enfer soit, mais
au bras de mon père Demono, le seul ange qui a eu mon âme, mais
son âme à lui ̃ âme d'airain était forgée par le marteau d'un Titan
Amour qui brûle sans tourments. Et le Monstre étreignant sa créature
féconde de sa semence des flancs généreux pour engendrer Seraphitus
Seraphita. Anna Demono pourrait parler longtemps mais son ami
ne l'entend plus. Il est mort vaincu brisé au choc de l'ouragan.

Le rideau se baisse et la foule surprise est en fureur vomit l'injure
contre Demono contre sa fille l'Immorale. Ah ce bon public vertueux
en masse, immonde seul dans l'alcôve. Je n'en veux rien dire
Survient le régisseur. Automatiquement il salue à gauche à droite
Messieurs et mesdames, transmissez vous Demono n'a certes pas le vrai
père d'Anna mais il a emporté son secret en mourant
Le bon public se tait apaisé, sa morale est sauve. Ah ce bon public
niot qu'on conduit avec quelques mots. Je n'en veux rien dire.
Bravo Demono Bravo cet auteur sauvage voilà qui est bien penser,
un seul acte. net décisif rien d'oiseux, un régisseur en une minute en
quelques mots nous donne la clef. Certes vous autres femmes nous n'avons pas
la force de nous libérer nous même de cet esclavage de notre chair de tra-
dition judaïque, source de prostitution. Voyons messieurs un bon mouve-
ment. libérez vous du mariage, nous applaudirons toutes sûres désormais
de pouvoir aimer sans nous prostituer, libres de notre corps de notre âme
russe. Mais surtout n'oubliez pas d'aller à Borabora voir jouer
l'Immorale au grand théâtre national rue de la petite Russie.
— Parténica —

Vite vite allons chercher le Souvrac.

Lecteurs! Excusez l'impression

pas du tout
pas du tout exercé
pas du tout

Paul Gauguin

Guignol

Souriez
Médor

amoureux, s'anime au feu de la discussion au point de livrer son secret.
Ah! mais cela devient très grave — Anna Demonio raconte son
existence seule avec son père dans un endroit sauvage des montagnes
de la Catalogne; son père, son créateur, devenu son amant, son maître.

« Cet amour criminel, — dit-elle — était doux à mon bras
L'enfer,. Soit; mais au bras de mon père Demonio, le seul ange
qui a eu mon âme; mais son âme à lui, âme d'airain, était
forgée par le marteau d'un Titan — amour qui brûle sans tourner.
Et le Monstre étreignant sa créature féconde de sa semence des
flancs généreux pour engendrer Seraphitus et Seraphita.
Anna Demonio pourrait parler longtemps mais son ami ne l'entend
plus; il est mort — vaincu, brisé au choc de l'ouragan.

Le rideau se baisse et la foule surprise est en fureur,
vomit l'injure contre Demonio, contre sa fille l'Immorale
Ce bon public vertueux en masse, immonde seul dans l'alcôve.
Je n'en veux rien dire.

Survient le régisseur. — automatiquement il salue à gauche, à droite.
Mrs et Mdames tranquillisez vous, Demonio n'est pas le vrai père
d'Anna, mais il a emporté son secret dans la tombe »
Le bon public se tait apaisé, la Morale est sauve — Ah! ce bon public
idiot qu'on conduit avec quelques mots!! Je n'en veux rien dire —

Bravo! Demonio — Bravo cet auteur sauvage; voilà qui est bien
pensé; un seul acte, net, décisif, rien d'obscur; un régisseur en
une minute en quelques mots nous donne la clef.

Certes nous autres femmes nous n'avons
pas la force de nous libérer nous même de cet
esclavage de notre chair, de tradition Judaïque,
source de prostitution, Alors voyons Messieurs
un bon mouvement libérez nous du mariage, no
applaudissons toutes, sûres désormais de pouvoir
aimer sans nous prostituer, libres de notre
corps, de notre âme aussi —
Mais surtout n'oubliez pas d'aller à
Bora Bora voir jouer l'Immorale; au
grand théâtre national rue de la
petite Russie —

— Paul Gauguin

Et le Monstre étreignant sa créature féconde de sa semence
des flancs généreux pour engendrer Seraphitus Seraphita —

Tahiti

Numéro original spécial.

Dédié à Mr Cardella

Paul Gauguin
août 1891

SOURIRES

Journal Sérieux.

Tant de délassement personnel, tant de classement d'idées aimées, quoique folles Peut-être, je rédige le Sourire. Informes et indécis à l'œil proche, ces écrits au recul et à l'examen deviendront précis si vous le voulez. Je ne vous dirai pas la vérité tout le monde se vante de la dire ; la Fable seule indiquera ma pensée si toutefois Rêver est Penser : maintes fois aussi un dessin, quelques traits seulement. (Hommes graves, souriez,)

Ici le titre vous y invite

Farine de Coco -

Que penser quand on attend chez le Chinois son cheval qui a du fer aux pattes ; que fais sinon de regarder chez le voisin son troupeau d'oies : comme un troupeau d'électeurs, elles s'en vont dodelinant de la tête inclinant leur regard et se disant : chez qui allons nous ; chez Goupil ou chez Cardella traîtreusement j'arrache une plume qui sera bouillie et taillée afin d'avoir toujours une plume arme perfide — On dit que l'Esprit vivifie quelle erreur ; il tue - Potins de la rue significatifs quelquefois annoncent d'oreille en oreille portant de l'une à l'autre leur haleine fétide. J'écoute et cela me distrait, m'intéresse : Dimanche s'annonce un grand jour : il s'agit de l'inauguration du chemin de fer de Papeete à Mataïea créé par un homme bienfaisant : Seuls les gens de la Haute inaugureront, tandisque la foule, pas de Ruit pas de Quant - N'importe, je vais réclamer ma carte de reporter et chose extraordinaire, je l'obtiens.

Dès le matin de ce jour fameux, la journée se devine toute belle malgré une marée exceptionnelle : la mer montait tellement qu'un peu plus elle envahissait les navires en rade et par suite les aurait fait couler ; Il n'en a été rien heureusement, mais revenons à notre sujet au lieu de nous égarer dans des faits divers dignes tout au plus du Figaro — à Villemessant -

Or donc, par conséquent, subséquemment comme dirait le brigadier, je pris le train, sans bagages mais élégant et fin ; pantalon roulé de bicue, gilet d'astrakan et un veston

reprised multiple times in graphic works. He accompanied the sketch with a sentence that also appears in the theatre review (as it does in the other copy of this issue), and which evokes Honoré de Balzac's novel of 1834, *Séraphîta*: 'And the monster, grasping his creature, fertilises those generous flanks with its seed to engender Seraphitus Seraphita' (fig. 60).[27] By linking *Oviri* with the protagonist of Balzac's novel, the androgyne Séraphîta-Séraphitüs, Gauguin confirmed the ambiguous gender of his ceramic, which he both identified as female, on one occasion calling it '*La Tueuse*' ('The Murderess'), and associated with himself.[28] That *Oviri* was intended to be a personification of his own savage self-image is made explicit in *Self-portrait 'Oviri'* (1894–5, fig. 61), a

bas-relief in plaster, where the word is inscribed above Gauguin's own likeness and accompanies, as on the ceramic, his 'PGo' monogram.

In the copy of *Le Sourire* in which the *Oviri* sketch appears, Gauguin signed the theatre review not as Paretenia, but with his own name (these alterations are another instance of his interest in activating the tension between the unique and the multiple, to which I shall return). The substitutability of the bylines across the two copies of the same issue clearly establishes Paretenia as an equivalent alter ego to *Oviri*, both of which enabled Gauguin to try out a female identity with primitive associations. Gauguin's advocacy of women's rights in this section of *Le Sourire* aligns with other statements that he

Fig. 61 *Self-portrait 'Oviri'*, 1894–5. Painted plaster, 35.5 × 34 cm. Whereabouts unknown

made on the subject of women's emancipation, notably in *L'Esprit moderne*, and as such his role play implies a genuine challenge to the restrictions of gendered identity.[29] Elsewhere, however, his comments on women's creativity, for instance, are stereotypically denigratory, and in this respect his female impersonations take on the air of a superficial performance, one designed to titillate rather than fundamentally to unsettle basic assumptions about femininity.[30] There are limits, in other words, to the subversiveness of Gauguin's self-conscious play with gender, and I emphasise instead its strategic value for his writing. His feminine proxies aided his artful construction of a particular literary identity. Aline, Madeleine, Paretenia and *Oviri* – each either youthfully innocent or 'wild' – served to represent the childlike authorial voice of which Gauguin boasted, and which is conjured by his repetitive, unstructured style.

Gauguin also employed another pseudonym in *Le Sourire*: although all of the journal's content was written by him, the majority of the articles are signed with the scabrous moniker 'Tit-Oïl', while for the remainder Gauguin signs as himself. Mostly, Tit-Oïl engages in the main task of taking down the governor and his cronies, but on a couple of occasions he indulges in autobiographical reminiscences, and both of these entail displays of masculine bravado. 'Tit-Oïl's first incarnation' ('Première incarnation de Tit-Oïl'), as the piece is titled, in which he specifically identifies himself as a Frenchman, describes him beating a group of Americans at a billiards game in New York, remaining calm and collected as he deftly annihilates his moneyed opponents.[31] In the 'Second incarnation' ('Deuxième incarnation') he is a circus ringleader and he and his wife are 'also wild animals' ('*des fauves aussi*').[32] These tales fit with Gauguin's propensity for self-aggrandisement, if not the precise factual details of his life history, but the image of macho nationalism that they present is so caricatured that it is tempting to see them as parodic.

In its coarse sexual allusions, Tit-Oïl, which evokes a Tahitian expletive, belongs with PGo, pronounced 'pego' (meaning 'prick'), which appears, reduced to a decorative cipher, as a woodcut monogram (see fig. 58) on several issues of *Le Sourire*. Both are emblems of Gauguin in the mode of 'rough sailor' or renegade journalist.[33] By endowing Tit-Oïl with a mock biography, Gauguin brings him to life, turning him into a character rather than simply a mask to hide behind. Instead of disguising his identity (after all, no one was fooled), the pseudonym allows him to project an alternative primitive persona – not the *ingénue* this time, but the gutsy reporter whose 'stripped down' and 'frequently shocking' language befits his uncompromising insights.[34]

Writing as a journalist was also another way, for Gauguin, of writing as an artist, for he stressed that both used a secretive code that could only be understood by those in the know. If painting is a 'parabolic language' ('*langage parabolique*') that becomes absurd when 'interpreted by the critics literally' ('*traduit par la critique littéralement*'), then likewise as a reporter he relies on a form of expression that is cryptic and oblique: 'It's not an easy business being a journalist, I can tell you – having to eat your words ten times before you speak.'[35] The first issue of *Le Sourire* opens with a warning not to interpret its contents literally: 'I will not tell you the truth, everyone brags about telling it. Fables alone will indicate what I am thinking, if indeed to dream is to think.'[36]

One such 'fable' is introduced as an 'anecdote translated from the Greek'. It recounts the adventures of 'the beautiful Toutoua' ('*la belle Toutoua*') and her lover, an anthropomorphised insect whom she squashes under her weight following a night of passion, and who is revived by the local pharmacist with a shot of insecticide. This is accompanied by a warning about the reliability of the translator, and in place of the byline is the phrase 'translation without government guarantee' ('*traduction sans g d g.* [*sans garantie du gouvernement*])', indicating that the tale is a grotesque caricature of Gauguin's enemies in the colonial administration, although his precise targets are obscure.[37] The framing of the episode connects

it to Gauguin's Zunbul-Zadi ruse. It is said to have taken place 'in the year X of the dynasty of Ramses' ('*En l'an X de la dynastie Ramsès*'), and concludes with the same formula as his fictional treatise: 'In the year X of the 18th Dynasty of Ramses all this took place' ('*En l'an X de la 18ème Dynastie Ramsès tout ceci se passa*').[38] As this link to his earlier writing suggests, in inhabiting the role of scandalmongering journalist, Gauguin was not only making what is typically seen as an ill-advised detour into local politics; he was also developing themes in which he had a longstanding interest, including caricature, the formation of identity, and the cultivation of a primitive authorial voice.

'How I Became a Journalist'

In an episode of *Avant et après*, Gauguin recounts his disillusionment with the inescapable presence of the colonial administration: there is no shelter from these 'evil people', he declares, not even on the 'island of Doctor Moreau' or on 'planet Mars'. The creep of civilisation is so pervasive that if one were to land on a deserted island not yet marked on the map, one would inevitably find it already populated by 'a governor, a sheriff's officer, and a dealer in tobacco and postage stamps'. In a fantastical anecdote he portrays Tahiti as merely a replica of France: he describes how, at a kiosk in the town square of Papeete, he distractedly requests a ticket for the Madeleine–Bastille omnibus, only to find at the end of the journey that he has arrived not at the Paris landmark, but back where he began, in Tahiti![39] Should a similar misfortune ever befall the reader – relocating to an exotic land in the hopes of escaping civilisation, only to find it replicated there – it would be wise, he warns, to avoid coming into contact with the French public prosecutor, or 'as happened to me, you will get burned'. Although he does not explain what happened, he implies that it was an altercation with the authorities that pushed him to take up the pen: 'And that is how I became a journalist, a polemicist if you like.'[40]

Most scholars follow Gauguin's own lead in attributing his new occupation to a personal grievance that got out of control.[41] Fleshing out the detail of the quarrel to which Gauguin alludes, Bengt Danielsson and Patrick O'Reilly explain that the artist was frustrated at the public prosecutor Édouard Charlier's refusal to investigate a series of thefts from his home in the Papeete suburb of Punaauia. After several unsuccessful attempts to persuade Charlier to pursue the matter (Gauguin's girlfriend, Pau'ura, had already been acquitted on appeal), he wrote a long letter detailing his complaint. Instead of sending it directly to Charlier, he took the opportunity to air his disgruntlement more widely by publishing his letter in the June 1899 issue of the recently launched monthly newspaper *Les Guêpes*.[42] It was thus by happenstance, Danielsson and O'Reilly suggest, that Gauguin's career as a journalist was born.[43]

However, since Gauguin was the author of two further articles in this same issue, his decision to publish in *Les Guêpes* must have been planned rather than merely opportunistic. In the first of these, 'Le Champignon parasol de Sumatra', in which Gauguin uses his Tit-Oïl pseudonym for the first time, he compares Tahiti's governor, Gustave Gallet, to a 'monstrous toad' encountered by the author during his visit to the London Zoo. There, the toad is sheltering under a 'three-tiered white helmet', which the guard identifies as 'the famous parasol mushroom of Sumatra' (evoking both a poisonous mushroom and a Rafflesia, a gigantic, foul-smelling and parasitic Indonesian flower).[44] The helmet is familiar from caricatures by Gauguin, where it appears as a symbol of the governor, to whom the toad 'bears a remarkable resemblance'. Tit-Oïl informs the reader that the French Minister of the Interior is intending to offer a similar odious creature to the inhabitants of Tahiti, but the impoverished colony cannot afford to house and maintain it. Instead, he proposes – in an allusion to Gallet's previous career in the penal colony of New Caledonia – it should be sent to Nouméa to 'do penance' in the penitentiary.[45]

In the second piece, which Gauguin signs with his own name, he reflects on 'two contrasting agents of colonialism': the poet Arthur Rimbaud (1854–1891), whose death he had learned of belatedly, and Major Jean-Baptiste Marchand, a key player in recent territorial disputes between France and Britain in Eastern Africa. Gauguin presents Rimbaud's efforts at commerce and diplomacy (he traded in coffee and second-hand guns in Ethiopia) as bringing 'industry' and 'dignity' to Africa, whereas Marchand is only motivated by military glory and territorial acquisitions. In celebrating the war hero over the poet, society has misunderstood the true meaning of colonialism, Gauguin claims, which is 'to cultivate a region, to make a hitherto uncultivated country produce things which are useful primarily to the people who inhabit it; a noble goal', and not to 'conquer that country, raise a flag over it, set up a parasitical administration ... by and for the glory of the mother country alone', which is 'shameful'.[46]

Together, Gauguin's open letter, burlesque sketch and rumination on colonialism give an indication of his flair for satirical commentary. The editors of *Les Guêpes* did not just seize on the opportunity, presented by Gauguin's spat with Charlier, to publish an attack on one of their political opponents; they purposefully engaged Gauguin *as a writer*. He, in turn, was not driven by personal grievance alone, but was also inspired by the prospect of becoming a 'journalist'. In their indispensable compendium of Gauguin's articles for *Les Guêpes*, Danielsson and O'Reilly set out to dispel the myth that the artist was a political agitator on behalf of the Indigenous population, and show him instead to have been a mere mouthpiece for the journal's owners: François Cardella, Tahiti's mayor (since 1890, when it acquired municipal status), and the wealthy plantation owner Victor Raoulx. As his piece on Rimbaud shows, on the pages of *Les Guêpes*, at least, Gauguin did not oppose colonialism or civilisation as such. He merely targeted certain factions of its representatives: namely those aligned with the Protestant party – one of two warring parties in the *Conseil général* that had been established in Tahiti in 1885 – and the colonial governors and high-level administrators from France stationed temporarily on the island, at great expense, Gauguin complained, to the tax-paying settler, and with little interest in their welfare.[47]

It was the community of French settlers, mostly *petit bourgeois* in origin and occupation, not primarily the Indigenous population, whom Gauguin defended against these career politicians and colonial functionaries.[48] Gauguin's employers at *Les Guêpes* belonged to the Catholic party, so-called because it represented the interests of Tahiti's small French settler community. Its rival, the Protestant party, was affiliated with Tahiti's Anglo-Polynesian commercial and social elite. Long before Tahiti became a French protectorate in 1842, Protestant missionaries from the London Missionary Society had successfully converted much of the population, and the continuation of their influence was assured when the *Société des missions évangeliques de Paris* sent French Protestant missionaries to replace them in 1867, at the request of the Polynesians. British missionaries, and British, German and American migrants, had established successful commercial ventures and powerful alliances with the Tahitian royal family, and the descendants of intermarriages between these groups dominated cultural and commercial life on the island. From the perspective of the French settlers, the Paris administration did little to challenge the supremacy of the Protestants or the Anglo-Polynesian elite.[49]

Since 1890, Mayor Cardella's Catholic party had controlled the *Conseil général*, but in 1899, with the support of Paris, Governor Gallet introduced changes to the voting laws that ensured the balance of power shifted in favour of the Protestants, thus fuelling the vitriol directed in *Les Guêpes* against the governor and his cronies.[50] It was into this provincial political fray that Gauguin entered when he joined the editorial team of *Les Guêpes*. He might not have been motivated by any strong ideological allegiances, only by an anti-authoritarian inclination, coupled with

resentment at his own exclusion from polite society (in 1892 his application for the post of magistrate on the Marquesas Islands was rejected and in 1898 he failed to secure the position of Secretary-Treasurer of the Agricultural Bank).[51] Nonetheless, he toed the party line, albeit with a hearty dose of cynicism. As he later put in *Avant et après*,

A newspaper in Tahiti that was not political would not be respectable. Elections in Tahiti are the equivalent of Picpus [referring to the Catholic Congregation of the Sacred Hearts of Jesus and Mary, named after their original location in Rue de Picpus in Paris] against the bear of Bern [an emblem of Prostestantism]. And so

here I am (who would have thought it!), turned into a Picpus so as not to be Swiss. ... Never, never in my life, not even when I made my first communion, was I so ardent a Catholic, and with good reason.[52]

Gauguin's are not the complaints of the religious ideologue, but the gripes of the *petit colon*, disregarded by the upper echelons of imperial bureaucracy, and under threat from competing interest groups. In his open letter to Charlier, Gauguin insists on his right, as a tax-paying settler, to the full support of the French authorities, and accuses the prosecutor of being in cahoots with the Tahitian chiefs in turning a blind eye to robberies by the Indigenous

Fig. 62 *Père Paillard*, 1902. Painted miro wood, 67.9 x 18 x 20.7 cm. National Gallery of Art, Washington, DC, Chester Dale Collection

population: 'How can settlers continue to feel safe in this district, subject as they are to the obvious bias of native chiefs, and your arbitrary and autocratic rulings?'[53] His outrage at the authorities leads him not (in *Les Guêpes*, at least) to a wholesale critique of imperialism, but to the contradictory conclusion, in the article on Rimbaud, that 'colonial politics is the enemy of colonisation'.[54] In the most egregious example of his loyalty to French settler interests in *Les Guêpes*, he published the text of a speech that he made on the occasion of a rally organised by the Catholic party to protest against Chinese immigration. Whether he meant what he said or was currying favour with his employers, the language of his attack is vilely racist, and conforms to the widespread anti-Chinese sentiment among the French colonial community, for whom the Chinese were major rivals in the small business sector. Complaining, repulsively, of 'a yellow blot on our country's flag', Gauguin hypocritically denounced the racial mixing of the Tahitians and Chinese, and opened his speech by noting his pride in his French identity and his allegiance to the metropole.[55]

Danielsson's and O'Reilly's verdict that Gauguin did not mount a campaign on behalf of the Tahitians in *Les Guêpes* is therefore correct, even if he did defend Indigenous interests later, in the Marquesas Islands, not always with obvious benefit to himself.[56] But their lament that 'such a brilliant artist wasted two precious years on such futilities' creates a false divide between the sanctified realm of Gauguin's art and the sordid truth of his life behind the scenes.[57] Gauguin was not only a painter of idyllic Tahitian landscapes, but also a carver of phallic sculptures lampooning figures of authority, such as *Père Paillard* (*Father Lechery*, 1902, fig. 62), a devilish, praying horned figure intended to ridicule Atuona's Catholic bishop Joseph Martin. Crude puns and

cruel physiognomies were part of his arsenal from the early days of his artistic career, and he was not beyond mocking himself. To dismiss his journalism as a regrettable interlude is to overlook its importance to his sense of identity as an artist-writer, and its significance to his artistic practice more broadly.

The fact that Gauguin narrated his debut as a reporter in *Avant et après*, a book that he described as 'a means of making myself known and understood' indicates the importance of this activity to his public image.[58] He not only wrote at least 25 pieces for the journal over the course of two years, but also acted as its editor-in-chief from February 1900 until August 1901, shortly before he departed for the Marquesas. Alongside the biting allegorical style that he adopted, there are other indications of a literary ambition that went beyond the routine task of political slander. In addition to his Tit-Oïl pen name, on one occasion Gauguin used the alias 'Noanoa' as the byline for two extracts – collectively titled 'Terre délicieuse' (Delicious earth) – from the version of *Noa Noa* that he wrote in collaboration with Charles Morice, thus using the journal as a forum for publicising his other writing projects.[59] Among these is his own spin-off newspaper, which is promoted in *Les Guêpes* in a brief announcement reminding subscribers that 'M. Gauguin's journal, the "smile" comes out each month at the same time as the "wasps" and can be purchased from [the publisher] M. Coulon'.[60]

LE SOURIRE: 'WICKED NEWSPAPER'

Les Guêpes, then, was also the impetus for a simultaneous project that was considerably more complex and ambitious: Gauguin's own, illustrated newspaper, *Le Sourire*.[61] Its nine issues (August 1899 – April 1900) similarly consist primarily of satirical

Following pages:
Fig. 63 *Le Sourire*, 1899–1900 (this version 1901). Masthead. Textile binding with woodcut plates, 40.6 × 29.2 × 0.4 cm (closed). Houghton Library, Harvard University, Cambridge, MA, MS Typ 611

Fig. 64 *Le Sourire*, 1899–1900 (this version 1901). Masthead. Textile binding with woodcut plates and manuscript dedication, 40.6 × 29.2 × 0.4 cm (closed). Houghton Library, Harvard University, Cambridge, MA, MS Typ 611

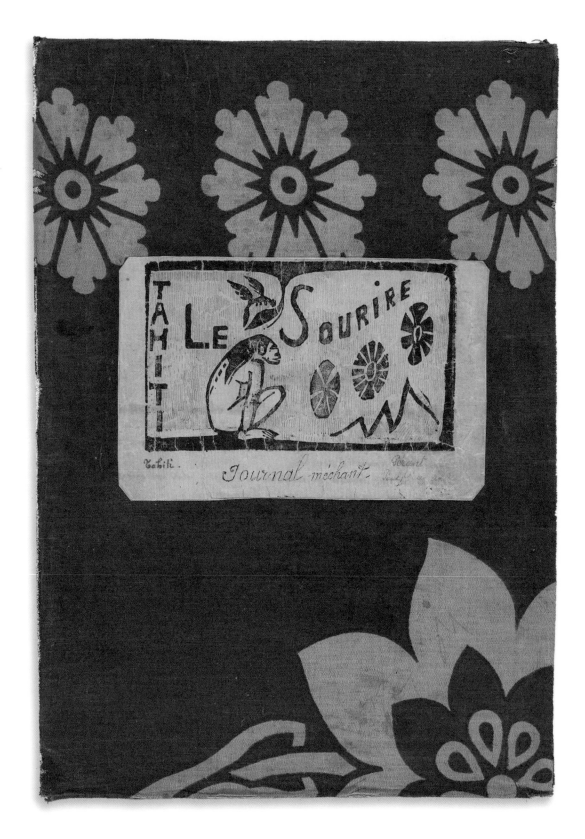

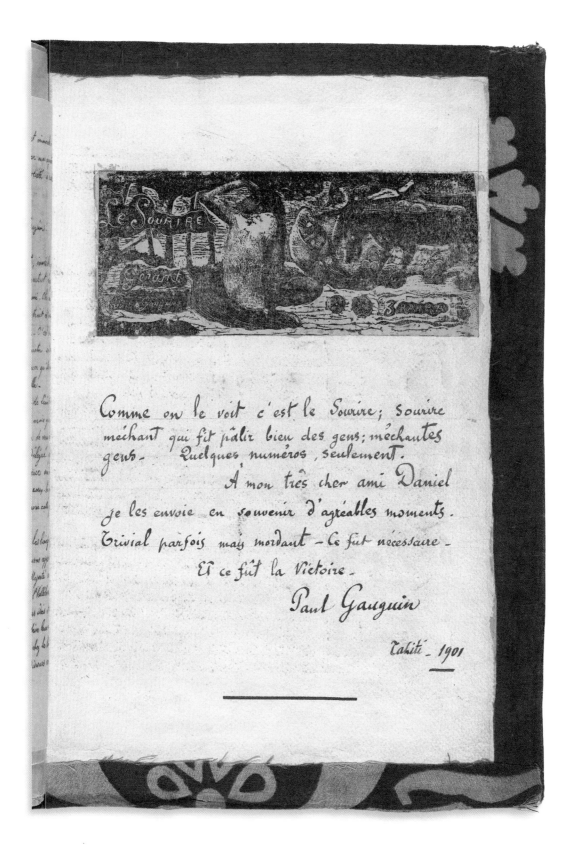

Comme on le voit c'est le Sourire; sourire
méchant qui fit pâlir bien des gens; méchantes
gens. Quelques numéros, seulement.

 À mon très cher ami Daniel
je les envoie en souvenir d'agréables moments.
Trivial parfois mais mordant – Ce fut nécessaire –
Et ce fût la Victoire –

 Paul Gauguin

 Tahiti – 1901

attacks on the venality and hypocrisy of colonial officials, often overlapping with topics covered in *Les Guêpes*. But *Le Sourire*, more diverse in its content, reaches beyond the circumscribed world of local infighting by virtue of its textual overlaps with Gauguin's other writings, the relationship of its illustrations to his graphic oeuvre more broadly, and its relevance to the wider context of interactions between literature and journalism, caricature and the satirical press in nineteenth-century France.

In December 1899, Gauguin described to De Monfreid how his career as an agent-provocateur was taking off:

Now, having gotten myself started, I have become a journalist and, truly, I did not think I had so much imagination; I am really pretty good at it. I will send you the entire series sometime. For I have founded a paper – "Le sourire", which I multigraph by the Edison system. It has made a great hit, but unfortunately it is passed from hand to hand and I don't sell many copies.[62]

Gauguin's investment in this new literary identity is apparent from the self-consciousness of this statement, as well as the care that he took in sending the journal to De Monfreid a couple of years later. In 1901 he copied out five issues by hand (comprising the content of the first six of the original issues), mimeographed the remaining three, and bound the collection in a patterned Tahitian cloth. On the cover, he pasted a woodcut (fig. 63), on which the newspapers's title, its epithet 'Wicked newspaper' ('*Journal méchant*'), his own name and identity as

'manager' ('*gérant*'), and its location, Tahiti, are all inscribed. A dedication on the inner back cover, in which Gauguin describes the contents as 'trivial sometimes, but biting' ('*trivial parfois, mais mordant*'), appears beneath another of the newspaper's woodcut mastheads (fig. 64). Listed on the inside front cover is a cast of characters (the villains of the piece), indicating Gauguin's desire to make his often-cryptic attacks more comprehensible to his European colleague.[63]

Gauguin's careful preparation of this collection for De Monfreid indicates a desire to extend the influence of his newspaper beyond its '21 readers' in Tahiti, and makes clear the attention he paid to its fabrication.[64] In the first issue, a line at the top of the second page proudly announces it as 'Tahiti's only illustrated newspaper' ('*le seul journal illustré de Tahiti*'), and it does differ in that respect from the few other newspapers, including *Les Guêpes*, that circulated in the colony.[65] It has more in common with the illustrated periodical press that burgeoned in France from the mid-nineteenth century, such as *Le Charivari* (1832–1937) or *Le Rire* (1894–1971), to name just two, with the crucial difference that in place of letterpress text and fine, detailed lithographs or chromotypographs, Gauguin used a technique that was both innovative and basic to reproduce his own handwriting and caricatural sketches.[66] Each issue consists of four pages, formed of a single sheet of fairly flimsy paper on which the writing and illustrations were printed using a mimeograph machine. This method produced small and progressively faded print runs by forcing

Fig. 65 *Le Sourire*, 1899. Masthead: *Three People, a Mask, a Fox and a Bird*. Woodblock print in black ink on thin ivory laid Japanese paper, 10 × 18.6 cm (image), 12.7 × 22.8 cm (sheet). The Art Institute of Chicago
Fig. 66 *Le Sourire*, 1899–1900. Masthead: *Tahitian Woman* (only state). Woodblock print in black ink on thin ivory laid Japanese paper, 10.4 × 18.7 cm (image), 12 × 20.1 cm (sheet). The Art Institute of Chicago

Following pages:
Fig. 67 *Le Sourire: Journal sérieux*, November 1899. PGO monogram (only state). Title block (only state). Masthead: *Three People, a Mask, a Fox and a Bird* (only state). Mimeograph in brownish-black ink, with woodblock prints in black ink on cream wove paper, 39.7 × 51.3 cm (full sheet), 39.7 × 25.6 cm (folded sheet). The Art Institute of Chicago
Fig. 68 *Le Sourire: Journal sérieux*, November 1899. Title block (only state). Masthead: *A Pig, a Dwarf, Flowers and Leaves* (only state). Mimeograph in brownish-black ink, with woodblock prints in black ink on cream wove paper, 39.7 × 51.3 cm (full sheet), 39.7 × 25.6 cm (folded sheet). The Art Institute of Chicago

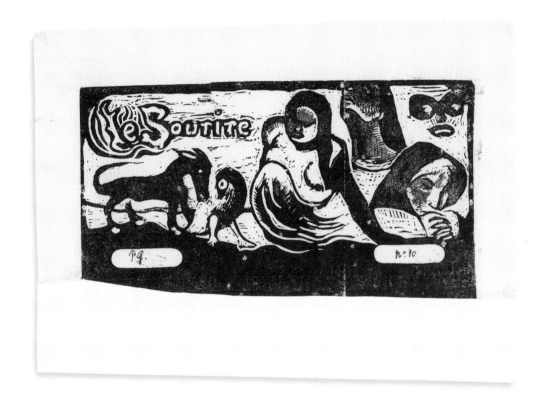

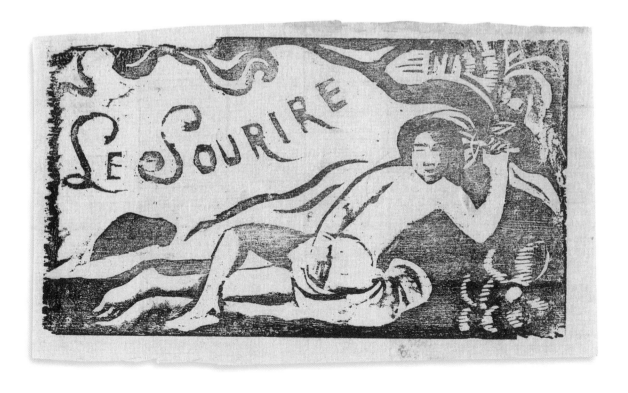

GAUGUIN'S AVATARS

Gérant Paul Gauguin

Journal Sérieux
Gérant Paul Gauguin — Novembre.

Critique littéraire — Alfred Jarry est un esprit curieux;
On joua de lui au théâtre de l'Oeuvre une petite pièce
intitulée Ubu Roi.

Ubu roi est un sale cloporte qui à la queue de ses sujets part en guerre, toujours prêt
à répliques extravagantes; Je ne dirai pas que la pièce fit fureur, mais elle fit horreur
car on ne voit pas avec plaisir la race à laquelle on appartient, bafouée, ravalée
à ce point. Néanmoins un type nouveau venait d'être créé.
Un homme politique quelconque se montre-t-il sous un aspect foireux et vil; on dit
c'est un Ubu. — Un procureur, quelconque aussi, qui entre seulement avec son
mouchoir les crachats qu'on dépose sur son museau, et dont les pantalons servent de
pissotière à tous ceux qui lèvent la cuisse = c'est un Ubu. Tout homme qui dans
son ménage sert sa femme de vadrouille pour essuyer les vases de nuit; C'est un Ubu.
En principe tout homme qui bête immonde souligne le dégoût est un cloporte qui fait
Couic quand on met le pied dessus; C'est un Ubu.
Désormais Ubu apparaîtra au rostrum ou de l'Académie; il déchirera les corps humains
qui ont une âme de Cloporte — Remercions Mr Alfred Jarry.

Sapristi quelle course en vélo, et cela sans dérater = Comme Jupiter qui
tourne seize fois plus vite que la Terre. Comme une envie humide Gallet
s'écria un jour qu'il avait le mal du pays, prit le paquebot sans oublier ses
économies, fruit de tant de labeurs à la sueur du peuple.
« Appelez-moi le Trésorier s'écria-t-il et celui-ci arrivé il lui dit « Je suis très pressé,
faites mon compte et n'oubliez pas le cheval de la Colonie = Si par hazard je laisse au
quelque chose à la traîne, voulez-vous l'envoyer à Paris à mon adresse, rue du
Salpingre près la rue du Vide Gousset. Et le Trésorier s'empressa d'obéir (on
a vu comment.
Rien que le temps de prendre 150 bouillons et notre cher Gallet bien aimé se pré-
sentait au pavillon de Flore = « Dès qu'il entre ce cher enfant et aussitôt entré »
Tiens! voilà Mathieu, comment ça va ma vieille, que nous apportes-tu de Bon.
Et Gallet tira de son sac quelques bourdes, quelques niaises —

Peste, s'écria le ministre;
quel trésor, comme ça brille.
— Et Gallet de répondre.

Le Sourire

- Journal Sérieux -
Gérant Paul Gauguin - Novembre.
Critique littéraire - Alfred Jarry est un esprit curieux:
On joua de lui au théâtre de l'Oeuvre, une petite pièce
intitulée Ubu Roi.

Ubu roi est un sale cloporte qui à la queue de ses sujets part en guerre, toujours pris
de tiques extravagantes; Je ne dirai pas que la pièce fit fureur. mais elle fit horreur
car on ne voit pas avec plaisir la race à laquelle on appartient, bafouée, ravalée
à ce point. Néanmoins un type nouveau venait d'être créé.
un homme politique quelconque se montre + il vous un aspect foure x et il ou dit
c'est un Ubu. _ Un procureur, quelconque aussi, qui salive seulement avec soin
montre les crachats qu'on dépose sur son museau, et dont les pantalons tiennent de
primitières à tous ceux qui lèvent la cuisse _ c'est un Ubu. Tout homme qui dans
son ménage sert à sa femme de vadrouille pour emuyer les vases de nuit; c'est un Ubu.
En principe tout homme qui bête immonde soulieve le dégoût est un cloporte qui fait
couac quand on met le pied dessus. C'est un Ubu.
Désormais Ubu appartient au dictionnaire de l'académie: il désignera les corps humains
qui ont une âme de cloporte. Remercions Mr Alfred Jarry.

S'agriti quelle course en vto, et cela sans dérator. Comme Jupiter qui
tourne suiza fois plus vite que la Terre. Comme une envie humide Gallet
s'écria un jour qu'il avait le mal du pays, prit le paquebot sans oublier ses
économies, fruit de tant de labeurs à la sueur du peuple.
" Appelez-moi le Trésorier s'écria t-il et celui-ci arrive il lui dit " Je suis très pressé.
faites mon compte et n'oubly pas le cheval de la Colonie. Si par hasard je laisse
quelque chose à la traine, vouelez me l'envoyer à Paris à mon adresse, rue du
Salpingre près la rue du Vide Gousset. Et le Trésorier s'empressa d'obeir (on
a vu comment.
Rien que le temps de prendre 150 bouillons et notre cher Gallet bien aimé se pré-
sentait au pavillon de Flore _ " Qu'il entre ce cher enfant et aussitôt entré "
Tiens! voilà Mathieu, comment ça va ma vieille, que nous apportes tu de Bon.
Et Gallet tira de son sac quelques bourdes, quelques nacres _

 Peste, s'écria le ministre;
quel trésor, comme ça brille.
 - Et Gallet de répondre.

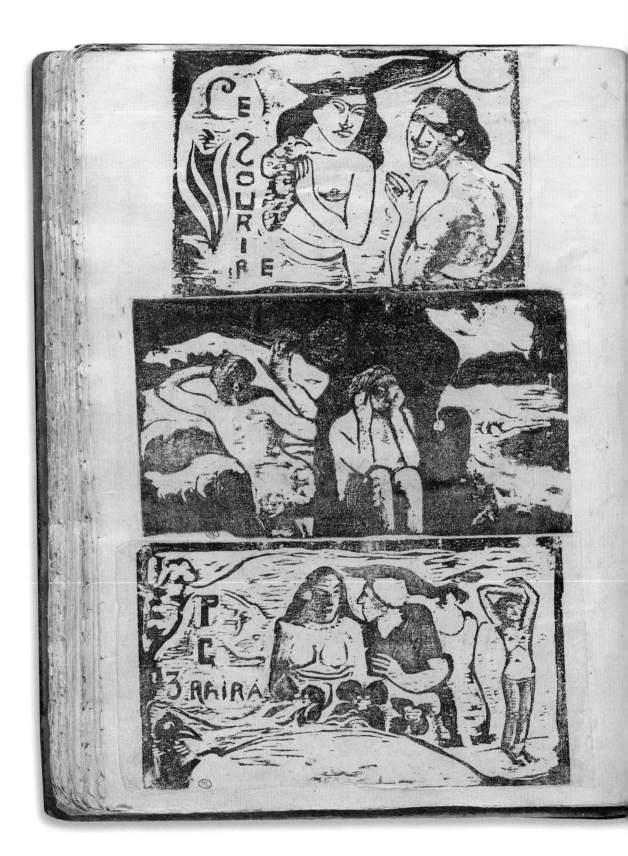

ink onto paper, through a stencil in which holes had been formed by an electric pen, using a flatbed duplicating process.[67] The resulting fragile and rudimentary appearance is in line with the crude, informal tone of the newspaper's content, but also draws attention to the balance of mass-produced and handcrafted effects that is a feature of Gauguin's work in other media.

From the fourth edition of *Le Sourire* onwards, Gauguin largely replaced his sketchy stencilled illustrations with bold woodcuts, principally in the form of masthead decorations, which he printed onto the sheet after mimeographing the text (fig. 55). In the final two issues, the masthead takes up the whole first page: in the one for March 1900 (fig. 1), Governor Gustave Gallet, recognisable by his signature hat, is the '*dindon de la farce*', literally 'turkey', as depicted, but also an idiomatic phrase meaning 'the butt of the joke'. These mastheads also had a life beyond the journal, as independent works of art, some of which he printed on fine paper, and sent to friends in France (compare figs 65 and 67).[68] Of the fifteen known woodcut designs featuring the newspaper's title, nine can be found in extant copies of *Le Sourire*, while the remaining six are known only in independent impressions (see, for example, fig. 66).[69] Gauguin used the mastheads interchangeably for different copies of the same issue (figs 67 and 68) – so that these additional impressions may have been used in other copies of the newspaper that have not survived – and sometimes retouched his mimeographed illustrations in watercolour (see fig. 58), giving individual copies the status of unique works as well as reproductions.

Le Sourire was not a self-contained project, but overlapped with other artistic ventures in which Gauguin experimented with methods of reproduction and combinations of media. These included the late series of woodblock prints known as the Vollard suite

(1898–9), of which Gauguin sent 475 impressions, pulled from 15 blocks, to his French dealer Ambroise Vollard in 1900, and which are similarly executed in a coarse, high-contrast style. On a page of the *Noa Noa* manuscript in the Louvre album, Gauguin pasted two of the *Le Sourire* mastheads on either side of a print from the Vollard suite, thus linking his newspaper (as well as his *Noa Noa* manuscript) to the wider context of his graphic work (fig. 69). In other instances, he adhered the mastheads onto works made using the transfer drawing method that he invented contemporaneously in 1899.[70] One, inscribed '*Cave canis* [sic]' ('beware the dog'; fig. 70), depicts Governor Gallet asleep while a dog with Gauguin's features watches over him, the *Le Sourire* masthead confirming the drawing's mocking intention. Another transfer drawing, *The Consultation* (fig. 71), again depicts the governor, this time as an invalid, his emblematic hat floating above his head. The caption manages to taunt him and to advertise Gauguin's newspapers at the same time, as the doctor prescribes an hourly peppermint enema and a strict diet of *Les Guêpes* and *Le Sourire*.[71]

Gauguin also connects *Le Sourire* with his other writings by using the same words to describe its apparently casual structure. Like both *Diverses choses* and *Avant et après*, he claims it was written 'partly for relaxation, partly to bring together certain favourite ideas'.[72] Many of these ideas are also found elsewhere, especially in *Avant et après*, written a few years later. This book, misleadingly translated as *Gauguin's Intimate Journals*, consists of personal reflections and reminiscences, but resists a linear narrative of developing selfhood, in favour of a jumbled chronology suggested by its actual title, meaning 'Before and after'.[73] The fact that many of its episodes previously appeared in Gauguin's publicly distributed newspaper likewise undermines the conventional privacy of the diary form. In the

Fig. 69 *Noa Noa*, 1894–1901, folio 96 verso (p. 186). Two mastheads for *Le Sourire* and third pasted woodcut, 31.5 × 23.2 cm. Musée d'Orsay (held at the Musée du Louvre), Paris, RF 7259, 1

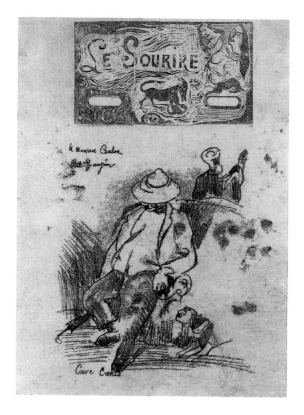

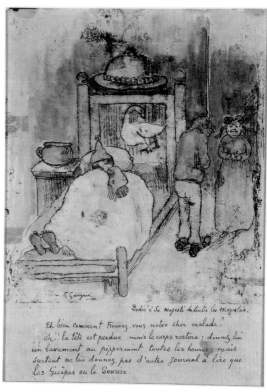

overlapping of these texts, we witness not the private unfolding of a unified identity, but the public dissemination of a fragmented one.

Le Sourire also avoids adopting a coherent perspective by foregrounding shifts in tone and authorship. Issues are variously titled either 'Serious newspaper' ('*Journal sérieux*') or 'Wicked newspaper' ('*Journal méchant*').[74] The blend of the popular and the esoteric that this implies is characteristic of other *fin de siècle* projects, such as *La Dernière Mode*, the fashion journal written and edited in 1874 by the Symbolist poet Stéphane Mallarmé, whose Tuesday *soirées* Gauguin had attended.[75] Like Gauguin with *Le Sourire*, Mallarmé directed and wrote the entire publication under the guise of various pseudonyms, including female monikers such as Miss Satin,

Marguerite de Ponty or, more generically, '*une dame créole*', in what has been called a 'proto-camp document'.[76] Gauguin's attribution of a theatre review to the Tahitian 'Paretenia' is not so different from Mallarmé's offering of a soup recipe by – in an alter ego combining racial classification with artistic allusion – '*Olympe, négresse*'.[77]

In addition to the ancient oriental painter Mani Vehbi-Zunbul-Zadi, the Tahitian woman theatre critic Paretenia, and Tit-Oïl the occasional circus owner, Gauguin also writes 'as an artist'. Although this is the one role to which he could authentically lay claim, it is also a position that he consciously adopted.[78] 'Artist' is an attribute that joins 'Tahitian', 'female' and 'childlike' as a sign of the primitive under which Gauguin writes. Whether autograph Gauguin,

Fig. 70 *Fox, Busts of Two Women, and a Rabbit* (masthead for *Le Sourire*) and *Cave Canis*, 1899–1900. Woodcut and oil transfer drawing, 39.5 × 29.8 cm. Private collection

Fig. 71 *The Consultation*, 1899–1900. Monotype, 28.1 × 19.7 cm. Ackland Art Museum, University of North Carolina at Chapel Hill

attributed quotation, unacknowledged borrowing, false attribution, invented author or pseudonym, all are presented as equivalent, but without the shifts between them being concealed. When Gauguin adopts the voice of a Polynesian woman or an ancient painter of imprecise eastern origin, it allows him to flirt with 'exotic' identities without losing the advantages of his own subject position; but it is also an instance of a wider literary engagement with citation, and anonymous or pseudonymous authorship among writers who challenged literary masculinity through their association with subjects or modes of writing considered feminine.[79] Gauguin's experimentation with authorial identities is not simply a cynical wearing of masks, but a working-through of his own, awkward position as an outsider to both colonial high society and the Indigenous community. It is also an attempt to deal with the paradox of writing as an artist who vociferously resisted literary authority, by exposing the essentially performative nature of the writer's position.

Victor Ségalen

"Durance" – Tahiti

23 Janvier 1903 –

Te Atua. P. Gauguin.

Conclusion

———··········——

WRITING PRIMITIVISM

N 1897, GAUGUIN SENT CHARLES MORICE a brief text and asked him to try to place it in a French journal. It consisted of an imaginary dialogue with an inhabitant of Raiatea, on the occasion of the French government's latest attempt to quell the island's longstanding resistance to French rule. Gauguin explains to his correspondent that France had given the order to open fire after the islanders refused to capitulate. 'You could make a nice newspaper article (the idea seems original to me)', he proposes, 'out of Paul Gauguin interviewing a native before the action begins.' In the script that follows, Gauguin asks, in the guise of the interviewer, 'Why don't you want to be governed by the French laws, the way Tahiti is?', and in the voice of the Raiatean he replies: 'Because we have not sold out, and also because we are very happy governed the way we are, with laws suited to our nature and our land. As soon as you move in somewhere, everything belongs to you, the land and the women ... We would be burdened with taxes which the natives have not the means to pay ... Fines and jail as soon as anyone sings or drinks, and all that so as to give us

so-called virtues that you don't practice yourselves.'[1]

Gauguin's fictional speech constitutes an attack on civilisation worthy of the eighteenth-century French *philosophes*. But it is a coda to an earlier occasion on which his anti-colonial credentials were considerably less secure. In 1895 he accompanied a diplomatic mission, led by Commissioner-General Isidore Chessé, as part of a previous effort to bring Raiatea under French control. Gauguin was the guest of the newly installed governor of Tahiti, Pierre Papinaud (an acquaintance of his loyal friend George-Daniel de Monfreid).[2] Admittedly, Gauguin did express reservations about the mission, commenting cynically on the prospect of violence being used to quash the resistance, in the name of 'civilisation'. But at the same time, he admitted that he was intrigued by the potential spectacle of battle, and happy to profit from the advantageous exchange rate prompted by the crisis.[3] This ambivalence had not completely disappeared by the time he sent his mock interview to Morice in 1897. On the one hand, he was apparently eager to side publicly with the rebels, telling Morice to send him copies of the article once it was published,

Previous:
Fig. 72 Victor Segalen, original manuscript of the *Journal des îles*, first page, with pasted-in fragment of Gauguin's woodcut *Maruru* (*Offerings of Gratitude*, 1893–4). 26 × 20 cm. Département des Manuscrits, Bibliothèque ationale de France, Paris, NAF 25786

since 'I'd like to show a few skunks over here that I've got some clout.'[4] On the other, he continued to curry favour with the French warships' commanders and personnel, persuading them to transport paintings back to France and asking one, the son of a publisher, to help him publish *Noa Noa*.[5]

This episode, like many others that could be cited, encapsulates the uncertainty of Gauguin's opposition to colonialism, and his fragile social status in Tahiti. In this complex colonial society, it was not simply a question of identifying (metaphorically) with either the Polynesians or the French, or even fluctuating in allegiance between these two groups, since both were socially stratified, internally fragmented, and interconnected. To the extent that Gauguin belonged anywhere, it was with other drifters and rebels among the French settlers, but he also formed alliances at times with Indigenous Polynesians and with the higher echelons of the colonial administration.[6] Above all, he thought of himself as an artist, as rising above the common fray, and he was constantly embittered when people did not acknowledge that he was innately superior despite his lack of wealth.[7] Gauguin's shifting authorial personae, I have argued in this book, are symptomatic of his troubled, liminal position. In the Raiatea dialogue, he plays both roles – the Frenchman and the Indigenous islander – but makes no effort to conceal the fiction from Morice.

Gauguin concluded his letter by observing, 'My dear Morice, you can see what a neat interview this could make, the whole thing in the very simple language that a native would use.'[8] As when he told André Fontainas that the style of *Avant et après* 'must be in harmony with the subject, stripped down like the whole man, and frequently shocking', this statement leaves no doubt that his 'primitive' voice is staged for a French literary audience.[9] His declared attempt to employ a literary idiom suited to his subject is equivalent to claims that he made for his visual art, as when he said of *Manaò tupapaú* (*Spirit of the Dead Watching*, 1892, fig. 21) that 'the painting has to be done very simply, since the motif is savage, childlike'.[10]

Morice did publish Gauguin's fictional dialogue that same year, but without the fanfare that the artist hoped for. Instead, he slotted it surreptitiously into the version of *Noa Noa* that he published under both their names in *La Revue blanche* in 1897, giving it the subtitle 'Note', without explaining its provenance.[11] His insertion of this fanciful report of Tahitian political events into their shared Symbolist novel prefigures, in reverse, Gauguin's placement of extracts from *Noa Noa* among his journalistic pieces in *Les Guêpes*. In this way, this episode also neatly captures the fragmentary structure of Gauguin's writing, as well as the haphazard fate that befell much of it.

The apparently casual structure of Gauguin's writings, and the piecemeal legacy of his texts, has encouraged their neglect, as discussed in the Introduction. But during the final years of his life and the early development of his posthumous reputation, his writings played a much greater role, contributing to the formation of his myth. In the Marquesas Islands, Gauguin's Vietnamese friend Nguyen Van Cam (known as Ky Dong), who had been deported for anti-colonial sedition in French Indochina, wrote a play in rhyming verse, called *Les Amours d'un vieux peintre aux Îles Marquises* (Loves of an Old Painter in the Marquesas Islands, 1902), recounting the artist's adventures. In it, the Gauguin character introduces himself as 'Paul, rentier, journalist / But my true profession is Symbolist painter' ('*Paul, rentier, journaliste / Mais ma profession vraie est peintre symboliste*'), implying that if painting was his true calling it was also not the main activity for which he was known at the time. The fictional Paul's declaration that 'My pen and my paintbrush – those powerful armaments – are used by me to overcome stupid prejudice' ('*Ma plume et mon pinceau, ces armes intrépides, / Vaincront du genre humain des préjugés stupides*') closely echoes similar statements by Gauguin himself.[12] For instance, in a passage of *Le Sourire* that Van Cam might have known, Gauguin portrayed himself as a reporter who always has a

'sharpened quill' ('*une plume ... taillée*') at the ready for use as a 'treacherous weapon' ('*arme perfide*').[13]

Gauguin repeatedly rejected the label of professional writer, or critic, but was willing to adopt the more rebellious and informal tag of 'journalist'. His reference to using his pen as a weapon appears in the inaugural issue of *Le Sourire*, which opens with a tale mocking the wealthy plantation owner August Goupil's plans for a railway linking Papeete to the district of Mataiea. In this unsigned piece, Gauguin masquerades as an investigative journalist, uncovering the true reason for Goupil's initiative, which is not to improve travel for inhabitants of the island, but to facilitate the transportation of his coconut products.

In a spoof report, he describes how, having finagled his way onto the inaugural train journey by acquiring his 'press pass' ('*ma carte de reporter*'), he discovers that all the stops on the route turn out to be not the villages between Papeete and Mataiea, but either coconut factories or Goupil's own mansion. On arrival back in the capital, as a 'common two-bit reporter' ('*commun reporter de 4 sols*'), he is excluded from the celebratory banquet and forced to dine on coconut flour.[14]

The authentic, unpretentious tone that Gauguin projected in such skits was admired and taken at face value by the early twentieth-century critics who helped to launch his international reputation as a precursor of modernism, and who regarded his immersion in an exotic culture as having enabled his embrace of pure form. Assessments of Gauguin's art prompted by the major display of 37 of his works at Roger Fry's *Manet and the Post-Impressionists* exhibition at the Grafton Galleries in London in 1910 were informed by readings of *Noa Noa* (via the 1897 publication in *La Revue blanche* and Morice's 1901 edition). Fry himself commented eight years later that '*Noa Noa* proves how readily a literary form of expression came to him, how much of a poet he was as well as a painter.'[15] Writing in the modernist journal *Rhythm* in 1911, the English novelist Michael Sadler (later known as

'Sadleir', 1888–1957) judged *Noa Noa* to be 'a piece of literature every bit as great as the finest of his painting'. He praised Gauguin's 'simple and sonorous' mode of writing and the 'wonderfully personal' nature of his narrative, and concluded that his pared-back descriptions of Tahiti create a much more vivid sense of place than would the 'chiselled periods of a more conscious stylist'.[16]

Sadler's assessment that 'when considered as a further expression of Gauguin's self [*Noa Noa*] becomes invaluable' indicates the extent to which the reading of Gauguin's texts facilitated the conflation of his art and life in his critical reception.[17] The emphasis on Gauguin as a martyr to his art, an artist whose primitive mode of expression was in line with his savage soul, was formed in the early twentieth century in response to his writing – and the mythical image that he projected of himself there – as much as to his art.[18] Even as this genius-savage image has been debunked, and then progressively nuanced over the ensuing century, the notion of Gauguin's writings as an unmediated account of his experience has remained largely unchallenged.

An alternative way of considering the legacy of Gauguin's writings – one that attends to the fragmentary style and sense of dislocation that I have emphasised in this book – can be found by turning to Victor Segalen, the doctor, ethnographer and writer who was responsible for saving much of what remained in Gauguin's Marquesan studio-home at his death. At the artist's estate sale in Papeete, Segalen purchased multiple items, including paintings, manuscripts and the sculpted wood panels that framed the door of Gauguin's self-styled 'Maison du Jouir' (House of Pleasure). It was Segalen's ship, the *Durance*, on which he was stationed as a naval doctor, that was charged with transporting Gauguin's belongings from the Marquesas to Papeete.[19] During his journey, the bundle of manuscripts primarily held Segalen's attention. In his *Journal des îles*, he records initially coming across 'traces' of Gauguin at the administrative

centre of the Marquesas on Nuku Hiva, 'especially that crate of papers in which I'd rummage with such curiosity'.[20] While on route from Nuku Hiva to Papeete, via Gauguin's home on Hiva Oa, Segalen absorbed Gauguin's writings, and copied passages into his *Journal*, whose first page (fig. 72) he decorated with a fragment of Gauguin's woodcut *Maruru* (*Offerings of Gratitude*, 1893–4), depicting a Polynesian deity and labelled by Segalen '*Te Atua*' (The Gods).[21]

Segalen's transcriptions indicate that he was receptive to the form as well as the content of Gauguin's writings. His selections from the *Cahier pour Aline*, for example, replicate the aphoristic structure of the original by sampling from Gauguin's own textual borrowings, including the passages by Edgar Allan Poe and Richard Wagner, as well as the artist's account of *Manaò tupapaú* in 'The genesis of a picture'.[22] Segalen concluded his copy of passages from the *Cahier* by juxtaposing the notebook's final sentence, a quotation from the occultist Joséphin Péladan, with its opening words: 'To my daughter Aline – scattered notes, without sequence like Dreams, like life all made up of fragments', thus reanimating Gauguin's own tendency to repeat and reorder.[23] He also registered the visual dimension of the artist's fondness for assemblage. Surrounding this final quotation from Gauguin's manuscript are three pasted-in scenes (a pencil drawing and a watercolour by the author, and a postcard; fig. 73) whose collaged arrangement is reminiscent of the mixed-media assemblages in the Louvre manuscript of *Noa Noa* that Segalen also had in his possession.

Segalen's encounter with Gauguin's writings had a formative influence on his theory of exoticism. This he came to develop in a body of writing that is recognised by postcolonial historians as an important early contribution to debates about globalisation and diversity.[24] In works like the unfinished 'Essay on Exoticism: An Aesthetics of Diversity' (written 1904–18), Segalen rejected the banal version of exoticism that he associated with figures such as Pierre Loti, for whom diversity was merely a function of geographical distance, easily overcome by immersion in a foreign culture and reduced to such clichés as 'coconut trees and torrid skies'.[25] Segalen defined diversity not as an inherent property of unfamiliar objects or peoples, whose effect could be mitigated, but as a 'sensation' to be cherished. 'Exoticism', he asserts, 'is not the perfect comprehension of something outside one's self that one has managed to embrace fully, but the keen and immediate perception of an eternal incomprehensibility.' Instead of believing that we can absorb and understand other customs and cultures, he argues, 'let us rejoice in our inability ever to do so, for we thus retain the eternal pleasure of sensing Diversity'.[26] For Segalen, the traveller's encounter with the exotic acts as a spur to recognise the relativity of difference – the 'shock' that passes between the 'traveller' and the 'object of his gaze' is not one-sided but 'rebounds' – and so to acknowledge that there are other perspectives than our own; to acquire 'the ability to conceive otherwise'.[27]

Segalen's championing of ethnographic diversity stemmed primarily from an aesthetic impulse – it is the '*sensation* of exoticism' and the 'beauty' of diversity that he promotes – rather than a concern with lived conditions.[28] His fascination with difference led him to stress absolute economic, gender and racial divisions rather than hybridity or multiculturalism; he condemned feminism, for instance, as a 'monstrous social inversion'.[29] But his theory of exoticism nonetheless diverged markedly from the prevailing colonialist mentality of his day in its protest against the homogenising influence of imperialism,

Following pages:
Fig. 73 Victor Segalen, original manuscript of the *Journal des îles*, folios 43 verso and 44 recto. Manuscript notes with drawing, watercolour and postcard. 26 × 20 cm (each sheet). Département des Manuscrits, Bibliothèque Nationale de France, Paris, NAF 25786

Dernières lignes du cahier :

"La ressemblance avec la vie ordinaire
frappe de popularité et rend inférieur
tout ce qui l'exprime. Pelladan."

Suivent des découpures d'articles
de journaux.

Le cahier est dédié :

"A ma fille Alice, — Notes éparses
sans suite comme les Rêves, comme la
Vie toute, faite de Morceaux."

NUKU-HIVA. 5 Août 03.
(Taio-Hae.)

ILES MARQUISES — La baie d'Anaho

and his emphasis on the possibility of resistance to the cultural decline that it precipitated.[30] The theme of fragmentation is central to Segalen's vision of the potential revivification of lost traditions. As he declares in the 'Essay on Exoticism', diversity will survive, so long as people remain able to perceive it, albeit only in glimpses:

We should have faith that some *fundamental* differences will never end up being a real fabric without some sewing or restitching of fragments; and that the increasing fusion, the destruction of barriers, the great shortcuts through space, must of their own accord compensate themselves by means of new partitions and unforeseen lacuna, a system of very fine filigree striated through the fields that one initially perceived as an unbroken space.[31]

Fragmentation, as Segalen describes it here, is not simply a symptom of the breaking down of cultural specificity in the face of colonialism. The disjointed way in which cultures re-emerge also acts as a counterpoint to the false seamlessness produced by the waning of difference.

Segalen's 'Essay on Exoticism' itself resembles a 'restitching of fragments' in its repetitive, aphoristic structure, which scholars have described as a deliberate reaction against novelistic conventions.[32] His interest in the fragment was inspired by the partial nature of his access to Gauguin via the artist's writings – his sense of encountering 'traces' of him after his death – such that his own salvaging of Gauguin's effects mimicked the artist's project of preserving the relics of Polynesian culture. But this interest was also, I emphasise, stimulated by his attraction to their piecemeal structure. This is made clear by the role that writing plays in Segalen's unfinished novel *Le Maître-du-Jouir* (The Master of Pleasure, written 1907–16). The protagonist is a western artist, named Paul Gauguin, who seeks to revitalise the dying population and customs of a Polynesian island (named 'L'Île du Grand-Jouir'). In the process, he counters both the

influence of European colonialism and the seeming inability of the Indigenous population to resist it. If the 'Essay on Exoticism' seemed to point, in the passage cited above, to the inherent capacity of cultures to survive and reconfigure themselves as if automatically, in *Le Maître-du-Jouir* it is the exceptional European outsider who acts as saviour.

The story of the fictional Gauguin's revitalisation of the island's old traditions is told from the perspective of the narrator who seeks to learn about events after the 'Master's' death. As Segalen was obliged to do with Gauguin, he pieces together the tale by gathering testimony from the artist's closest companions, and by reading what remains of his writings. In one episode, a character named Tioka – the namesake of Gauguin's real-life Marquesan friend – hands him a 'carelessly bound' bundle of papers from which 'sheets were escaping', which he initially takes to be Tioka's own musings. As he tries to catch the fluttering papers that elude his grasp, it dawns on him that they contain 'the germ of [the Master's] work and the basis of his formidable mind'. In a passage that is itself riddled with ellipses, as if to convey the narrator's breathless excitement at the discovery of Gauguin's words ('There is more ... said Tioka who was watching. There is more'), the contents of this precious bundle are described as snippets: sheets of paper are missing, torn, nibbled by insects, or 'contained only parts of sentences'. When the narrator subsequently gains possession of further 'precious papers', in which the Master describes his efforts to invent new gods, he finds that these contain 'new words' and 'new names'. Although based on actual Hindu and Polynesian deities, their composite forms, such as 'Agni-Oro-Rudro-Mahui', recall Gauguin's fictitious hybrid, Mani Vehbi-Zunbul-Zadi.[33]

What Segalen saw in Gauguin was not an attempt to 'go native' but a keen awareness of cultural alterity. Undoubtedly he mythologised the artist, overlooking the various ways in which he was implicated in, and at times actively identified with, the colonial infrastructures that he denounced.[34] But he also

identified in the fragmentary structure of Gauguin's writing something other than the clumsiness of the amateur writer, or the authentic expression of a savage mentality. His emulation of Gauguin's non-linear technique and proclivity for assemblage shows that he recognised these to be a literary device for conveying the experience of cultural displacement.

Towards the end of *Avant et après*, Gauguin asserts, 'It was not my desire to make a book that should have the very least appearance of a work of art (I should not be able to do so).' This statement reinforces the theme of the manuscript's opening words, 'This is not a book', which are subsequently reiterated like a refrain.[35] However, a few pages before this closing disclaimer, he also makes a more complicated declaration:

The subterfuges of language, the artifices of style, brilliant turns of phrase that sometimes please me as an artist are not suited to my barbaric heart ... One understands them and tries one's hand at them; it is a luxury which harmonises with civilisation and which for its beauties I do not disdain. Let us learn to employ it and rejoice in it boldly, the sweet music which at times I love to hear – till the moment when my heart asks for silence again. There are savages who clothe themselves now and again.[36]

Here, Gauguin explicitly affirms the link that he made between 'civilisation' and a refined style of writing. On the one hand, his statement has a familiar tone of primitive posturing: he presents himself as appreciating and aspiring to literary sophistication as an outsider, someone with a 'barbaric' nature; as the final phrase implies, beneath the raiments of a borrowed style, he remains a savage. On the other, it contains an admission that he *does* at times employ a self-consciously literary idiom, and that he is attracted to the 'luxuries' of civilisation. In Gauguin's ambivalent attitude to writing, both his strategies for identifying with the primitive, and the contradictions of this position, come to the fore.

Principal Manuscripts, Newspapers and Editions

This list does not include articles published in French periodicals, published or unpublished correspondence, or shorter manuscripts of a few pages in length that are held in various museums and libraries. It lists editions in French only.

Ancien Culte mahorie, 1893

Original manuscript:
• Musée du Louvre, Département des Arts Graphiques, Paris (RF 10755, 1)

Facsimile editions:
• *Ancien Culte mahorie*, ed. René Huyghe (Paris: La Palme, 1951; reprint Paris: Hermann, 1961 and 2001)
• *Ancien Culte mahorie*, ed. Bérénice Geoffroy-Schneiter (Paris: Gallimard, 2017)
• *Gauguin écrivain: Noa Noa, Diverses choses, Ancien Culte mahorie*, CD-ROM, ed. Isabelle Cahn (Paris: Réunion des Musées Nationaux, 2003)

Cahier pour Aline, 1893

Original manuscript:
• Bibliothèque de l'Institut National d'Histoire de l'Art, Collections Jacques Doucet (NUM MS 227)

Viewable on the website of the Institut National d'Histoire de l'Art (INHA), Paris:
<http://bibliotheque-numerique.inha.fr/idurl/1/8348>

Facsimile editions:
• *Cahier pour Aline*, ed. Suzanne Damiron (Paris: Société des amis de la Bibliothèque d'art et d'archéologie de l'Université de Paris, 1963), 2 vols

• *À ma fille, Aline, ce cahier est dédié: notes éparses, sans suite comme les rêves, comme la vie toute faite de morceaux: journal de jeune fille*, ed. Victor Merlhès, 2 vols (Paris: Société des amis de la Bibliothèque d'art et d'archéologie / Bordeaux: William Blake, 1989; reprint 2015)

Printed pocket edition:
• *Cahier pour Aline*, ed. Philippe Dagen (Paris: Éditions du Sonneur, 2009)

Noa Noa – Draft manuscript, 1893

Original manuscript:
• Getty Research Institute, Los Angeles (850041)

Viewable on the website of the Getty Research Institute:
<http://hdl.handle.net/10020/850041>

Facsimile editions:
• *Noa Noa*, ed. Berthe Sagot-Le Garrec (Paris: Sagot-Le Garrec, 1954)
• *Noa Noa*, eds Gilles Artur, Jean-Pierre Fourcade and Jean-Pierre Zingg (Tahiti and New York: Association des Amis du Musée Paul Gauguin à Tahiti, 1987; reprint 2001)

Printed editions:
• *Noa Noa*, ed. Jean Loize (Paris: André Balland, 1966)

• *Noa Noa*, ed. Pierre Petit (Paris: Pauvert, 1988)

Noa Noa – Louvre manuscript, 1894–1901 (in collaboration with Charles Morice)

Original manuscript:
• Musée du Louvre, Département des Arts Graphiques, Paris (RF 7259, 1)

Facsimile editions:
• *Noa Noa*, Berlin: R. Piper / Munich: Marées-Gesellschaft, 1926; reprint Stockholm: Jan Förlag, 1947
• *Noa Noa*, Paris: Réunion des Musées Nationaux, 2017
• *Gauguin écrivain: Noa Noa, Diverses choses, Ancien Culte mahorie*, CD-ROM, ed. Isabelle Cahn (Paris: Réunion des Musées Nationaux, 2003)

Printed editions:
• *Noa Noa. Édition définitive* (Paris: Crès, 1924)
• Paul Gauguin and Charles Morice, *Noa Noa*, ed. Claire Moran (Cambridge: Modern Humanities Research Association, 2017)
• Multiple other editions, often unfaithful to the original text, e.g. excising some or all of what are assumed to be Morice's contributions, using different illustrations, etc.

Noa Noa – reworked version of the collaboration in Charles Morice's hand, 1897

Original manuscript:
• Charles Morice Papers, Samuel L. Paley Library, Temple University, Philadelphia (Collection SPC.MSS.LT016, Series 3, Box 10)

Printed editions (with minor variations to the 1897 manuscript):
• Paul Gauguin and Charles Morice, *Noa Noa* (Paris: Éditions de la Plume, 1901)
• Paul Gauguin and Charles Morice, *Noa Noa. 4e édition (Éd. 1901)* (Paris: Hachette livre / BNF, 2018) [facsimile of the 1901 edition]

Diverses choses, 1896–8

Original manuscript (bound in the same volume as the Louvre manuscript of Noa Noa but with a separate title page):
• Musée du Louvre, Département des Arts Graphiques, Paris (RF 7259, 1)

Facsimile edition:
• *Gauguin écrivain: Noa Noa, Diverses choses, Ancien Culte mahorie*, CD-ROM, ed. Isabelle Cahn (Paris: Réunion des Musées Nationaux, 2003)

L'Esprit moderne et le catholicisme, 1897–1902

Original manuscript:
• Saint Louis Art Museum, MO (Object Number 287: 1948)

First scholarly transcription in preparation by Elizabeth C. Childs (Washington University in St Louis), to be made available via the website of the Saint Louis Art Museum, MO

Printed edition
• Philippe Verdier, 'Un manuscrit de Gauguin: L'Esprit moderne et le catholicisme', *Wallraf-Richartz Jahrbuch*, vol. 46–7 (1985–6), pp. 273–98, followed by his annotated transcription of *L'Esprit moderne et le catholicisme*, pp. 299–328

Le Sourire, August 1899 – April 1900: newspaper written and published by Gauguin

Complete original print runs:
• Kroepelien Collection, University of Oslo Library, Norway (among Gauguin's possessions at his death)
• Houghton Library, Harvard University, Cambridge, MA (manuscript and mimeographed set of issues sent by Gauguin to George-Daniel de Monfreid)

Facsimile edition:
• *Le Sourire de Paul Gauguin: collection complète en facsimile*, ed. L.-J. Bouge (Paris: Maisonneuve, 1952)

Les Guêpes, 1899–1901: articles written by Gauguin for Tahiti-based newspaper

Printed edition:
• Articles collated by Bengt Danielsson and Patrick O'Reilly, *Journal de la Société des Océanistes*, vol. XXI (December 1965), pp. 20–53, and accompanied by their essay 'Gauguin journaliste à Tahiti et ses articles des Guêpes', pp. 1–19

Racontars de rapin, 1902

Original manuscript:
• Josefowitz Collection, Lausanne, Switzerland

Facsimile edition:
• *Racontars de rapin*, ed. Victor Merlhès (Taravao, Tahiti: Éditions Avant et après, 1994)

Printed editions:
• *Racontars de rapin* (Paris: Falaize, 1951)
• *Racontars de rapin* (Monaco: Sauret, 1993)
• *Racontars de rapin*, ed. Bertrand Leclair (Paris: Mercure de France, 2003)
• *Racontars de rapin* (Angoulême: M. Waknine, 2013)

Avant et après, 1903

Original manuscript:
• private collection

Facsimile edition:
• *Avant et après* (Leipzig: Wolff, 1918; reprint Copenhagen: Scripta / Poul Carit Andersen, 1951)

Printed editions:
• *Avant et après* (Paris: Crès, 1923)
• *Avant et après* (Taravao, Tahiti: Éditions Avant et Après, 1989)
• *Avant et après*, ed. Jean-Marie Dallet (Paris: Table Ronde, 1994; reprint 2017)

Notes

I have consulted all of the manuscripts by Gauguin that I discuss here in facsimile, and his shorter essays from periodicals in their original published form. Where available, I cite the editions that are likely to be most accessible to readers, except where these differ from the original. Translations are my own unless otherwise stated. Original French quotations are supplied in cases where there is no published edition or a publication is particularly difficult to access. A list of the manuscripts and significant editions can be found in the appendix on pp. 162–3. For citations from Gauguin's correspondence, I use Merlhès 1984, of which only the first volume has been published so far, as the most comprehensive and reliable collection for the years up to 1888. For the later period, I refer mostly to Malingue 1946; other editions are cited as necessary or where the dating is more accurate. I indicate the correspondent and as precise a date as is available, in either the chapter or the first corresponding note. I reference the most recent anthology of Gauguin's writings (Gauguin 2017), in preference to the earlier standard edition (Gauguin 1974), as it includes more of his shorter texts in unabridged form.

INTRODUCTION

1– Gauguin 1923, p. 1. References to the French edition are to Gauguin 1994a, here p. 9. Subsequent citations from these editions provide the page number for the English translation, followed by the corresponding page number in the French edition.

2– *Ceci n'est pas un conte* (written 1772), in Diderot 1951, pp. 753–72. In his newspaper *Le Sourire*, Gauguin comments that 'Diderot's writings should be better known'. Gauguin 1952 (no. 4, November [1899], p. 2).

3– For instance, at one point he says: 'It is quite obvious that I am not writing a novel, since I am neglecting everything that a novelist would not fail to put in.' (*Jacques le Fataliste et son maître*, in Diderot 1951, p. 484).

4– Gauguin 1923, p. 1 (translation modified) / 1994a, p. 10.

5– See pp. 162–3 for a list of Gauguin's writings. The 'Procès-verbal d'inventaire des immeubles, meubles et objets de toute nature appartenant au sieur Gauguin, Paul, Henri, Eugène, artiste-peintre, décédé à Atuana, île Hiva Oa (Marquises), le 8 mai', in *Dossier de la succession Paul Gauguin* 1957, pp. 26–30, lists 13 manuscripts, one of which is identifiable as it is listed as a 'manuscript dedicated to his daughter Aline' (item 15), as well as a 'bundle containing 12 notebooks' (item 16). Item 4 lists '3 manuscripts' and item 17 '1 bundle containing 9 manuscripts'. Of the seven extant manuscripts, at least two had been sent to France, meaning that of the thirteen remaining in his possession at least eight are unaccounted for.

6– On Segalen's encounter with Gauguin's writings and influence on his legacy, see Forsdick 2010.

7– Joly-Segalen 1950, with a preface by Victor Segalen, 'Homage to Paul Gauguin' (first published 1918); see Thomson 2010b, p. 13.

8– On *Noa Noa*, see Maubon 1991, Hobbs 2002, Goddard 2009 and 2012a, chapter two (pp. 65–112), and Wright 2018; and on *Avant et après*, see Drell Reck 1991, Hobbs 1991 and Maubon 1995. Edmond 1997 and Hughes 2001 address *Noa Noa* in the context of a wider tradition of French literature on the 'exotic', which I discuss in chapter two. In a rare overview, Elizabeth C. Childs (Childs 2003) has examined Gauguin's motivations and influences as a writer in a succinct but comprehensive survey of the major manuscripts. Vaiana Giraud's doctoral thesis (Giraud 2010) offers a wide-ranging discussion of the place of writing in Gauguin's oeuvre that takes account of the broader French literary environment and is particularly useful in contextualising his later journalistic writings.

9– Wright and Brown 2010; Figura 2014a; Groom 2017. Dario Gamboni (Gamboni 2014) also addresses the wide range of media employed by Gauguin, the circulation and metamorphosis of motifs between his paintings, ceramics, sculpture and prints, and the artist's interest in the properties of different artistic materials.

10– Particularly significant in this respect is Alastair Wright's identification of a 'melancholy logic of reproduction' in Gauguin's distinctive approach to printmaking (Wright 2010). Focusing in particular on Gauguin's *Noa Noa* woodcut suite, Wright shows how Gauguin actively foregrounds reproduction by drawing attention to the status of each iteration as a slight variation on the original. For Wright, this allows Gauguin to signal his regretful awareness that he can no longer access an 'original' Tahiti, untainted by European colonisation, and that his experience of it is already mediated by pre-existing representations.

11– Figura 2014b, pp. 15 and 33, n. 1, acknowledges writing as a facet of Gauguin's intermedial practice, but concedes that she cannot explore it. Wright 2010, pp. 74–5, 81–5, and 88–90, discusses the recycling of both images and words in Gauguin's manuscripts, but the primary focus of his analysis of the metaphoric significance of reiteration in Gauguin is on the artist's prints. Although the manuscripts help to reveal the 'logic of reproduction' in Gauguin's work, Wright concludes that 'their ragtag juxtaposing of textual citations and pasted-in images should not be taken to speak for his work as a whole' (p. 85).

12– Gauguin 1896–8, pp. 236–7, 238–9.

13– This is unlike a traditional monotype, whereby an existing composition is offset using uniform pressure. See Lotte Johnson, '*Le Sourire* and Printing Experiments', catalogue entry in Figura 2014a, p. 178; Marjorie Shelley, 'Gauguin's Works on Paper: Observations on Materials and Techniques', in Ives and Stein 2002, pp. 197–215 (here pp. 212–13); and Broadway 2016.

14– Gauguin 2016, p. 14. References to the French edition are to Gauguin 2003, here p. 11. Subsequent citations from these editions provide the page number for the English translation, followed by the corresponding page number in the French edition.

15– Malingue 1946, p. 305 (September 1902).

16– Malingue 1946, p. 308 (February 1903).

17– Extracts from Van Gogh's letters to Émile Bernard were published in four instalments from April to July 1893 (*Mercure de France*, vols 7–8) and to Theo van Gogh in ten instalments from August to November 1893 (vols 8–9) and in January and March (both vol. 10), July (vol. 11) and September 1894 (vol. 12), February 1895 (vol. 13) and August 1897 (vol. 23). On these, see <http://vangoghletters.org/vg/publications_2.html#intro.IV.2.3> (accessed 21 July 2018).

18– Hobbs 2002.

19– As influentially described by White and White 1993. On the rivalry between artists and writers in France, see, among others, Bourdieu 1994, Gamboni 2011 and Goddard 2012a.

20– Gauguin 2016, p. 19 / 2003, p. 20.

21– Hobbs 2002, p. 181. See also Hobbs 1996.

22– Couture 1867, p. 79. On recurrent tropes in nineteenth- and twentieth-century artists' writings, and issues relating to their interpretation and categorisation, see Goddard 2012b.

23– Henry Jouin, 'Introduction: les artistes écrivains', in *Conférences de l'Académie Royale de Peinture et de Sculpture, recueillies, annotées et précédées d'une étude sur les artistes écrivains par M. Henry Jouin* (Paris: Quantin, 1883), p. lxvi. Blanc's comment is also reproduced in a later anthology of artists' writings – Paul Ratouis de Limay, *Les Artistes Écrivains* (Paris: Librarie Felix Alcan, 1921) – revealing the extent to which the notion of an artist's unstructured prose was common currency. Echoing this position in 1949, Robert Motherwell declared that, regardless of their academic shortcomings, 'the statements of artists themselves constitute the literature that is most inspiring to others, and especially to younger artists' (Robert Motherwell, 'A Personal Expression', lecture delivered in 1949, in Motherwell 1999, p. 60).

24– Joly-Segalen 1950, p. 192 (October 1902).

25– Jansen, Luijten and Bakker 2009 (letter 646, 22 July 1888, to Vincent van Gogh); Merlhès 1984, p. 210 (14 August 1888, to Émile Schuffenecker).

26– Gauguin 1910. Daniel Guérin (Gauguin 1974, p. 22) dates the essay to 1884–5 since Gauguin wrote it in a notebook purchased in Rouen in 1884 (published in facsimile as *Paul Gauguin: A Sketchbook*, eds Raymond Cogniat and John Rewald [New York: Hammer Gallery, 1962]), and it overlaps with ideas expressed in his correspondence at this time.

27– 'Préceptes', *L'Art Moderne de Bruxelles* (10 July 1887),

reprinted in Fénéon 1970, vol. 1, p. 81. See the discussion in chapter four.

28– Gauguin published the following articles in French periodicals: 'Notes sur l'art: À l'Exposition Universelle', Parts 1 and 2, *Le Moderniste illustré*, 4 and 13 July 1889, pp. 84–6 and 90–91; 'Qui trompe-t-on ici?', *Le Moderniste illustré*, 21 September 1889, pp. 170–71; 'Natures mortes', *Essais d'art libre* 4 (January 1894), pp. 273–5; 'Exposition de la Libre Esthétique', *Essais d'art libre* 5 (February to April 1894), pp. 30–32; 'Sous deux latitudes', *Essais d'art libre* 5 (May 1894), pp. 75–80; 'Lettre de Paul Gauguin', *Journal des artistes* 46 (18 November 1894), p. 818; 'Armand Seguin', *Mercure de France*, vol. 13, no. 62 (February 1895), pp. 222–4 (catalogue preface for an exhibition of Armand Seguin at the Galerie Le Barc de Boutteville); 'Strindberg contre Monet', *L'Éclair*, 16 February 1895, p. 2; 'Une Lettre de Paul Gauguin: À propos de Sèvres et du dernier four', *Le Soir*, 23 April 1895, p. 1; 'Les peintres français à Berlin', *Le Soir*, 1 May 1895, p. 2. Extracts from half of these are anthologised in Gauguin 1974. A more comprehensive, though not fully complete, selection has recently been collected in Gauguin 2017.

29– Gauguin 2001; Moerenhout 1837, published in English as *Travels to the Islands of the Pacific Ocean*, trans. Arthur R. Borden, Jr. (Lanham, MD: University Press of America, 1993).

30– Malingue 1946, p. 249 (October 1893, to Mette Gauguin).

31– Gauguin discusses his father and grandmother in a section on his family history in *Avant et après* (Gauguin 1923, pp. 74–5 / 1994a, pp. 142–3).

32– See Childs 2004. The manuscript is transcribed and accompanied by an essay in Verdier 1985–6. Elizabeth C. Childs (Washington University in St Louis) is currently preparing a new, more accurate transcription of *L'Esprit moderne*, to be accompanied by a critical essay and a translation, which will be made available via the website of the Saint Louis Art Museum, MO.

33– Joly-Segalen 1950, p. 192 (October 1902, to George-Daniel de Monfreid).

34– Wadley 1985, p. 101; Wayne Andersen, 'Introduction', in Gauguin 1996, p. xviii.

35– Loize 1961, p. 69.

36– Dorra 2007, p. 21; Richard R. Brettell, 'Foreword: Henri Dorra and Paul Gauguin', in Dorra 2007, p. xiii.

37– Merlhès 1989a, p. 63 (20 February 1888, to Émile Schuffenecker).

38– Malingue 1946, p. 308 (February 1903).

39– Against the general grain of the criticism of Gauguin's writing, some scholars have stressed its centrality to his artistic practice and self-fashioning, while remaining alert to the literary status of the texts themselves: see Childs 2003 and 2004; Hobbs 1991 and 2002; Moran 2017; and Wright 2018. Others have related Gauguin's writings to the intellectual currents of his time, and provided valuable information about their themes and sources, but have not been primarily concerned with his authorial style, or the material form of his manuscripts: see in particular Amishai-Maisels 1985 and Vance 1986, and in the context of editions and translations, Merlhès 1984, 1989b and 1994, and Vouitsis 2016. Dario Gamboni has drawn inventively on Gauguin's writings, not as tools for iconographic interpretation, but as theoretical guides that alert the viewer to the ambiguity or polyiconicity that Gamboni sees as central to Gauguin's art (Gamboni 2013 and 2014). Efforts to position Gauguin's writing within a tradition of literary modernism have helped to challenge the perception of his amateur status, but tend to minimise the historical specificity of his genre-crossing activity, presenting him instead as a polymorphous genius who was ahead of his time (see especially Draperi 1989, p. 66).

40– In this book, I use 'primitive', 'civilised' and related terms on the understanding that they are mythical concepts reflecting Gauguin's attitude, and do not always place them in quotation marks.

41– Gauguin 1910, p. 52.

42– Gauguin 1896–8, p. 207. Like many others, he used flowers and flourishing as metaphors for the rejuvenating powers of the primitive. In *Noa Noa*, for example, the narrator imagines seeing, in the eyes of Queen Marau, 'plants beginning to burgeon in the first sunshine', and describes an encounter between his newly acquired Tahitian wife and a Frenchwoman who insults her as 'decrepitude … staring at the new flowering'. (Gauguin

1985, pp. 13, 35). References to the French edition of this version are to Gauguin 1988, here pp. 35, 71. Subsequent citations from these editions provide the page number for the English translation, followed by the corresponding page number in the French edition.

43– Solomon-Godeau 1992 (first published in 1989 in *Art in America*, no. 7, pp. 118–29); Pollock 1992.

44– See in particular Eisenman 1997; Hal Foster, 'Primitive Scenes', chapter one in Foster 2004, pp. 1–52 (first published in *Critical Inquiry* 20, Autumn 1993); Lee Wallace, 'Gauguin's *Manao tupapau* and Sodomitical Invitation', chapter five in Wallace 2003, pp. 109–37.

45– Norma Broude, 'Introduction: Gauguin after Postmodernism', in Broude 2018a, p. 3.

46– Scholarship on Gauguin has often pointed out the extent to which his typically massive and inscrutable female figures avoid becoming objects of the heterosexual male gaze even as their 'breasts rhymed with fruit' (Solomon-Godeau 2007, p. 77) affirm the stereotypical association between the (non-western) female body and nature. Despite her general emphasis, in 'Going Native', on Gauguin's reliance on exoticist tropes, Abigail Solomon-Godeau nonetheless observed in his representations of women 'something in their wooden stolidity, their massive languor, their zombielike presence that belies the fantasy they are summoned to represent' (Solomon-Godeau 1992, p. 328). In a later essay she takes up what was previously an anomalous thread in her argument, in order to emphasise instead 'the striking *difference* between Gauguin's depictions of Tahiti … and the century and a half visual archive that preceded him' (Solomon-Godeau 2007, p. 76). In an often-cited revisionist reading, Peter Brooks stressed that Gauguin's quest for 'a body that could be naked and sexual without sin, fear, or loathing' (Brooks 1993, p. 195) posed a radical challenge to the titillating and morally circumscribed European tradition of the nude, but his suggestion that the 'dignity' and 'self-sufficiency' of Gauguin's figures encourages 'guilt-free' looking (pp. 194–5) arguably perpetuates Gauguin's own fantasy. Subsequently, other scholars (notably Eisenman 1997 and Wallace 2003) have emphasised how Gauguin's allusions to androgyny and homosexuality complicate the

assumption of passively alluring bodies on which critiques of the artist are often based. For a particularly well-balanced, recent reassessment of feminist critical responses to Gauguin, see Broude 2018b.

47– Solomon-Godeau 1992, p. 326. Her source for this unpublished letter is Danielsson 1965, whose translator prudishly modified part of the quotation; in Gauguin 15 January 1897 the original wording is more accurately translated as 'makes my simple everyday grub and gives me a great blow job' ('*me fait la simple tambouille de tous les jours, me taille des plumes à merveille*').

48– Gauguin 1974, p. 214, cited and translated in Broude 2018b, p. 74.

49– Eisenman 1997, p. 176. Danielsson 1975, p. 290, cites evidence of the gifts that Gauguin made to the family of one girl, Vaeoho Marie-Rose, who came to live with him after he persuaded her parents to withdraw her from the school (descendants of her child with Gauguin still live on Hiva Oa). Bengt Danielsson describes multiple instances of Gauguin's altercations with the colonial authorities but tends to see them exclusively as cynically motivated. Stephen Eisenman was the first to expand this line of enquiry; while remaining alert to Gauguin's contradictions and failings, he offers a more favourable view of the artist as genuinely driven by anti-imperialist convictions. Caroline Boyle-Turner (Boyle-Turner 2016) has recently presented further evidence of his political manoeuvring in the Marquesas. The ambiguities and critical debate surrounding his (anti-) colonial position are discussed further in chapter four in relation to his journalism for *Le Sourire* and *Les Guêpes*.

50– Jolly 2000, p. 98.

51– Danielsson 1975, pp. 72–5.

52– In a scene in his unfinished novel inspired by Gauguin, *Le Maître-du-Jouir* (The Master of Pleasure), Victor Segalen imagines Gauguin and Tioka exchanging blood, but the artist angrily refusing his friend's suggestion that they swap names (Segalen 2003, p. 85). Guillaume Le Bronnec, who arrived in the Marquesas in 1910, seven years after Gauguin's death, and conducted interviews with local inhabitants who had known the artist, also mentions the name exchange with Tioka, this time as having occurred

without incident (Le Bronnec 1956, p. 195). The precise source of his information in this instance is not clear, but he is unlikely to have derived it from Segalen, who encountered Gauguin's acquaintances in 1903, but whose novel-in-progress was not published until long after his death.

53– The most detailed recent accounts of Gauguin's social circle in the Marquesas and his altercations with the colonial authorities in this period are Eisenman 1997, pp. 168–77, Sweetman 1995, pp. 496–531, and Boyle-Turner 2016, pp. 192–204. Important earlier records are Le Bronnec 1956 (first published as 'La vie de Gauguin aux îles Marquises et ses intimes [depuis son arrivée en 1901 jusqu'à sa mort en 1903]', *Bulletin de la Société des Études Océaniennes*, vol. 9, no. 106, March 1954, pp. 198–211) and Danielsson 1975, pp. 283–335.

54– In an often-quoted example of his self-diagnosed dualism, he declared to his wife: 'You have to remember that I have two natures – the Indian and the sensitive.' (Merlhès 1984, p. 170, late January or early February 1888). And in *Avant et après* he wrote 'You drag your double along with you, and yet the two contrive to get on together.' (Gauguin 1923, p. 129 / 1994a, p. 234).

55– These are the formulations respectively of Albert Memmi (*The Colonizer and the Colonized*, Boston: Beacon Press, 1991, pp. 41–4 [first published in French in 1957]) and James Clifford (in Clifford 1998, p. 79), cited in Childs 2013, pp. 123, 98, who uses these terms to help clarify Gauguin's marginal social status in Tahiti.

56– Gates 1991, p. 462, cited, among others, by Edmond 1997, p. 10.

57– Analyses of his work from a Pacific Studies perspective, notably by Wallace 2003, Childs 2013 and Waldroup 2018, have stressed the importance of locating it within the context of Pacific history and culture.

58– Sherman 2011, p. 8. As Jolly 2000, p. 99, notes, 'many anticolonial movements ... are ultimately in argument with that "state of nature" that imagines people as but part of a beautiful, wild place'.

59– The notion of Gauguin's 'critical primitivism' was proposed by Eisenman 1997, pp. 29, 201, who argues (Eisenman 2000, p. 125) that Gauguin's 'highly impure'

art, with its discordant style and ambiguous attitude to art-historical tradition and literary narrative, necessitated an equally transgressive 'life lived on a border'. Gauguin's simultaneous embrace and dismissal of writing is a vital component of the 'impure' approach that Eisenman identifies.

60– With particular reference to *Noa Noa*, I discuss the deliberate naivety of Gauguin's writing in Goddard 2010, his tactical partnership with Morice in Goddard 2008 and 2012a, chapter two (pp. 65–112), and its connections with travel writing in Goddard 2009. Focusing on *Diverses choses*, I relate his fragmentary approach to composition to contemporary literary practices in Goddard 2011. I incorporate updated and expanded versions of this material here. An initial exploration of the parallel between Gauguin's tense involvement with literature and his uncertain colonial identity occurs in Goddard 2018, where I also discuss his adoption of literary personae and alter egos.

61– Recent studies that attend closely to Gauguin's writings in the course of discussing his investment in contemporary theological, spiritual and scientific debates, include Palermo 2015, pp. 50–60, Hargrove 2018 and Larson 2018.

62– For a general survey, from a broadly semiotic perspective, of the myriad functions of language within Gauguin's oeuvre, including titles, signatures, inscriptions, annotations and his writing, see Regnault 2005. Drawing on research by Hiriata Millaud ('Les Titres tahitiens de Gauguin', in *Ia Orana Gauguin*, exh. cat., Musée de Tahiti et des Îles, Te Fare Manaha, and Paris: Somogy, 2003, pp. 81–90), Dario Gamboni makes the case that Gauguin had a better understanding of the Tahitian language than has previously been assumed, and that he was attuned to its essential 'ambiguity and polysemy'. He discusses the artist's 'pansemiotic' approach to visual and verbal signs, his enjoyment of the visual and aural properties of language, and interest in graphology, philology and universal languages (Gamboni 2014, p. 108 and passim).

CHAPTER ONE: THE ARTIST AS ANTI-CRITIC
1– Malingue 1946, p. 290.
2– Malingue 1946, p. 287.

3– Fontainas 1899, p. 238. Gauguin cites the critic's words in his letter. On this painting and its exhibition alongside nine related works at the Galerie Vollard from 17 November to 10 December 1898, see Shackelford 2004.

4– Malingue 1946, pp. 288–9.

5– Malingue 1946, p. 293 (August 1899).

6– Malingue 1946, pp. 286, 288–90.

7– Malingue 1946, p. 293.

8– Malingue 1946, p. 294.

9– Malingue 1946, p. 287.

10– In the March letter, Gauguin prefaces the purported citation from Mallarmé with the words 'Also heard from Mallarmé in front of my Tahitian pictures'; he claims to be quoting the poet when he describes his own work as a 'musical poem' and notes that 'the essence of a work consists precisely in "that which is not expressed"', and attributes to him the satirical description of the critic cited in the epigraph to this chapter (Malingue 1946, pp. 288–9). To the best of my knowledge, none of these phrases is a direct citation from Mallarmé's published writings, and they were probably paraphrased or possibly invented by Gauguin. In August, he cites (Malingue 1946, p. 293) a passage from what he considers to be an exemplary article by Achille Delaroche, 'D'un point du vue esthétique: à propos du peintre Paul Gauguin' (*L'Ermitage*, January 1894, pp. 35–9), having included an unattributed phrase from this same text in the earlier letter ('colour which is vibration, like music, grasps what is most general and therefore vaguest in nature, its interior force', Malingue 1946, p. 288). Gauguin was fond of citing Delaroche's article, and transcribed it in *Diverses choses* (Gauguin 1896–8, pp. 246–51) and *Avant et après* (Gauguin 1923, pp. 20–4 / 1994a, pp. 41–50).

11– Malingue 1946, pp. 305–10 (September 1902 and February 1903).

12– On these artists' ambivalent relationships with writers and literature, see, respectively, Hannoosh 1995, Cooke 2003 and Gamboni 2011.

13– The tensions between word and image as expressed in nineteenth-century French art criticism have been well mapped. See, for instance, Scott 1988, Kearns 1989, Gamboni 1989 and Goddard 2012a.

14– For instance, Gamboni 2011, pp. 315–19, uses Gauguin as a case study to contextualise his analysis of Redon's attitude towards literature, showing how with his outspoken ripostes he intervened in the power struggles between artists and writers. See also Gamboni 1989 and 2003.

15– As noted by Jirat-Wasiutynksi 1978, p. 352, and by Gamboni 2011, p. 315. See also Goddard 2012a, chapters one and two.

16– See Moran 2017. Belinda Thomson, in particular, has revealed the depth of his literary influences and knowledge, despite his protestations to the contrary (Thomson 2010b and 2016).

17– Aurier 1889.

18– Wrigley 1995, pp. 223–30.

19– On the question of authority in artists' statements, see also Gamboni 2011, pp. 306–22, and Adamson and Goddard 2012.

20– Letter to Theo van Gogh, 20 or 21 November 1889, in Cooper 1983, pp. 161, 163; translation in George T. M. Shackelford, 'Introduction', in Shackelford and Frèches-Thory 2004, p. 10.

21– Jansen, Luijten and Bakker 2009, letter 817 (*c*.10–13 November 1889). He also described it in his letter to Bernard of early September 1889 as 'the best and strangest thing that I've done in sculpture' (Malingue 1946, p. 167).

22– Malingue 1946, p. 167 (to Bernard).

23– To Vincent he writes that 'despite the inscription the people look sad, in contradiction to the title' and to Theo that certain figures 'express the opposite of the advice ("you will be happy"), to show that it is fallacious'. To Bernard, he identifies the figure as 'Gauguin (in the guise of a monster)', and to Vincent, 'a monster who looks like me'.

24– Joly-Segalen 1950, p. 182 (August 1901). Writing to Émile Schuffenecker on 16 October 1888, he boasted that 'I shall be understood less and less' (Merlhès 1984, p. 255) and to Bernard in early September 1889 that 'I expect to become more and more incomprehensible' (Malingue 1946, p. 167). On Gauguin's cultivation of his inscrutability, see Gamboni 2018, p. 103.

25– On Gauguin's careful control over the dissemination of

meaning in his letters, see Thomson 2010b, p. 18, Goddard 2012a, pp. 93–102, and Thomson 2016.

26– Joly-Segalen 1950, p. 63 (to George-Daniel de Monfreid, 8 December 1892); Malingue 1946, p. 237 (to Mette, 8 December 1892).

27– Malingue 1946, p. 238.

28– Malingue 1946, p. 237.

29– Malingue 1946, p. 236.

30– Sweetman 1995, p. 361, claims that Gauguin 'had not allowed Morice to put French translations alongside the Tahitian titles in the catalogue [for the Durand-Ruel exhibition]', and this assertion is sometimes repeated by other scholars. However, the translations can be found in Charles Morice, *Exposition d'œuvres récentes de Paul Gauguin* (Paris: Galerie Durand-Ruel, November 1893), and it was the earlier Danish exhibition from which they were excluded; see Thomson 2016, p. 185.

31– '*Malgré l'ennui d'avoir à parler de moi, je le fais ici pour expliquer mon art tahitien, puisqu'il est reputé pour être incompréhensible ... je veux me défendre*' (Gauguin 1896–8, p. 255).

32– Gamboni 2014, p. 17.

33– Joly-Segalen 1950, p. 182 (August 1901).

34– I address the relation between episodes in *Noa Noa* and the works that they describe in Goddard 2010 and 2012a, pp. 74–80.

35– Gauguin 1985, p. 38 / 1988, p. 79.

36– Gauguin 1985, p. 20 / 1988, p. 49.

37– Gauguin 1910, p. 52.

38– Gauguin 1985, p. 32 / 1988, p. 63.

39– On the photographic source, see Childs 2013, pp. 112, 114–15, 266, n. 56. Gauguin's narrative resembles a similarly voyeuristic waterfall scene in the popular romance by Pierre Loti (Julien Viaud), *Le Mariage de Loti* (1880): when Loti first spies his young Tahitian mistress, Rarahu, she is lying naked in the Apiré Falls, unaware of his presence (Loti 2002, pp. 21–2). For another example of this theme, see Monchoisy 1888, pp. 56–7.

40– Malingue 1946, pp. 237–8 (to Mette, 8 December 1892); Joly-Segalen 1950, p. 63 (to George-Daniel de Monfreid, 8 December 1892).

41– Merlhès 1989b, p. 69. See also Gamboni 2003.

Gamboni's detailed analysis of Gauguin's verbal deconstruction of *Manaò tupapaú* is an exemplary study of his 'intervention in the market of interpretations', in the context of competition with critics. Since Gamboni also treats Gauguin's discursion as a serious reflection upon the creative process with a certain (judiciously handled) 'heuristic value' for the interpretation of the picture, he plays down – while still acknowledging – the differences between the accounts, taking the most formal version (in *Cahier pour Aline*) to stand for the others, whereas I emphasise here that the discrepancies between them are revealing in themselves.

42– Gauguin 2009, p. 30.

43– Gauguin 2009, p. 33.

44– On this example, see Goddard 2012a, pp. 99–102, and House 2012, pp. 338–9.

45– Joly-Segalen 1950, p. 119 (February 1898).

46– Joly-Segalen 1950, pp. 118–19. See House 2012, pp. 335–6. Eisenman 2007b, p. 29, also warns that the suicide attempt could have been made up as part of his 'avant-garde self-promotion'. More commonly, it is reported as biographical fact based on the sole evidence of this letter.

47– Malingue 1946, pp. 300–01 (July 1901).

48– Malingue 1946, pp. 301–2. Malingue transcribes this summary (without the diagram) by following the order of the text from left to right, beginning with 'Where are we going?' (this phrase is actually omitted by Gauguin, although it is implied by the presence of the other two parts of the title) and concluding with 'Where do we come from?', thus reversing the order of the painting's title. However, as the text in the left-hand box runs on into the main body of the letter as it continues below (an effect lost in Malingue's transcription), the implication is that both the painting, and its diagrammatic summary in the letter, can be read from right to left. In effect, Gauguin leaves both possibilities open, thus maintaining an element of ambiguity in his otherwise quite prescriptive synopsis.

49– House 2012, p. 336.

50– See Introduction, n. 17.

51– Gauguin 1923, p. 8 / 1994a, p. 22.

52– 'Lettres de Vincent van Gogh à son frère Théodore (Arles, 1887–1891)', *Mercure de France*, vol. 23, no. 92,

August 1897, pp. 267–89 (here p. 285). For the translation and the original letter, see Jansen, Luijten and Bakker 2009, letter 604 (3 October 1888). Van Gogh is referring to Gauguin's letter of 1 October 1888, in which he describes his *Self-Portrait with Portrait of Émile Bernard (Les Misérables)*, discussed below.

53– On the mythical conception of Gauguin's artistic identity established by himself and his colleagues, see Jirat-Wasiutynski 1978, chapter four, pp. 292–363; Françoise Cachin, 'Gauguin Portrayed by Himself and by Others', in Brettell et al. 1988, pp. xv–xxvi; Thomson 2010b and section introduction 'Identity and Self-Mythology', in Thomson 2010a, pp. 71–5; and Moran 2017, especially pp. 38–60, 95–100.

54– On the enduring role of biography in the history of art and the formation of the image of the artist, see the classic account by Kris and Kurz (1979); and on the dominance of the biographical model in the nineteenth century, see, for example, Thomas 2002 and Sturgis et al. 2006.

55– Merlhès 1984, p. 198 (8 July 1888). See Moran 2017, especially pp. 45–6.

56– Merlhès 1984, p. 284 (third or fourth week of November 1888). On the identification of the pot, see Ferlier-Bouat 2017, p. 51. This pot (Groom 2017, cat. 30) corresponds to Gauguin's description, in the letter to Bernard, of a 'bird decoration on a blue-green background'.

57– Merlhès 1984, p. 284. On the association that Gauguin established between his own artistic identity and the medium of ceramics, particularly via the moulding of clay and the heat of the kiln as metaphors for divine artistic creativity and martyrdom, see Gamboni 2013 and Ferlier-Bouat 2017, pp. 50–51.

58– Malingue 1946, p. 194 (Malingue dates the letter to June 1890; Françoise Cachin in Brettell et al. 1988, p. 128, redates it to late 1889). In late November 1889, Gauguin wrote to Madeleine asking her to tell Bernard to retrieve from Schuffenecker a 'large pot that he saw me make, which vaguely resembles the head of Gauguin the savage', which he wanted to give to her (Malingue 1946, p. 180).

59– Malingue 1946, p. 194.

60– Malingue 1946, p. 194.

61– Gauguin 1889, p. 90.

62– Gauguin 1895b. On Gauguin's anticipation of the early twentieth-century creed of 'truth to materials', see Gamboni 2014, chapter four, 'Matter and Material', especially pp. 180–84.

63– Aurier 1891, cited in Gauguin 1895b. Similarly, Aurier's description of the bas-relief *Soyez amoureuses* as 'ironically titled' appears to take its cue from Gauguin's letters to Theo van Gogh and Bernard, discussed earlier.

64– Merlhès 1984, p. 234 (1 October 1888). Gauguin likened inspiration to boiling lava in the aesthetic credo that he wrote in the guise of a fictitious oriental painter and reiterated on several occasions, including in *Diverses choses* (Gauguin 1896–8, p. 212), while Baudelaire, as cited by Gauguin in the same text (Gauguin 1896–8, p. 208), compares creative passion to 'burning bitumen on the volcano floor' ('*le bitume enflammé dans le sol d'un volcan*'). For other iterations, see Gamboni 2013, especially p. 93.

65– Merlhès 1984, p. 249 (8 October 1888).

66– Merlhès 1984, p. 249.

67– Merlhès 1984, p. 235.

68– Merlhès 1984, pp. 235, 249.

69– Gauguin wrote to Bernard in late November 1888 that 'He [Van Gogh] is romantic whereas I tend more towards a primitive state' (Merlhès 1984, p. 284).

70– Merlhès 1984, p. 235.

71– Merlhès 1984, p. 249.

72– Eugène Tardieu, 'Interview de Paul Gauguin', *L'Écho de Paris* (13 May 1895), reproduced as 'Raphaël, Rembrandt, Vélasquez, Botticelli, Cranach ont déformé la nature', in Gauguin 2017, pp. 43–6 (p. 44); translation in Gauguin 1996, p. 109. In the nineteenth century, music was deemed to be the most abstract and therefore 'purest' of the arts, and the model to which the others should aspire. Gauguin repeatedly advised artists to employ colour in a 'musical' rather than 'literary' sense; that is, without concern for fidelity to nature. In *Racontars de rapin*, for example, he proposed a synaesthetic 'analogy' between painting and music, arguing that 'in terms of colours, the poem should be more musical than literary', and affirmed that 'coloured painting is entering a musical phase' (Gauguin 2003, pp. 33–4).

73– Joly-Segalen 1950, p. 101 (14 February 1897).

74– Albert Mockel, 'La littérature des images', *La Wallonie*, December 1887, in Mockel 1962, p. 227. For instance, Aurier, whose article of 1891, 'Le Symbolisme en peinture: Paul Gauguin', used Gauguin's example to advocate a subjective rather than literal approach to the representation of nature, nonetheless observed a year later that for painters, in comparison to writers, the 'call for the right to the ideal is all the more conclusive since for them it is not possible to survive by cutting themselves off too completely from the material world' (Aurier 1892, p. 474).

75– Gauguin 1896–8, p. 263.

76– Merlhès 1984, p. 220 (*c.*7–9 September 1888). Gauguin's conceit – of appreciating a painting before knowing what it represented – was derived from a passage by Delacroix that he copied into *Diverses choses*: 'there is an effect created by a certain arrangement of colours, lights, shadows etc. It is what one would call the music of the painting. Before even knowing what the painting represents ... you are struck by this magical harmony' (Piron 1865, pp. 409–10; Gauguin 1896–8, p. 223).

77– For of an account of how the term came to be used in this expanded sense from the eighteenth century onwards, see Bright 1985. Again, Delacroix provided an example in a statement immediately preceding the passage copied by Gauguin (see the previous note): 'Whoever talks about art is talking about poetry. There is no art without a poetic aim' (Piron 1865, p. 409), but he also noted in his *Journal* that the dual use of the term to indicate both 'art' in general, and the poetic genre specifically, had the unfortunate effect of implying that verbal art was superior (see Hannoosh 1995, pp. 24–5).

78– Gauguin 2009, p. 46.

79– In August 1901 he wrote to De Monfreid that 'the painter's literary poetry is special, and not the illustration, through shapes, of something written'. Three months later he reminded his correspondent of his disdain for 'false ideas of Symbolist or any kind of literature in painting', but expressed his confidence that 'robust' works could withstand the 'wild imaginings of literary critics' (Joly-Segalen 1950, pp. 182, 185). Gauguin's anti-literary attitude and his suspicion of critics were shared by other nineteenth-century painters; his terminology recalls that of James McNeill Whistler who, in his '10 O'Clock Lecture' of 1885, dismissed the critic as a 'middle man' who distorts the 'painter's poetry' of colours and forms with literary explanations (Whistler 2004, pp. 86–7).

80– Merlhès 1984, p. 88 (14 January 1885).

81– Merlhès 1984, p. 306 (*c.*20 December 1888). Jirat-Wasiutynski 1978, pp. 191–207, has shown how Gauguin's notion of painting as parable was informed by Van Gogh's religious conception of art, and his theories of colour symbolism. On the parable as recurrent trope in Gauguin's writing, see Gamboni 2014, pp. 22–6, who notes that it allowed him to 'contrast two levels of message and two circles of addressees' (p. 23). In *Diverses choses*, he was precise about its biblical provenance: 'The Gospel of Saint Luke. Jésus says to his disciples "to you it has been given to know the secret of the kingdom of God, but for the rest: it is only offered in parables so that seeing they may not see and hearing they may not understand"' ('*Evangile St Luc. Jesus dit à ses disciples "pour vous il vous a été donné de connaître le mystère du royaume de Dieu, mais pour les autres: il ne leur est proposé qu'en paraboles afin qu'en voyant ils ne voient pas et qu'entendant ils ne comprennent pas*"', Gauguin 1896–8, p. 266/6. (Gauguin inserted a small lined notebook between pages 266 and 267 of *Diverses choses*, with pages numbered one to seven).

82– Merlhès 1984, p. 88 (14 January 1885) (original formatting and emphasis). In *Diverses choses*, Gauguin described his own painting, *Pape Moe* (1893, fig. 23), in similar terms as a mysterious parable that is perceived by the crowd as 'madness' ('*folie*', Gauguin 1896–8, p. 266/5). On Gauguin's notion of visual art as a 'language', but one that is not subordinate to the verbal, see Gamboni 2014, p. 19. Van Gogh also defined parables in terms that were opposed to conventional literary categories, in a letter to Bernard: 'This great artist – Christ – although he disdained writing books on ideas and feelings – was certainly much less disdainful of the spoken word – THE PARABLE above all' (Jansen, Luijten and Bakker 2009, letter 632, 26 June 1888).

83– Jean-Hippolyte Michon, *Système de Graphologie, L'Art de connaître les hommes d'après leur écriture* (Paris,

1875), 6th edn, 1880, pp. 144–5, cited in Merlhès 1984, pp. 409–10; see Merlhès 1984, p. 399, on Michon as Gauguin's likely source. Gauguin wrote to Camille Pissarro in October 1884 of his obsession with the study of character through handwriting and in late November or early December 1884 advised him that 'the writings of the mystics are s e p a r a t e d' (Merlhès 1984, pp. 71, 77). The phrases from the excerpt from Michon reproduced by Merlhès are those quoted by Gamboni in his discussion of Gauguin's attraction to graphology. He makes the interesting observation that, in his painting *Man with an Axe* (1891), Gauguin depicted the leaves, which he described in *Noa Noa* as 'the letters of an unknown, mysterious language' distinctly separated from one another (Gamboni 2014, p. 22).

84– Gauguin 2016, p. 18 / 2003, p. 20.

85– Gauguin 1910, p. 52.

86– Paul Gauguin, 'Huysmans et Redon' (first published by Jean Loize as 'Un inédit de Gauguin', in *Les Nouvelles littéraires*, 7 May 1953), in Gauguin 2017, p. 14. On Redon's 'monsters' in relation to contemporary theories of evolution, degeneration and racial theory, see Larson 2005, especially pp. 78–84.

87– Gauguin 2017, pp. 14–15.

88– Gauguin 1894, pp. 75, 76. In several paragraphs that have been excised from the essay as reproduced in the standard edition of Gauguin's collected writings (Gauguin 1974), he lingers over the musical structure and emotional impact of the *himene*, and registers the varied cultural backgrounds of its participants as well as its appeal to European visitors; the full essay is reproduced in Gauguin 2017, pp. 27–30.

89– Gauguin 1894, pp. 78, 80. He predicted a less hostile reception for himself, too, in the '17th latitude'. A couple of months after publishing this article, he wrote to Schuffenecker, in anticipation of his return to Polynesia, that while 'the Europeans won't give me a break, these good savages will understand me' (Merlhès 1995, p. 83, 26 July 1894). Gauguin repeatedly stressed the innate artistic sensibility of 'the savage': in *Noa Noa*, a neighbour who visits his home is drawn to a reproduction of Manet's *Olympia*: 'She told me this Olympia was truly beautiful: I smiled at that opinion and was moved by it. She had the sense of the beautiful (and the École des Beaux Arts considers that [picture] horrible!).' Gauguin 1985, p. 21 / 1988, p. 47. The trope of the naïve viewer as the ideal critic was a longstanding topos in art writing: see Wrigley 1995, p. 123, who cites the example of an eighteenth-century Salon pamphlet written from the perspective of a 14-year-old girl.

90– Gauguin 1895a, p. 222.

91– Gauguin 1895a, p. 223.

92– Gauguin 2016, p. 13 / 2003, p. 11.

93– Gauguin 2016, p. 14 / 2003, p. 11.

94– Gauguin 2016, p. 14 / 2003, p. 13. One of his particular targets is the Symbolist writer Gustave Kahn, who argued, as related by Gauguin, that criticism's literary analogies benefited artists in 'allowing them to compare visual art with the literary arts' (Gauguin 2016, p. 15 / 2003, p. 14). Such declarations of textual authority were common among writers. See Goddard 2012a, pp. 3–4, 55.

95– Gauguin 2016, pp. 15–16 / 2003, p. 15.

96– Gauguin 2016, pp. 29–30 / 2003, pp. 35–6.

97– Gauguin 2016, p. 20 / 2003, p. 22.

98– Gauguin 1895c.

99– Simpson 2009 describes how the oppositional stance adopted by avant-garde artists, and their literary supporters, in relation to market values and the related structures of state sponsorship, criticism and academic technique, itself became 'marketable currency' in *fin de siècle* art discourse.

CHAPTER TWO: NOA NOA AND THE ARTIFICE OF AUTOBIOGRAPHY

1– Gauguin 1985, pp. 12, 42 / 1988, pp. 31, 95. The original manuscript for this edition (which is Gauguin's Draft of 1893) is in the Getty Research Institute, Los Angeles. It was published in facsimile in 1954 and 1987. The most reliable transcript is the 1988 edition by Pierre Petit. Jean Loize's 1966 edition is not entirely faithful to Gauguin's original text, but the annotations and essays by Loize are valuable, as are those in Nicholas Wadley's 1985 translated edition. In the Draft, Gauguin's name is mentioned once, in reported dialogue, in an 'Appendix' to the main narrative. In later versions of *Noa Noa* it appears in an introductory chapter written in the third person.

2– As is often noted, Pomare's death was but a figurative end to Tahitian self-governance, as control had long since passed to the colonial authorities, but it allowed Gauguin to set the tone of disappointment at the fading of the 'true' Tahiti that he had hoped to find – a disillusionment that is in itself a literary trope.

3– Gauguin 1985, p. 25 / 1988, p. 53. Field 1977, p. 43, calls it 'a wish fulfillment modeled after Pierre Loti'.

4– Bouvier and Schwander 2015. For Reeves's reading on 8 February 2015, see 'Keanu Reeves Reading from Paul Gauguin's *Noa Noa*', Fondation Beyeler (published 12 February 2015) <www.youtube.com/watch?v=cj1YVgxm8bU> (accessed 12 March 2018).

5– Examples include Morice 1920 (first published 1919), De Rotonchamp 1925 and Burnett 1937, although these represent just the tip of the iceberg. Exceptions to the biographical bias in studies of *Noa Noa* include Hobbs 2002, who places it in the context of nineteenth-century artists' writings, and Wright 2018, who pays rare attention to Gauguin's use of language.

6– The landmark texts here are Solomon-Godeau 1992 (first published in 1989 in *Art in America*, no. 7, pp. 118–29) and Pollock 1992.

7– The Swedish anthropologist Bengt Danielsson, the first biographer to offer a more realistic and less romanticised account of the artist's life in Polynesia, takes Gauguin to task for painting a falsely idyllic image of Tahiti in *Noa Noa* (Danielsson 1975, pp. 180–81), but bases his chapter 'The Marriage of Koke [Gauguin]', which describes how the artist met his young Tahitian wife, on the very account whose authenticity he questions, without even acknowledging it as the source (pp. 121–36). This is just one of many cases in which scholars present this and other episodes from *Noa Noa* as though they were records of actual events.

8– Sweetman 1995, p. 332. Similarly, Mowll Mathews 2001, p. 178, observes that 'it is difficult to rely on *Noa Noa* for factual information', but also that 'the writing seems rooted in his actual experience'.

9– I use the former spelling to refer to Gauguin's character, and the latter to her potential historical referent. Conducting fieldwork in Polynesia in the 1950s and 60s, Danielsson met a man who claimed to have married Teha'amana after Gauguin left, and other local residents who testified to aspects of her behaviour and appearance. He notes that her death certificate, which records her date of death as 9 December 1918, is preserved in the Registry Office in Papeete, but he provides no further information (such as a full name) to securely connect the Teha'amana of the certificate to the one recalled by his informants. See Danielsson 1975, pp. 343–4, n. 57, p. 344, n. 60, pp. 344–5, n. 66.

10– Danielsson 1975, p. 126. Tehamana is also the name of a minor character in Pierre Loti's *Le Mariage de Loti* (1880), which served as a (counter-) model for *Noa Noa*, as we shall see. Childs 2018, p. 232, notes that the name was in use in 1890s Tahiti.

11– As Childs 2018, p. 232, notes, 'If she indeed existed as an individual, rather than being created by the artist out of an amalgam of his encounters with Pacific Islander women, she is the classic subaltern about whom the traces have vanished in the colonial archive.'

12– Moerenhout 1837.

13– Gauguin 1985, p. 43 / 1988, p. 97.

14– For a similar emphasis on *Noa Noa*'s critical distance from dominant colonialist narratives, especially in comparison to Loti, see Edmond 1997, pp. 246–64; Goddard 2009; and, recently, Wright 2018, pp. 131–2, 140.

15– Malingue 1946, p. 249. In December 1893, Gauguin mentioned the project to his wife again, referring to 'a book on my journey which is giving me a lot of work' (Malingue 1946, p. 251).

16– Gauguin 1985, p. 21 / 1988, p. 49.

17– Perelman 2017, p. 65.

18– For recent contributions to the literature on the *Noa Noa* suite, see Wright and Brown 2010 and Gamboni 2016a.

19– Eugène Tardieu, 'Interview de Paul Gauguin', *L'Écho de Paris* (13 May 1895), reproduced as 'Raphäel, Rembrandt, Vélasqeuz, Botticelli, Cranach ont déformé la nature', in Gauguin 2017, pp. 43–6 (p. 46). This is the occasion on which both the collaboration and the title are first mentioned.

20– Cahn 2004, p. 95, decries the 'stylistic frills and naive explanations' of Morice's revisions.

21– Joly-Segalen 1950, p. 188 (May 1902) (original emphases).

22– On the history of the different versions of *Noa Noa*, see Loize 1966, Wadley 1985, Cahn 2004, Goddard 2008 and Goddard 2012a, pp. 83–97.

23– Gauguin and Morice 1901. This edition was recently reprinted in facsimile (Gauguin and Morice 2018). A manuscript of *Noa Noa* in Morice's hand, dated 1897, in the Charles Morice Papers, Samuel L. Paley Library, Temple University, Philadelphia, contains minor variations to this published edition. The whereabouts of his copy of the joint manuscript of 1894–5 is unknown. In 1897, Morice published a version of *Noa Noa* – in which the wording is closer to the 1901 edition and his 1897 manuscript than to the collaborative text of 1894–5 in the Louvre manuscript – in two instalments in *La Revue blanche*, vol. 14, no. 105, pp. 81–103, and no. 106, pp. 166–90.

24– The original manuscript is in the Département des Arts Graphiques, Musée du Louvre, Paris. It was published in facsimile in 1926, 1947 and 2017. The first transcript was published in 1924 (with Gauguin listed as sole author) and a new edition in 2017. Citations here are from Gauguin and Morice 2017a, except where it is necessary to refer to the facsimile (Gauguin and Morice 2017b). None of these publications includes *Diverses choses* (see n. 28).

25– Gauguin and Morice 2017b, p. 169. There are numerous discrepancies between the table of contents at the start of the manuscript and the chapters themselves, contributing to the impression of a work in progress.

26– Moran 2017, pp. 147–51, discusses how the process of editing is made visible on the pages of the Louvre manuscript, creating a layered effect.

27– As first observed by Nicholas Wadley, 'Introduction', in Gauguin 1985, p. 8 and Wadley 1985, p. 97.

28– *Diverses choses* (1896–8) can be consulted in facsimile on the CD-ROM *Gauguin écrivain / Gauguin the Writer* (Cahn 2003). Extracts are included in Gauguin 1974 and Gauguin 2017.

29– Paul Gauguin, *Les Marges*, vol. 5, no. 21 (May 1910), pp. 169–74, with editorial note by Eugène Montfort, p. 169. Unaware of the Draft manuscript's existence, Montfort considered the one in De Monfreid's possession to be Gauguin's original version. Jean Loize, 'Bibliographie', in Gauguin 1966, pp. 151–67, here p. 160, remarks that the passage printed in *Les Marges* in fact differs little from Morice's 1901 edition and argues that Montfort's epithet 'spicier' is only really applicable to the Draft. This is broadly true of the passage as a whole, which relates the famous episode in which the narrator is guided by a young Tahitian man to find wood for carving, and is attracted by his androgynous physique (corresponding to the text of the Louvre manuscript in Gauguin and Morice 2017a, pp. 47–50). However, Morice omitted from his 1901 edition a phrase found in both the Draft and the Louvre manuscripts (and, accordingly, the extract in *Les Marges*), which he must have found too 'spicy'. Finding himself alone with the Tahitian man, the narrator feels a 'premonition of crime' (Gauguin 1988, p. 57; Gauguin and Morice 2017a, p. 49). In Gauguin and Morice 1901, p. 87, this becomes, less explicitly, 'my head pounded feverishly and my knees trembled'.

30– Morice kept Gauguin's Draft manuscript until 1908, when, in need of funds, he sold it to Sagot. The 1954 facsimile published by Berthe Sagot-Le Garrec (Gauguin 1954) includes the letter from Charles Morice to Edmond Sagot, postmarked 30 October 1908, offering the manuscript for sale.

31– Loize 1966, p. 74. He describes it as 'merely a first state, obviously incomplete, of the version sketched out by Gauguin's collaborator, Charles Morice' (Loize 1961, p. 69; see also Loize 1966, p. 69). At this point, Morice's reputation as 'irresponsible would-be modern poet' and 'evil-doer of the written word' was cemented, and it has proved difficult to dislodge. Stuckey 1988, p. 210; Daniel Guérin, 'Foreword', in Gauguin 1996, p. xxxv.

32– Nicholas Wadley, 'Introduction', in Gauguin 1985, p. 8.

33– Wadley 1985, p. 101. Cahn 2004, p. 94, similarly surmises that he 'did not want to risk writing a book on his own' and preferred to 'entrust the composition of the final text to a professional writer'.

34– Wadley 1985, p. 149.

35– Malingue 1946, p. 285. Malingue dates this letter, of which only a fragment survives, to February 1899.

36– Loize 1966, p. 72.

37– I do not mean to suggest that it is inappropriate to focus on the Draft manuscript. Alastair Wright has perceptively shown how the fragmentary nature of Gauguin's prose in the Draft conveys the artist's sense of his inability to comprehend Tahiti fully, and pointed out that this effect is muted in the more refined prose of the Louvre manuscript (Wright 2018, especially pp. 130 and 152, n. 4). The distancing and fragmentary effect that Wright describes is, I think, still strikingly present in the Louvre manuscript when considered as a physical object, but it is true that the sometimes-confusing syntax is smoothed out, and the ellipses in Gauguin's narrative chapters filled in. The problem, as occurs in some accounts, is with identifying the Draft as the only version that accurately records Gauguin's intentions (and, it is implied, biographical experiences).

38– Pierre Petit, editorial note in Gauguin 1988, p. 30, also describes the pages that precede the opening words in Gauguin's Draft manuscript.

39– Wright 2018, p. 130, points to Gauguin's revisions to the opening paragraph as evidence of his editorial input and hence the text's constructedness, and discusses the sketch and accompanying note in terms of the disjunctive and distancing effects of Gauguin's writing in the Draft (pp. 137–8).

40– These are mostly visible in the facsimile editions and are meticulously recorded by Pierre Petit in his editorial notes to Gauguin 1988. Nicholas Wadley, in Gauguin 1985, p. 80, n. 69, notes that alterations such as Gauguin's correction of '*finalement*' (finally) to '*finement*' (subtly) on p. 28 of the Draft, where 'the mistake is that of the copyist misreading the word, rather than of someone having second thoughts about the meaning', imply that he was working from earlier notes.

41– Morice 1920, p. 169. The text is inserted, with minor alterations, into the Louvre manuscript (Gauguin and Morice 2017a, pp. 36–8). See Wadley 1985, p. 88, who prints the three episodes as an appendix to his edition of the Draft manuscript, thus categorising them as autograph Gauguin. Morice downplayed Gauguin's involvement in the writing of *Noa Noa*. Annoyed that his name was left out of the billing when an extract from their collaborative text was published in *Les Marges*, he wrote to the editor, Eugène Montfort, protesting that '*Noa Noa* is mine ... much more than Gauguin's' and implying that he composed it based on conversations with the artist, not his written words: 'we spoke intimately; I wrote' (cited in Loize 1966, p. 98).

42– Gauguin 1987, p. 20. This is the passage on 'The Birth of the Stars', copied with minor changes from Gauguin 1951, pp. 39, 41–2. Huyghe 2001 (first published 1951) was the first to discuss Gauguin's transcription of selected passages from Moerenhout into this illustrated notebook, which then served as the source for the legends incorporated into *Noa Noa*.

43– Gauguin 1985, pp. 20–21 / 1988, p. 49. In their respective editions of the Draft (Gauguin 1966, Gauguin 1985, Gauguin 1988), Loize, Wadley and Petit each make different decisions about how to insert the text on this and other appended sheets into the main narrative.

44– Loize 1966, p. 111. There is ample evidence that Gauguin carefully considered and rewrote his texts. For instance, Danielsson and O'Reilly 1965, pp. 3–4, refer to notes from which he developed longer articles for the journal *Les Guêpes*, and a draft of the dedication to his daughter found in the *Cahier pour Aline*, with slightly different wording, can be found on the reverse of a drawing (see Hannah Klemm and Nancy Ireson, 'Gauguin, Cat. 38, Tahitian Eve [recto], Fragment of Inscription [verso] [1949.649 R/V]: Commentary', in Groom and Westerby 2016, para 7). In a larger sense, expanding and revising his previous texts was central to Gauguin's literary method generally.

45– Further evidence of this is the overlap between a passage at the start of chapter four of the Louvre manuscript (one of those in which 'the storyteller speaks') and Gauguin's article 'Sous deux latitudes', published in *Essais d'art libre* in May 1894. A brief reference in the Draft manuscript to 'strange music without instruments' (Gauguin 1985, p. 23) is developed in the Louvre manuscript into a paragraph describing the *himene* (Tahitian chant) (Gauguin and Morice 2017a, p. 46). This matches a section of 'Sous deux latitudes' almost verbatim (Gauguin 1894, p. 76), strongly suggesting that Gauguin, not Morice, was responsible for expanding the

artist's initial draft in this instance, and therefore plausibly in others.

46– Gauguin 1987, p. 12; Gauguin and Morice 2017a, pp. 48–9.

47– Gauguin and Morice 2017a, p. 22.

48– '"It is extraordinary that one is able to put so much mystery into so much brilliance." Stéphane Mallarmé (overheard)'. Gauguin and Morice 2017a, p. 23.

49– Gauguin and Morice 2017a, p. 23.

50– Gauguin and Morice 2017a, p. 29.

51– Gauguin and Morice 2017a, p. 26. The phrase also appears in Morice's 1901 edition (Gauguin and Morice 1901, p. 24), but the focus on Gauguin and his artistic approach is reduced overall in this version.

52– Gauguin and Morice 2017a, p. 23.

53– Gauguin and Morice 2017a, p. 23.

54– Gauguin 1896–8, pp. 240, 244.

55– Morehead 2014.

56– Gauguin 1896–8, p. 244.

57– Loize 1966, p. 105.

58– Malingue 1946, p. 285 (February 1899 to 'an unknown woman' [probably Morice's wife]).

59– Parts of this section of the chapter were first published in Goddard 2009.

60– The literature on this topic is extensive. Studies dealing in detail with Gauguin include Bongie 1991, Edmond 1997, Hughes 2001 and Childs 2013.

61– Edmond 2002, p. 150.

62– De Bovis 1909, p. 66. Danielsson 1965, p. 100, suggests that Gauguin read this source.

63– Le Chartier 1887, pp. 94–5.

64– Druick and Zegers 1991 and Druick and Zegers 2001. On the literature available to Gauguin at the Exposition Universelle, see also Frèches-Thory 2004 and Staszak 2003, pp. 83–103.

65– Malingue 1946, p. 184. Malingue dates the letter to February 1890, but Claire Frèches-Thory in Shackelford and Frèches-Thory 2004, p. 312, n. 1, adjusts this to June or July 1890.

66– Henrique 1889, p. 25. Gauguin also quotes this passage from Henrique at greater length, almost verbatim, in a letter to the artist Jens Ferdinand Willumsen (Paul Gauguin, 'Lettre au peintre danois Willumsen', *Les Marges*, 15 March 1918, pp. 165–70), and in a parenthesis at the end credits the passage to 'Conference on Tahiti, Van der Veene'. There is also a footnote to this source in Henrique 1889, but it relates to an earlier passage not copied by the artist; the phrases used by Gauguin are instead attributed to 'E. Raoul, *Tahiti*'.

67– Gauguin 1951, p. 39, refers to *Le Journal des Voyages*. Druick and Zegers 1991, p. 101, identify this as *Le Tour du Monde, nouveau journal des voyages*.

68– Monchoisy 1888, Cotteau 1888, Le Chartier 1887. Gray 1963, p. 49, suggests that Gauguin read Le Chartier and Monchoisy.

69– Once in Tahiti, Gauguin made further use of European accounts – in particular, Moerenhout's *Voyages aux îles du grand océan*, from which he derived his partial and second-hand knowledge of ancient Polynesian myth and religion.

70– Henrique 1889, n.p. (preface); see Vance 1986, p. 27. Matsuda 2005, p. 32, observes that '[Loti's] renown illustrates how little distinction was often made between "official" documents and "fiction" in the writing of nineteenth-century empire. Many were the writers, historians and political journalists who cited his tales to capture their own adventures and impressions of the South Pacific.'

71– Gauguin presents the narrator's night-time conversations with Tehamana, during which he teaches her about European religion and 'she, in turn, tells me the names of the stars in her language' (Gauguin 1985, p. 37 / 1988, p. 75), as a pretext for recounting the Tahitian cosmogony as drawn from Moerenhout (first copied into *Ancien Culte mahorie*). In the Louvre manuscript, more material from *Ancien Culte mahorie* is added to this episode, which forms part of a chapter entitled 'The Polynesian genesis'. For material drawn from Moerenhout in the colonial guidebooks, some of which overlaps with that used by Gauguin, see Monchoisy 1888, pp. 174–8; Le Chartier 1887, pp. 92, 96–101.

72– Gauguin 1985, p. 12 / 1988, p. 31.

73– Gauguin 1985, pp. 12–13, 14 / 1988, pp. 33, 37.

74– Henrique 1889, p. 25.

75– Loti 2002, pp. 15, 33 / 1928, pp. 7, 36.

76– Monchoisy 1888, pp. 32, 31.

77– Malingue 1946, p. 195. Gauguin refers to the 'studio of the tropics' in an earlier letter, also dated by Malingue (p. 191) to June 1890.

78– Alfred Werner, 'Introduction', in Gauguin, *Noa Noa* (New York: Noonday Press, 1961), p. xii; Stuckey 1988, p. 210. Peter Brooks, 'Gauguin's Tahitian Body', in Brooks 1993, pp. 162–98, describes *Noa Noa* as 'misleading' in its 'narrative of shedding civilisation, progressing back to primitivism, and becoming savage' (p. 181). As if to debunk Gauguin's myth-making, Brooks points out that 'if food grew on trees, he didn't know how to gather it' (p. 182); however, this is precisely the predicament that *Noa Noa*'s narrator himself describes.

79– Gauguin 1985, p. 19 / 1988, p. 45.

80– Druick and Zegers 2001, pp. 84, 96, 99. In *Avant et après*, Gauguin disparagingly identified Loti's 'innumerable adjectives' as the mark of a 'talent for description' (Gauguin 1923, p. 105 / 1951, p. 117).

81– Druick and Zegers 2001, pp. 343–4.

82– Octave Mirbeau, 'Retour de Tahiti' (*L'Écho de Paris*, 14 November 1893), newspaper cutting in Gauguin 1989, vol. 2, n.p. Wadley 1985, p. 144, describes the article as 'obviously briefed by Gauguin'. Nonetheless, he judges that Gauguin's 'strenuous efforts to dissociate himself seem justified' and concludes that 'the comparison between Gauguin and Loti has little to offer'.

83– Several scholars have noted that Loti's tale was a stimulus for *Noa Noa*. Belinda Thomson presented a detailed account of Loti's influence on Gauguin's art and writing in an unpublished paper, 'Bridging the *"distance infranchissable"* separating Paul Gauguin and Pierre Loti', delivered at the conference '*Invitation au Voyage*: the exotic in French art and literature since 1800', Centre for the Study of Visual and Literary Cultures in France, University of Bristol (2007).

84– Analyses of Gauguin's and Loti's texts can be found in Edmond 1997, pp. 241–64, and Hughes 2001, pp. 9–40. Hughes aligns the two and argues that 'Gauguin is unequivocal about his incorporation into Polynesian culture' (p. 36). I agree with Edmond, who distinguishes them, and notes that in *Noa Noa* the narrator's 'attempt to recreate himself as a "savage" is repeatedly ironised' (p. 247).

85– Gauguin 1985, p. 13 / 1988, p. 33; Loti 2002, p. 18 / 1928, p. 11.

86– Gauguin 1985, pp. 13, 19, 23 / 1988, pp. 37, 45, 51.

87– Gauguin 1985, pp. 23–4 / 1988, p. 51.

88– Loti 2002, p. 126 / 1928, p. 178.

89– Hughes 2001, p. 15.

90– Loti 2002, pp. 12, 11 / 1928, pp. 2–3.

91– Loti 2002, pp. 132, 90, 126 / 1928, pp. 188, 121, 178–9. See Hargreaves 1981, p. 55.

92– Loti 2002, p. 57 / 1928, p. 74.

93– Gauguin 1985, p. 33 / 1988, p. 69.

94– Homi K. Bhabha addresses the ambivalence of colonial subjectivity in his classic essay, 'The Other Question ...' (Bhabha 1983).

95– Gauguin 1985, p. 33 / 1988, p. 69.

96– Gauguin 1985, p. 16 / 1988, p. 41 (original emphasis).

97– Gauguin 1985, p. 23 / 1988, p. 51. (Translation modified: Jonathan Griffin's translation in Gauguin 1985 of '*je devinais qu'elles voulaient être prises sans un mot – prise brutale. En quelque sorte: désir de viol*' as 'I wanted them to be willing to be taken without a word: taken brutally. In a way a longing to rape' alters the sense of the original.)

98– Wettlaufer 2007, pp. 41–2, and Stotland 2018, pp. 47–8, explore the ambivalent blend of fear, desire and identification that the narrator expresses during his encounter with Princess Vaitua, one of the additional narrative episodes in the Louvre manuscript (Gauguin 1985, pp. 51–2; Gauguin and Morice 2017a, pp. 36–8). The narrator's move from initial repulsion ('I saw only the jaws of a cannibal ... she seemed wholly unattractive') to attraction ('how one changes! because now I found her beautiful'), which results ultimately in a sense of comradely sympathy with the androgynous Tahitian princess, mirrors Strindberg's and Morice's gradual appreciation of Gauguin's own initially rebarbative artworks.

99– Gauguin 1985, p. 25 / 1988, p. 57.

100– Gauguin 1985, pp. 25, 28 / 1988, pp. 55, 57.

101– Gauguin 1985, p. 28 / 1988, pp. 57, 59.

102– Stuckey 1988, p. 210.

103– Edmond 1997, p. 251. Wadley 1985, pp. 125, 127, also

notes Gauguin's references to his European identity in *Noa Noa*, but nonetheless proposes that the text narrates his conversion into a 'savage', and that after the incident with the woodcutter, 'the conversion is completed' (p. 129).

104– In particular, see Hal Foster, 'Primitive Scenes', in Foster 2004, pp. 1–52 (first published in *Critical Inquiry*, no. 20, Autumn 1993), and Lee Wallace, 'Gauguin's *Manao Tupapau* and Sodomitical Invitation', in Wallace 2003, pp. 109–37.

105– Gauguin 1985, p. 25 / 1988, pp. 55, 57.

106– Wettlaufer 2007, p. 49, also notes that after this episode 'Gauguin spends the remainder of *Noa Noa* oscillating between his personae as "*un sauvage*" and the "*vieux civilisé*" whom he can never truly escape.'

107– Gauguin 1985, pp. 32, 35, 40 / 1988, pp. 65, 71–2, 87.

108– Gauguin 1985, p. 57 / Gauguin and Morice 2017a, p. 73. The name of the narrator's wife is changed from Tehamana in the Draft to Tehura in the Louvre manuscript.

109. Gauguin 1985, p. 20 / 1988, p. 47.

CHAPTER THREE: 'SCATTERED NOTES'

1– Although *Diverses choses* is dated 1896–7 on its title page, the words 'end of the volume, January 1898' ('*fin du volume, janvier 1898*') appear on the final page, p. 346.

2– I cite from the manuscript in the Musée du Louvre (Gauguin 1896–8). A facsimile is available on CD-ROM (Cahn 2003). In Gauguin 2017, several passages in which he discusses artistic matters are included, out of sequence, under invented headings (such as 'on perspective'), and intermixed with similar passages extracted from *Avant et après*. In Gauguin 1974, passages from *Diverses choses* are listed under its proper title, but the editor, Daniel Guérin, admits (p. 157) to having reorganised the text, incorporating portions of it into Gauguin's other writings where the themes connect.

3– '*Notes éparses, sans suite comme les Rêves, comme la vie toute faite de morceaux: Et de ce fait que plusieurs y collaborent; l'amour des belles choses aperçues dans la maison du prochain.*' (Gauguin 1896–8, p. 205). See Wright 2010, p. 74.

4– Gauguin 2009, p. 17; Gauguin 1923, p. 15 / 1994a, p. 32.

5– There is, of course, an extensive literature on the

'Romantic fragment', including the classic study by Philippe Lacoue-Labarthe and Jean-Luc Nancy, *The Literary Absolute: The Theory of Literature in German Romanticism*, trans. Philip Barnard and Cheryl Lester (Albany: State University of New York Press, 1988); originally published as *L'Absolu littéraire* (Paris: Éditions du Seuil, 1978). For a useful overview of literary fragmentation in Romanticism, see Janowitz 1999. On the French context see, among others, Susini-Anastopoulos 1997 and, for the nineteenth century in particular, Hamon 2001. While an in-depth exploration of the broader interest in fragmentary modes of composition in nineteenth-century French literature and visual culture falls outside the scope of this chapter, it is clear that Gauguin was familiar with this tradition, since in his writings he cites a number of authors associated with it. I address some of these instances in this chapter.

6– '*Mon Dieu, que de choses enfantines on pourra trouver en ces pages, écrites tant de délassement personnel, tant de classement d'idées aimées*'; '*si œuvre d'art était œuvre d'hasard, toutes ces notes seraient presque inutiles. Je ne pense point ainsi: j'estime que la pensée qui a pu guider mon œuvre ou une œuvre partielle est liée très mystérieusement à mille autres, soit miennes, soit entendues d'autres hommes.*' (Gauguin 1896–8, p. 205). He repeated many of the sentences from the opening section of *Diverses choses*, as well as other passages from this manuscript, in *Avant et après*.

7– Baudelaire, for instance, famously described genius as 'childhood recovered at will' (Baudelaire 1975–6, vol. 2, p. 1159, cited in Gamboni 2014, p. 68). On Gauguin's valorisation of childhood and its metaphorical connection to the primitive, see Gamboni 2014, especially pp. 67–8, 275–81. One indication of this is Van Gogh's observation in a letter to his brother Theo that 'Gauguin and Bernard are now talking about doing "children's painting"' (Jansen, Luijten and Bakker 2009 [letter 668, 23 or 24 August 1888]).

8– Jules Huret, 'Paul Gauguin devant ses tableaux', *L'Écho de Paris* (23 February 1891), in Gauguin 1974, p. 70; Gauguin 1896–8, p. 207.

9– '*bien loin, plus loin que les chevaux du Parthénon … jusqu'au dada de mon enfance, le bon cheval de bois!*' (Gauguin 1896–8, p. 208).

10– '*Si … je me suis attaché à tel fait, telle vision, telle lecture, ne faut-il pas, en un mince recueil, prendre souvenance? Je crois que l'homme a certains moments de jeu, et les choses enfantines sont loin d'être nuisibles à une œuvre sérieuse*' (Gauguin 1896–8, p. 207).

11– Gauguin 1896–8, p. 208.

12– Alongside his discussion of Schumann and the rocking horse, Gauguin also evokes Camille Corot's *A Morning: Dance of the Nymphs* (1850), praising the artist for his 'naivety' (he knows how to 'make [the nymphs] dance' despite a lack of 'study') and his ability to convert 'the hovels of Parisian suburbs into true pagan temples' ('*Ce délicieux Corot, sans aucune étude de danse à l'Opéra, tout naïvement du reste … sut les faire danser, toutes ces nymphes, et … transformer tous les cabanons de la banlieue de Paris en vrais temples païens*') (Gauguin 1896–8, p. 207).

13– In the painted version (1888), the girl holds a sprig of blossoming oleander in her left hand, conjuring Gauguin's comparison of artists to flowers in *Diverses choses*. Gauguin connected artists, children and flowers on another occasion: in the letter to Van Gogh, discussed in chapter one, describing his *Self-Portrait with Portrait of Émile Bernard (Les Misérables)* (1888, fig. 28), he comments that 'the girlish little background, with its childish flowers, is there to signify our artistic virginity' (Jansen, Luijten and Bakker 2009 [letter 692, 1 October 1888]).

14– Gauguin 1896–8, pp. 240–45. For the context of the exchange with Strindberg, see chapter two, p. 80.

15– As cited in Gauguin 1896–8, p. 243, in his letter to the artist Strindberg had written that 'in your paradise dwells an Eve who is not my ideal – for I, too, have one or two ideals when it comes to women!' ('*dans votre paradis habite une Eve qui n'est pas mon idéal – car j'ai vraiment moi aussi un idéal de femme ou deux!*').

16– 'The Maori or Turanian language, which my Eve speaks' ('*la langue maorie ou touranienne, que parle mon Eve*') (Gauguin 1896–8, p. 245; translation in Gauguin 1996, p. 105).

17– Gauguin 1896–8, p. 245; translation in Gauguin 1996, p. 105.

18– Gauguin and Morice 2017b, pp. 50–51.

19– Gauguin 1896–8, p. 245; trans. in Gauguin 1996, p. 105.

20– According to Bengt Danielsson, the verses that Gauguin copied were from a popular Tahitian song entitled 'Oviri', on the theme of a 'savage' heart torn between two love interests (Danielsson 1975, p. 130). Danielsson provides a French translation (pp. 130–31) and notes (p. 344, n. 58) that Morice's poem, 'Vivo' (Flute), transcribed by Gauguin on the preceding pages (Gauguin and Morice 2017b, pp. 48–9), is loosely based on it. Scholars have debated the extent to which Gauguin knew, or made efforts to learn, Tahitian. By giving his artworks Tahitian titles, incorporating passages of Tahitian into his manuscripts, and using misspelled Tahitian words as puns, he may have intended to make his writing more mysterious and perhaps also to signal his integration into the local culture. In order better to understand Gauguin's particular employment of Tahitian, further research would be required into linguistic practices in 1890s Polynesia. This might suggest parallels between the complexities of language use in the colonial context, and Gauguin's hybrid combinations of French and Tahitian, which may or may not be idiosyncratic in comparison to the linguistic habits and knowledge of other western travellers in the region.

21– On nineteenth- and twentieth-century French authors' enthusiasm for the *fait divers*, see Walker 1995 and Jullien 2009.

22– Loize 1966, p. 86, claims that 'the idea of Gauguin's illustrating *Noa Noa* in a sustained fashion is appealing, but simplistic, and incorrect', although he does also assert loose links between some of the prints and watercolours in chapter four (one of the 'storyteller's' tales of life in Tahiti) and the surrounding text (Loize 1996, pp. 79, 125–6).

23– Gauguin and Morice 2017a, p. 22. See chapter two for an account of the different versions of *Noa Noa*, and the artist's collaboration with Morice.

24– It is not certain whether the painter or the poet authored the preface: it does not appear in either Gauguin's original Draft or Morice's 1901 edition, and the manuscript, dated 1897, in Morice's hand (Charles Morice Papers, Samuel L. Paley Library, Temple University, Philadelphia) contains a different preface.

25– The clearest indication that this was their purpose is Gauguin's comment in a letter to Morice that he had just

'finished my work (engraving) for *Noa Noa*. I believe that will contribute much to the success of the book.' (Unpublished letter cited in Loize 1966, p. 76). Several efforts have been made to suggest a sequence for the prints or to relate them to episodes in *Noa Noa*. However, it is likely that they were destined for a separate portfolio and that their order was intended to be flexible. Gamboni 2016a, para. 40, provides a useful overview of scholarly debate on the topic.

26– These probably belong to a group of around 13 watercolour and wash compositions that the artist also created in 1894. Morice wrote to Gauguin in March 1897 and on 22 May 1901, indicating that his coarse-grained paper made it difficult to reproduce his designs photo-mechanically; see Gamboni 2016b, paras 4 and 9. In his unpublished journal, Morice makes multiple references to sending and retrieving a drawing, or drawings, by the artist ('*un dessin*' or '*les dessins de Gauguin*') from various publishers, on 9, 27 October 1896 (Charles Morice, *Petit Journal I*, Bibliothèque et Archives des Musées Nationaux, Musée du Louvre, Paris), 29 October, 3 November 1897, 29, 30 January 1899, and on 4 September and 3 December 1908 he notes plans for an 'illustrated *Noa Noa*' ('*Noa Noa illustré*') (Charles Morice, *Petit Journal*, Samuel L. Paley Library, Temple University, Philadelphia).

27– As recorded by Hungarian artist József Rippl-Rónai on the back of an impression of *Te Nave Nave Fenua* (National Gallery of Art, Washington, DC) presented to him by Gauguin (Gamboni 2016a, para 27, n. 50).

28– Julien Leclercq, 'Exposition Paul Gauguin', *Mercure de France*, no. 13 (February 1895), pp. 121–2; translation in Wright 2010, p. 77.

29– '*Croquis japonais, estampes d'Hokusai, lithographies de Daumier, de Forain, école de Giotto*' (Gauguin 1896–8, pp. 231, 232). A sequence of reproductions of works by artists corresponding to Gauguin's list, with the addition of Lucas van Leyden, appears on pp. 236–9. The same passage, including the list of artists and the reference to a 'little exhibition', appears in *Avant et après*, but the corresponding images are absent (Gauguin 1994a, pp. 106–7).

30– See Perelman 2017, p. 69.

31– René Huyghe (Huyghe 2001, first published 1951) identified Moerenhout as the source for *Ancien Culte mahorie*. In three appendices, he details the passages from Moerenhout that make up *Ancien Culte mahorie*, and the correspondences between the latter and *Noa Noa* in terms of both text and illustrations.

32– Gauguin wrote to André Fontainas in February 1903 regarding *Avant et après*: 'Reading between the lines you will understand my personal and mischievous interest in getting this book published. I WANT it to be, even in a simple edition. I am not anxious for it to be read by many – certain people only.' (Malingue 1946, p. 308).

33– Childs 2003, pp. 75–6, makes a persuasive connection to one particular souvenir travel album by naval officer A. P. Godey, a fellow voyager on Gauguin's return to France in 1893, which combines personal reminiscences with sketches, photographs and quotations, including a poem entitled 'Tiare Noa noa Tahiti'.

34– For definitions of the album in the Romantic period, see Le Men 1987; Higonnet 1992 addresses several examples from the second half of the nineteenth century.

35– Monnier 1832, pp. 199–200; see Le Men 1987, p. 43. The feminine associations of Gauguin's scrapbook method align with his use of female aliases, discussed in the next chapter.

36– Higonnet 1992, p. 179.

37– Theodore Reff, 'Introduction', in Reff 1976, vol. 1, p. 2. These are notebooks 28 (J. Paul Getty Museum, compiled *c*.1877) and 29 (Morgan Library, compiled *c*.1877–80) in Reff's catalogue.

38– Known as '*Carnet 1*' (Bibliothèque Nationale de France, compiled *c*.1859–64); notebook 18 in Reff 1976. On Degas's exploration of repetition and reproduction in this sketchbook, see O'Rourke 2016. Degas's own experimental printmaking, like Gauguin's, challenged the distinction between creating and reproducing. Like the younger artist, he repeated and reworked motifs across a range of media, and extended the limits of the monotype by using it as a basis for further compositions; see Hauptman 2016.

39– See, among others, Stuckey 1988, p. 212.

40– See Childs 2003, pp. 74–5, who notes that the first volume of the *Journal de Eugène Delacroix* (Paris: Plon,

1893–5), published in 1893, reproduced a page of notes and drawings from his Moroccan sketchbook (Delacroix 1893, facing p. 168). This album, acquired by the Louvre in 1891, was one of several sketchbooks from Delacroix's North African journey. As well as reproducing one of the pages, the 1893 edition of the *Journal* extracts the notes from it. Gauguin could also have known of Delacroix's plans for a book about his travels, provisionally titled *Souvenirs d'un voyage dans le Maroc*, as the project was mentioned by the artist's executor, Eugène Piron, in an anthology of Delacroix's writings from which Gauguin quoted in *Diverses choses*, as discussed below (Piron 1865, p. 90). Michèle Hannoosh recently unearthed this manuscript, and published it in her edition of Delacroix's diaries (Delacroix 2009, vol. 1, pp. 264–324; see also p. 181, n. 31).

41– Unpaginated Preface [p. 1] in Delacroix 1893.

42– Paul Flat, 'Eugène Delacroix', in Delacroix 1893, p. v. On Delacroix's awareness of the public value of his *Journal*, his self-conscious reworking and repackaging of its contents, and his fascination with the autobiographies of public figures, see Hannoosh 1995, pp. 3–4, 6–7.

43– 'Notes de Delacroix', in Gauguin 1896–8, pp. 219–21, as first noted by Huyghe 1952, pp. 33–4.

44– Piron 1865, pp. 430, 437.

45– Piron 1865, p. 419.

46– Hannoosh 1995, pp. 55–92 and passim.

47– An earlier version of this and the following five paragraphs was previously published in Goddard 2011. See that essay for further discussion of Gauguin's assemblage method and use of borrowed texts in *Diverses choses*.

48– Gauguin 1895c. In this article Gauguin elected himself to speak on behalf of those artists not selected by the French jury to take part in the 1895 International Exhibition in Berlin, and noted the conspicuous absence of 'avant-garde writers' from the debate. Roger Marx's review, 'L'Exposition Paul Gauguin', appeared in *La Revue encyclopédique*, vol. 4, no. 76 (1 February 1894), pp. 33–4.

49– Gauguin 1896–8, p. 229. Marx notes that Baudelaire and Gauguin both embarked on their travels at a young age, and describes Baudelaire's prose poem as a 'a reliable forecaster of Gauguin's obsessions' ('*annonciateur fidèle des hantises de Gauguin*'). Accordingly, the passage quoted

from 'Les Projets' includes images familiar from Gauguin's paintings and texts, such as 'On the sea shore, a charming wooden hut surrounded by all these strange and glistening trees' ('*au bord de la mer, une belle case en bois enveloppée de tous ces arbres bizarres et luisants*'), and ends with the anti-materialist statement: 'Yes, to tell the truth, *that* was indeed the setting that I was looking for. What would I do with a palace?' ('*Oui, en vérité, c'est bien là le décor que je cherchais. Qu'ai-je à faire de palais?*').

50– '*groupés en ce recueil, non par hasard, de par ma volonté, tout à fait intentionnée. Parce que d'apparences différentes je veux en démontrer les liens de parenté*' (Gauguin 1896–8, p. 231).

51– Gauguin 1896–8, p. 231. See n. 10 above.

52– Gauguin 1896–8, p. 233. He is referring to his pasted-in photograph (see fig. 10) of Giotto's fresco of *Mary Magdalene arriving in Marseilles with her Companions* from the Lower Church of San Francesco, Assisi.

53– Gauguin 1896–8, p. 232.

54– '*prétendu grand peintre [qui] marche à pieds joints sur toutes les règles de perspective*' (Gauguin 1896–8, p. 232).

55– Gauguin 1896–8, p. 252.

56– '*que c'est difficile la peinture quand on veut exprimer sa pensée avec des moyens picturaux et non littéraires*'; '*Et je dirai comme Paul Verlaine. Qu'as tu fait, o toi que voilà.*' (Gauguin 1896–8, p. 252).

57– Gauguin 1896–8, pp. 253, 224, 206.

58– Gauguin's masquerade as 'the great professor Mani Vehbi-Zunbul-Zadi' ('*le grand professeur Mani Vehbi-Zunbul-Zadi*') (Gauguin 1896–8, p. 209) is discussed in the following chapter. Citations from the Bible appear throughout *Diverses choses*. Gauguin copied out (Gauguin 1896–8, pp. 258–9) part of a translated Icelandic Viking saga, 'Chant de mort de Regner Lodbrog, roi de Danemark' from P. H. Mallet's *Histoire de Dannemarc*, Brussels, 1787, vol. 2, pp. 295–8; see Amishai-Maisels 1985, p. 104.

59– Gauguin 2009, pp. 19–22; Gauguin 1896–8, pp. 213–15. Gauguin's source was probably the translation by Émile Hennequin, *Contes grotesques par Edgar Poe* (Paris: Paul Ollendorff, 1882); see Merlhès 1989b, p. 44.

60– The manuscript is in the Bibliothèque de l'Institut National d'Histoire de l'Art [INHA] (NUM MS 227) and is

accessible online at <www.purl.org/yoolib/inha/5749> (accessed 27 October 2018). There are two facsimile editions (1963 and 1989; reprint 2015). Since it is unpaginated, for ease of reference I refer to the transcript (Gauguin 2009) when citing from the text, but this edition does not reproduce the illustrations or press cuttings. The pasted-in article by Dolent (which Gauguin also copied into *Diverses choses*, Gauguin 1896–8, pp. 227, 230) obscures a longer dedication to Aline, and the arrangement of the page as illustrated here is preserved only in the 1963 facsimile. In the 1989 transcript and on the INHA website, the full text appears (as in the 2009 transcript), the newspaper cuttings re-glued onto a separate page by the conservators.

61– Gauguin 2009, pp. 23–6. Gauguin's source was Camille Benoît, *Richard Wagner: Musiciens, poètes et philosophes: aperçus et jugements* (Paris: G. Charpentier, 1887), and his extracts combined citations from Wagner's articles and letters with Benoît's commentary; see Merlhès 1989b, pp. 50–54. Gauguin first copied passages from this source in an untitled and undated manuscript (*c.*1885–6) held in the Département des Manuscrits Occidentaux, Bibliothèque Nationale de France, Paris (NAF 14903), comprising unattributed passages from Wagner and from Robert Schumann (fols 44–5) and followed (fols 45–6) by the 'Zunbul-Zadi' text. He reproduced these phrases from Wagner again in *Diverses choses*, Gauguin 1896–8, pp. 215–17, and shorter extracts on several other occasions.

62– Gauguin 2009, p. 22.

63– Gauguin 2009, p. 48.

64– Gauguin 1896–8, p. 208. Wright 2010, pp. 89–90, makes a similar point regarding a reproduction of *Ia Orana Maria* (1891) that Gauguin cut from *Le Figaro illustré* (January 1894) and pasted into the Louvre album (Gauguin 1896–8, p. 125), making its status as a reproduction clearly visible by allowing the newsprint to remain visible at the edges.

65– On the shift, in the more recent literature, towards acknowledgement and analysis of Gauguin's tendency towards repetition, see my discussion in the introduction.

66– Camille Pissarro, letter of 23 November 1893 to his son Lucien (Pissarro 1950, p. 217).

67– Solomon-Godeau 1992, p. 326.

68– Gauguin and Morice 2017b, p. 131. Wadley 1985, pp. 111–12, also stresses Gauguin's open acknowledgement of Moerenhout (I have corrected Gauguin's habitual misspelling of the author's name as 'Morenhout'). As can be seen in the facsimile, Gauguin mentions Moerenhout's name on three other occasions in the Louvre album, sometimes in footnotes (Gauguin and Morice 2017b, pp. 130, 131, 134, 153). Neither of the two transcripts of this version (Gauguin 1924 and Gauguin and Morice 2017a) includes all of these instances.

69– In an influential study, Richard Field showed in detail how Gauguin reworked a borrowed image to fit its different contexts. He concluded that as an anti-realist it was logical for him to draw inspiration from an archive of images rather than from direct observation of nature (Field 1960, see especially pp. 139, 141). Richard Brettell continued in this tradition when he proposed that the artist absorbed his sources so fully that the borrowed passages '*become Gauguin*' and are scarcely distinguishable from his own voice. Although he downplays the significance of copying as such, Brettell provides a useful account of how the mobility of paper as a medium facilitated the artist's fondness for reproduction (Brettell 2007).

70– Gauguin and Morice 2017b, p. 130. Gauguin does not credit Moerenhout consistently. The prayer that Tehura utters after she admits that she has been unfaithful and the 'old Maori saying' with which she bids the narrator goodbye both derive from his account, but Gauguin does not identify their provenance on these occasions. Gauguin and Morice 2017b, pp. 199–200, 204.

71– Gauguin and Morice 2017b, p. 134.

72– Charles Palermo also interprets Gauguin's attribution of knowledge to Tehura as well as Moerenhout as deliberate, suggesting that the artist may have intended to 'create an opposition between revelation received from an old book and revelation passed down through a living link with its origins' (Palermo 2015, p. 195, n. 22).

73– Teilhet-Fisk 1983, p. 25; D'Alleva 2011, p. 174 and passim.

74– Childs 2013, pp. 168–9.

75– Norma Broude has recently reinterpreted the predominance of women as symbols of a lost Tahitian past

in Gauguin's work, not as reaffirming a pejorative connection between the feminine, the primitive and the natural, but as alluding to the important cultural and political roles held by Tahitian women, especially in the precolonial era (Broude 2018b, pp. 84–91). On the continuation of women's authority in 1890s Tahiti, see also D'Alleva 2011, pp. 179–80.

76– Moerenhout acknowledges his debt to Orsmond, if not the full extent of it, as well as to the English missionary William Ellis, in Moerenhout 1837, vol. 1, pp. 445 (footnote), xiv (footnote). In the introduction to part two of his book, on 'Ethnography', he describes how Chief Tati introduced him to an unnamed old Tahitian priest on Raiatea, who informed Moerenhout about traditional religion and culture. Adding to the theatrical character of the account, the author presents this section as an extract from his diary, in which he recalls being summoned by the elusive priest with a piece of paper on which is written a fragment of a legend, before hurriedly undertaking a dangerous journey overnight by canoe to reach his host (Moerenhout 1837, vol. 1, pp. 382–94).

77– Gauguin and Morice 2017b, p. 153.

78– Gauguin and Morice 2017b, p. 134. Gauguin is referring to *Poèmes barbares* (1862), the collection by Charles Leconte de Lisle (1818–1894), which included the poem 'La genèse polynésienne', based on Moerenhout. As discussed in chapter two, Gauguin consulted a number of other guidebooks to Polynesia, both before and after his departure from France in 1891, and several of these themselves relied on Moerenhout, despite being written half a century later.

79– Rosen and Zerner 1984, pp. 24–6. In the Romantic fragment tradition, a disjointed literary style often went hand in hand, as it did in Gauguin's writing, with literary borrowings, whether through the inclusion of maxims and aphorisms, parody or unacknowledged citation, as in the work of writers such as Gérard de Nerval (1808–1855) and Comte de Lautréamont (1846–1870). On Nerval, see for example Cummins 2006, pp. 54–61, and Gille 2010, pp. 50–51, who compares the fragmentary form of Nerval's travel writings to that of Gauguin's.

80– For an analysis of the project, see Bertrand Marchal,

'Notice [Notes en vue du "Livre"]', in Mallarmé 1998–2003, vol. 1, pp. 1372–83, who suggests that 'Mallarmé knows that he will never write the Book, and, at the same time, that he is always writing it' (p. 1375).

81– Stéphane Mallarmé, 'Observation relative au poème *Un coup de Dés jamais n'abolira le Hasard*' (1897), in Mallarmé 1998–2003, vol. 1, p. 391.

82– Charles Baudelaire, 'À Arsène Houssaye', in Baudelaire 1975–6, vol. 1, p. 275. (This letter was first published in *La Presse*, of which Houssaye was the editor, on 26 August 1862, and was used as the preface when the collection was published posthumously in 1869.) Hamon 2001, p. 37, cites Baudelaire in his study of how nineteenth-century literature emulated the non-linearity of the image, in an era saturated with new forms of visual media.

83– Anon., 'Les Cahiers d'André Walter', *L'Art Moderne*, vol. 11, no. 26 (28 June 1891), pp. 203–4. To mention just one example of the tendency towards brief, disconnected literary forms, *Le Mercure de France*, to which Gauguin subscribed while in Tahiti, ran a series of 'Petits aphorismes' in 1891–3 alongside its articles on philosophical and aesthetic subjects.

84– '*Me relisant, j'aurais honte de l'enfantillage de ces écrits, si dès le début je n'avais formulé mes aptitudes enfantines.*' (Gauguin 1896–8, p. 346).

CHAPTER FOUR: GAUGUIN'S AVATARS

1– Bouge 1952, p. 11. See n. 61 below for further details.

2– Malingue 1946, p. 279 (November 1897). *L'Esprit moderne* is signed and inscribed with the date '1897 1898' on the front cover (see fig. 56), establishing its connection to the earlier essay in *Diverses choses*. It is this first version, 'L'Église catholique et les temps modernes', to which Gauguin refers in his letter of 1897 to Morice, promising to copy it out and send it to him. As Childs 2004, p. 241, points out, the dedication to Morice at the end of *L'Esprit moderne* (at which point the date 1902 appears) confirms his intention to follow through on this promise and send the manuscript to Paris, although this ultimately did not happen.

3– See chapter one, p. 37.

4– With reference to *L'Esprit moderne*, Andersen 1972,

p. 241, concludes that Gauguin, too ill to paint, 'indulged in the elder statesman's occupation of setting down his *pensées* for posterity'. In contrast, Childs 2004, pp. 224–7, emphasises the intensity of his labour on this and other texts during this period and the seriousness with which he took 'his status as a published author' (p. 224).

5– Recent accounts have shown that Gauguin's self-mythologising involved an element of self-awareness, irony and even melancholy, as the variety of personae and alter egos that he adopted allowed him to explore the mutability and constructedness of identity. Notable examples are Thomson 2010a and Thomson 2010b, Wright 2010, Moran 2017 and Stotland 2018.

6– Joly-Segalen 1950, p. 151 (December 1899, original emphasis).

7– On the distrust of artists who write, see Goddard 2012b, pp. 411–12. Commenting, in a letter of February 1903 to De Monfreid, on *Le Mercure de France*'s refusal to publish *Racontars de rapin*, Gauguin observes sarcastically that literary men 'are happy to criticise painters, but they don't like it when painters come and expose their stupidity' (Joly-Segalen 1950, p. 195).

8– For other accounts of Gauguin's use of literary alter egos and pseudonyms, see Wright 2010, pp. 66–7 (where he also notes that this was a broader phenomenon among the artist's colleagues), 74–5, and Moran 2017, pp. 100–07. Parts of the remainder of this section of the chapter were previously published in an earlier form in Goddard 2018.

9– Daftari 1991, pp. 46–63. Fereshteh Daftari details Gauguin's different iterations of this text and the circulation of copies among the Neo-Impressionists, and identifies, but rules out, potential Ottoman sources, concluding that Gauguin invented it. In an untitled manuscript in the Bibliothèque Nationale de France (NAF 14903, fol. 45), under the heading '*Tiré du livre des métiers de Vehbi-Zunbul-Zadi*', Gauguin began, 'So says Mani, the painter giver of precepts' ('*Ainsi parle Mani, le peintre donneur de préceptes*'), which gives the impression that he is recording 'Mani's' words as cited in a *Book of Crafts* by Vehbi-Zunbul-Zadi. However, when he included a version of the text in *Diverses choses* (Gauguin 1896–8, pp. 209–12) and *Avant et après* (Gauguin 1923, pp. 31–3 / 1994a, pp. 63–7), he

combined the names to form 'the great professor Mani Vehbi-Zunbul-Zadi, the painter and giver of precepts' ('Mani' is omitted from the published edition of *Avant et après*, Gauguin 1923, p. 31 / 1994a, p. 63, but in the facsimile, Gauguin 1951, p. 35, the dot on the 'i' is visible and an empty space implies the word). A briefer extract in *Cahier pour Aline* (Gauguin 2009, p. 27) refers instead simply to 'Zunbul-Zadi'.

10– He adds, 'If you are curious to know what this artist could have said in these barbarous times, listen.' The episode finishes, 'In the year X all this took place.' (Gauguin 1923, pp. 31, 33 / 1994a, pp. 63, 67; Gauguin 1896–8, pp. 209, 212).

11– See chapter one, n. 64.

12– 'M. Félix Fénéon sends us the translation of several passages from the *Book of Crafts*, by the Hindu Wehli-Zunbul-Zadé' ('Préceptes', *L'Art Moderne de Bruxelles* [10 July 1887], reprinted in Fénéon 1970, vol. 1, p. 81).

13– Any remaining illusion is definitively shattered when Mani is interrupted by 'such evil-sounding words as Naturalist, Academician, and the like' issuing from the woods but carried away on the wind (Gauguin 1923, p. 33 / 1994a, p. 66; Gauguin, 1896–8, p. 212).

14– Paul Gauguin, 'Exposition de la Libre Esthétique', *Essais d'art libre*, vol. 4 (February 1894), p. 30 (reprinted in Gauguin 2017, p. 24). In *Racontars de rapin*, the sentence in question (with minor variations), 'Do not work too much after you have finished, you will cool the lava of boiling blood, you will make a stone of it. Even if it is a ruby, throw it far away', is prefaced by 'the painter from the East told his disciples' (Gauguin 2016, p. 33 / 2003, p. 39). Gauguin also included it, without any attribution, in a letter to an unknown correspondent (probably Madame Morice), dated by Maurice Malingue to February 1899 (Malingue 1946, p. 286).

15– Seurat and Gustave Kahn may have been deceived, as the latter wrote, 'Seurat was worried by what people called Gauguin's paper … it was an extract from an oriental text on the colouring of carpets.' (Kahn 1924, p. 16). However, Gauguin's early biographers saw through the ruse; see Morice 1920, p. 230, and De Rotonchamp 1925, p. 247. When Fénéon republished the text in 1914, he

acknowledged that Gauguin was probably its author (Félix Fénéon, 'Extrait du *Livre des Métiers*, de l'Hindou Wehli Zunbul Zadé', *Petit Bulletin*, no. 4 [14 March 1914], reprinted in Fénéon 1970, vol. 1, pp. 280–82).

16– As in *Diverses choses*, for instance, where he describes colour in synaesthetic terms as 'the language of the eye which listens' and observes that the 'Orientals, Persians and others' ('*Les Orientaux, Persans et autres*') have employed it with a 'marvellous eloquence' in their carpets ('*ont doté leurs tapis d'une merveilleuse éloquence*') (Gauguin 1896–8, pp. 266/3–4).

17– Merlhès 1984, p. 88 (14 January 1885). See chapter one, p. 59 and n. 83

18– Merlhès 1984, p. 410, provides other examples of contemporary characterisations of Cézanne as mystical and oriental. In *Avant et après*, Gauguin similarly bestowed Edgar Degas with timeless wisdom, while also mocking biographical conventions: 'Degas was born … I don't know when, but it was so long ago that he is as old as Methuselah' (Gauguin 1923, p. 62 / 1994a, p. 122). The use of racial descriptors to convey artists' passionate and unconventional temperaments was widespread. Charles Baudelaire's reference to Eugène Delacroix's 'Peruvian or Malay-like colouring' and suggestion that 'his whole being in short suggested the idea of an exotic origin' ('L'Œuvre et la vie d'Eugène Delacroix' [1863]; translation in Mayne 1995, p. 68) may have encouraged Gauguin's own self-image as a 'savage from Peru'.

19– Merlhès 1989b, p. 39. The state of the dedication page as Gauguin left it, with the longer dedication obscured, is visible only in the 1963 facsimile (Gauguin 1963). In the 1989 facsimile (Gauguin 1989), the full text appears, as in the 2009 transcript (Gauguin 2009) and the digitised version on the INHA website. See chapter three, n. 60.

20– Gauguin 2009, p. 15. On Gauguin's identification with another female member of his family, his grandmother Flora Tristan, and their shared interest in the constructed nature of identity, see Wettlaufer 2007.

21– The phrase was identified by Suzanne Damiron in her 1963 facsimile edition of Gauguin's *Cahier pour Aline* (Gauguin 1963, vol. 1, unpaginated). Others have drawn a similar conclusion from this inscription. Wayne Andersen

('Introduction', in Gauguin 1996, p. xxiii) doubts Gauguin ever intended to give the notebook to his daughter and judges it 'more likely reserved for the daughter within himself', and Alastair Wright (Wright 2010, p. 75) interprets it to mean that 'Gauguin began writing it as an adult male using the voice of a girl.' Linnea S. Dietrich's observation (Dietrich 1991, p. 65) that 'it is as if some sympathetic person, like a daughter, had written and collected all this material about him in a scrapbook' hints at the fact that the *form* of the manuscript is also gendered.

22– Gauguin 2009, p. 15; Gauguin 1896–8, p. 205. Wright 2010, p. 74, also identifies *La Mousmé* as 'the figurehead – the spokeswoman, as it were – of Gauguin's text'.

23– 'To make Mme Gloanec accept the painting, Gauguin finally signed it Madeleine B., declaring that it was in fact the work of a *débutante*. When I bought it, many years later, Mme Gloanec assured me that she had not been taken in for a moment.' (Maurice Denis, 'Paul Sérusier, sa vie, son œuvre', in Paul Sérusier, *ABC de la peinture, suivi d'une étude sur la vie et l'œuvre de Paul Sérusier, par Maurice Denis* [Paris: Floury, 1942], p. 59; cited by Françoise Cachin, catalogue entry for *Still Life: Fête Gloanec*, in Brettell et al. 1988, p. 107).

24– On the distinct association of albums and scrapbooks with young women in the nineteenth-century French context, see Higonnet 1992 and Le Men 1987, pp. 41–3, who quotes the observation by L'Hermite de la Chaussée d'Antin (Victor Joseph Étienne de Jouy) in 1811 that 'every woman is inseparable from her Album' (p. 42).

25– '*Il faut vous dire que je suis une femme et que je suis toujours prête à applaudir lorsque j'en vois une autre plus hardie que moi combattre pour notre liberté de mœurs à l'égal de l'homme.*' Gauguin 1952 (no. 1, 21 August [1899], p. 3). The individual issues in the facsimile edition of *Le Sourire* are not numbered or paginated, nor dated in a consistent format, but their order is clear. I supply an issue number and date following Bouge 1952, as well as page numbers.

26– Gauguin 1952 (no. 1, 21 August [1899], p. 4).

27– '*Et le monstre, étreignant sa créature, féconde de sa semence des flancs généreux pour engendrer Seraphitus Seraphita*' (Paul Gauguin, 'numéro original du "Sourire"',

Cabinet des Dessins, Musée du Louvre, RF 28844; trans. Chris Miller in Gamboni 2014, pp. 124–5). In this handwritten copy of the first issue of *Le Sourire*, which Gauguin dedicated to François Cardella, mayor of Tahiti, the sentence thus appears twice on the final page, both within the review and as a caption to the illustration.

28– Paul Gauguin, letter to Ambroise Vollard, cited in John Rewald, 'The Genius and the Dealer', *Art News*, vol. 58, no. 3 (May 1959), pp. 30–31, 62–5 (p. 62), as referenced in Charles F. Stuckey, catalogue entry for *Oviri*, in Brettell et al. 1988, p. 371. For a discussion of *Oviri* in relation to concepts of creativity and the theme of androgyny in Balzac's novel, see Gamboni 2013, pp. 100–01.

29– On the passage in *L'Esprit moderne*, see the Introduction in this volume, and Childs 2004, pp. 235–6, who discusses the influence of the feminist and socialist writer and campaigner Flora Tristan, Gauguin's grandmother, on his critique of marriage and advocacy of equality for women, while also noting the differences in their positions. Gauguin's denunciation of marriage as a form of prostitution was in the service of a libertarian (and self-interested) commitment to free love, rather than primarily invested in the notion of women's economic security. For a discussion of the limitations of Gauguin's feminism along these lines, see Mathews 1999, pp. 163–5, and for detailed analyses of the relation between Tristan's ideas and Gauguin's, see Wettlaufer 2007 and Broude 2018b. On Gauguin's knowledge of Tristan's writings and their influence on his satirical journalism, see also Thomson 2010b, pp. 13–14.

30– For example, 'Zunbul-Zadi' concludes his advice by warning that he will not make recommendations about which type of brush or paper to use since 'These are things that are asked by girls with long hair and limited intelligence who reduce our art to the level of embroidering slippers or making delicious cakes.' ('*Ce sont là choses que demandent les jeunes filles à longs cheveux et à esprit court qui mettent notre art au niveau de celui de broder des pantoufles et de faire de succulents gâteaux.*') (Gauguin 1896–8, p. 212).

31– Gauguin 1952 (no. 2, 19 September [1899], p. 3). This tale also appears in *Diverses choses* (Gauguin 1896–8,

p. 329) and *Avant et après* (Gauguin 1923, p. 26 / 1994a, p. 54), but is not attributed to Tit-Oïl on these occasions.

32– Gauguin 1952 (no. 3, 13 October [1899], p. 3).

33– 'Tit-Oïl' is close to Tahitian words related to male masturbation: *titoi* and *titoitoi*, as first noted by Danielsson and O'Reilly 1965, p. 3, n. 1. See the *Dictionnaire en ligne de l'Académie Tahitienne – Fare Vana'a* <www.farevanaa.pf/dictionnaire.php> (accessed 2 December 2018). See also Eisenman 1997, p. 100, who also suggests a connection to *titio* (shit). As for PGo, Wayne Andersen ('Introduction', in Gauguin 1996, p. xxiii) observes that it is 'pronounced "pego" no doubt; a piece of slang, meaning "prick", picked up from Gauguin's merchant marine years'. The pun results in an anglicised phonetic representation of the first syllable of his surname as 'Go', which complements the British origin of this eighteenth-century slang word. Gauguin described himself as a 'rough sailor' in *Avant et après* (Gauguin 1923, p. 79 / 1994a, p. 148).

34– Gauguin used these terms to describe the literary style of *Avant et après* (where several passages of *Le Sourire* are repeated) in a letter of February 1903 to André Fontainas (Malingue 1946, p. 308). In *Cahier pour Aline*, he celebrated argot for its innovation, saying, 'It is at Mazas [prison] that the genius of language is to be found; there a new word is introduced and forever after understood. At the Academy one can only proceed by etymology and it takes a century to adopt a new expression.' (Gauguin 2009, pp. 40–41).

35– Gauguin 1896–8, p. 255. '*Ah! Si vous croyez que c'est une petite affaire que d'être journaliste: obligé de tourner sa langue 10 fois avant de parler.*' Gauguin 1952 (no. 7, February [1900], p. 3). Similarly, in *Avant et après*, Gauguin writes that 'to navigate these rocky waters without crashing is no small affair. I had to study the detours to avoid going to prison.' (Gauguin 1994a, p. 73).

36– '*Je ne vous dirai pas la vérité, tout le monde se vante de la dire; la Fable seule indiquera ma pensée si toutefois rêver est penser.*' Gauguin 1952 (no. 1, 21 August [1899], p. 1). In the second issue, he repeats '*Je ne vous dirai pas la vérité, tout le monde se vante de la dire.*' Gauguin 1952 (no. 3, 13 October [1899], p. 2).

37– In full the preamble reads: 'Anecdotes translated from the Greek are often entertaining. To offer one here without

guaranteeing the reliability of the translator does not seem an audacity beyond my means but rather a jolly game.' (*'Anecdotes traduites du grec souvent divertissent: en raconter une ici sans garantir la fidelité du traducteur ne me paraît pas une hardiesse hors de mes moyens mais plûtot un jeu de joyeux compagnon.'*) Gauguin 1952 (no. 2, 19 September [1899], p. 1). As Giraud 2010, pp. 74, 254, observes, 'Toutoua' is a phonetic representation of the Tahitian word *tutu'a*, meaning a sore or a flea bite, or 'bitten by an insect', and distorted Tahitian words are central to the coded language of *Le Sourire*. The anecdote also appears in *Avant et après* (Gauguin 1994a, pp. 73–7), where Gauguin presents it as an example of his cunning use of linguistic 'detours' to avoid getting into trouble.

38– Gauguin 1952 (no. 2, 19 September [1899], pp. 1, 3); see n. 10.

39– Gauguin 1923, pp. 36–7 / 1994a, pp. 71–2.

40– Gauguin 1994a, pp. 71–3. This final section, as well as the passage that follows, which is a repeat of the 'Toutoua' story, have been omitted from the English edition (Gauguin 1923).

41– Scholarship on Gauguin's journalistic writings tends to be limited to brief accounts of the circumstances that led to his new vocation, and of the political context of his partisan attacks (the most detailed of these is Boime 2008, pp. 214–18), or alternatively to a discussion of *Le Sourire* that focuses primarily on its visual dimension and relation to his graphic works. For instance, Harriet K. Stratis's view that 'the often-incoherent text [of *Le Sourire*] distracts from the graphic impact of the fifteen small woodblock prints and several mimeographed sketches that accompany it' (Stratis 2017, p. 42) demonstrates the tendency to interpret Gauguin's writing as an unfortunate distraction from his art. However, for a more developed discussion of Gauguin's literary approach in his journalism, see Giraud 2010, pp. 105–26 and passim, and Moran 2017, pp. 100–07. See also the useful introductions in Bouge 1952 and Danielsson and O'Reilly 1965, and, on *Le Sourire*, Broadway 2016.

42– Paul Gauguin, 'Tribune Libre', *Les Guêpes*, no. 5 (12 June 1899), in Danielsson and O'Reilly 1965, pp. 23–4. Danielsson and O'Reilly note that the lacunary state of the Bibliothèque Nationale de France's holdings of *Les Guêpes*, despite the legal deposit requirement, obliged them to collate issues of the journal from a variety of sources. In a table (between pp. 2 and 3) they enumerate all the issues of the journal and list the articles signed by Gauguin (or Tit-Oïl). On the basis of commonalities of style, and a manuscript in Gauguin's hand consisting of notes for an unsigned article published in the journal, they conclude that he probably wrote many of the anonymous pieces too (pp. 3–4).

43– Danielsson and O'Reilly 1965, pp. 5–7. Teilhet-Fisk 1983, p. 138, and Sweetman 1995, pp. 471–2, similarly present Gauguin's journalistic endeavours as a serendipitous result of the feud with Charlier. Nancy Mowll Mathew's suggestion that Gauguin may have had a hand in launching *Les Guêpes* in March 1899, two months before the publication of the first issue in which articles appeared under his name, is more plausible (Mowll Mathews 2001, p. 232).

44– Danielsson and O'Reilly 1965, p. 22, footnote.

45– Tit-Oïl, 'Le Champignon parasol de Sumatra', in Danielsson and O'Reilly 1965, pp. 22–3.

46– Paul Gauguin, Untitled [Rimbaud et Marchand], in Danielsson and O'Reilly 1965, pp. 24–7 (here p. 25); translation in Eisenman 1997, p. 159.

47– Aldrich 1990, p. 157, notes that the average length of posting for a governor in Tahiti was 15 months, and that colonists often complained that these brief terms resulted in ignorance and lack of concern about local conditions.

48– On the social demographic of French settlers in Tahiti, see Aldrich 1990, pp. 141–3, and Sweetman 1995, p. 278.

49– Aldrich 1990, pp. 152–3.

50– For a fuller discussion of Gallet's reform, see Danielsson and O'Reilly 1965, pp. 12–13. Membership of the *Conseil général* was limited to those who could speak and write French.

51– On the incident in 1892, see Danielsson 1975, pp. 105–7. Gauguin described his rejection by Governor Étienne Théodore Lacascade in bitter and racist terms in the appendix to the Draft manuscript of *Noa Noa*, repeatedly calling him 'the negro Lacascade' (Gauguin 1985, pp. 43–4 / 1988, pp. 101–3). On Gauguin's efforts to gain

employment in the colonial administration in 1898, and his tenure as a draughtsman in the Department of Public Works, see Mowll Mathews 2001, p. 228.

52– Gauguin 1923, p. 38 / 1994a, p. 79 (translation modified). He goes on to explain how this stood him in good stead when he needed to buy land from the Catholic Church on Hiva Oa: 'Hypocrisy has its good points. When my hut was finished, I no longer thought of making war on the Protestant pastor, who was a well brought up young man with a liberal mind besides; nor did I think any longer of going to church.' (Gauguin 1923, p. 39 / 1994a, pp. 80–81).

53– Paul Gauguin, 'Tribune Libre', *Les Guêpes*, no. 5 (12 June 1899), in Danielsson and O'Reilly 1965, pp. 23–4; translation in Sweetman 1995, p. 471.

54– Paul Gauguin, Untitled [Rimbaud et Marchand], in Danielsson and O'Reilly 1965, pp. 24–7 (here p. 26). He repeats 'The administration is the enemy of colonisation' in Paul Gauguin, 'La Machine Colbert', *Les Guêpes*, no. 6 (12 July 1899), in Danielsson and O'Reilly 1965, pp. 28–9 (here p. 29).

55– Gauguin observes that the crowd at the rally is united by their fidelity 'to the wishes of the metropole, above all the sense of pride in being French. It is as a Frenchman, a name that is particularly dear to me, that I wished ... to claim your attention for a few minutes.' (Paul Gauguin, 'Bulletin mensuel', *Les Guêpes*, no. 21 [12 October 1900], in Danielsson and O'Reilly 1965, pp. 47–9). White plantation owners in Tahiti imported Chinese labourers, notably to work on a Tahitian cotton plantation in the 1860s. Among those who survived the harsh conditions of transportation and labour, some remained when the project folded, and established a growing community. On the history of the Chinese population in Tahiti, see Aldrich 1990, pp. 166–7, and on Gauguin's contribution to the anti-Chinese rally, see Danielsson 1975, pp. 266–9; Sweetman 1995, pp. 485–7; and Boime 2008, pp. 216–18.

56– See the discussion in the Introduction. Gauguin's attacks on the Catholic Church and colonial authorities in Atuona, and his support of the Marquesans, indicate that he adopted an increasing distance from French colonial society at the end of his life, which was facilitated

by the smaller community on Hiva Oa. However, this shift of allegiance did not necessarily indicate a complete change of heart (as suggested, for example, by Boime 2008, p. 202). His opportunism, anti-establishmentarianism, and empathy for the social outcast, meant that an enemy in one context might become a friend in another (Protestants, not Catholics, were the underdog in the Marquesas), and support and sympathy for the Indigenous community increased when it intersected with his own liberationist goals.

57– Danielsson and O'Reilly 1965, p. 19.

58– Joly-Segalen 1950, p. 195 (February 1903, to George-Daniel de Monfreid).

59– Noanoa, 'Terre délicieuse', *Les Guêpes*, no. 15 (12 April 1900), in Danielsson and O'Reilly 1965, pp. 44–5. The extracts are from the introductory first chapter, entitled 'Songeries' in the Louvre manuscript, and from a prose poem entitled 'Vivo' by Morice, at the beginning of chapter 3.

60– 'Avis' (Notice) in *Les Guêpes*, no. 9 (12 October 1899), in Danielsson and O'Reilly 1965, p. 31.

61– Copies and editions of *Le Sourire* are rare. A complete set, which was among Gauguin's possessions at his death, is now in the Kroepelien collection in the University of Oslo Library, where it has been digitised and can be viewed at <https://bibsys-almaprimo.hosted.exlibrisgroup.com/primo-explore/fulldisplay?docid=BIBSYS_ILS71481929910002201&context=L&vid=UIO&lang=en_US (accessed 8 April 2019). However, some of the pages have been reproduced out of sequence. In 1952, L.-J. Bouge published a facsimile of Gauguin's set accompanied by an essay and annotations (Gauguin 1952), which is the source I reference here. Gauguin also sent a copy of eight issues to George-Daniel de Monfreid, the first five of which he copied out by hand, which is now in the Houghton Library, Harvard University. A manuscript copy of the first issue of *Le Sourire*, which Gauguin dedicated to Tahiti's mayor François Cardella, is in the Cabinet des Dessins of the Musée du Louvre. The Art Institute of Chicago holds six of the nine issues as well as a second copy of the November issue, which are catalogued and accompanied by an introductory essay in Groom and Westerby 2016.

62– Joly-Segalen 1950, p. 151; translation in *The Letters of Paul Gauguin to Georges Daniel de Monfreid*, foreword by Frederick O'Brien, trans. Ruth Pielkovo (New York: Dodd, Mead, 1922), p. 127.

63– Paul Gauguin, *Le Sourire* (MS Typ 611–611.1), Houghton Library, Harvard University. Bouge 1952, pp. 12–13, outlines the principal differences between the original set and the copies produced for De Monfreid. He also provides (Gauguin 1952, pp. 17–21) very brief summaries of each issue in the facsimile, noting any differences in the corresponding De Monfreid ones, and a list of the woodcuts found in the journal, or featuring its masthead (p. 22). Bouge notes that the paper used for the copies sent to De Monfreid is of a superior quality to that on which Gauguin printed his newspaper in Tahiti.

64– In 'Le Gouverneur automate de Vaucanson', a parody of Governor Gallet as one of the automata of Jacques de Vaucanson (1709–1782), Gauguin remarks that 'The Petit Journal has a print run of a million and Le Sourire twenty-one – add to that 4 copies, but free, for the legal deposit. Injustice of the day.' ('*Le petit journal tire à un million d'exemplaires et le Sourire à vingt et un – ajoutez y 4 numéros mais gratis au dépôt legal. Injustice des temps.*') Gauguin 1952 (no. 3, 13 October [1899], pp. 1–2). This suggests that Gauguin printed about 25 copies of each issue. At the end of the story, he asks, 'Well, my 21 readers ... isn't Le Sourire better than Le Petit Journal?' ('*Eh bien, mes 21 lecteurs ... le Sourire ne vaut-il mieux que le petit Journal?*')

65– These included *Le Journal officiel des Établissements français de l'Océanie* and *Messager de Tahiti* (1884–99). Confusingly, the former newspaper was founded in 1852 as *Messager de Tahiti: Journal officiel des Établissements français de l'Océanie*, but retained only the subtitle from 1884.

66– On the illustrated periodical press in nineteenth-century Europe, see Mainardi 2017, pp. 73–118. Giraud 2010, p. 115, notes the similarity between *Le Sourire*'s title and that of several satirical journals of the period, such as *L'Éclat de rire* or *Le Pétard*. Belinda Thomson suggests another model in *Le Fifre*, edited by the artist Jean-Louis Forain (Thomson 2010a, p. 203).

67– For more on the mimeograph printing method, see Broadway 2016, paras 1–4. A mimeograph machine was sold at the auction of Gauguin's effects after his death (see *Dossier de la succession Paul Gauguin 1957*, p. 41, item 90). The format of *Le Sourire* is unusual. If opened out to form a single folio, the left-hand side forms the first page, and the right-hand side the second, and this logical sequence continues when the sheet is flipped over, with the left- and right-hand sides forming the third and fourth pages respectively. However, this means that when folded in half (in three cases, a single separate leaf is also inserted and labelled 'Supplement'), the title page ends up on the back if the spine is on the left-hand side. To read the issue in sequence, it is necessary to turn it over and begin on the back page, then flip to the front for page two, before opening it up to read the third and fourth pages. The suggestion, in the Art Institute of Chicago's catalogue of their holdings, that 'the pages are turned from left to right when the text is read in its proper sequence' is therefore not quite accurate (Broadway 2016, para. 8). Bouge 1952 does not comment on this arrangement, which adds to the somewhat bewildering experience of reading *Le Sourire*.

68– Bouge 1952, p. 16.

69– These are reproduced in an appendix in Gauguin 1952, with the corresponding identifications by Bouge on p. 22. Impressions of four of these masthead designs are in the collection of the Art Institute of Chicago (Groom and Westerby 2016, cats 18–21).

70– See the Introduction, p. 13, for a discussion of this method.

71– '*un lavement au pippermint*'; '*surtout ne lui donnez pas d'autre journal à lire que les Guêpes ou le Sourire*'. Gauguin also promotes his various endeavours in *Le Sourire*: 'If you want to educate yourself, read Les Guêpes; If you want entertainment, read Le Sourire; If you want to learn how to draw, go to Coulon's place to see the collection of drawings by the caricaturist P. Gauguin' ('*Qui veut s'instruire, qu'il lise les Guêpes; Qui veut s'amuser, qu'il lise le Sourire; Qui veut apprendre le dessin, qu'il aille chez Coulon voir la collection de dessins du caricaturiste P. Gauguin*'). Gauguin 1952 (no. 8, March [1900], p. 4).

72– '*Tant de délassement personnel, tant de classement*

d'idées aimées, quoique folles, peut-être, je rédige Le Sourire.' Gauguin 1952 (no. 1, 21 August [1899], p. 1). See also Gauguin 1896–8, p. 206; Gauguin 1994a, p. 32.

73– See Hobbs 2002.

74– The first four issues are subtitled '*Journal sérieux*'; issues five to seven are subtitled '*Journal méchant*'; issue eight has no subtitle but begins with an article titled 'Serious things' ('*Choses sérieuses*'); the ninth issue has no subtitle and begins with an article titled 'Unlikely tales' ('*Racontars improbables*').

75– Mallarmé 1978. He produced eight issues between September and December 1874.

76– Garelick 1998, p. 48. On Mallarmé's use of female pseudonyms, see Lyu 2000.

77– Mallarmé 1978, p. 60 (20 December 1874). On *La Dernière Mode*'s 'hybridity as both private artwork and public circular', see Brevik-Zender 2016, p. 687. Wright 2010, p. 99, n. 93, observes that *Le Sourire* combines 'the *technology* of mass circulation and the *look* and *sound* of something like a rarified Symbolism'.

78– As when he asserted in *Racontars de rapin*, 'I'm going to try to talk about painting, not as one of the literati, but as a painter.' (Gauguin 2016, p. 13 / 2003, p. 11).

79– Garelick 1998, pp. 61–2, interprets Mallarmé's *La Dernière Mode* as a 'precursor of a modern drag performance' and discusses other nineteenth-century French authors who adopted female pseudonyms, were involved with fashion journals, or generally exhibited the 'sexual ambiguity' associated with dandyism. On models of literary masculinity, and challenges to them, in the nineteenth century, see also Harkness 2007.

CONCLUSION: WRITING PRIMITIVISM

1– Letter of January 1897 to Charles Morice, in Gauguin 1974, pp. 151–2; translation in Gauguin 1996, pp. 122–3. An abbreviated version of this letter is published in Malingue 1946, pp. 274–5, omitting the part with the interview. The complete dialogue is cited in Danielsson 1975, pp. 228–9.

2– When France established a protectorate in Tahiti in 1842 it signed a treaty with England recognising the independence of Huahine, Bora-Bora and Raiatea-Tahaa in the Îles Sous-le-Vent (or Leeward Islands) archipelago.

After the treaty was repealed in 1887 the islands continued to resist French governance and trade laws. In 1895 the rulers of Huahine and Bora-Bora accepted Chessé's diplomatic overtures, but Raiatea stood firm. In a final, ultimately successful effort to conquer Raiatea, France sanctioned an attack led by Tahiti's governor, Gustave Gallet, in 1897. On Gauguin's participation in the expedition of 1895, see Eisenman 1997, pp. 157–9, and Danielsson 1975, pp. 211–13.

3– Letter of October 1895 to the composer William Molard, in Gauguin 1974, p. 143; translation in Gauguin 1996, p. 115. In an earlier letter to Molard of July 1895, he wrote, 'what is a disaster for the colony and for commerce is an advantage to me, that is the rate of exchange'. See Eisenman 1997, p. 158.

4– Gauguin 1974, p. 153; translation in Gauguin 1996, p. 123.

5– See Danielsson 1975, pp. 229–30. This attempt to publish *Noa Noa* did not come to fruition.

6– Jolly 2000, p. 92, describes him as 'moving not so much beyond as down the hierarchy of white colonial society' and defines him ultimately as 'an avant-garde rebel within an imperial system' (p. 98).

7– In the same letter to Morice, he complains about having been classed as a 'pauper' in a recent application for treatment at the hospital, adding, 'You will easily understand that, although in great pain, I had to refuse to go in with a mixed lot of soldiers and servants.' (Gauguin 1974, p. 153; translation in Gauguin 1996, p. 124). On Gauguin's reactionary celebration of a bygone aristocratic era in which artists were accorded appropriate respect, and his trumpeting of his own 'noble' origins via his maternal ancestors, members of the Spanish colonial elite in Peru, see Dagen 2010, pp. 45–6.

8– Gauguin 1974, p. 153; translation in Gauguin 1996, p. 123.

9– Malingue 1946, p. 308 (February 1903).

10– Malingue 1946, p. 238 (letter of December 1892 to Mette Gauguin).

11– Paul Gauguin and Charles Morice, 'Noa Noa', *La Revue blanche*, vol. 14, no. 105 (15 October 1897), pp. 81–103, and no. 106 (1 November 1897), pp. 166–90. The 'Note' appears in the second instalment, on pp. 183–4.

12– Ky Dong (Nguyen Van Cam) 1989, pp. 44, 48;

translation in Eisenman 1997, p. 190. On Van Cam's play, see Eisenman 1997, pp. 189–91.

13– Gauguin 1952 (no. 1, 21 August [1899], p. 1). Using a similar formulation, Gauguin wrote to Maurice Denis in 1895 congratulating him for having publicly attacked art critics, and urging him to continue fighting 'whether with the brush or with the pen' (letter of March 1895 in Malingue 1946, p. 267), and in his open letter in *Les Guêpes* to the prosecutor Édouard Charlier, with whom he had quarrelled (see chapter four, p. 138), he provocatively declared that he knew 'how to hold a pen and a sword' (Paul Gauguin, 'Tribune Libre', *Les Guêpes*, no. 5 [12 June 1899], in Danielsson and O'Reilly 1965, p. 24).

14– Gauguin 1952 (no. 1, 21 August [1899], pp. 1–2).

15– Fry 1918. See Thomson 2010b, pp. 19–20.

16– Sadler 1911, p. 30. Like Fry, he calls Gauguin a 'painter and poet' (p. 32). Referring to the Post-Impressionist exhibition organised by Fry the previous year, Sadler relies on the passage of *Noa Noa* in which the narrator describes coming home to find his Tahitian wife alone and afraid in the dark for his interpretation of *Manaò tupapaú*.

17– Sadler 1911, p. 31. The German writer Julius Meier-Graefe similarly stressed the dual merits of Gauguin's writing: '[*Noa Noa*] is not merely a unique poem in contemporary literature ... it is also the history of Gauguin's art.' Julius Meier-Graefe, *Modern Art: Being a Contribution to a New System of Aesthetics* [1904] (trans. London, 1908), p. 63, cited in Dickson 2010, p. 66. As Amy Dickson observes, the influence of Gauguin's writings on Meier-Graefe's text demonstrates 'the artist's own role in the creation of a "Gauguin myth"'.

18– Gavin Parkinson also charts the significance of Gauguin's writing and his 'personal legend' for his appeal to the Surrealists (see, for example, Parkinson 2018, pp. 207–9).

19– On Segalen and Gauguin, see especially Manceron 2004 and Forsdick 2010. An initial auction of household items was held in Atuona (Hiva Oa), but a crate of documents, including the manuscripts, was sent to Nuku Hiva, to be included in the subsequent auction in Papeete (Tahiti). These are listed as items 1 to 18 *bis* in *Dossier de la succession Paul Gauguin* 1957, p. 26.

20– Segalen 1989, p. 84 (entry for 4 August 1903); translation in Manceron 2004, p. 333, n. 10. Segalen's *Journal des îles* is in the Bibliothèque Nationale de France, Département des Manuscrits, NAF 25786 (here folio 40v). The *Journal* is digitised and can be viewed online at <https://gallica.bnf.fr/ark:/12148/btv1b525104022/f133.planchecontact> (accessed 20 December 2018).

21– Among the 13, mostly unidentified, manuscripts in this box were certainly the *Cahier pour Aline*, the Louvre album containing *Noa Noa* and *Diverses choses*, and *L'Esprit moderne et le catholicisme* (see the Introduction, n. 5). In addition, '1 collection of the journal Le Sourire' is listed as item 47 in the *Dossier de la succession Paul Gauguin* 1957, p. 28.

22– Segalen 1989, pp. 84–8. In a paper titled 'Masters of Pleasure: Segalen, Gauguin, Nietzsche', delivered at the annual conference of the College Art Association in New York (2017), Paul Galvez explored the ways in which Segalen was particularly alert to questions of form and materiality in Gauguin's art.

23– Segalen 1989, p. 88. The passages from *Cahier pour Aline* are copied onto folios 40–43 of the original *Journal*.

24– See Schlick 2002, p. 3. Segalen's writings on Gauguin comprise passages in his *Journal des îles*; 'Gauguin dans son dernier décor', *Mercure de France*, vol. 50, no. 174 (June 1904), pp. 679–85; 'Hommage à Gauguin', in *Lettres de Paul Gauguin à Georges-Daniel de Monfreid* (Paris: Crès, 1918), pp. 1–77 (revised edn Joly-Segalen 1950, pp. 11–47); and the unfinished novel *Le Maître-du-Jouir* (centred on a character named Gauguin). These three texts are reprinted in Victor Segalen, *Hommage à Gauguin, l'insurgé des Marquises*, ed. Jean-Luc Coatalem (Paris: Magellan, 2003). However, as Charles Forsdick notes, the artist's influence is evident across Segalen's literary output and correspondence (Forsdick 2010, pp. 57, 62).

25– Segalen 2002, p. 13. References to the French edition are to Segalen 1986, here p. 33. Subsequent citations from these editions provide the page number for the English translation, followed by the corresponding page number in the French edition.

26– Segalen 2002, p. 21 / 1986, p. 44.

27– Segalen 2002, pp. 14, 19 / 1986, pp. 36, 41. Segalen

notes that in his writings on 'the Maori race' (these included his published novel *Les Immémoriaux*, 1907), he wanted to reverse the usual perspective and account for 'the effect that the traveller has on the living milieu rather than the milieu's effect on the traveller' (Segalen 2002, p. 14 / 1986, p. 36).

28– Segalen 2002, pp. 15, 29 / 1986, pp. 37, 54 (original emphasis).

29– Segalen 2002, p. 63 / 1986, p. 95. Elsewhere in the 'Essay on Exoticism', he advocates social and economic 'diversity' by praising aristocratic rule and the concept of the 'great man', makes a laconic reference to *Essai sur l'inégalité des races humaines*, the 1853–5 racist tract of Joseph-Arthur de Gobineau (1816–1882), and expresses a horror of 'intermingling' (Segalen 2002, pp. 63, 65, 69, 62 / 1986, pp. 94, 97, 105, 94). On these problematic aspects of Segalen's thought, see Forsdick 2010, p. 56, and Schlick 2002, pp. 3–4. In *Le Maître-du-Jouir*, the part-Polynesian, part-European or possibly Chinese Sara is an object of both fascination and disgust to the character named Gauguin. He rejects Sara's love for him on the grounds of her mixed ethnicity, describing her as 'worse than the bastard offspring of a snake and a bird' with her 'Maori eyes' but pale skin, 'too heavy breasts', 'too thin lips' and weak shoulders (Segalen 2003, p. 111).

30– James Clifford observes that Segalen 'reckoned with more troubling, less stable encounters with the exotic' than those typified by Pierre Loti. However, he senses 'an elegiac lament for the vanishing primitive' in Segalen's novel *Les Immémoriaux*, which charts the crisis precipitated by its Polynesian protagonist's memory lapse during the recitation of a sacred genealogy (Clifford 1998, pp. 152, 154). Charles Forsdick, in contrast, sees Segalen as invested in the 'struggle to maintain difference' rather than the 'inevitability of its decline' (Forsdick 2000, p. 104). Segalen himself is at pains to distinguish between exoticism and colonialism (see Segalen 2002, p. 66 / 1986, p. 105) and to contrast the '*exot*' (defined as a 'born traveller'), who appreciates diversity, with the colonial bureaucrat, who is motivated only by commerce (Segalen 2002, pp. 20, p. 35 / 1986, pp. 42, 61).

31– Segalen 2002, pp. 57–8 / 1986, p. 88 (original emphasis).

32– See Schlick 2002, p. 4. Charles Forsdick also discusses how Segalen experimented with the form of the novel and invented new generic categories (Forsdick 2000, pp. 112–13).

33– Segalen 2003, pp. 94–5.

34– In his *Journal des îles*, Segalen focuses exclusively on Gauguin's supposed affinity with Indigenous Polynesians: 'He was loved by the natives, whom he defended against the police, the missionaries, and the whole apparatus of murderous "civilisation". He also taught the Marquesans that no one could force them to attend school. *In a sense, it was the final support of the ancient religion.*' (Segalen 1989, p. 93; translation in Manceron 2004, p. 276 [original emphasis]).

35– Gauguin 1923, p. 138 / 1994a, p. 251.

36– Gauguin 1923, p. 132 / 1994a, p. 240.

BIBLIOGRAPHY

Adamson, Natalie, and Linda Goddard, 2012, 'Artists' Statements: Origins, Intentions, Exegesis', *Forum for Modern Language Studies*, vol. 48, no. 4, pp. 363–75

Aldrich, Robert, 1990, *The French Presence in the South Pacific, 1842–1940* (Basingstoke: Macmillan)

Amishai-Maisels, Ziva, 1985, *Gauguin's Religious Themes* (New York: Garland)

Andersen, Wayne, with the assistance of Barbara Klein, 1972, *Gauguin's Paradise Lost* (London: Secker and Warburg)

Aurier, Albert (as Marc d'Escaurailles), 1889, 'La critique sans phrases', *Le Moderniste illustré* (27 June), p. 76

Aurier, Albert, 1891, 'Le Symbolisme en peinture: Paul Gauguin', *Mercure de France*, vol. 2, no. 15 (March), pp. 155–65

———1892, 'Les Symbolistes', *Revue encyclopédique* (April), pp. 474–86

Baudelaire, Charles, 1975–6, *Œuvres complètes*, ed. Claude Pichois (Paris: Gallimard), 2 vols

Bhabha, Homi K., 1983, 'The Other Question ...', *Screen*, vol. 24, no. 6, pp. 18–36

Boime, Albert, 2008, *Revelations of Modernism: Responses to Cultural Crises in Fin-de-siècle Painting* (Columbia, MO and London: University of Missouri Press)

Bongie, Chris, 1991, *Exotic Memories: Literature, Colonialism and the Fin de Siècle* (Stanford, CA: Stanford University Press)

Bouge, L.-J., 1952, 'Introduction', in Gauguin 1952, pp. 7–16

Bourdieu, Pierre, 1994, 'The Link Between Literary and Artistic Struggles', trans. Elinor Dorday, in Peter Collier and Robert Lethbridge (eds), *Artistic Relations: Literature and the Visual Arts in Nineteenth-Century France* (New Haven and London: Yale University Press), pp. 30–39

Bouvier, Raphaël, and Martin Schwander (eds), 2015, *Paul Gauguin*, exh. cat., Fondation Beyeler, Riehen, Basel

Boyle-Turner, Caroline, 2016, *Paul Gauguin and the Marquesas: Paradise Found?* (Pont-Aven: Éditions Vagamundo)

Brettell, Richard, et al., 1988, *The Art of Paul Gauguin*, exh. cat., National Gallery of Art, Washington / Art Institute of Chicago

———2007, 'Gauguin and Paper. Writing, Copying, Drawing, Painting, Pasting, Cutting, Wetting, Tracing, Inking, Printing', in Eisenman 2007a, pp. 59–67

Brevik-Zender, Heidi, 2016, 'Family Matters: Mallarmé's *Gazette du monde et de la famille*', *Modern Language Review*, vol. 111, no. 3 (July), pp. 684–702

Bright, Michael, 1985, 'The Poetry of Art', *Journal of the History of Ideas*, vol. 46, no. 2 (April–June), pp. 259–77

Broadway, Mary, 2016, 'Gauguin, Cats. 106–121, *Le sourire*: All the Rage', in Groom and Westerby 2016

Brooks, Peter, 1993, *Body Work: Objects of Desire in Modern Narrative* (Cambridge, MA and London: Harvard University Press)

Broude, Norma (ed.), 2018a, *Gauguin's Challenge: New Perspectives After Postmodernism* (New York and London: Bloomsbury)

———2018b, 'Flora Tristan's Grandson: Reconsidering the Feminist Critique of Paul Gauguin', in Broude 2018a, pp. 69–100

Burnett, Robert, 1937, *The Life of Paul Gauguin* (New York: Oxford University Press)

Cahn, Isabelle, 2003, *Gauguin écrivain / Gauguin the Writer*, trans. Charles Penwarden, booklet in French and English accompanying the CD-ROM *Gauguin écrivain: Noa Noa, Diverses choses, Ancien Culte mahorie* (Paris: Réunion des Musées Nationaux)

———2004, '*Noa Noa*: The Voyage to Tahiti', in Shackelford and Frèches-Thory 2004, pp. 91–113

Childs, Elizabeth C., 2003, 'Gauguin as Author: Writing the Studio of the Tropics', *Van Gogh Museum Journal*, pp. 71–87

———2004, '"Catholicism and the Modern Mind": The Painter as Writer in Late Career', in Shackelford and Frèches-Thory 2004, pp. 223–41

———2013, *Vanishing Paradise: Art and Exoticism in Colonial Tahiti* (Berkeley, Los Angeles and London: University of California Press)

———2018, 'Taking Back Teha'amana: Feminist Interventions in Gauguin's Legacy', in Broude 2018a, pp. 229–49

Clifford, James, 1998, *The Predicament of Culture: Twentieth-Century Ethnography, Literature, and Art* (Cambridge, MA and London: Harvard University Press)

Cooke, Peter, 2003, *Gustave Moreau et les arts jumeaux* (Oxford and New York: Peter Lang)

Cooper, Douglas (ed.), 1983, *Paul Gauguin: 45 Lettres à Vincent, Théo et Jo van Gogh* (The Hague: Staatsuitgeverij)

Cotteau, Edmond, 1888, *En Océanie: voyage autour du monde en 365 jours, 1884–1885* (Paris: Hachette)

Couture, Thomas, 1867, *Méthodes et entretiens d'atelier* (Paris: Guérin)

Cummins, Linda, 2006, *Debussy and the Fragment* (Amsterdam and New York: Rodopi)

Daftari, Fereshteh, 1991, *The Influence of Persian Art on Gauguin, Matisse, and Kandinsky* (New York: Garland)

Dagen, Philippe, 2010, 'Gauguin's Politics', trans. Anna Hiddleston, in Thomson 2010a, pp. 40–47

D'Alleva, Anne, 2011, 'On 1890s Tahiti', in *Gauguin, Polynesia*, ed. Suzanne Greub, exh. cat., Ny Carlsberg Glyptotek, Copenhagen / Seattle Art Museum, pp. 174–87

Danielsson, Bengt, 1965, *Gauguin in the South Seas*, trans. Reginald Spink (London: G. Allen and Unwin)

———1975, *Gauguin à Tahiti et aux îles Marquises* (Papeete: Éditions du Pacifique)

Danielsson, Bengt, and Patrick O'Reilly, 1965, 'Gauguin journaliste à Tahiti et ses articles des *Guêpes*', *Journal de la Société des Océanistes*, vol. XXI (December), pp. 1–19, followed by a reprint of Gauguin's articles for *Les Guêpes*, pp. 20–53

De Bovis, Edmond, 1909, *État de la société tahitienne à l'arrivée des Européens* (Papeete: Imprimerie du Gouvernement; first published in the *Revue Coloniale*, 1855)

Delacroix, Eugène, 1893, *Journal de Eugène Delacroix, tome premier, 1823–1850, précédé d'une étude sur le Maître par M. Paul Flat, notes et éclaircissements par MM Paul Flat et René Piot* (Paris: Plon, 1893)

———2009, *Journal (1822–1857)*, ed. Michèle Hannoosh (Paris: José Corti), 2 vols

De Man, Paul, 1984, 'Autobiography as De-Facement' [1979], in *The Rhetoric of Romanticism* (New York: Columbia University Press), pp. 67–81

De Rotonchamp, Jean, 1925, *Paul Gauguin, 1848–1903* (Paris: Crès)

Dickson, Amy, 2010, 'Gauguin: A Very British Reception', in Thomson 2010a, pp. 64–9

Diderot, Denis, 1951, *Œuvres*, ed. André Billy (Paris: Gallimard)

Dietrich, Linnea S., 1991, 'Paul Gauguin's *Notebook for Aline*', *Art Criticism*, vol. 7, no. 1, pp. 60–66

Dorra, Henri, 2007, *The Symbolism of Paul Gauguin: Erotica, Exotica, and the Great Dilemmas of Humanity* (Berkeley, Los Angeles and London: University of California Press)

Dossier de la succession Paul Gauguin, 1957 (Papeete: Société des Études Océaniennes)

Draperi, Philippe, 1989, 'Gauguin et l'écriture', in Paule Laudon (ed.), *Rencontres Gauguin à Tahiti, Actes du colloque, 20 et 21 juin 1989* (Papeete: Aurea), pp. 64–70

Drell Reck, Rima, 1991, 'Gauguin écrivain', *The French Review*, vol. 64, no. 4 (March), pp. 632–42

Druick, Douglas W. and Peter Kort Zegers, 1991, 'Le Kampong et la pagode: Gauguin à l'exposition universelle de 1889', in *Gauguin: Actes du colloque Gauguin, Musée d'Orsay, 11–13 January 1889* (Paris: La Documentation Française), pp. 101–42

———2001, *Van Gogh and Gauguin: The Studio of the South*, exh. cat., Art Institute of Chicago / Van Gogh Museum, Amsterdam

Edmond, Rod, 1997, *Representing the South Pacific: Colonial Discourse from Cook to Gauguin* (Cambridge: Cambridge University Press)

———2002, 'The Pacific / Tahiti: Queen of the South Sea Isles', in Peter Hulme and Tim Youngs (eds), *The Cambridge Companion to Travel Writing* (Cambridge: Cambridge University Press), pp. 139–55

Eisenman, Stephen F., 1997, *Gauguin's Skirt* (London and New York: Thames and Hudson)

———2000, 'Anti-Imperial Primitivist: Paul Gauguin in Oceania', *Pacific Studies*, vol. 23, nos. 1–2 (March/June), pp. 111–28

———(ed.), 2007a, *Paul Gauguin: Artist of Myth and Dream*, exh. cat., Complesso del Vittoriano, Milan

———2007b, 'Paul Gauguin, Artist of Myth and Dream', in Eisenman 2007a, pp. 19–33

Fénéon, Félix, 1970, *Œuvres plus que complètès*, ed. Joan U. Halperin (Geneva: Droz), 2 vols

Ferlier-Bouat, Ophélie, 2017, 'The Alchemist and the Savage: Truth and Self-Reflection in Gauguin's Three-Dimensional Work', trans. Timothy Stroud, in Groom 2017, pp. 46–55

Field, Richard, 1960, 'Gauguin plagiaire ou créateur?', in *Gauguin*, texts by René Huyghe et al. (Paris: Hachette), pp. 138–69

———1977, *Paul Gauguin: The Paintings of the First Voyage to Tahiti* (New York: Garland)

Figura, Starr (ed.), 2014a, *Gauguin: Metamorphoses*, exh. cat., Museum of Modern Art, New York

———2014b, 'Gauguin's Metamorphoses: Repetition, Transformation, and the Catalyst of Printmaking', in Figura 2014a, pp. 15–35

Fontainas, André, 1899, 'Revue du mois: Art moderne', *Mercure de France*, vol. 29, no. 109 (January), pp. 235–42

Forsdick, Charles, 2000, *Victor Segalen and the Aesthetics of Diversity* (Oxford: Oxford University Press)

———2010, 'Gauguin and Segalen: Exoticism, Myth and the "Aesthetics of Diversity"', in Thomson 2010a, pp. 56–63

Foster, Hal, 2004, *Prosthetic Gods* (Cambridge, MA and London: MIT Press)

———2014, 'The Primitivist's Dilemma', in Figura 2014a, pp. 49–59

Frèches-Thory, Claire, 2004, 'The Paintings of the First Polynesian Sojourn', in Shackelford and Frèches-Thory 2004, pp. 17–45

Fry, Roger, 1918, 'On a Composition by Gauguin', *The Burlington Magazine*, vol. 32, no. 180 (March), p. 85.

Gamboni, Dario, 1989, 'Après le régime du Sabre le régime de l'homme de lettres: la critique d'art comme pouvoir et enjeu', in Jean-Paul Bouillon (ed.), *La critique d'art en France 1850–1900 (Actes du colloque Clermont-Ferrand)* (Saint-Étienne: Université de Saint-Étienne), pp. 205–20

———2003, 'Paul Gauguin's *Genesis of a Picture*: A Painter's Manifesto and Self-Analysis', *Nineteenth-Century Art Worldwide*, vol. 2, no. 3 <www.19thc-artworldwide.org/index.php/autumn03/274-paul-gauguins-genesis-of-a-picture-a-painters-manifesto-and-self-analysis> (accessed 14 June 2018)

———2011, *The Brush and the Pen: Odilon Redon and Literature*, trans. Mary Whittall (Chicago: University of Chicago Press)

———2013, 'Volcano equals head equals kiln equals phallus: Connecting Gauguin's metaphors of the creative act', *RES: Anthropology and Aesthetics*, no. 63/64, pp. 93–107

———2014, *Paul Gauguin: The Mysterious Centre of Thought*, trans. Chris Miller (London: Reaktion)

———2016a, 'Gauguin, Cats. 51–60, The *Noa Noa* Suite: "Veiled in a Cloud of Fragrance"', in Groom and Westerby 2016

———2016b, 'Gauguin, Cats. 61–3, Drawings for the *Noa Noa* Suite, 1893/94: Variation and Explication', in Groom and Westerby 2016

———2017, 'Paul Gauguin's Crucible of Forms', in Groom 2017, pp. 27–33

———2018, 'Gauguin and the Challenge of Ambiguity', in Broude 2018a, pp. 103–28

Garelick, Rhonda K., 1998, *Rising Star: Dandyism, Gender, and Performance in the Fin de Siècle* (Princeton: Princeton University Press)

Gates, Jr, Henry Louis, 1991, 'Critical Fanonism', *Critical Inquiry*, no. 17, pp. 457–70

Gauguin, Paul, 1889, 'Notes sur l'art: À l'Exposition Universelle', I and II, *Le Moderniste illustré*, nos. 11 and 12 (4 and 11 July) (Geneva: Slatkine Reprints, 1971), pp. 84–6, 90–91

---1894, 'Sous deux latitudes', *Essais d'art libre*, vol. 5 (May) (Geneva: Slatkine Reprints, 1971), pp. 75–80

---1895a, 'Armand Seguin', *Mercure de France* (February), pp. 222–4

---1895b, 'Une Lettre de Paul Gauguin à propos de Sèvres et du dernier four', *Le Soir* (25 April), p. 2

---1895c, 'Les peintres français à Berlin', *Le Soir* (1 May), p. 2

---1896–8, *Diverses choses* (Paris: Musée du Louvre, Département des Arts Graphiques, RF 7259, 1)

---15 January 1897, 'Lettre de Gauguin à Armand Seguin', Bibliothèque Nationale de France, Département des Manuscrits (NAF 14827)

---1910, 'Notes synthétiques' [1884–5], *Vers et Prose*, no. 22, pp. 51–5

---1923, *The Intimate Journals of Paul Gauguin* [1903], trans. Van Wyck Brooks (London: Heinemann)

---1924, *Noa Noa. Édition définitive* [1893–7] (Paris: Crès)

---1951, *Avant et après* [1903], facsimile (Copenhagen: Scripta / Poul Carit Andersen)

---1952, *Le Sourire de Paul Gauguin: collection complète en facsimile*, ed. L.-J. Bouge (Paris: Maisonneuve)

---1954, *Noa Noa* [1893], facsimile, ed. Berthe Sagot-Le Garrec (Paris: Sagot-Le Garrec)

---1963, *Cahier pour Aline* [1893], ed. Suzanne Damiron (Paris: Société des amis de la Bibliothèque d'art et d'archéologie de l'Université de Paris), 2 vols

---1966, *Noa Noa* [1893], ed. Jean Loize (Paris: André Balland)

---1974, *Oviri: Écrits d'un sauvage*, ed. Daniel Guérin (Paris: Gallimard)

---1985, *Noa Noa: Gauguin's Tahiti* [1893], ed. Nicholas Wadley, trans. Jonathan Griffin (Oxford: Phaidon)

---1987, *Noa Noa* [1893], facsimile, eds Gilles Artur, Jean-Pierre Fourcade and Jean-Pierre Zingg (Tahiti and New York: Association des Amis du Musée Paul Gauguin à Tahiti)

---1988, *Noa Noa* [1893], ed. Pierre Petit (Paris: Pauvert)

---1989, *À ma fille, Aline, ce cahier est dédié: notes éparses, sans suite comme les rêves, comme la vie toute faite de morceaux: journal de jeune fille*, ed. Victor Merlhès (Paris: Société des amis de la Bibliothèque d'art et d'archéologie / Bordeaux: William Blake), 2 vols

---1994a, *Avant et après* [1903], ed. Jean-Marie Dallet (Paris: Table Ronde)

---1994b, *Racontars de Rapin* [1902], facsimile, ed. Victor Merlhès (Taravao, Tahiti: Éditions Avant et après)

--- 1996, *The Writings of a Savage*, ed. Daniel Guérin, trans. Eleanor Levieux, with an Introduction by Wayne Andersen (New York: Da Capo Press)

---2001, *Ancien Culte mahorie* [1893], facsimile, ed. René Huyghe (Paris: Hermann; first published by La Palme, 1951)

---2003, *Racontars de rapin* [1902], ed. Bertrand Leclair (Paris: Mercure de France)

---2009, *Cahier pour Aline* [1893], ed. Philippe Dagen (Paris: Éditions du Sonneur)

---2016, *Ramblings of a Wannabe Painter* [1902], ed. and trans. Donatien Grau (New York: David Zwirner)

---2017, *Écrits sur l'art*, ed. Frédéric Chaleil (Paris: Éditions de Paris)

Gauguin, Paul, and Charles Morice, 1901, *Noa Noa* (Paris: Éditions de la Plume)

---1926, *Noa Noa* [1894–1901], facsimile (Berlin: R. Piper / Munich: Marées-Gesellschaft)

---1947, *Noa Noa* [1894–1901], facsimile (Stockholm: Jan Förlag)

---2017a, *Noa Noa* [1894–1901], ed. Claire Moran (Cambridge: Modern Humanities Research Association)

---2017b, *Noa Noa* [1894–1901], facsimile (Paris: Réunion des Musées Nationaux)

---2018, *Noa Noa. 4e édition (Éd. 1901)* (Paris: Hachette livre / BNF)

Gille, Vincent, 2010, 'The Last Orientalist: Portrait of the Artist as Mohican', trans. Anna Hiddleston and Nancy Ireson, in Thomson 2010a, pp. 48–55

Giraud, Vaiana, 2010, *Paul Gauguin écrivain: rôle et place de l'écrit dans son œuvre*, PhD Dissertation, Université de Poitiers

Goddard, Linda, 2008, '"The Writings of a Savage"? Literary Strategies in Paul Gauguin's *Noa Noa*', *Journal of the Warburg and Courtauld Institutes*, vol. LXXI, pp. 277–93

–––2009, 'Gauguin's Guidebooks: *Noa Noa* in the Context of Nineteenth-Century Travel Writing', in Francesca Orestano and Francesca Frigerio (eds), *Strange Sisters: Literature and Aesthetics in the Nineteenth Century* (Oxford and New York: Peter Lang), pp. 233–54

–––2010, '"Following the Moon": Gauguin's Writing and the Myth of the "Primitive"', in Thomson 2010a, pp. 32–9

–––2011, '"Scattered Notes": Authorship and Originality in Gauguin's *Diverses choses*', *Art History*, vol. 34, no. 2, pp. 352–69

–––2012a, *Aesthetic Rivalries: Word and Image in France, 1880–1926* (Oxford and New York: Peter Lang)

–––2012b, 'Artists' Writings: Word or Image?', *Word & Image*, vol. 27, no. 4, pp. 409–18

–––2018, 'Gauguin's Alter Egos: Writing the Other and the Self', in Broude 2018a, pp. 15–40

Gray, Christopher, 1963, *Sculpture and Ceramics of Paul Gauguin* (Baltimore: Johns Hopkins University Press)

Groom, Gloria (ed.), 2017, *Gauguin: Artist as Alchemist*, exh. cat., Art Institute of Chicago

Groom, Gloria, and Genevieve Westerby (eds), 2016, *Gauguin: Paintings, Sculpture, and Graphic Works at the Art Institute of Chicago*, with Mel Becker Solomon, texts by Richard R. Brettell, Dario Gamboni, Harriet K. Stratis, Peter Zegers et al. (Chicago: Art Institute of Chicago) <https://publications.artic.edu/gauguin/reader/gauguinart/section/139805> (accessed 1 June 2018)

Hamon, Philippe, 2001, *Imageries: littérature et image au XIXe siècle* (Paris: José Corti)

Hannoosh, Michèle, 1995, *Painting and the Journal of Eugène Delacroix* (Princeton: Princeton University Press)

Hargreaves, Alec, 1981, *The Colonial Experience in French Fiction: A Study of Pierre Loti, Ernest Psichari and Pierre Mille* (London: Macmillan)

Hargrove, June, 2017, *Gauguin* (Paris: Citadelles & Mazenod)

–––2018, '"All Men Could Be Buddhas": Paul Gauguin's Marquesan Diptych', in Broude 2018a, pp. 203–25

Harkness, Nigel, 2007, *Men of Their Words: The Poetics of Masculinity in Nineteenth-Century Fiction* (Leeds: Legenda)

Hauptman, Jodi (ed.), 2016, *Degas: A Strange New Beauty*, exh. cat., Museum of Modern Art, New York

Henrique, Louis, 1889, *Les Colonies Françaises: Tahiti, Îles Sous-le-Vent* (Paris: Maison Quantin)

Higonnet, Anne, 1992, 'Secluded Vision: Images of Feminine Experience in Nineteenth-Century Europe', in Norma Broude and Mary D. Garrard (eds), *The Expanding Discourse: Feminism and Art History* (New York: Harper Collins / Icon Editions), pp. 179–85

Hobbs, Richard, 1991, '*Avant et après*: Paul Gauguin aux Marquises', in Philippe Delaveau (ed.), *Écrire la peinture* (Paris: Éditions Universitaires), pp. 229–40

–––1996, 'L'apparition du peintre-écrivain', in Keith Cameron and James Kearns (eds), *Le Champ littéraire 1860–1900: études offertes à Michael Pakenham* (Amsterdam: Rodopi), pp. 127–37

–––2002, 'Reading Artists' Words', in Paul Smith and Carolyn Wilde (eds), *A Companion to Art Theory* (Oxford and Malden, MA: Blackwell), pp. 173–82

House, John, 2012, 'Working with Artists' Letters', *Word & Image*, vol. 28, no. 4, pp. 335–9

Hughes, Edward, 2001, *Writing Marginality in Modern French Literature: From Loti to Genet* (Cambridge: Cambridge University Press)

Huyghe, René, 1952, *Le Carnet de Paul Gauguin* (Paris: Quatre Chemins)

–––2001, 'La Clef de *Noa Noa*' [1951], in Gauguin 2001, pp. 3–31

Ives, Colta, and Susan Alyson Stein, 2002, *The Lure of the Exotic: Gauguin in New York Collections*, exh. cat., Metropolitan Museum of Art, New York

Janowitz, Anne, 1999, 'The Romantic Fragment', in *A Companion to Romanticism*, ed. Duncan Wu (Oxford: Blackwell), pp. 479–88

Jansen, Leo, Hans Luijten and Nienke Bakker (eds), 2009, *Vincent van Gogh – The Letters*, Version: December 2010 (Amsterdam and The Hague: Van Gogh Museum and Huygens ING) <www.vangoghletters.org> (accessed 25 June 2018)

Jirat-Wasiutynksi, Voytech, 1978, *Paul Gauguin in the Context of Symbolism* (New York and London: Garland)

Jolly, Margaret, 2000, 'Fraying Gauguin's Skirt: Gender, Race, and Liminality in Polynesia', *Pacific Studies*, vol. 23, nos. 1–2 (March/June), pp. 86–103

Joly-Segalen, Annie (ed.), 1950, *Lettres de Paul Gauguin à Georges-Daniel de Monfreid* (Paris: Georges Falaize)

Jullien, Dominique, 2009, 'Anecdotes, "Faits divers", and the Literary', *SubStance*, vol. 38, no. 1, pp. 66–76

Kahn, Gustave, 1924, 'Au temps du pointillisme', *Mercure de France*, no. 171 (1 April), pp. 5–22

Kearns, James, 1989, *Symbolist Landscapes: The Place of Painting in the Poetry and Criticism of Mallarmé and his Circle* (London: Modern Humanities Research Association)

Kris, Ernst, and Otto Kurz, 1979, *Legend, Myth and Magic in the Image of the Artist: A Historical Experiment* [1934] (New Haven and London: Yale University Press)

Ky Dong (Nguyen Van Cam), 1989, *Les Amours d'un Vieux Peintre aux Îles Marquises* [1901?], ed. Jean-Charles Blanc (Paris: A Tempera)

Larson, Barbara, 2005, *The Dark Side of Nature: Science, Society and the Fantastic in the Work of Odilon Redon* (University Park, PA: Pennsylvania State University Press)

———2018, 'Gauguin: Vitalist, Hypnotist', in Broude 2018a, pp. 179–202

Le Bronnec, Guillaume, 1956, 'Les dernières années', *Gazette des Beaux-Arts* (January–April), pp. 189–200

Le Chartier, Henri, 1887, *Tahiti et les colonies françaises de la Polynésie* (Paris: Combet)

Le Men, Ségolène, 1987, 'Quelques définitions romantiques de l'album', *Art et métiers du livre*, no. 143 (January), pp. 40–47

Loize, Jean, 1961, 'Post-Script: The Real *Noa Noa* and the Illustrated Copy', in Paul Gauguin, *Noa Noa: Voyage to Tahiti*, trans. Jonathan Griffin (Oxford: Bruno Cassirer), pp. 57–70

———1966, 'Gauguin sous le masque ou cinquante ans d'erreur autour de *Noa Noa*', in Gauguin 1966, pp. 66–137

Loti, Pierre, 1928, *Le Mariage de Loti* [1880] (Paris: Calmann-Lévy)

———2002, *The Marriage of Loti* [1880], trans. Clara Bell (London: Kegan Paul)

Lyu, Claire, 2000, 'Stéphane Mallarmé as Miss Satin: The Texture of Fashion and Poetry', *L'Esprit Créateur*, vol. 40, no. 3 (Fall), pp. 61–71

Mainardi, Patricia, 2017, *Another World: Nineteenth-Century Illustrated Print Culture* (New Haven and London: Yale University Press)

Malingue, Maurice (ed.), 1946, *Paul Gauguin: Lettres à sa femme et à ses amis* (Paris: Bernard Grasset)

Mallarmé, Stéphane, 1978, *La Dernière Mode: Gazette du monde et de la famille* [1874] (Paris: Éditions Ramsay, 1978)

———1998–2003, *Œuvres complètes*, ed. Bertrand Marchal (Paris: Gallimard), 2 vols

Manceron, Gilles, 2004, 'Koké and Tépéva: Victor Segalen in Gauguin's Footsteps', in Shackelford and Frèches-Thory 2004, pp. 273–83, 332–6

Mathews, Patricia, 1999, *Passionate Discontent: Creativity, Gender, and French Symbolist Art* (Chicago: University of Chicago Press)

Matsuda, Matt K., 2005, *Empire of Love: Histories of France and the Pacific* (Oxford: Oxford University Press)

Maubon, Catherine, 1991, 'Noa Noa: une fable exotique', *Littérature*, no. 81, pp. 19–46

———1995, 'Paul Gauguin: les mots du peintre', in Brunella Eruli (ed.), *L'obiettivo e la parola* (Pisa: ETS / Geneva: Slatkine), pp. 61–73 <www.filologiafrancese.it/wp-content/uploads/2015/06/11-5.pdf> (accessed 13 June 2018)

Mayne, Jonathan (ed. and trans.), 1995, *Charles Baudelaire: The Painter of Modern Life and Other Essays* (London: Phaidon)

Merlhès, Victor (ed.), 1984, *Correspondance de Paul Gauguin, 1873–88* (Paris: Fondation Singer-Polignac), vol. 1

–––(ed.), 1989a, *Paul Gauguin et Vincent van Gogh, 1887–1888: Lettres retrouvées, sources ignorées* (Taravao, Tahiti: Éditions Avant et après)

–––1989b, '"Le Cahier pour Aline": Histoire et signification', vol. 1 in Gauguin 1989

–––1994, 'Art de Papou et Chant de rossignoou: la lutte pour les peintres', in Gauguin 1994b, pp. 1–112

–––(ed.), 1995, *De Bretagne en Polynésie: pages inédites* (Taravao, Tahiti: Éditions Avant et après)

Mockel, Albert, 1962, *Esthétique du symbolisme*, ed. Michel Otten (Brussels: Palais des académies)

Moerenhout, Jacques-Antoine, 1837, *Voyages aux îles du grand océan* (Paris: Arthus Bertrand), 2 vols

Monchoisy (M. Mativet), 1888, *La Nouvelle Cythère* (Paris: Charpentier, 1888)

Monnier, Henry, 1832, 'La manie des albums', in *Paris ou le livre des cent-en-un* (Paris: Ladvocat), vol. 5, pp. 199–207

Moran, Claire, 2017, *Staging the Artist: Performance and the Self-Portrait from Realism to Expressionism* (London and New York: Routledge)

Morehead, Allison, 2014, 'Understanding and Translating: Gauguin and Strindberg in 1895', *Nineteenth-Century Art Worldwide*, vol. 13, no. 1 <www.19thc-artworldwide.org/spring14/morehead-on-gauguin-and-strindberg-in-1895> (accessed 23 May 2018)

Morice, Charles, 1920, *Paul Gauguin* [1919] (Paris: Floury)

Motherwell, Robert, 1999, *The Collected Writings of Robert Motherwell*, ed. Stephanie Terenzio (Berkeley, Los Angeles and London: University of California Press)

Mowll Mathews, Nancy, 2001, *Paul Gauguin: An Erotic Life* (New Haven and London: Yale University Press)

O'Rourke, Stephanie, 2016, 'The Singular Multiple', in Hauptman 2016, pp. 56–9

Palermo, Charles, 2015, *Modernism and Authority: Picasso and His Milieu around 1900* (Oakland, CA: University of California Press)

Parkinson, Gavin, 2018, *Enchanted Ground: André Breton, Modernism, and the Surrealist Appraisal of Fin-de-Siècle Painting* (New York: Bloomsbury)

Perelman, Allison, 2017, '"The Burning Yellow Atelier"', in Groom 2017, pp. 65–71

Piron, Eugène, 1865, *Delacroix, sa vie et ses œuvres* (Paris: Jules Claye)

Pissarro, Camille, 1950, *Lettres à son fils Lucien* (Paris: Plon)

Pollock, Griselda, 1992, *Avant-Gambits 1888–1893: Gender and the Colour of Art History* (London: Thames and Hudson)

Reff, Theodore, 1976, *The Notebooks of Edgar Degas: A Catalogue of the Thirty-Eight Notebooks in the Bibliothèque Nationale and Other Collections* (Oxford: Clarendon Press), 2 vols

Regnault, Martine, 2005, *Paul Gauguin: La trace écrite* (Dijon: Éditions Universitaires de Dijon)

Rosen, Charles, and Henri Zerner, 1984, *Romanticism and Realism: The Mythology of Nineteenth-Century Art* (New York: Viking Press)

Sadler, Michael T. H., 1911, 'L'Esprit veille', *Rhythm: Art Music Literature Quarterly*, vol. 1, no. 3, pp. 29–32

Schlick, Yaël Rachel, 2002, 'Introduction', in Segalen 2002, pp. 1–6

Scott, David, 1988, *Pictorialist Poetics* (Cambridge: Cambridge University Press)

Segalen, Victor, 1986, *Essai sur l'exotisme: une esthétique du divers* [1904–18] (Paris: Livre de Poche)

–––1989, *Journal des îles, suivi de vers les sinistrés* (Fontfroide: Bibliothèque artistique et littéraire)

–––2002, *Essay on Exoticism: An Aesthetics of Diversity* [1904–18], ed. and trans. Yaël Schlick (Durham, NC and London: Duke University Press)

–––2003, *Le Maître-du-Jouir* [1907–16], in Victor Segalen, *Hommage à Gauguin, l'insurgé des Marquises*, ed. Jean-Luc Coatalem (Paris: Magellan), pp. 69–130

Shackelford, George T. M., 2004, 'Where do we come from? What are we? Where are we going?', in Shackelford and Frèches-Thory 2004, pp. 167–221

Shackelford, George T. M., and Claire Frèches-Thory (eds), 2004, *Gauguin Tahiti: The Studio of the South Seas*, exh. cat., Grand Palais, Paris / Museum of Fine Arts, Boston

Sherman, Daniel J., 2011, *French Primitivism and the Ends of Empire, 1945–1975* (Chicago and London: University of Chicago Press)

Silverman, Debora, 2000, *Van Gogh and Gauguin: The Search for Sacred Art* (New York: Farrar, Straus and Giroux)

Simpson, Juliet, 2009, 'Relative Values? Ideas of "Real" and "Symbolic" Worth in *Fin-de-Siècle* Art Criticism', in Carol Adlam and Juliet Simpson (eds), *Critical Exchange: Art Criticism of the Eighteenth and Nineteenth Centuries in Russia and Western Europe* (Oxford and New York: Peter Lang), pp. 99–112

Sloan, Rachel, 2012, 'Word into image: Maurice Denis, "Les Amours de Marthe", and *Amour*', *Word & Image*, vol. 28, no. 4, pp. 348–58

Solomon-Godeau, Abigail, 1992, 'Going Native: Paul Gauguin and the Invention of Primitivist Modernism' [1989], in Norma Broude and Mary D. Garrard (eds), *The Expanding Discourse: Feminism and Art History* (New York: Harper Collins / Icon Editions), pp. 315–29

–––2007, 'Dreams of Happiness, Chimeras of Pleasure: Polynesia in the French Visual Imaginary', in Eisenman 2007a, pp. 69–79

Staszak, Jean-François, 2003, *Géographies de Gauguin* (Rosny-sous-Bois: Bréal)

Stotland, Irina, 2018, 'Paul Gauguin's Self-Portraits in Polynesia: Androgyny and Ambivalence', in Broude 2018a, pp. 41–67

Stratis, Harriet K., 2017, 'Disrupting Convention: Gauguin's Unique Multiples and Transfers', in Groom 2017, pp. 34–45

Stuckey, Charles, 1988, 'The First Tahitian Years', in Brettell et al. 1988, pp. 210–16

Sturgis, Alexander, et al., 2006, *Rebels and Martyrs: The Image of the Artist in the Nineteenth Century*, exh. cat., National Gallery, London

Susini-Anastopoulos, Françoise, 1997, *L'Écriture fragmentaire: définitions et enjeux* (Paris: Presses Universitaires de France)

Sweetman, David, 1995, *Paul Gauguin: A Complete Life* (London: Hodder and Stoughton)

Teilhet-Fisk, Jehanne, 1983, *Paradise Reviewed: An Interpretation of Gauguin's Polynesian Symbolism* (Ann Arbor: University of Michigan Research Press)

Thomas, Greg, 2002, 'Instituting Genius: The Formation of Biographical Art History in France', in Elizabeth Mansfield (ed.), *Art History and its Institutions: Foundations of a Discipline* (London and New York: Routledge), pp. 260–70

Thomson, Belinda, 1993, 'Paul Gauguin: Interpreting the Words', in Belinda Thomson (ed.), *Gauguin by Himself* (London: Little, Brown), pp. 7–9

–––2003, 'A Frenchman and a Scot in the South Seas: Paul Gauguin and Robert Louis Stevenson', *Van Gogh Museum Journal*, pp. 56–69

–––(ed.), 2010a, *Gauguin: Maker of Myth*, exh. cat., Tate Modern, London

–––2010b, 'Paul Gauguin: Navigating the Myth', in Thomson 2010a, pp. 10–23

–––2016, 'The Conflicted Status of Narrative in the Art of Paul Gauguin', in Peter Cooke and Nina Lübbren (eds), *Painting and Narrative from Poussin to Gauguin* (Oxford and New York: Routledge), pp. 176–89

Vance, Mary Lynn Zink, 1986, *Gauguin's Polynesian Pantheon as a Visual Language*, PhD Dissertation, University of California at Santa Barbara

Verdier, Philippe, 1985–6, 'Un manuscrit de Gauguin: L'Esprit moderne et le catholicisme', *Wallraf-Richartz Jahrbuch*, vol. 46–7, pp. 273–98, followed by his annotated transcription of Gauguin's manuscript *L'Esprit moderne et le catholicisme*, pp. 299–328

Vouitsis, Elpida, 2016, *The Disruptions of Meaning in Paul Gauguin's Texts and Works of Art*, PhD Dissertation, University of Texas at Dallas

Wadley, Nicholas, 1985, 'The Facts and Fictions of *Noa Noa*', in Gauguin 1985, pp. 83–149

Waldroup, Heather, 2018, 'Re-Possessing Gauguin: Material Histories and the Contemporary Pacific', in Broude 2018a, pp. 251–74

Walker, David H., 1995, *Outrage and Insight: Modern French Writers and the 'Fait Divers'* (Oxford: Berg)

Wallace, Lee, 2003, *Sexual Encounters: Pacific Texts, Modern Sexualities* (Ithaca and London: Cornell University Press)

Wettlaufer, Alexandra K., 2007, 'She is Me: Tristan, Gauguin, and the Dialectics of Colonial Identity', *The Romanic Review*, vol. 98, no. 1, pp. 23–50

Whistler, James McNeill, 2004, 'Mr Whistler's "10 O'Clock", 20 February 1885', in *Whistler on Art*, ed. Nigel Thorp (Manchester: Carcanet Press), pp. 74–95

White, Harrison, and Cynthia White, 1993, *Canvases and Careers: Institutional Change in the French Painting World* [1965] (Chicago and London: University of Chicago Press)

Wright, Alastair, 2010, 'Paradise Lost: Gauguin and the Melancholy Logic of Reproduction', in Wright and Brown 2010, pp. 49–99

–––2018, 'On Not Seeing Tahiti: Gauguin's *Noa Noa* and the Rhetoric of Blindness', in Broude 2018a, pp. 129–56

Wright, Alastair, and Calvin Brown, 2010, *Gauguin's Paradise Remembered: The Noa Noa Prints*, exh. cat., Princeton University Art Museum

Wrigley, Richard, 1995, *The Origins of French Art Criticism: From the Ancien Régime to the Restoration* (Oxford: Clarendon Press)

Index

ACKNOWLEDGEMENTS

I would like to thank the many people and institutions that have supported my research on Gauguin over the years. The late John House offered encouragement from the beginning, while Christopher Green, Richard Hobbs and Peter Read have always been generous with their time and help. I began this project as a British Academy postdoctoral fellow at the Courtauld Institute of Art and the University of St Andrews. A year spent as a Louise and John Steffens Founders' Circle Member in the School of Historical Studies at the Institute for Advanced Study (IAS) in Princeton was vital to my progress, and recently a Paul Mellon Visiting Senior Fellowship at the Center for Advanced Study in the Visual Arts (CASVA) at the National Gallery of Art, Washington, DC, enabled me to complete the manuscript in the most stimulating setting.

Like anyone who writes on Gauguin, I have greatly benefited from the wealth of existing research. I thank those scholars in the field with whom I have been able to talk about Gauguin in person, including Elizabeth C. Childs, Richard Field, Starr Figura, Paul Galvez, Gloria Groom, June Hargrove, Richard Hobbs, Cornelia Homburg, Nancy Ireson, Claire Moran, Mary Morton, Charles Palermo, Gavin Parkinson, Belinda Thomson, Heather Waldroup, Alastair Wright and Marnin Young. Norma Broude's invitation to contribute to her edited volume, *Gauguin's Challenge*, helped me shape the argument in my book. Particular thanks are due to Liz Childs, who has been a great source of support and whose generosity and scholarship are inspiring in equal measure. I am very grateful to two pairs of anonymous peer reviewers: those who read the proposal and those who supplied detailed and constructive comments on the manuscript, and helped me to see aspects of it in new ways.

At the University of St Andrews, I thank all my colleagues in the School of Art History, especially Luke Gartlan, Julian Luxford, Stephanie O'Rourke, Alistair Rider, Sam Rose and Catherine Spencer, who either read parts of my work in progress, or generally made the task of completing it less daunting. Marika Knowles brought her expertise and editorial eye to parts of the manuscript, for which I am very grateful. My writing group – Kate Ferris, Caron Gentry, Emily Michelson and Catherine O'Leary – provided motivation and moral support.

The communities of scholars at both the IAS and CASVA are unparalleled: I cannot mention individually all the people from whose kindness and intelligence I benefited, but particular thanks to Sarah Betzer, Yve-Alain Bois, Dan Burt, Suzannah Clark, Michael Cole, Sheila Crane, Elizabeth Cropper, Vincent Debiais, Louise Dolan, Marilyn Aronberg Lavin, the late Irving Lavin, Rachel Grace Newman and Alex Potts. Michelle Foa was a wonderful interlocutor and generous reader at a point when the end was in sight but seemed difficult to reach.

A warm thank you to Sophie Neve at Yale University Press for her interest in this project and for keeping me on schedule so sympathetically; Sophie Oliver for her judicious comments on early chapters, which helped to sharpen and streamline my argument; Lise Connellan for her meticulous copy-editing; Faye Robson for bringing everything together so brilliantly; Georgia Vaux for her beautiful design; and everyone at Yale who made the process so enjoyable and efficient. Andrew Demetrius at St Andrews provided vital help with the picture research. Staff at museums and libraries have been accommodating in answering queries and providing access to their resources.

In addition to friends mentioned above, Grace Brockington, Claire Broderick, Ariane Fennetaux, Gwen Jeans, Sara Lodge, Lorenzo Martelli, Jenny Piening, Julia Prest, Kate Quinn, John-Paul Stonard, Aurélie Verdier and Teresa Watkins all make life more fun. For their love and support, I thank my parents Helen and Peter Goddard and brother Michael, as well as Pamela, Timothy, Helen and Mary Rider, and Claude Piening. My partner Alistair read the whole text and enabled me to see the wood for the trees at several challenging moments. He and our daughter Astrid gave me the time and space I needed to finish this book, and were also the best distractions from it.

Picture Credits

Fig. 1 The Art Institute of Chicago, Print Sales Miscellaneous Fund, 1947.685

Figs 7, 8, 9, 10, 11, 14, 31, 34, 35, 40, 41, 42, 43, 44, 45, 46, 48, 54, 59, 69 Photo © RMN-Grand Palais (musée d'Orsay)/Hervé Lewandowski

Figs 12, 15, 16, 23, 53, 57 Bibliothèque numérique de l'INHA – Bibliothèque de l'Institut National d'Histoire de l'Art, Paris, Collections Jacques Doucet

Fig. 13 (recto) Gift of Abby Aldrich Rockefeller (by exchange), Vincent d'Aquila and Harry Soviak Bequest Fund (by exchange), and acquired through the generosity of The Abby Aldrich Rockefeller Endowment for Prints, Carol O. Selle (by exchange), Sue and Edgar Wachenheim III, Mary M. Spencer, and Stephen F. Dull. Acc. no.: 860.2013.a-b New York Museum of Modern Art (MoMA). © 2019. The Museum of Modern Art, New York/Scala, Florence

Fig. 17 The Artchives/Alamy Stock Photo

Fig. 18 Photo © RMN-Grand Palais (musée d'Orsay)/Thierry Le Mage

Fig. 19 Wildenstein 561. Tompkins Collection – Arthur Gordon Tompkins Fund 36.270. Photograph © 2019 Museum of Fine Arts, Boston

Fig. 20 Gray 076. Arthur Tracy Cabot Fund, 57.582. Photograph © 2019 Museum of Fine Arts, Boston

Fig. 21 Collection Albright-Knox Art Gallery, Buffalo, New York, A. Conger Goodyear Collection, 1965

Fig. 22 By permission of Ny Carlsberg Glyptotek, Copenhagen (MIN 1828). Photo: Ole Haupt

Fig. 23 Photo: akg-images/Erich Lessing

Fig. 25 Anonymous Gift. Photograph © 2019 Museum of Fine Arts, Boston

Fig. 27 Gift of Jean Schmit, 1938, OA 9050. Photo © RMN-Grand Palais (musée d'Orsay)/Hervé Lewandowski

Fig. 29 © The Samuel Courtauld Trust

Fig. 30 Ordrupgaard, Copenhagen.Photo: Anders Sune Berg

Fig. 32 The Art Institute of Chicago, Gift of Mr. and Mrs. Charles Deering McCormick

Figs 47, 49 and frontispiece Photo © RMN-Grand Palais (musée d'Orsay)/Stéphane Maréchale

Figs 50, 51, 52, 72, 73 Bibliothéque nationale de France

Fig. 55 The Art Institute of Chicago, Mr. and Mrs. Carter H. Harrison Collection, 1948.418

Fig. 56 Saint Louis Art Museum. Gift of Vincent L. Price Jr., in memory of his parents, Marguerite and Vincent L. Price 287:1948

Fig. 58 Photo © musée du quai Branly - Jacques Chirac, Dist. RMN-Grand Palais/image musée du quai Branly - Jacques Chirac

Fig. 60 Photo © RMN-Grand Palais (musée d'Orsay)/Jean-Gilles Berizzi

Fig. 65 The Art Institute of Chicago, Gift of Edward McCormick Blair, 2002.243

Fig. 66 The Art Institute of Chicago, Clarence Buckingham Collection, 1951.37

Fig. 67 The Art Institute of Chicago, Mr. and Mrs. Carter H. Harrison Collection, 1948.420

Fig. 68 The Art Institute of Chicago, Mr. and Mrs. Carter H. Harrison Collection, 1948.421

Fig. 71 Ackland Art Museum, The University of North Carolina at Chapel Hill. Burton Emmett Collection, 58.1.233